650
5-85
X

Ruskin's Venice

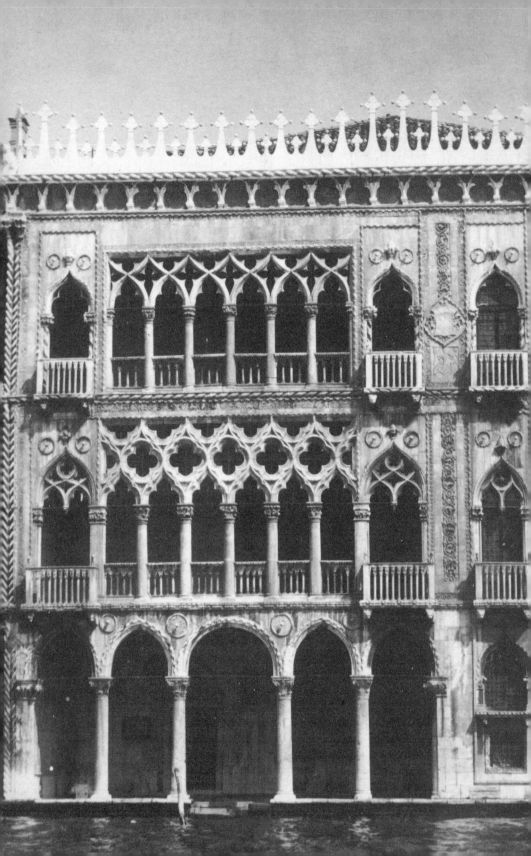

RUSKIN'S
VENICE

Editor
ARNOLD WHITTICK

Preface by
SIR ASHLEY CLARKE
Vice-Chairman: Venice in Peril Fund

THE WHITNEY LIBRARY OF DESIGN

First published in the United States in 1976
by Watson-Guptill Publications,
a division of Billboard Publications, Inc.,
1515 Broadway, New York, New York 10036
The Whitney Library of Design is an imprint of Watson-Guptill Publications

First published in Great Britain in 1976
by George Godwin Limited
2-4 Catherine Street, London WC2

Manufactured in Great Britain by
The Garden City Press Limited
Letchworth, Hertfordshire SG6 1JS

Library of Congress Cataloging in Publication Data

Ruskin, John, 1819–1900.
 Ruskin's Venice.

 "Edited for the modern traveller from [the author's]
The stones of Venice."
 Bibliography: p. 307
 Includes index.
 1. Architecture—Venice—Guide-books. 2. Art,
Venetian. 3. Venice—Description—Guide-books.
I. Whittick, Arnold, 1898– II. Ruskin, John,
1819–1900. The stones of Venice. III. Title.
NA1121.V4R7 1976 914.5'31 76–12351
ISBN 0-8230-7445-5

Contents

Preface

BY SIR ASHLEY CLARKE, GCMG, GCVO

Vice-Chairman of the Venice in Peril Fund
Formerly British Ambassador in Rome

Long before I chose to make my home in Venice and serve it as best I could, I read Ruskin's 'effectual blows' in the long forgotten 'Battle of the Styles'. When Arnold Whittick told me of his intention to make Ruskin's writings on Venice more accessible to the modern reader, I was happy to give him encouragement and to provide some notes on the present-day problems of Venice.

Ruskin complained that no one believed a word he said, though everybody praised his manner of saying it, and although this may be one of his characteristic exaggerations it is true that the imagery and forcefulness of his prose continue to give pleasure long after some of his strongly held convictions have been shown to be ill-founded and his battle against 'this pestilent art of the Renaissance' has been irretrievably lost.

All good anthologies provoke a very personal response from individual readers and if I (or anyone else, for that matter) were to re-read Ruskin's *Stones of Venice* and select the passages we most wanted to present to the modern reader they would not necessarily be the same as those appearing in this book.

My part has simply been to make a number of suggestions concerning the current physical problems of the city and the restoration work which has lately been undertaken. Together with other readers I prefer to savour the edited extracts of Ruskin and reserve the right to say that, in all probability, I would have done it differently.

No one has written more critically, even virulently, than Ruskin about the restoration of works of art, which for him was equivalent to their total destruction. But one is not obliged to conclude that therefore he would have disapproved of the activities of Venice in Peril and the other organizations which are doing so much to preserve Venice today. What he was inveighing against was the contemporary habit of what he called 'painting over' a picture or substituting for the worn surface of a piece of sculpture or architecture some imagined or 'copied' finish. So when he said (in the

Seven Lamps of Architecture) '. . . it is *impossible*, as impossible as to raise the dead, to restore anything that ever has been great or beautiful in architecture', he was referring specifically to the nineteenth century conception of restoration, which was indeed often mischievous and arrogant.

Ruskin well knew the paramount need to care for and preserve precious works of art. Repairs, he wrote himself, were 'in many instances necessary'. Though in one passage he speaks of a 'sullen cloud of black smoke brooding over the northern part' of Venice, he did not perhaps foresee how grave would be the effects of industrial pollution in the twentieth century. But it is clear that in nature he apprehended it. Speaking of the Swiss mountains and lakes (in *The Queen of the Air*) he said: '. . . the air which once inlaid the cleft of their golden crags with azure is now inlaid with languid coils of smoke, belched from worse than volcanic fires; . . . the waters that once sank at their feet into crystalline rest are now dimmed and foul'. This could well have been prophetic of the conditions in Venice with which those who love her now actively contend. The modern approach to restoration has been above all to clean, consolidate and protect; and in so doing to reveal the spirit and intention of the creators of works of art; and further to accept genuine accretions of later centuries but to eliminate arbitrary interpretations or distortions of the original. This means no 'painting over' and precious little Viollet-Le-Duc.

Thus the restorations of recent years in Venice have been aimed at permitting the observer to see what Ruskin saw and even what Ruskin, by the 'charities of the imagination', could only guess at and would have been happy to see had it not been obscured by time and dirt from his view.

This is what makes a new version of *The Stones of Venice* opportune at the present time. What Ruskin wrote of Tintoretto's great 'Crucifixion' in the Scuola di S. Rocco—'beyond all analysis and above all praise'—now has a significance which was much less evident thirty years ago when I saw it for the first time. The purple passage about the 'Last Judgment' in the Madonna dell'Orto now comes alive in a way which would scarcely have been possible barely ten years ago.

Of course, there are also inexplicable gaps. Of S. Nicoló del Lido it is understandable, that from his point of view, Ruskin should have decreed it 'of no importance': but how did he overlook S. Nicoló dei Mendicoli, now revealed as a result of restoration to be one of the most characteristic and interesting of Venetian churches?

It is the lagoon—neither lake nor sea, but partaking of the nature of both—which makes Venice unique: not only because it surrounds the city on all sides but also because of its characteristics compounded of mystery and melancholy and constant movement. It still exists because the doges, in mediaeval times, determined that it must at all costs be preserved.

The Napoleonic destruction of the ducal system of administration, in-

cluding the strict control of the lagoon by the Magistrature of the Waters, meant that by the time of Ruskin's visits in the mid-nineteenth century the lagoon had largely silted up. So much so that Ruskin speaks of the city as 'standing in a dark plain of sea-weed' at the complete ebb tide. Today the risk is just the opposite owing to the sinking of Venice, the widening of the entrances and dredging—some of it injudicious—in order to allow large ships to enter. The disastrous flood of November 1966 put Italy and the world on notice that the sea and the lagoon might one day engulf the city.

The reaction in Italy and the world has been salutary and it is permissible to be somewhat more sanguine of the future than Ruskin was. If Venice were simply a fossilization of the architecture of Europe during the past thousand years it would be remarkable enough. But, so far from being a fossil or some kind of overgrown museum, it is a living modern city and the plans of the Italian authorities, as set forth in the Special Law of 1973, are designed to keep it so. I *think* Ruskin would have been pleased.

ASHLEY CLARKE
Venice
January 1976

Acknowledgments

In the pleasurable compilation of this guide I am conscious of indebtedness to several persons for assistance, particularly to Sir Ashley Clarke for information relating to the causes of the flooding, sinking and pollution of Venice and measures to overcome them; to Joyce Plesters of the Scientific Department of the National Gallery, regarding the restoration of some of the Tintorettos in Venice; to Dr Lorenzo Lazzarini of the Laboratory of S. Gregorio, for information about the stone used in the building of Venice; to Mr J. G. Links, Hon Treasurer of the Venice in Peril Fund, for looking at the proofs and for many helpful suggestions; to Mrs Humphrey Brooke, Hon Secretary of the Venice in Peril Fund who gave useful information on several matters; to Diana Kaley, Associate Director of the Information Centre in Venice of the International Fund for Monuments, New York, for much assistance during a recent visit to Venice; to Mr James S. Dearden for facilitating the reproduction of Ruskin's water colour drawing of Ca' d'Ore, which is now in the Ruskin Galleries at Bembridge (Isle of Wight) of which Mr Dearden is curator; to my wife who sympathetically accompanied me on my visits to Venice and who helped with notes; and to Julia Burden, of George Godwin Ltd, who gave valuable assistance in obtaining information from various sources, and for taking many photographs for illustration.

ARNOLD WHITTICK
Crawley
January 1976

Sources for illustrations

Architectural Association: 110

Azienda Autonoma di Soggiorno e Torismo, Venezia: pages 114, 131, 200, 289

Osvaldo Böhm: pages 17, 35, 128, 129, 187, 194, 220, 221, 222, 228, 231, 233, 236, 239, 242, 245, 283, 291

Julia Burden: pages 15, 30, 37, 40, 43, 58, 59, 62, 66, 71, 72, 74, 75, 78, 82, 84, 86, 88, 96, 116, 119, 133, 143, 145, 151, 153, 159, 169, 171, 186, 193, 205, 206, 208 (right), 214, 253, 254, 259 and also the frontispiece.

Italian State Tourist Office, London: pages 7, 44, 277, 283, 290, 292

National Gallery, London: pages 33, 215

National Portrait Gallery, London: page 2

Pamela Poulter: pages xiv-xv, 295

John Ruskin: pages 28, 46, 53, 64, 99, 101, 109, 111, 118, 168, 173, 177, 179, 191, 203, 207, 209, 265, 267, 272, 273, 282, 285

Arnold Whittick: pages 50, 68, 208 (left), 210, 269

Key to map

The main buildings given in the 'Venetian Index' are marked on the map of Venice overpage. This is not intended as a substitute for a good street map but should be used in conjunction with one.

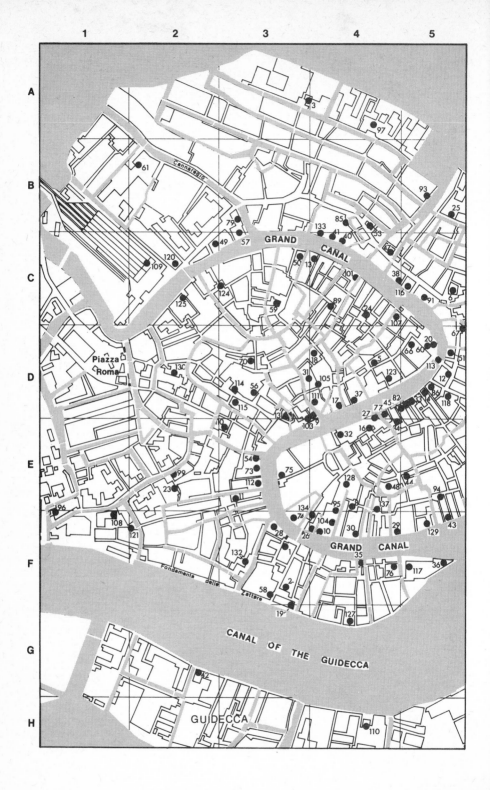

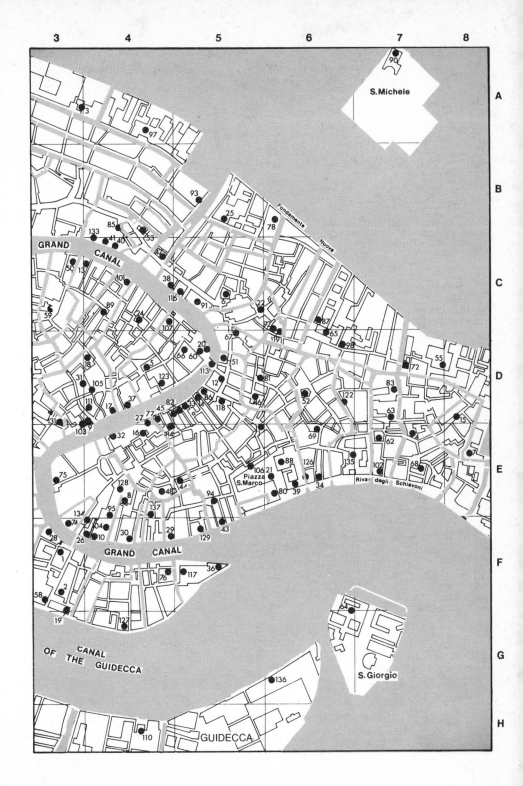

Editor's introduction

Before my first visit to Venice many years ago I looked at many guide books and took with me two very well-known ones. I also took Ruskin's *The Stones of Venice* and, appropriately, stayed in the house where he had lived in 1877.* I conscientiously began looking at the architecture, sculpture and paintings, and although I found the two guides factually useful, my constant companion was the 'Venetian Index' from *The Stones of Venice*, which I found both instructive and stimulating. Later I came to believe that here was, as far as I knew, the best guide to Venice in English literature.

Although the 'Venetian Index' is much more subjective than the usual guide book, with a strong expression of likes and dislikes, this in itself is stimulating, for Ruskin's comments can be useful and can be enjoyed even though one may not always agree with them. I, for one, cannot always agree with his criticisms of Renaissance architecture, but they are preferable to the conventionally reiterated praise of the average guide book. For the most part Ruskin praises and criticizes justly and searchingly, while *The Stones of Venice* contains some of the finest architectural appraisals and analyses of paintings, especially of the Tintorettos, that have been written. This is borne out by the value placed on the work by historians of art and architecture. For example, Edoardo Arslan in his *Gothic Architecture in Venice* (English edition 1971), one of the most thorough recent books on the subject, says that 'the "orders" established more than a century ago by Ruskin to distinguish the successive phases of Venetian secular Gothic have not, even today, lost much of their validity'. Again in speaking of Ruskin's sequence for establishing the evolution of forms from the progressive enrichment of motifs, Arslan sees 'no reason to give up in this treatment the use of a terminology (aiming to define the propounding of variants in time and also in space) which has shown itself until today to be the clearest'. This testimony to the analysis and classification of architectural forms and enrichment in *The Stones of Venice* by one of the chief modern authorities on the subject indicates that Ruskin's work is as serviceable today as when it was written.

* On the Zattere and now La Calcina, a *pensione*.

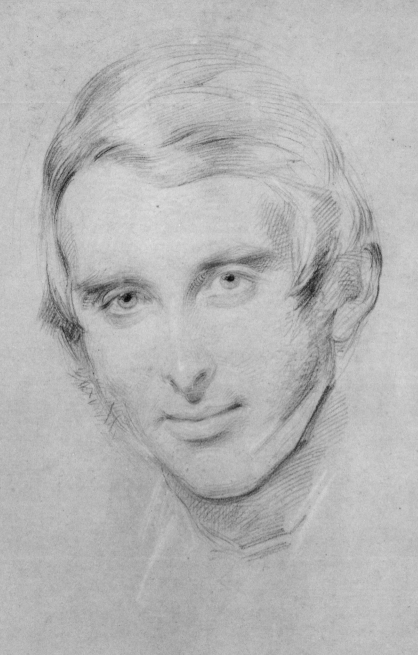

Portrait of John Ruskin by George Richmond, drawn about 1857, a few years after publication of *The Stones of Venice* (National Portrait Gallery, London).

The Stones of Venice

In the appreciation of the architecture, sculpture and painting of Venice, *The Stones of Venice* was in many respects a pioneer work. Shelley, Byron and others had taken a romantic interest in the city, but Ruskin more than any inspired enthusiasm for its art and architecture, and ever since *The Stones of Venice* there has been a steady stream of aesthetically actuated pilgrims every year to Venice.

Ruskin's work on Venice was in many respects innovatory. In 1849 he travelled to the city to establish various facts for his work. 'To my consternation', he says, 'I found that the Venetian antiquaries were not agreed within a century as to the date of the building of the façades of the Ducal Palace, and that nothing was known of any other civil edifice of the early city, except that at some time or other it had been fitted up for somebody's reception, and been thereupon fresh painted. Every date in question was determinable only by internal evidence; and it became necessary for me to examine not only every one of the older palaces, stone by stone, but every fragment throughout the city which afforded any clue to the formation of its styles. This I did as well as I could, and I believe there will be found, in the following pages, the only existing account of the details of early Venetian architecture on which dependence can be placed, as far as it goes.'

Some critics would say that as a work of modern scholarship on the art of Venice, Ruskin's *The Stones of Venice* was the first and is still the best. Furthermore, an infectious enthusiasm is imparted to others. As Henry James said in one of his several delightful essays on Venice, Ruskin 'beyond anyone helps us to enjoy'. James adds: 'Among the many strange things that have befallen Venice, she had had the good fortune to become the object of a passion to a man of splendid genius, who has made her his own and in doing so has made her the world's. There is no better reading at Venice, therefore, as I say, than Ruskin, for every true Venice-lover can separate the wheat from the chaff. The narrow theological spirit, the moralism *à tout propos*, the queer provincialities and prudieries, are mere wild weeds in a mountain of flowers.'*

The first volume of *The Stones of Venice* was originally published in 1851 by Smith Elder and Co. At the same time Ruskin published *Examples of the Architecture of Venice selected and drawn to measurement from the edifices*—fifteen plates in all which offer excellent examples of Ruskin's careful and exact architectural draughtmanship.

The first volume of *The Stones of Venice* was followed in 1853 by the second and third volumes. A second edition of Volume I appeared in

* This essay on Venice, written in 1882, is included with others in *Italian Hours*.

1858, with II and III in 1867; and a third, limited to 1,500 copies, was published in 1874. This edition was limited because Ruskin wished to maintain the standard of the plates of the earlier editions; he certified it by signing each copy.

A traveller's edition, abbreviated in two volumes, appeared in 1879. (Reference is made to this later.) The fourth edition of 1886 contained a few additions and some revisions. In 1903–1904 a library edition was published, when the fifteen plates of Ruskin's *Examples of the Architecture of Venice* were incorporated for the first time. Since then numerous pocket editions have appeared. At the time of writing all editions are out of print in Britain and a copy of *The Stones of Venice* is difficult to obtain, except from libraries.

Few people, other than students of Ruskin, would now read *The Stones of Venice* from cover to cover, and it could hardly be recommended in its entirety as a guide to Venice for it is very discursive and includes much of a general interest but without specific reference to Venice.

Only the first and last chapter (No. XXX) of the first volume are specifically concerned with Venice. The first, entitled 'The Quarry', consists of general introductory notes on the history of Venice and its art. The next twenty-eight chapters are, like *The Seven Lamps of Architecture*, a general treatise on architecture concentrating mainly on the various architectural components. Then the last chapter, entitled 'The Vestibule' returns the reader to Venice and concludes with the approach eastwards along the road from Padua by the Brenta, with a description of the first sight of the city from the lagoon.

The second and third volumes are divided into three main historical parts: 'First, or Byzantine, Period', 'Second, or Gothic, Period', and 'Third, or Renaissance, Period'. Under these chronological classifications, Ruskin surveys various specific buildings as well as examining related aspects of architecture.

The second chapter of part one of Volume II is devoted to Torcello, mainly to the cathedral; the third to Murano, mainly, to the church of San Donato; the fourth to St Mark's; and the fifth to Byzantine Palaces. The second part, also in Volume II, begins with a chapter on 'The Nature of Gothic', followed by one on Gothic palaces, in which he makes his valuable classification of the six orders of Venetian arches. The third chapter is a long detailed appreciation of the Ducal Palace (now usually referred to as the Doge's Palace). The third part on the Renaissance period (Volume III) Ruskin wrote less enthusiastically. He divides the period into Early Renaissance (Chapter I), Roman Renaissance (II), Grotesque Renaissance (III), ending with a discursive chapter that forms the conclusion. Then follows the 'Venetian Index', a succinct guide in alphabetical form to the major buildings, painting and sculpture of Venice, with

appropriate references to the main body of the text for specific buildings which are treated there.

Ruskin apparently realized that *The Stones of Venice* was far too voluminous and discursive for the average serious student of Venetian art visiting the city, so he produced an abridgement which subsequently went into a large number of editions. This was hardly a satisfactory abridgement or guide, and one wonders how the thorough and painstaking Ruskin could have been responsible for it. For it was a selection of only part of *The Stones of Venice*, with some of the most important and significant parts omitted. What was and still is required is an abridgement or adaptation which comprehends, in a succinct and accessible form, all the material that is concerned with Venice whilst excluding the general reflections of a symbolic, religious and moral character.

The Venetian Index

This has been my aim in extracting and amplifying the 'Venetian Index'. In the Index regular reference is made to the main text of *The Stones of Venice* in order to amplify certain entries. In order to make this guide complete, it was necessary therefore to introduce these into the sequence of the Index and to explain their context, in the book. Thus the guide became to some extent an adaptation of *The Stones of Venice*.

It has also been necessary to make certain additions to ensure that the guide is comprehensive, and these have been set in italics in order to distinguish them from Ruskin's text. The architecture, sculpture and paintings of Venice have changed remarkably little since Ruskin's day. Nevertheless there have inevitably been certain changes of location and rearrangement of some sculpture and paintings, and a note has been added where this has occurred. In addition, a few details which are no longer pertinent to present-day readers have been deleted.

Ruskin's main architectural interests were with the Byzantine, Romanesque and Gothic periods, and much less with Renaissance architecture. Short notes on some notable examples which Ruskin does not mention have therefore been added.

In addition to a selection of Ruskin's drawings, taken from *The Stones of Venice*, illustrations of various palaces, churches, paintings and sculpture have been included so that Ruskin's descriptions and comments can be more readily understood and appreciated.

Finally a word on Ruskin's classification of architectural periods. This is a little different from that adopted by many architectural historians who give a separate classification for the Romanesque style or period,

which Ruskin includes partly in Byzantine and partly in early Gothic. For example, Banister Fletcher (*History of Architecture on the Comparative Method*) includes the architecture of Venice of various periods under the heads of Early Christian, Byzantine, Romanesque, Gothic and Renaissance. Some of the palaces that Ruskin speaks of as Byzantine, Banister Fletcher classifies as Romanesque. Then again, Ruskin uses the term 'Grotesque Renaissance' in place of the more usual word 'Baroque'. Terminology apart, Ruskin's appreciation of the varying periods of architecture remains lively and, indeed on occasions, provocative.

It is hoped that this attempt to adapt *The Stones of Venice* will have produced first and foremost an illuminating and serviceable guide to Venice for today. If, at the same time, the spirit of Ruskin in this adaptation enchants the reader so much that he is led to the discursive and unique original, then the labour of the compilation will be well rewarded.

Some practical hints for visitors to Venice

To see all in Venice of aesthetic merit, its architecture, sculpture and paintings, would take months of concentrated effort. Ruskin's guide, like all guides, is a limited selection, a very personal and sometimes too exclusive one, with a main concentration on Byzantine and Gothic architecture and on the paintings of Tintoretto. To see and appreciate all that Ruskin admires and recommends for attention would take the average visitor hardly less than a month. Yet these days most visitors have to try to see all they can in a much shorter time. It is therefore important to make the best use of the time available and to do this it is helpful to be aware of Italian habits of life.

Aerial view of Venice. In the foreground are St Mark's Square and Basilica and the Ducal Palace, with a glimpse of the Bridge of Sighs. The Grand Canal can be seen in the middle distance, with the lagoon and mainland beyond. Upper left is the long railway and road causeway.

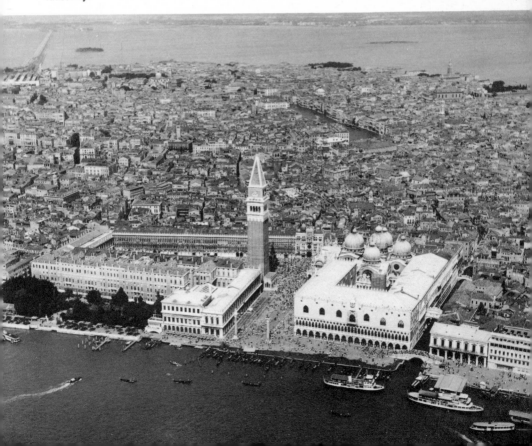

It is not the task of this guide to give full information on accommodation, opening times and the like, details of which tend to change from year to year. However, there are certain *practical points* to be borne in mind. Lunch, for example, forms a very definite break in the day. It begins about 12.30 p.m. and is followed by a siesta, and little is done between 12.30 and 3.30 p.m. This means that most churches and schools and several galleries and museums are closed for about three hours in the middle of the day. On the other hand churches are open early. A typical example is the church of S. Giovanni e Paolo which opens from 7.00 a.m. to 12.0 p.m. and from 3.30 to 6.30 p.m. Thus, to make the maximum use of time, it is best to follow the Italian habit and enjoy the long mid-day break and start visiting churches early in the morning. There are some useful exceptions to the rule such as St Mark's and the Ducal Palace which keep open in the middle of the day, and one of the best times to visit these places is the early afternoon (as Henry James found) when most Venetians and many visitors are dozing.

Another important factor is getting to the places you want to see without wasting time finding the way. Getting about Venice mainly on foot, with the assistance of water buses (*vaporetti*) and other water vehicles to convenient points, is no easy matter and one can easily get lost and lose valuable time aggravated by a sense of frustration. The first requisite, therefore, is a *large-scale reliable map*. (One that can be recommended is produced by Ediziono Storti, Venice.) It is necessary to stress the word 'reliable' because too often the summary maps provided with guides and the pictorial maps are not sufficiently exact and are apt to be misleading —canals are missing, buildings wrongly orientated, and *vaporetto* stations are not precisely placed. The map included in this guide is intended to help the reader 'place' the various buildings and cannot hope to show everything in sufficient detail.

The visitor to Venice will soon become aware of the many *tours* of the city and surrounding islands arranged for his benefit. Their usefulness depends much on what one wants from them. There is an all-day leisurely tour along the Brenta which gives a good impression of the many villas —some famous—along this waterway and which can be recommended, but it is expensive. There are also three-hour tours to Burano, Torcello and Murano which, if you want a good look at the famous buildings like the Cathedral at Torcello or St Donato at Murano, hardly gives sufficient time. It is perhaps better to use the regular boat services and let the interest of the buildings determine the length of your stay.

The *public water transport service* in Venice is excellent. The *vaporetti* go the entire length of the Grand Canal from the bus and railway stations and on to the Lido. This is easily the best way of getting a good impression of the Venetian *palazzi*, for much of the finest architecture (with some

exceptions) faces this canal. It is a good idea to make several journeys in both directions and at different times of the day so as to see the maximum number of façades in sunlight, for the winding course of the canal means that the different palaces face nearly all points of the compass.

Faster, smaller boats take more direct routes but these are mainly for business people, residents and others anxious to get to their destinations as quickly as possible. The quickest way, of course, is by hired motor boat. For leisurely more romantic travel the gondola, in diminishing numbers, is very pleasant, while there are still many ferry gondolas that take you across the canal for a very modest sum.

The interiors of the churches and many of the rooms in the Ducal Palace are dark, which makes it difficult to see and appreciate many of the paintings they contain, while the paintings themselves are often rather dim with age. Fortunately, since about 1969, many of the paintings have been, or are being cleaned, although when this has been done it is still difficult to see them properly in the dark interior. In many instances this difficulty has been overcome by the provision of strong concentrated artificial lighting effectively manipulated and which operates by placing a coin in a box. Thus the visitor today can perhaps see some of the pictures more clearly than could Ruskin, although artificial light is less satisfactory than daylight.

The visitor to Venice who wishes a good impression of the city's buildings, paintings and sculpture, and who wants to get the most out of a limited time, would be well advised to plan ahead for a visit. The buildings commended by Ruskin for special attention can be located on the map and be grouped for visiting. This guide is intended to be read, therefore, before as well as during a visit. And a study after the visit will, it is hoped, prompt many pleasant memories.

Arnold Whittick

Ruskin's Venetian Index

to 'The Stones of Venice' with amplifications from the body of the work as indicated by Ruskin

The first edition has been followed. Amplifications from the body of the text have been referenced in Roman numerals by volume, chapter and paragraph, in that sequence. These references hold good for the first three editions of The Stones of Venice.

The editor's notes have been given in italics. Where it has been necessary to add a comment within Ruskin's text, this has been given in italics and between square brackets.

In the fourth edition of The Stones of Venice *Ruskin writes that he gives 'the old index almost as it was, cutting out of it only the often-repeated statements that such and such churches or paintings were of "no importance". The modern traveller is but too likely to say so for himself.' The editor has preferred to retain these comments from the original edition as expressive of Ruskin's attitude. The editor has added some brief factual details in such cases and at places an indication that, in spite of Ruskin's opinion, the building does have its admirers. Possibly the reader may not always agree with Ruskin.*

Buildings are indexed under their particular name: that is to say, Palazzo Loredan under Loredan. A number of churches share the common name 'Maria', with an additional title distinguishing them (eg, Church of S. Maria della Salute). Where this occurs, the church has been indexed under its distinctive name (eg, Salute).

Ruskin has not been consistent in the use of English or Italian versions of a name, and with justification. He argues that the reader is more likely to refer to 'Mark' rather than 'Marco', but 'Rocco' in preference to 'Roche'. The editor has followed Ruskin, making minor alterations to the spelling of names where this has changed since Ruskin's time.

The names of palaces have sometimes changed, mainly because of a change in family ownership, and several palaces have been known by different names at successive periods. In some cases a palace is still known by the name of the original owner, in others by the name of a subsequent owner, or even by several family names. Publications do not always agree as to nomenclature; the editor has tried to avoid confusion and inaccuracies as much as possible.

Ruskin periodically uses the word 'casa' or 'ca' rather than the more common modern word 'palazzo' when indexing some of the palaces. (Ca' d'Oro is still common parlance, but Palazzo Businello is now preferred to Casa Businello.) Ruskin's text has been followed but an editor's note usually indicates the more common version.

Ruskin periodically cites contemporary sources of information on Venice: the Marchese Selvatico's work, Architettura di Venezia, *and* Lazari's Guida di Venezia. *There is also the* Guida artistica e storica di Venezia, *written jointly by Selvatico and Lazari and published in 1852. For further details see the bibliography.* **AW**

I have endeavoured to make the following index as useful as possible to the traveller, by indicating only the objects which are really worth his study. A traveller's interest, stimulated as it is into strange vigour by the freshness of every impression, and deepened by the sacredness of the charm of association which long familiarity with any scene too fatally wears away, as too precious a thing to be heedlessly wasted; and as it is physically impossible to see and to understand more than a certain quantity of art in a given time, the attention bestowed on second-rate works, in such a city as Venice, is not merely lost, but actually harmful—deadening the interest and confusing the memory with respect to those which it is a duty to enjoy, and a disgrace to forget. The reader need not fear being misled by any omissions; for I have conscientiously pointed out every characteristic example, even of the styles which I dislike, and have referred to Lazari in all instances in which my own information failed: but if he is anywise willing to trust me, I should recommend him to devote his principal attention, if he is fond of paintings, to the works of Tintoretto, Paul Veronese and John Bellini, not of course neglecting Titian, yet remembering that Titian can be well and thoroughly studied in almost any great European gallery, while Tintoretto and Bellini can be judged of *only* in Venice, and Paul Veronese, though gloriously represented by the two great pictures in the Louvre, and many others throughout Europe, is yet not to be fully estimated until he is seen at play among the fantastic chequers of the Venetian ceilings.

I have supplied somewhat copious notices of the pictures of Tintoretto, because they are much injured, difficult to read, and entirely neglected by other writers on art. . . . Finally, the reader is requested to observe, that the dates assigned to the various buildings named in the following index, are almost without exception conjectural; that is to say, founded exclusively on the internal evidence. . . . It is likely, therefore, that here and there, in particular instances, further inquiry may prove me to have been deceived; but such occasional errors are not of the smallest importance with respect to the general conclusions of the preceding pages, which will be found to rest on too broad a basis to be disturbed. [*cf. Editor's introduction*].

John Ruskin

A

ACCADEMIA DELLE BELLE ARTI. Notice above the door the two bas-reliefs of St Leonard and St Christopher, chiefly remarkable for their rude cutting at so late a date, 1377; but the niches under which they stand are unusual in their bent gables, and in the little crosses within circles which fill their cusps. The traveller is generally too much struck by Titian's great picture of the 'Assumption' to be able to pay proper attention to the other works in this gallery. [*This picture is now in the Frari Church—see editor's note below.*] Let him, however, ask himself candidly how much of his admiration is dependent merely upon the picture being larger than any other in the room, and having bright masses of red and blue in it: let him be assured that the picture is in reality not one whit the better for being either large or gaudy in colour; and he will be better disposed to give the pains necessary to discover the merit of the more profound and solemn works of Bellini and Tintoretto. One of the most wonderful works in the whole gallery is Tintoretto's 'Death of Abel', on the left of the 'Assumption'; the 'Adam and Eve', on the right of it, is hardly inferior; and both are more characteristic examples of the master, and in many respects better pictures, than the much vaunted 'Miracle of

Reliefs of St Leonard and St Christopher in niches by the entrance of the old Scuola della Carità, now the Accademia (1377).

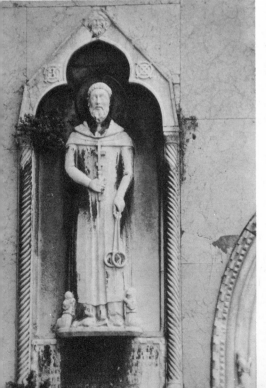
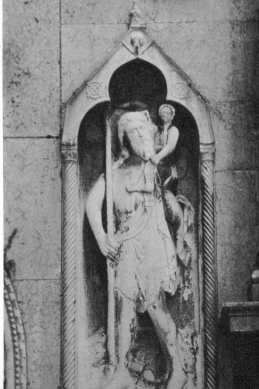

St Mark'. All the works of Bellini in this room are of great beauty and interest. In the great room, that which contains Titian's 'Presentation of the Virgin', the traveller should examine carefully all the pictures by Vittor Carpaccio and Gentile Bellini, which represent scenes in ancient Venice; they are full of interesting architecture and costume. Marco Basaiti's 'Agony in the Garden' is a lovely example of the religious school. The Tintorettos in this room are all second rate, but most of the Veroneses are good, and the large ones are magnificent.

The Accademia delle Belle Arti, founded in 1750, occupied the present premises in 1807, formerly the Scuola di Santa Maria della Carità, designed in part by Palladio. (See CARITA.)

Since the publication of The Stones of Venice, *the collection of the Accademia has been enlarged and the arrangement altered.*

Titian's famous 'Assumption of the Virgin' was originally in the Frari church and was later moved to the Accademia. In 1885 a special room (II) was built in the Accademia to house the picture. In the present century it was returned to the Frari Church and placed behind the high altar. In the summer of 1974 it was taken down and cleaned in the church. For further discussion of the painting, see under FRARI.

Before considering other works in the Accademia, some general comments from Ruskin are included on the differing qualities to be found in the works of Giovanni Bellini, Titian and Tintoretto.

I–I–XIII. Now, John Bellini was born in 1423, and Titian in 1480. John Bellini, and his brother Gentile, two years older than he, close the line of the sacred painters of Venice. But the most solemn spirit of religious faith animates their works to the last. There is no religion in any work of Titian's: there is not even the smallest evidence of religious temper or sympathies either in himself, or in those for whom he painted. His larger sacred subjects are merely themes for the exhibition of pictorial rhetoric —composition and colour. His minor works are generally made subordinate to purposes of portraiture. The Madonna in the Church of the Frari is a mere lay figure, introduced to form a link of connection between the portraits of various members of the Pesaro family who surround her.

Now this is not merely because John Bellini was a religious man and Titian was not. Titian and Bellini are each true representatives of the school of painters contemporary with them; and the difference in their artistic feeling is a consequence not so much of difference in their own natural characters as in their early education: Bellini was brought up in faith; Titian in formalism. Between the years of their births the vital religion of Venice had expired.

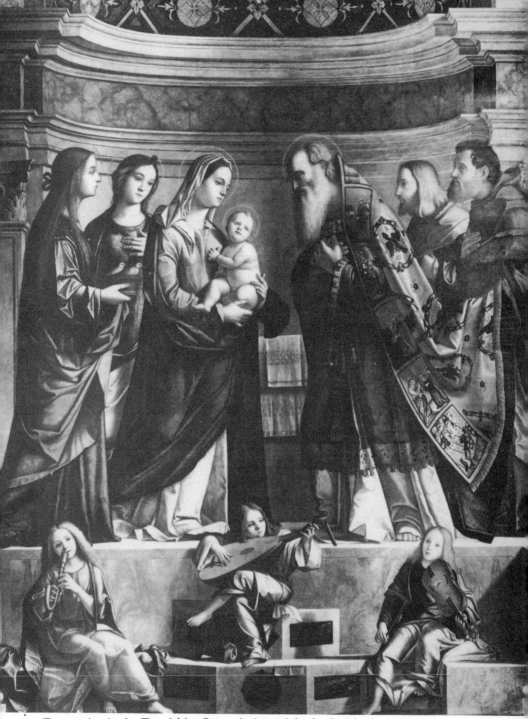

'Presentation in the Temple' by Carpaccio (*c.*1510) in the Accademia,
a picture much admired by Ruskin.

XIV. The *vital* religion, observe, not the formal. Outward observance was as strict as ever; and doge and senator still were painted, in almost every important instance, kneeling before the Madonna or St Mark; a confession of faith made universal by the pure gold of the Venetian sequin. But observe the great picture of Titian's, in the ducal palace, of the Doge Antonio Grimani kneeling before Faith: there is a curious lesson in it. The figure of Faith is a coarse portrait of one of Titian's least graceful female models: Faith had become carnal. The eye is first caught by the flash of the Doge's armour. The heart of Venice was in her wars, not in her worship.

The mind of Tintoretto, incomparably more deep and serious than that of Titian, casts the solemnity of its own tone over the sacred subjects which it approaches, and sometimes forgets itself into devotion; but the principle of treatment is altogether the same as Titian's: absolute subordination of the religious subject to purposes of decoration or portraiture.

Among the pictures that Ruskin particularly admired in the Accademia, and which he describes in another work, Guide to the Principal Pictures in the Academy of Fine Arts, *are Giovanni Bellini's 'Madonna enthroned with Six Saints and Three Playing Angels', which he says is the best of the Giovanni Bellinis; Carpaccio's 'Presentation in the Temple', which he considered the best picture in the Accademia; and Bartolomeo Vivarini's 'Madonna and Child with Saints'. He selects three Tintorettos for especial praise—'The Death of Abel', 'The Miracle of St Mark' and 'Eve driven out of Paradise'—and describes them as the 'finest possible Tintorettos, best possible examples of what, in absolute power of painting, is supremest work, so far as I know, in all the world'.*

The two Tintorettos which Ruskin describes as being in the Church of SS. Giovanni e Paolo, namely 'The Crucifixion' and 'Our Lady with the Camerlenghi', are now in the Accademia, the latter now called 'The Madonna with the Treaurers'. Ruskin's description of these two works is included here.

The Crucifixion. A picture fifteen feet long by eleven or twelve high. I do not believe that either the 'Miracle of St Mark', or the great 'Crucifixion' in the Scuola di S. Rocco, cost Tintoretto more pains than this comparatively small work, which is now utterly neglected, covered with filth and cobwebs, and fearfully injured. As a piece of colour, and light and shade, it is altogether marvellous. Of all the fifty figures which the picture contains, there is not one which in any way injures or contends with another; nay, there is not a single fold of garment or touch of the pencil which could be spared; every virtue of Tintoretto, as a painter, is there in its highest degree—colour at once the most intense and the most

delicate, the utmost decision in the arrangement of masses of light, and yet half tones and modulations of endless variety; and all executed with a magnificence of handling which no words are energetic enough to describe. I have hardly ever seen a picture in which there was so much decision, and so little impetuosity, and in which so little was conceded to haste, to accident, or to weakness. It is too infinite a work to be describable; but among its minor passages of extreme beauty should especially be noticed the manner in which the accumulated forms of the human body, which fill the picture from end to end, are prevented from being felt heavy, by the grace and elasticity of two or three sprays of leafage which spring from a broken root in the foreground, and rise conspicuous in shadow against an interstice filled by the pale blue, grey, and golden light in which the distant crowd is invested, the office of this foliage being, in an artistical point of view, correspondent to that of the trees set by the sculptors of the Ducal Palace on its angles. But they have a far more important meaning in the picture than any artistical one. If the spectator will look carefully at the root which I have called broken, he will find that, in reality, it is not broken, but cut; the other branches of the young tree having *lately been cut away*. When we remember that one of the principal incidents in the great S. Rocco Crucifixion is the ass feeding on withered palm leaves, we shall be at no loss to understand the great painter's purpose in lifting the branch of this mutilated olive against the dim light of the distant sky; while, close beside it, St Joseph of Arimathea drags along the dust a white garment—observe, the principal light of the picture—stained with the blood of that King before whom, five days before, his crucifiers had strewn their own garments in the way.

The Madonna with the Treasurers (Our Lady with the Camerlenghi).
A remarkable instance of the theoretical manner of representing Scriptural facts, which, at this time, as noted in the second chapter of [*Volume III*], was undermining the belief of the facts themselves. Three Venetian chamberlains desired to have their portraits painted, and at the same time to express their devotion to the Madonna; to that end they are painted kneeling before her, and in order to account for their all three being together, and to give a thread or clue to the story of the picture, they are represented as the Three Magi; but lest the spectator should think it strange that the Magi should be in the dress of Venetian chamberlains, the scene is marked as a mere ideality, by surrounding the person of the Virgin with saints who lived five hundred years after her. She has for attendants St Theodore, St Sebastian, and St Carlo (query St Joseph). One hardly knows whether most to regret the spirit which was losing sight of the verities of religious history in imaginative abstractions, or to praise the modesty and piety which desired rather to be represented as

kneeling before the Virgin than in the discharge or among the insignia of important offices of state.

As an 'Adoration of the Magi', the picture is, of course, sufficiently absurd: the St Sebastian leans back in the corner to be out of the way; the three Magi kneel, without the slightest appearance of emotion, to a Madonna seated in a Venetian loggia of the fifteenth century, and three Venetian servants behind bear their offerings in a very homely sack, tied up at the mouth. As a piece of portraiture and artistical composition, the work is altogether perfect, perhaps the best piece of Tintoretto's portrait-painting in existence. It is very carefully and steadily wrought, and arranged with consummate skill on a difficult plan. The canvas is a long oblong, I think about eighteen or twenty feet long, by about seven high; one might almost fancy the painter had been puzzled to bring the piece into use, the figures being all thrown into positions which a little diminish their height. The nearest chamberlain is kneeling, the two behind him bowing themselves slightly, the attendants behind bowing lower, the Madonna sitting, the St Theodore sitting still lower on the steps at her feet, and the St Sebastian leaning back, so that all the lines of the picture incline more or less from right to left as they ascend. This slope, which gives unity to the detached groups, is carefully exhibited by what a mathematician would call co-ordinates—the upright pillars of the loggia and the horizontal clouds of the beautiful sky. The colour is very quiet, but rich and deep, the local tones being brought out with intense force, and the cast shadows subdued, the manner being much more that of Titian than of Tintoretto. The sky appears full of light, though it is as dark as the flesh of the faces; and the forms of its floating clouds, as well as of the hills over which they rise, are drawn with a deep remembrance of reality. There are hundreds of pictures of Tintoretto's more amazing than this, but I hardly know one that I more love.

Other pictures which Ruskin singles out for praise are most of the Carpaccios, Cima da Conegliano's 'Madonna and Child Enthroned', and 'The Annunciation' and 'Madonna and Child Enthroned' by Paolo Veronese. Writing of another work by Veronese, 'The Supper in the House of Simon', (catalogued as 'The Feast in the House of Levi') Ruskin tells how the artist was summoned before the Inquisition regarding the figure of a dog which he had painted in the foreground. This was considered unsuitable and he was asked to replace the figure of the dog with that of the Magdalene. He agreed to do this but the matter lapsed and the dog remained.

A L G A. See GIORGIO.

ALVISE, CHURCH OF S. I have never been in this church, but Lazari dates its interior, with decision, as of the year 1388, and it may be worth a glance, if the traveller has time.

In another book on Venice, entitled St Mark's Rest, *Ruskin refers to this church and the pictures it contains: the ceiling by Tiepolo and eight pictures by Carpaccio, the latter of which he admires. The subjects of these are: (1) 'Rachel at the Well' (2) 'Jacob and his Sons before Joseph' (3) 'Tobias and the Angel' (4) 'The three Holy Children' (5) 'Job' (6) 'Moses and the Adoration of the Golden Calf' (7) 'Solomon and the Queen of Sheba' (8) 'Joshua and falling Jericho'. James Morris, in his reference to S. Alvise in his book on Venice (see bibliography) speaks of Tiepolo's mighty ' "Way to Calvary" and the appealing little knightly pictures known as the Baby Carpaccios—which do look as though they might have been painted by some artist of genius in his nursery days, and in fact bear (not altogether convincingly) Carpaccio's signature'. Doubts have been cast on the authenticity of these works.*

ANDREA, CHURCH OF S. Well worth visiting for the sake of the peculiarly sweet and melancholy effect of its little grass-grown campo, opening to the lagoon and the Alps. The sculpture over the door, 'St Peter walking on the Water', is a quaint piece of Renaissance work. Note the distant rocky landscape, and the oar of the existing gondola floating by St Andrew's boat. The church is of the later Gothic period, much defaced, but still picturesque. The lateral windows are bluntly trefoiled, and good of their time.

ANGELI, CHURCH DEGLI, at Murano. The sculpture of the 'Annunciation' over the entrance-gate is graceful. In exploring Murano, it is worth while to row up the great canal thus far for the sake of the opening to the lagoon.

ANTONINO, CHURCH OF S. Of no importance.
The Church of S. Antonino is a Renaissance church of the sixteenth century. The paintings by Palma Giovane in the S. Saba Chapel were restored in 1967 by the Association France-Italie.

APOLLINARE, CHURCH OF S. Of no importance.
The Church of S. Apollinare (S. Aponal) is a fifteenth-century church which contains an interesting marble monument to General Vittorio Capello by Antonio Rizzo, 1480.

APOSTOLI, CHURCH OF THE. The exterior is nothing. There is said to be a picture by Veronese in the interior, 'The Fall of the Manna'. I have not seen it; but, if it be of importance, the traveller should compare it carefully with Tintoretto's, in the Scuola di S. Rocco, and in S. Giorgio Maggiore.

The church of the S. Apostoli was rebuilt in 1672 in the Renaissance style and replaced an earlier church built in 1530. Ruskin mentions in the 1879 abridgement that the picture by Veronese is an imitation of that by Tintoretto in S. Giorgio and is not worth losing time upon.

APOSTOLI, PALACE AT, II–VII–XXX, on the Grand Canal, near the Rialto, opposite the fruit-market. A most important transitional palace. Its sculpture on the first story is peculiarly rich and curious; I think Venetian, in imitation of Byzantine. The sea story and first floor are of the first half of the thirteenth century, the rest modern. Observe that only one wing of the sea story is left, the other half having been modernized. The traveller should land to look at the capital drawn in Plate II of Volume III, figure 7 [*see page 111*].

Elsewhere in The Stones of Venice *Ruskin cites this palace as an example of the second order of windows (for further details of Ruskin's classification of windows see* ORDER OF VENETIAN ARCHES).

II–VII–XXX. . . . The second order window soon attained nobler development [*than the first*]. At once simple, graceful, and strong, and there is hardly a street in Venice which does not exhibit some important remains of palaces built with this form of window in many stories, and in numerous groups. The most extensive and perfect is one upon the Grand Canal in the parish of the Apostoli, near the Rialto, covered with rich decoration, in the Byzantine manner, between the windows of its first story; but not completely characteristic of the transitional period, because still retaining the dentil in the arch mouldings, while the transitional houses all have the simple roll.

ARSENAL. Its gateway is a curiously picturesque example of Renaissance workmanship, admirably sharp and expressive in its ornamental sculpture; it is in many parts like some of the best Byzantine work. The Greek lions in front of it appear to me to deserve more praise than they have received; though they are awkwardly balanced between conventional and imitative representation, having neither the severity proper to the one, nor the veracity necessary for the other.

The Arsenal was founded in 1104 and its buildings were successively enlarged in the fourteenth, fifteenth and nineteenth centuries. The antique lions were brought to Venice from Athens in 1687 and 1716. The Arsenal is now a museum of naval relics and military weapons.

B

BADOER, PALAZZO, in the Campo S. Giovanni in Bragora [*now Bandiera e Moro*]. A magnificent example of the fourteenth-century Gothic, circa 1310–1320, anterior to the Ducal Palace, and showing beautiful ranges of the fifth order window [*for further details of these orders, see under* ORDERS OF VENETIAN ARCHES], with fragments of the original balconies, and the usual lateral window larger than any of the rest. In the centre of its arcade on the first floor is [*an*] inlaid ornament. . . . The fresco painting on the walls is of later date; and I believe the heads which form the finials have been inserted afterwards also, the original windows having been pure fifth order.

The building is now a ruin, inhabited by the lowest orders; the first floor, when I was last in Venice, by a laundress.

The palazzo has been restored and modernised.

BAFFO, PALAZZO, in the Campo S. Maurizio. The commonest late Renaissance. A few olive-leaves and vestiges of two figures still remain upon it, of the frescoes by Paul Veronese with which it was once adorned.

BALBI, PALAZZO, in Volta di Canal. Of no importance. *The Palazzo Balbi is a late sixteenth-century Renaissance building designed by Alesandro Vittoria (1525–1608) in 1582.*

BARBARIGO, PALAZZO, on the Grand Canal, next the Casa Pisani. Late Renaissance: noticeable only as a house in which some of the best pictures of Titian were allowed to be ruined by damp, and out of which they were then sold to the Emperor of Russia.

BARBARO, PALAZZO, on the Grand Canal, next the Palazzo Cavalli. These two buildings form the principal objects in the foreground of the view which almost every artist seizes on his first traverse of the Grand Canal, the Church of the Salute forming a most graceful distance.

Neither is, however, of much value, except in general effect; but the Barbaro is the best, and the pointed arcade in its side wall, seen from the narrow canal between it and the Cavalli, is good Gothic of the earliest fourteenth-century type.

BARNABA, CHURCH OF S. Of no importance.
S. Barnaba is a Renaissance church with classical façade (a clear deriva-tion from the Greek temple form).

BARTOLOMEO, CHURCH OF S. I did not go to look at the works of Sebastian del Piombo which it contains, fully crediting M. Lazari's statement, that they have been 'barbaramente sfigurati da mani imperite, che pretendevano ristaurarli' [*barbarously disfigured by the unskilled hands which professed to restore them*]. Otherwise the church is of no importance.

The paintings of Sebastiano del Piombo are of four saints: St Sinibald, St Louis, St Bartholomew and St Sebastian. They are early works in the style of Giorgione.

BASSO, CHURCH OF S. Of no importance.
The church of S. Basso is a Renaissance building of about 1670, the architect of which is thought to have been Giuseppe Benoni (1618–1684). It is no longer a church and serves as a museum and lecture hall for S. Marco.

BATTAGLIA, PALAZZO, on the Grand Canal. Of no importance.
The Palazzo Battaglia is a late Renaissance building erected to the design of Baldassare Longhena in 1668.

BECCHERIE. See QUERINI.

BEMBO, PALAZZO, on the Grand Canal, next the Casa Manin. A noble Gothic pile, circa 1350–1380, which before it was painted by the modern Venetians with the two most valuable colours of Tintoretto, *bianco e nero*, by being whitewashed above, and turned into a coal ware-house below, must have been among the most noble in effect on the whole Grand Canal. It still forms a beautiful group with the Rialto, some large shipping being generally anchored at its quay. Its sea story and entresol are of earlier date, I believe, than the rest; the doors of the former are Byzantine . . . and above the entresol is a beautiful Byzantine cornice, built into the wall, and harmonizing well with the Gothic work.

BEMBO, PALAZZO, in the Calle Magno, at the Campo de' due Pozzi, close to the Arsenal. Noticed by Lazari and Selvatico as having a

very interesting staircase. It is early Gothic, circa 1330, but not a whit more interesting than many others of similar date and design. See CONTARINI PORTA DI FERRO, MOROSINI, SANUDO, and MINELLI.

BENEDETTO, CAMPO OF S. Do not fail to see the superb, though partially ruinous, Gothic palace fronting this little square. It is very late Gothic, just passing into Renaissance; unique in Venice, in masculine character, united with the delicacy of the incipient style. Observe especially the brackets of the balconies, the flower-work on the cornices, and the arabesques on the angles of the balconies themselves.

BENEDETTO, CHURCH OF S. Of no importance.
The Church of S. Benedetto is a Renaissance building of about 1685, built on the ruins of a thirteenth-century church. It contains many paintings with one altar piece by Tiepolo of S. Francesco di Paola.

BERNARDO, PALAZZO, on the Grand Canal. A very noble pile of early fifteenth-century Gothic, founded on the Ducal Palace. The traceries in its lateral windows are both rich and unusual.

BERNARDO, PALAZZO, at S. Polo. A glorious palace, on a narrow canal, in a part of Venice now inhabited by the lower orders only. It is rather late central Gothic, circa 1380–1400, but of the finest kind, and superb in its effect of colour when seen from the side. A capital in the interior court is much praised by Selvatico and Lazari, because its 'foglie d' acanto' (anything, by the by, *but* acanthus), 'quasi agitate da vento si attorcigliano d' intorno alla campana, concetto non indegno della bell' epoca greca!' [*'acanthus leaves, as if shaken by the wind, twist themselves around the bell—a concept not unworthy of Greece's most brilliant epoch'*]. Does this mean 'epoca Bisantina'? The capital is simply a translation into Gothic sculpture of the Byzantine ones of St Mark's and the Fondaco dei Turchi ... and is far inferior to either. But, taken as a whole, I think that, after the Ducal Palace, this is the noblest in effect of all in Venice.

BRAGORA, CHURCH OF S. GIOVANNI IN. See GIOVANNI.

BRENTA, Banks of the, villas on the, I–XXX–VII, VIII.
References to the banks of, and villas on, the River Brenta occur in the description of the approach to Venice, mentioned at the end of this book in the section 'Venice Preserved'. Ruskin speaks: of the much vaunted 'villas on the Brenta': a glaring, spectral shell of brick and stucco,

its windows with painted architraves like picture-frames, and a court-yard paved with pebbles in front of it, all burning in the thick glow of the feverish sunshine, but fenced from the high road, for magnificence sake, with goodly posts and chains; then another, of Kew Gothic, with Chinese variations, painted red and green; a third, composed for the greater part of dead wall, with fictitious windows painted upon it, each with a pea-green blind, and a classical architrave in bad perspective; and a fourth with stucco figures set on the top of its garden-wall. . . . This is the architecture to which her studies of the Renaissance have conducted modern Italy.

BUSINELLO, CASA, II–Appendix 11.

In Appendix 11 on 'Situations of Byzantine Palaces', Ruskin mentions the view across the canal from the Casa Grimani, then the Post Office and now the Court of Appeal, towards the Terraced House (it has apparently no other name) and to the left of this: . . . is a modern palace, on the other side of which the Byzantine mouldings appear again in the first and second stories of a house lately restored. It might be thought that the shafts and arches had been raised yesterday, the modern walls having been deftly adjusted to them, and all appearance of antiquity, together with the ornamentation and proportions of the fabric, having been entirely destroyed. I cannot, however, speak with unmixed sorrow of these changes, since, without his being implicated in the shame of them, they fitted this palace to become the residence of the kindest friend I had in Venice. It is generally known as the Casa Businello.

The friend to whom Ruskin refers is Rawdon Brown, who spent much of his life in Venice, cataloguing the papers in the State Archives which were of interest to scholars of English history. He became a close friend of both Ruskin and his wife, Effie. Writing to her father from the Danieli Hotel, where the Ruskins were then staying, Effie says: 'Mr. Brown is also exceedingly kind to us. We went to see his house the other day and were quite delighted with it, it was furnished in such exquisite taste.' (6th January 1850).

In Rawdon Brown's defence, it should be added that, at that time, the Palazzo Businello was in fact owned by the dancer, Taglioni.

BYZANTINE PALACES generally, II–V.

Chapter V of Volume II deals with Byzantine palaces. Ruskin is discursive but the essential details of their architecture are contained in the following extract (II–V–IV).

[*The Byzantine palaces*] all agree in being round-arched and incrusted with marble, but there are only six in which the original disposition of the

parts is anywise traceable; namely, those distinguished in [*Appendix 11*] as the Fondaco de' Turchi, Casa Loredan, Casa Farsetti, Rio-Foscari House, Terraced House, and Madonnetta House [*Ruskin adds: 'Of the Braided House and the Casa Businello, described in the Appendix, only the great central arcades remain'*] and these six agree further in having continuous arcades along the entire fronts from one angle to the other, and in having their arcades divided, in each case, into a centre and wings; both by greater size in the midmost arches, and by the alternation of shafts in the centre, with pilasters, or with small shafts, at the flanks.

v. So far as their structure can be traced, they agree also in having tall and few arches in their lower stories, and shorter and more numerous arches above: but it happens most unfortunately that in the only two cases in which the second stories are left the ground floors are modernized, and in the others where the sea stories are left the second stories are modernized; so that we never have more than two tiers of the Byzantine arches, one above the other. These, however, are quite enough to show the first main point on which I wish to insist, namely, the subtlety of the feeling for proportion in the Greek architects: and I hope that even the general reader will not allow himself to be frightened by the look of a few measurements, for, if he will only take the little pains necessary to compare them, he will, I am almost certain, find the result not devoid of interest.

vi. . . . The Fondaco de' Turchi has sixteen arches in its sea story, and twenty-six above them in its first story, the whole based on a magnificent foundation, built of blocks of red marble, some of them seven feet long by a foot and a half thick, and raised to a height of about five feet above high-water mark. At this level, the elevation of one half of the building, from its flank to the central pillars of its arcades, is rudely given in [*the drawing—see Ruskin's own illustration*]. It is only drawn to show the arrangement of the parts, as the sculptures which are indicated by the circles and upright oblongs between the arches are too delicate to be shown in a sketch three times the size of this. The building once was crowned with an Arabian parapet; but it was taken down some years since, and I am aware of no authentic representation of its details. The greater part of the sculptures between the arches, indicated in the woodcut only by blank circles, have also fallen, or been removed, but enough remain on the two flanks to justify the representation given in the diagram of their original arrangement.

And now observe the dimensions. The small arches of the wings in the ground story, *a, a, a,* measure in breadth, from

					ft	in
shaft to shaft	4	5
interval *b*		.	.	.	7	6½
interval *c*		.	.	.	7	11
intervals *d*, *e*, *f*, &c.		.	.	.	8	1

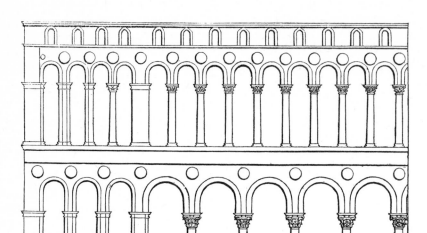

$$a \qquad a \qquad a \qquad b \qquad c \qquad d \qquad e \qquad f$$

Ruskin's drawing of one half of the elevation of the Fondaco dei Turchi (Volume II, Figure IV). The building is also illustrated on page 113.

The difference between the width of the arches *b* and *c* is necessitated by the small recess of the cornice on the left hand as compared with that of the great capitals; but this sudden difference of half a foot between the two extreme arches of the centre offended the builder's eye, so he diminished the next one, *unnecessarily*, two inches, and thus obtained the gradual cadence to the flanks, from eight feet down to four and half in a series of continually increasing steps. Of course the effect cannot be shown in the diagram, as the first difference is less than the thickness of its lines. In the upper story the capitals are all nearly of the same height, and there was no occasion for the difference between the extreme arches. Its twenty-six arches are placed, four small ones above each lateral three of the lower arcade, and eighteen larger above its central ten; thus throwing the shafts into all manner of relative positions, and completely confusing the eye in any effort to count them: but there is an exquisite

symmetry running through their apparent confusion; for it will be seen that the four arches in each flank are arranged in two groups, of which one has a large single shaft in the centre, and the other a pilaster and two small shafts. The way in which the large shaft is used as an echo of those in the central arcade, dovetailing them, as it were, into the system of the pilasters—just as a great painter, passing from one tone of colour to another, repeats, over a small space, that which he has left—is highly characteristic of the Byzantine care in composition. There are other evidences of it in the arrangement of the capitals, which will be noticed below in the seventh chapter. The lateral arches of this upper arcade measure 3 ft 2 in across, and the central 3 ft 11 in, so that the arches in the building are altogether of six magnitudes.

Another illustration of the Fondaco dei Turchi is given under its own heading. The passage continues to examine the arrangement of the arches in the Palazzo Loredan, the Palazzo Farsetti, the Terraced House and the Rio-Foscari House, demonstrating that their proportions show too the delicacy of balance in Byzantine palace architecture.

C

CALCINA, PENSIONE, LA. *In this famous house on the Zattere Apostolo Zeno, the famous Venetian scholar, lived and died (in 1750). John Ruskin lived there in 1877, and another well-known inhabitant was Gustav Ludwig, the famous German scholar.*

CAMERLENGHI, PALACE OF THE, beside the Rialto. A graceful work of the early Renaissance (1525) passing into Roman Renaissance. Its details are inferior to most of the work of the school. The 'Camerlenghi', properly 'Camerlenghi di Comune', were the three officers or ministers who had care of the administration of public expenses.

CAMPANILE OF S. MARCO. *Ruskin does not mention the Campanile in the Piazza S. Marco in the Venetian Index, but only in the main body of* The Stones of Venice, *in Volume I–XIX, 'Superimposition'. He gives a drawing of the Campanile with other towers alongside for comparison. Following is an abstract from his description:*

The old tower is that of St Mark's at Venice, not a very perfect example, for its top is Renaissance, but as good Renaissance as there is in Venice; . . . it owes none of its effect to ornament. It is built as simply as it well can be to answer its purpose; no buttresses; no external features whatever,

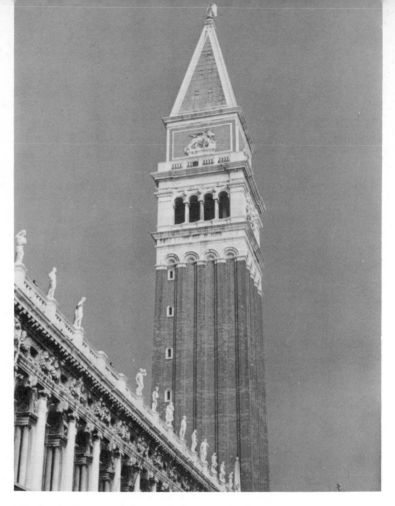

The Campanile of St Mark's with the Libreria Vecchia.

except some huts at the base, and the loggia, afterwards built . . . one bold square mass of brickwork; double walls, with an ascending inclined plane between them, with apertures as small as possible, and these only in necessary places, giving just the light required for ascending the stair or slope, not a ray more; and the weight of the whole relieved only by the double pilasters on the sides, sustaining small arches at the top of the mass, each decorated with the scallop or cockle shell, presently to be noticed as frequent in Renaissance ornament, and here, for once, thoroughly well applied. Then, when the necessary height is reached, the belfry is left open, as in the ordinary Romanesque campanile, only the shafts more slender, but severe and simple, and the whole crowned by as much spire as the tower would carry, to render it more serviceable as a landmark. The arrangement is repeated in numberless campaniles throughout Italy.

The Campanile of S. Marco was originally built in stages between 940 and 1148, with the bell tower added in 1170. It was struck by lightning in 1489, and it was largely rebuilt in 1510 by Bartolomeo Bon. It suffered from an earthquake almost immediately afterwards in 1511; and was subsequently struck by lightning several times. Several recessions were made in the interior of the Campanile and a chase was cut near the base of the tower in order to secure the Loggetta more soundly to the tower. These works no doubt contributed to the complete collapse of the tower in July 1902. It subsided gently without casualties, and the only damage done was to part of the library and the almost complete destruction of the Loggetta. The Campanile was rebuilt exactly as it was before from 1903 to 1912.

The design of the Campanile, like most others in Venice, was derived from the monastic campanile of the Levant. Set on sturdy foundations is a square brick shaft about 35 feet wide at its base, tapering by a little over 3 feet. Above this is the bell-chamber pierced with four Romanesque arches on each side, and higher still is the square attic surmounted by a tall pyramid on which is perched the original bronze angel. The total height is 322 feet, which makes it the highest building in Venice. Most of the numerous other campanile in Venice are of similar design, although generally smaller. Several have collapsed and not all have been replaced. In 1347 the Campanile of Chioggia collapsed; in 1410 the towers of S. Fosca and the Corpus Domini; in 1455 the Campanile of S. Angelo; in 1596 that of S. Leonardo; in 1774 that of S. Giorgio Maggiore; and in 1880 that of S. Ternita.

CANCELLARIA, II–VIII–XV. *'Cancellaria' means chancery—a court of law and a place where records are kept. In describing the Ducal Palace, Ruskin says:* ... the newly constituted Senate had need of other additions to the ancient palace besides the Council Chamber. A short, but most significant, sentence is added to Sansovino's account of the construction of the room. 'There were, *near it* [*Sansovino's italics*],' he says, 'the Cancellaria, and the *Gheba* or *Gabbia*, afterwards called the Little Tower.'

Ruskin explains further: Gabbia means a 'cage' and there can be no question that certain apartments were at this time added at the top of the palace and on the Rio Façade which were to be used as prisons ... [*they*] were still used as prisons as late as the beginning of the seventeenth century.

CANCIANO, CHURCH OF S. Of no importance.
A Renaissance building of the eighteenth century built on very old foundations by Antonio Gaspari. There are a considerable number of

paintings by minor artists the most important of which are two by Domenico Zanchi, 'The Pool of Bathesda' and 'The Miracle of Bread and Fishes' on the side walls of the chancel.

CAPPELLO, PALAZZO, at S. Aponal. Of no interest. Some say that Bianco Cappello fled from it; but the tradition seems to fluctuate between the various houses belonging to her family.

Referring to some research carried out by his friend, Rawdon Brown, Ruskin in fact links the name of Bianca Cappello to another palace, given later in the Index, the Palazzo Trevisan. For the story of Bianco Cappello, see under that heading.

CARITA, CHURCH OF THE. Once an interesting Gothic church of the fourteenth century, lately defaced, and applied to some of the usual important purposes of the modern Italians. The effect of its ancient façade may partly be guessed at from the pictures of Canaletto, but only guessed at; Canaletto being less to be trusted for renderings of details, than the rudest and most ignorant painter of the thirteenth century.

The best view of the church by Canaletto is in the picture entitled 'The Stonemason's Yard—S. Maria della Carità from across the Grand Canal'. The picture shows the campanile which collapsed in 1744, and the spot it occupied is now the south end of the Accademia bridge, originally built of iron in 1854, and replaced by a wooden bridge built in 1932.

The Gothic church of S. Maria della Carità was built in 1466, and the convent in 1552, partly designed by Palladio. It was enthusiastically admired by Goethe when he saw it in 1786 (see his Travels in Italy*). Goethe generally liked the Renaissance buildings of Venice, especially those of Palladio, and he gave them much more attention than the earlier Byzantine and Gothic buildings, and offers a contrast in taste to Ruskin.*

CARMINI, CHURCH OF THE. A most interesting church, of late thirteenth-century work, but much altered and defaced. Its nave, in which the early shafts and capitals of the pure truncate form are unaltered, is very fine in effect; its lateral porch is quaint and beautiful, decorated with Byzantine circular sculptures [*of which the central one is given in Figure 5 of Ruskin's illustration on page 203*], and supported on two shafts whose capitals are the most archaic examples of the pure rose form that I know in Venice.

There is a glorious Tintoretto over the first altar on the right in entering; the 'Circumcision of Christ'. I do not know an aged head either more beautiful or more picturesque than that of the high priest. The cloister is full of notable tombs, nearly all dated; one, of the fifteenth

'The Stonemason's Yard: S. Maria della Carità from across the Grand Canal', 1726–7, by Canaletto (reproduced by courtesy of the Trustees, National Gallery, London). To the right of the church can be seen the Scuola della Carità which, together with the church and the associated monastery, were taken over as accommodation for the Accademia delle Belle Arti in 1807.

century, to the left on entering, is interesting from the colour still left on the leaves and flowers of its sculptured roses.

The paintings in the Church of the Carmini were cleaned and restored in 1972 by funds made available by the American Committee to Rescue Italian Art.

CASSANO, CHURCH OF S. [*Usually spelt* CASSIANO.] This church must on no account be missed, as it contains three Tintorettos, of which one, the 'Crucifixion', is among the finest in Europe. There is nothing worth notice in the building itself, except the jamb of an ancient door (left in the Renaissance buildings, facing the canal), which has been given among the examples of Byzantine jambs; and the traveller may therefore devote his entire attention to the three pictures in the chancel.

1. *The Crucifixion.* (On the left of the high altar.) It is refreshing to find a picture taken care of, and in a bright, though not a good light, so that such parts of it as are seen at all are seen well. It is also in a better state than most pictures in galleries, and most remarkable for its new and strange treatment of the subject. It seems to have been painted more for the artist's own delight, than with any laboured attempt at composition; the horizon is so low, that the spectator must fancy himself lying full length on the grass, or rather among the brambles and luxuriant weeds, of which the foreground is entirely composed. Among these, the seamless robe of Christ has fallen at the foot of the cross; the rambling briars and wild grasses thrown here and there over its folds of rich, but pale, crimson. Behind them, and seen through them, the heads of a troop of Roman soldiers are raised against the sky; and above, them, their spears and halberds form a thin forest against the horizontal clouds. The three crosses are put on the extreme right of the picture, and its centre is occupied by the executioners, one of whom, standing on a ladder, receives from the other at once the sponge and the tablet with the letters INRI. [*INRI being Latin for 'Jesus Nazaraeus Rex Judeorum', Jesus of Nazareth, King of the Jews, the inscription over the figure of Christ on the cross.*] The Madonna and St John are on the extreme left, superbly painted, like all the rest, but quite subordinate. In fact, the whole mind of the painter seems to have been set upon making the principals accessory, and the accessories principal. We look first at the grass, and then at the scarlet robe; and then at the clump of distant spears, and then at the sky, and last of all at the cross. As a piece of colour, the picture is notable for its extreme modesty. There is not a single very full or bright tint in any part, and yet the colour is delighted in throughout; not the slightest touch of it but is delicious. It is worth notice also, and especially, because this

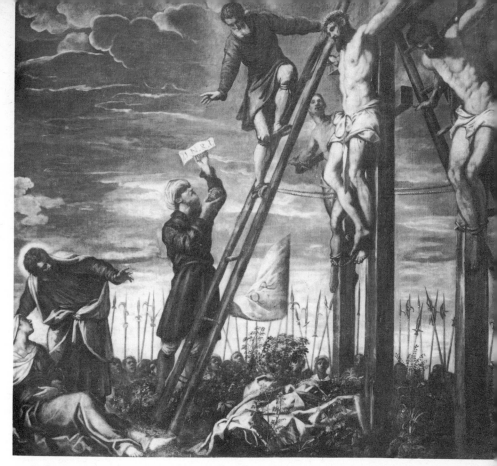

'The Crucifixion' by Tintoretto in the Church of S. Cassiano.

picture being in a fresh state, we are sure of one fact, that, like nearly all other great colourists, Tintoretto was afraid of light greens in his vegetation. He often uses dark blue greens in his shadowed trees, but here where the grass is in full light, it is all painted with various hues of sober brown, more especially where it crosses the crimson robe. The handling of the whole is in his noblest manner; and I consider the picture generally quite beyond all price. It was cleaned, I believe, some years ago, but not injured, or at least as little injured as it is possible for a picture to be which has undergone any cleaning process whatsoever.

2. *The Resurrection.* (Over the high altar.) The lower part of this picture is entirely concealed by a miniature temple, about five feet high on the top of the altar; certainly an insult little expected by Tintoretto, as, by getting on steps, and looking over the said temple, one may see that the lower figures of the picture are the most laboured. It is strange that the painter never seemed able to conceive this subject with any power, and

in the present work he is marvellously hampered by various types and conventionalities. It is not a painting of the Resurrection, but of Roman Catholic saints, *thinking* about the Resurrection. On one side of the tomb is a bishop in full robes, on the other a female saint, I know not who; beneath it, an angel playing on an organ, and a cherub blowing it; and other cherubs flying about the sky, with flowers; the whole conception being a mass of Renaissance absurdities. It is, moreover, heavily painted, over-done, and over-finished; and the forms of the cherubs utterly heavy and vulgar. I cannot help fancying the picture has been restored in some way or another, but there is still great power in parts of it. If it be a really untouched Tintoretto, it is a highly curious example of failure from over-labour on a subject into which his mind was not thrown; the colour is hot and harsh, and felt to be so more painfully, from its opposition to the grand coolness and chastity of the 'Crucifixion'. The face of the angel playing the organ is highly elaborated; so, also, the flying cherubs.

3. *The Descent into Hades.* (On the right-hand side of the high altar.) Much injured and little to be regretted. I never was more puzzled by any picture, the painting being throughout careless, and in same places utterly bad, and yet not like modern work; the principal figure, however, of Eve, has either been re-done, or is scholar's work altogether, as I suspect, most of the rest of the picture. It looks as if Tintoretto had sketched it when he was ill, left it to a bad scholar to work on with, and then finished it in a hurry: but he has assuredly had something to do with it; it is not likely that anybody else would have refused all aid from the usual spectral company with which common painters fill the scene. Bronzino, for instance, covers his canvas with every form of monster that his sluggish imagination could coin. Tintoretto admits only a somewhat haggard Adam, a graceful Eve, two or three Venetians in court dress, seen amongst the smoke, and a Satan represented as a handsome youth, recognizable only by the claws on his feet. The picture is dark and spoiled, but I am pretty sure there are no demons or spectres in it. This is quite in accordance with the master's caprice, but it considerably diminishes the interest of a work in other ways unsatisfactory. There may once have been something impressive in the shooting in of the rays at the top of the cavern, as well as in the strange grass that grows in the bottom, whose infernal character is indicated by its all being knotted together; but so little of these parts can be seen, that it is not worth spending time on a work certainly unworthy of the master, and in great part probably never seen by him.

The Church of S. Cassiano was built in 1611. The Carlo del Medico Chapel was restored in 1967 by the Association France-Italie.

CATTARINA, CHURCH OF S., said to contain a *chef-d'œuvre* of Paul Veronese, the 'Marriage of St Catherine'. I have not seen it.

'The Marriage of St Catherine' was painted by Veronese in 1572 and is one of his most famous paintings.

CAVALLI, PALAZZO, opposite the Academy of Arts. An imposing pile, on the Grand Canal, of Renaissance Gothic, but of little merit in the details; and the effect of its traceries has been of late destroyed by the fittings of modern external blinds. Its balconies are good, of the later Gothic type. See BARBARO.

This palace was extensively restored in 1896. It is now occupied by the Federal Institute of Savings Banks of the Veneto.

CAVALLI, PALAZZO, next the Casa Grimani (or Post Office—*no longer the post office but now the Court of Appeal: Editor*), but on the other side of the narrow canal. Good Gothic, founded on the Ducal Palace,

Palazzo Cavalli on the Grand Canal opposite the Accademia (the first described by Ruskin under that name). Also known as the Palazzo Franchetti or Palazzo Cavalli-Franchetti. Late Gothic extensively restored in the late nineteenth century.

circa 1380. The capitals of the first story are remarkably rich in the deep fillets at the necks. The crests, heads of sea-horses, inserted between the windows, appear to be later, but are very fine of their kind.

CICOGNA, PALAZZO, at S. Sebastiano. II–VII–XLIII. *Ruskin here considers the question which faced the Venetian builders as to how* ... the intervals between the arches, now left blank by the abandonment of the Byzantine sculptures, should be enriched in accordance with the principles of the new school. Two most important examples are left of the experiments made at this period: one at the Ponte del Forner, at S. Cassano, a noble house in which the spandrils of the windows are filled by the emblems of the four Evangelists, sculptured in deep relief, and touching the edges of the arches with their expanded wings; the other now known as the Palazzo Cicogna, near the Church of S. Sebastiano, in the quarter called 'of the Archangel Raphael', in which a large space of wall above the windows is occupied by an intricate but rude tracery of involved quatrefoils.

CLEMENTE, CHURCH OF S. On an island to the south of Venice, from which the view of the city is peculiarly beautiful. See SCALZI. [*This island lies south of the Guidecca.*]

CONTARINI, PORTA DI FERRO, PALAZZO, near the Church of St John and Paul, so called from the beautiful ironwork on a door, which was some time taken down by the proprietor and sold. Mr Rawdon Brown rescued some of the ornaments from the hands of the blacksmith who had bought them for old iron. The head of the door is a very interesting stone arch of the early thirteenth century ... In the interior court is a beautiful remnant of staircase, with a piece of balcony at the top, circa 1350, and one of the most richly and carefully wrought in Venice. The palace, judging by these remnants (all that are now left of it, except a single traceried window of the same date at the turn of the stair), must once have been among the most magnificent in Venice.

CONTARINI (DELLE FIGURE), PALAZZO, on the Grand Canal, III–I–XXIII.
In a chapter on the early Renaissance, Ruskin considers a number of buildings where Renaissance characteristics were engrafted on to Byzantine types: ... there are several palaces, of which the Casa Contarini (called 'delle Figure') is the principal, belonging to the same group, though somewhat later, and remarkable for the association of the Byzantine principles of colour with the severest lines of the Roman pediment,

gradually superseding the round arch. The precision of chiselling and delicacy of proportion in the ornament and general lines of these palaces cannot be too highly praised; and I believe that the traveller in Venice, in general, gives them rather too little attention than too much. But while I would ask him to stay his gondola beside each of them long enough to examine their every line, I must also warn him to observe most carefully the peculiar feebleness and want of soul in the conception of their ornament, which mark them as belonging to a period of decline; as well as the absurd mode of introduction of their pieces of coloured marble: these, instead of being simply and naturally inserted in the masonry, are placed in small circular or oblong frames of sculpture, like mirrors or pictures, and are represented as suspended by ribbons against the wall; a pair of wings being generally fastened on to the circular tablets, as if to relieve the ribbons and knots from their weight, and the whole series tied under the chin of a little cherub at the top, who is nailed against the façade like a hawk on a barn door.

But chiefly let him notice, in the Casa Contarini delle Figure, one most strange incident, seeming to have been permitted, like the choice of the subjects at the three angles of the Ducal Palace, in order to teach us, by a single lesson, the true nature of the style in which it occurs. In the intervals of the windows of the first story, certain shields and torches are attached, in the form of trophies, to the stems of two trees whose boughs have been cut off, and only one or two of their faded leaves left, scarcely observable, but delicately sculptured here and there, beneath the insertions of the severed boughs.

C O N T A R I N I D E G L I S C R I G N I, P A L A Z Z O, on the Grand Canal. A Gothic building, founded on the Ducal Palace. Two Renaissance statues in niches at the sides give it its name.

C O N T A R I N I F A S A N, P A L A Z Z O, on the Grand Canal, II–VII–XVIII. The richest work of the fifteenth-century domestic Gothic in Venice, but notable more for riches than excellence of design. In one respect, however, it deserves to be regarded with attention, as showing how much beauty and dignity may be bestowed on a very small and unimportant dwelling-house by Gothic sculpture. Foolish criticisms upon it have appeared in English accounts of foreign buildings, objecting to it on the ground of its being 'ill-proportioned', the simple fact being, that there was no room in this part of the canal for a wider house, and that its builder made its rooms as comfortable as he could, and its windows and balconies of a convenient size for those who were to see through them, and stand on them, and left the 'proportions' outside to take care of themselves; which indeed they have very sufficiently done; for though

Palazzo Contarini Fasan, on the Grand Canal, Gothic fourteenth century.
This palace is also known as the House of Desdemona.

the house thus honestly confesses its diminutiveness, it is nevertheless one of the principal ornaments of the very noblest reach of the Grand Canal, and would be nearly as great a loss, if it were destroyed, as the Church of La Salute itself.

Reference II–VII–XVIII is to the traceried parapet, chiefly used in the Gothic of the North from which the parapets in the Palazzo Contarini Fasan are derived.

CONTARINI, PALAZZO, at S. Luca. Of no importance.
This is generally known as the Palazzo Contarini dal Bovolo which is

near the Church of S. Luca. It is called 'dal Bovolo' because it contains a spiral staircase, which was built of Istrian marble by Giovanni Candi in the late fifteenth century ('bovolo' being Venetian dialect for 'spiral'). This is the same palace as the Palazzo Minelli which Ruskin lists under that name, and by which it has sometimes been called. Writing under that heading, Ruskin does allow that the palace is 'very picturesque' but repeats his judgment that it is 'without merit'.

CORNER DELLA CA' GRANDE, PALAZZO, on the Grand Canal. One of the worst and coldest buildings of the central Renaissance. It is on a grand scale, and is a conspicuous object, rising over the roofs of the neighbouring houses in the various aspects of the entrance of the Grand Canal, and in the general view of Venice from S. Clemente.

This Palazzo was designed by Jacopo Sansovino in 1532, and does have its admirers. It is now the Prefecture.

CORNER DELLA REGINA, PALAZZO. A late Renaissance building of no merit or interest.

This Palazzo is an eighteenth-century Renaissance building. Queen Catherine of Cyprus was born in a palace that formerly occupied the site, and the present building derives its name from the circumstance.

CORNER MOCENIGO, PALAZZO, at S. Polo. Of no interest. *The Palazzo Corner-Mocenigo in the Renaissance style was designed by Michele Sanmichele about the year 1540. It is now the headquarters of the Customs Office.*

CORNER SPINELLI, PALAZZO, on the Grand Canal. A graceful and interesting example of the early Renaissance, remarkable for its pretty circular balconies.

The Palazzo Corner Spinelli was originally designed by Mauro Coducci in the late fifteenth century and restored and partly rebuilt in the middle of the sixteenth century by Michele Sanmichele.

CORRER, RACCOLTA. I must refer the reader to M. Lazari's Guide for an account of this collection, which, however, ought only to be visited if the traveller is not pressed for time.

The Correr museum is a miscellaneous collection of costume, pottery, musical instruments, armour, sculpture and pictures, the last of which include works by Carpaccio, Giovanni Bellini and Antonello da Messina. The collection was formed by Theodore Correr and given to the city in

1830. It was first housed in the Fondaco dei Turchi, together with the Morosini collection of antiquities and some municipal collections. These were then transferred to the Procuratie Nuove, but the collection proved to be so large that it had to be broken up into a number of individual collections and transferred elsewhere. The collection of glassware went to the Museo Vetrario at Murano, and the eighteenth-century collection to the Palazzo Rezzonico (qv). The paintings of the Venetian school, the museum of Venetian history and that of the Risorgimento remained, however, in the Procuratie Nuove.

In the 1879 abridgement Ruskin adds a note that 'Carpaccio's portrait-study of the two ladies with their pets is the most interesting piece of his finished execution existing in Venice ... there are many other curious and some beautiful pictures.'

D

DANDOLO, PALAZZO, on the Grand Canal. Between the Casa Loredan and Casa Bembo is a range of modern buildings, some of which occupy, I believe, the site of the palace once inhabited by the Doge Henry Dandolo. Fragments of early architecture of the Byzantine school may still be traced in many places among their foundations, and two doors in the foundation of the Casa Bembo itself belong to the same group. There is only one existing palace, however, of any value, on this spot, a very small but rich Gothic one of about 1300, with two groups of fourth order windows in its second and third stories, and some Byzantine circular mouldings built into it above. This is still reported to have belonged to the family of Dandolo, and ought to be carefully preserved, as it is one of the most interesting and ancient Gothic palaces which yet remain.

For further details of Ruskin's window orders see under ORDERS OF VENETIAN ARCHES.

DANIELI, HOTEL. *Although not given an entry in the original index, it is of interest as Ruskin stayed in the Hotel Danieli, on the Riva degli Schiavoni, on five visits to Venice from 1841–51, and wrote much of* The Stones of Venice *there. He records in* Praeterita *'seeing the gondola-beak come actually inside the door at Danieli's, when the tide was up, and the water two feet deep at the foot of the stairs; and then, all along the canal side, actual marble walls rising out of the salt sea, with hosts of little brown crabs on them, and Titians inside'. That was in May 1841.*

It was once the Palazzo Dandolo (not to be confused with the other

palace of that name on the Grand Canal) and was converted into a hotel in 1822 by Joseph dal Niel, who combined the two names to give it its new title.

D A P O N T E, P A L A Z Z O. Of no interest.
A building in the classical Renaissance style, built in the sixteenth century for the Doge Bicolo da Ponte (1578–1585), with external frescoes by Giulio Cezare Lombardo.

D A R I O, P A L A Z Z O, I–Plate I, I–Appendix 6.
The references are to the wall veil decoration of coloured marbles disks or bosses (also to be found in the Palazzo Trevisian). These are clearly

Palazzo Dario (right) on the Grand Canal, fifteenth century.
To the left, the Palazzo Barbaro.

visible in the photograph of the palace and a detail is given in one of Ruskin's own drawings (not illustrated).

The Palazzo Dario is the work of the late fifteenth century and may have been designed by a member of the Lombardo family of architects.

D O G A N A D I M A R E, at the separation of the Grand Canal from the Giudecca. A barbarous building of the time of the Grotesque Renaissance (1676), rendered interesting only by its position. The statue of Fortune forming the weathercock, standing on the world, is alike characteristic of the conceits of the time, and of the hopes and principles of the last days of Venice.

The Dogana di Mare at the southern end of the Grand Canal was the principal custom-house of Venice and was built to the design of Giuseppi Benoni.

D O G E ' S P A L A C E. See DUCAL PALACE.

D O N À , P A L A Z Z O, on the Grand Canal. I believe the palace described under this name as of the twelfth century, by M. Lazari, is that which I have called the Braided House.

Church of S. Donato, Murano. View of the apse.

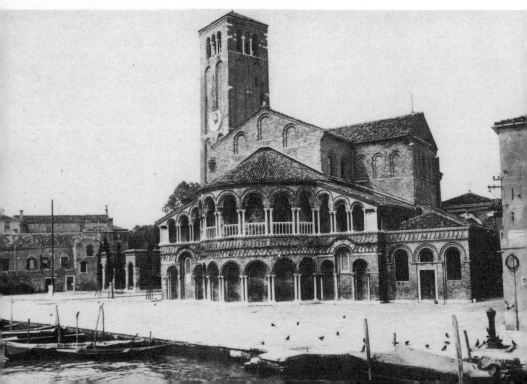

The reason Ruskin calls this the Braided House is because of the braided decoration on capitals on its façade. He gives the following note in Vol II–Appendix 11.

Leaving the steps of the Casa Grimani, and turning the gondola away from the Rialto, we will pass the Casa Businello, and the three houses which succeed it on the right. The fourth is another restored palace, white and conspicuous, but retaining of its ancient structure only the five windows in its second story, and an ornamental moulding above them which appears to be ancient, though it is inaccessible without scaffolding, and I cannot therefore answer for it. But the five central windows are very valuable; and as their capitals differ from most that we find (except in St Mark's), in their plaited or braided border and basket-worked sides, I shall call this house, in future, the Braided House.

DONATO, CHURCH OF S., II–III–VI to XL.
The description of this church occurs in the chapter on Murano. Ruskin is discursive and the digressions and sections less pertinent to the building have therefore been omitted.

VII. [*The Church of S. Donato, the 'Matrice', or 'Mother' Church of Murano, and the heavy campanile detached from it a few yards stand*] in a small triangular field of somewhat fresher grass than is usual near Venice, traversed by a paved walk with green mosaic of short grass between the rude squares of its stones, bounded on one side by ruinous garden walls, on another by a line of low cottages, on the third, the base of the triangle, by the shallow canal from which we have just landed. Near the point of the triangular space is a simple well, bearing date 1502 in its widest part, between the canal and campanile, is a four-square hollow pillar, each side formed by a separate slab of stone, to which the iron hasps are still attached that once secured the Venetian standard.

The cathedral itself occupies the northern angle of the field, encumbered with modern buildings, small outhouse-like chapels, and wastes of white wall with blank square windows, and itself utterly defaced in the whole body of it, nothing but the apse having been spared; the original plan is only discoverable by careful examination, and even then but partially. The whole impression and effect of the building are irretrievably lost, but the fragments of it are still most precious.

Ruskin then speculates about the legendary origins of the church. This is excluded and the more factual details given.

VIII. . . . the emperor Otho the Great, being overtaken by a storm on the Adriatic, vowed, if he were preserved, to build and dedicate a church to

the Virgin, in whatever place might be most pleasing to her; that the storm thereupon abated; and the Virgin appearing to Otho in a dream, showed him, covered with red lilies, that very triangular field on which we were but now standing amidst the ragged weeds and shattered pavement. The emperor obeyed the vision; and the church was consecrated on the 15th of August 957. . . .

Ruskin's plan of the Church of S. Donato at Murano (Volume II, Plate I).

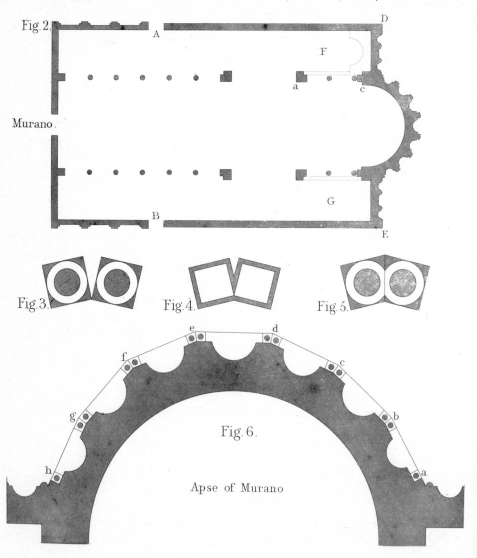

Fig. 2.

Murano.

Fig. 3. Fig. 4. Fig. 5.

Fig. 6.

Apse of Murano

x. . . . The Doge Domenico Michele, having in the second crusade secured such substantial advantages for the Venetians as might well counterbalance the loss of part of their trade with the East, crowned his successes by obtaining possession in Cephalonia of the body of S. Donato, bishop of Euroea; which treasure he having presented on his return to the Murano basilica, that church was thenceforward called the Church of Sts Mary and Donato. Nor was the body of the saint its only acquisition; S. Donato's principal achievement had been the destruction of a terrible dragon in Epirus; Michele brought home the bones of the dragon as well as of the saint; the latter were put in a marble sarcophagus, and the former hung up over the high altar. . . .

xii. . . . That great alterations were made to the basilica at the time of the acquisition of the body of S. Donato is . . . highly probable, the mosaic pavement of the interior, which bears its date inscribed, 1140, being probably the last of the additions. I believe that no part of the ancient church can be shown to be of more recent date than this; and I shall not occupy the reader's time by any inquiry respecting the epochs or authors of the destructive modern restorations: the wreck of the old fabric, breaking out beneath them here and there, is generally distinguishable from them at a glance; and it is enough for the reader to know that none of these truly ancient fragments can be assigned to a more recent date than 1140, and that some of them may with probability be looked upon as remains of the shell of the first church, erected in the course of the latter half of the tenth century. We shall perhaps obtain some further reason for this belief as we examine these remains themselves.

xiii. Of the body of the church, unhappily, they are few and obscure; but the general form and extent of the building, as shown in the plan [*Figure 2*], are determined, first, by the breadth of the uninjured east end D E; secondly, by some remains of the original brickwork of the clerestory, and in all probability of the side walls also, though those have been refaced; and finally by the series of nave shafts, which are still perfect. The doors A and B may or may not be in their original positions; there must of course have been always, as now, a principal entrance at the west end. The ground plan is composed, like that of Torcello, of nave and aisles only, but the clerestory has transepts extending as far as the outer wall of the aisles. The semi-circular apse, thrown out in the centre of the east end, is now the chief feature of interest in the church, though the nave shafts and the eastern extremities of the aisles, outside, are also portions of the original building; the latter having been modernized in the interior, it cannot now be ascertained whether, as is probable, the aisles had once round ends as well as the choir. The spaces F G form small chapels, of

which G has a straight terminal wall behind its altar, and F a curved one, marked by the dotted line; the partitions which divide these chapels from the presbytery are also indicated by dotted lines, being modern work.

XIV. The plan is drawn carefully to scale, but the relation in which its proportions are disposed can hardly be appreciated by the eye. The width of the nave from shaft to opposite shaft is 32 ft 8 in; of the aisles, from the shaft to the wall, 16 ft 2 in, or allowing 2 in for the thickness of the modern wainscot, 16 ft 4 in, half the breadth of the nave exactly. The intervals between the shafts are exactly one-fourth of the width of the nave, or 8 ft 2 in, and the distance between the great piers which form the pseudo-transept is 24 ft 6 in, exactly three times the interval of the shafts. So the four distances are accurately in arithmetical proportion; ie,

	ft	in
Interval of shafts	8	2
Width of aisle	16	4
Width of transept	24	6
Width of nave	32	8

The shafts average 5 ft 4 in in circumference, as near the base as they can be got at, being covered with wood; and the broadest sides of the main piers are 4 ft 7 in wide, their narrowest sides 3 ft 6 in. The distance *a c* from the outmost angle of these piers to the beginning of the curve of the apse is 25 ft, and from that point the apse is nearly semi-circular, but it is so encumbered with Renaissance fittings that its form cannot be ascertained with perfect accuracy. It is roofed by a concha, or semi-dome; and the external arrangement of its walls provides for the security of this dome by what is, in fact, a system of buttresses as effective and definite as that of any of the northern churches, although the buttresses are obtained entirely by adaptations of the Roman shaft and arch, the lower story being formed by a thick mass of wall lightened by ordinary semi-circular round-headed niches, like those used so extensively afterwards in Renaissance architecture, each niche flanked by a pair of shafts standing clear of the wall, and bearing deeply moulded arches thrown over the niche. The wall with its pillars thus forms a series of massy buttresses (as seen in the ground plan), on the top of which is an open gallery, backed by a thinner wall, and roofed by arches whose shafts are set above the pairs of shafts below. On the heads of these arches rests the roof. We have, therefore, externally a heptagonal apse, chiefly of rough and common brick, only with marble shafts and a few marble ornaments; but for that very reason all the more interesting, because it shows us what may be done, and was done, with materials such as are now at our own command; and because in its proportions, and in the use of the few

ornaments it possesses, it displays a delicacy of feeling rendered doubly notable by the roughness of the work in which laws so suubtle are observed, and with which so thoughtful ornamentation is associated.

xv. First, for its proportions: I shall have occasion [*elsewhere*] to dwell at some length on the peculiar subtlety of the early Venetian perception for ratios of magnitude; the relations of the sides of this heptagonal apse supply one of the first and most curious instances of it. The proportions above given of the nave and aisles might have been dictated by a mere love of mathematical precision; but those of the apse could only have resulted from a true love of harmony.

In [*Figure 6*] the plan of this part of the church is given on a large scale, showing that its seven external sides are arranged on a line less than a semicircle, so that if the figure were completed, it would have sixteen sides; and it will be observed also, that the seven sides are arranged in four magnitudes, the widest being the central one. The brickwork is so much worn away, that the measures of the arches are not easily ascertainable, but those of the plinth on which they stand, which is nearly uninjured, may be obtained accurately. This plinth is indicated by the open line in the ground plan, and its sides measure respectively:

	ft	in
1st *a b* in plan	6	7
2nd *b c*	7	7
3rd *c d*	7	5
4th d e (central)	7	10
5th *e f*	7	5
6th *f g*	7	8
7th *g h*	6	10

xvi. Now observe what subtle feeling is indicated by this delicacy of proportion. How fine must the perceptions of grace have been in those builders who could not be content without *some* change between the second and third, the fifth and sixth terms of proportion, such as should oppose the general direction of its cadence, and yet *were* content with a diminution of two inches on a breadth of seven feet and a half! For I do not suppose that the reader will think the curious lessening of the third and fifth arch a matter of accident, and even if he did so, I shall be able to prove to him hereafter that it was not, but that the early builders were always desirous of obtaining some alternate proportion of this kind. The relations of the numbers are not easily comprehended in the form of feet and inches, but if we reduce the first four of them into inches, and then subtract some constant number, suppose 75, from them all, the remainders

4, 16, 14, 19, will exhibit the ratio of proportion in a clearer, though exaggerated form.

XVII. The pairs of circular spots at *b*, *c*, *d*, etc, on the ground plan [*Figure 6*] represent the bearing shafts, which are all of solid marble as well as their capitals. Their measures and various other particulars respecting them are given in Appendix 6, 'Apse of Murano' [*this is a more detailed description of the shafts, given at the end of Volume II, and of particular interest to architects*]; here I only wish the reader to note the colouring of their capitals. Those of the two single shafts in the angles (*a*, *h*) are both of deep purple marble; the two next pairs, *b* and *g*, are of white; the pairs *c* and *f* are of purple, and *d* and *c* are of white: thus alternating with each other on each side; two white meeting in the centre. Now observe, *the purple capitals are all left plain; the white are all sculptured.* For the old builders knew that by carving the purple capitals they would have injured them in two days; first, they would

Detail of the sculptured triangles set in bands round the apse of S. Donato at Murano.

have mixed a certain quantity of grey shadow with the surface hue, and so adulterated the purity of the colour; secondly, they would have drawn away the thoughts from the colour, and prevented the mind from fixing upon it or enjoying it, by the degree of attention which the sculpture would have required. So they left their purple capitals full broad masses of colour; and sculptured the white ones, which would otherwise have been devoid of interest.

XVIII. But the feature which is most to be noted in this apse is a band of ornament, which runs round it like a silver girdle, composed of sharp wedges of marble, preciously inlaid, and set like jewels into the brick-work; above it there is another band of triangular recesses in the bricks; of nearly similar shape, and it seems equally strange that all the marble should have fallen from it, or that it should have been originally destitute of them. The reader may choose his hypothesis; but there is quite enough left to interest us in the lower band, which is fortunately left in its original state, as is sufficiently proved by the curious niceties in the arrangement of its colours, which are assuredly to be attributed to the care of the first builder. A word or two, in the first place, respecting the means of colour at his disposal.

XIX. I stated that the building was, for the most part, composed of yellow brick. This yellow is very nearly pure, much more positive and somewhat darker than that of our English light brick, and the material of the brick is very good and hard, looking in places, almost vitrified, and so compact as to resemble stone. Together with this brick occurs another of a deep full red, and more porous substance, which is used for decoration chiefly, while all the parts requiring strength are composed of the yellow brick. Both these materials are *cast into any shape and size* the builder required, either into curved pieces for the arches, or flat tiles for filling the triangles; and, what is still more curious, the thickness of the yellow bricks used for the walls varies considerably, from two inches to four; and their length also, some of the larger pieces used in important positions being a foot and a half long.

With these two kinds of brick, the builder employed five or six kinds of marble: pure white, and white veined with purple; a brecciated marble of white and black; a brecciated marble of white and deep green; another, deep red, or nearly of the colour of Egyptian porphyry; and a grey and black marble, in fine layers.

XX–XXI. . . . The different triangles are, altogether, of ten kinds. . . . The band . . . composed of these triangles, set close to each other in varied but not irregular relations, is thrown, like a necklace of precious stones, round

the apse and along the ends of the aisles; each side of the apse taking, of course, as many triangles as its width permits.

Ruskin then discusses the patterning produced by these varied triangles. He speaks of colour and points out that only the white marble capitals and triangles are carved whereas the coloured are left plain.

XXVII. We come now to the most interesting portion of the whole east end, the archivolt at the end of the northern aisle.

It was stated [*the passage is excluded*], that the band of triangles was broken by two higher arches at the ends of the aisles. That, however, on the northern side of the apse does not entirely interrupt, but lifts it, and thus forms a beautiful and curious archivolt. The upper band of triangles cannot rise together with the lower, as it would otherwise break the cornice prepared to receive the second story, and the curious zigzag with which its triangles die away against the sides of the arch, exactly as waves break upon the sand, is one of the curious features in the structure.

It will be also seen that there is a new feature in the treatment of the band itself when it turns the arch. Instead of leaving the bricks projecting between the sculptured or coloured stones, reversed triangles of marble are used, inlaid to an equal depth with the others in the brickwork, but projecting beyond them so as to produce a sharp dark line of zigzag at their junctions.

XXVIII. The keystone, if it may be so called, is of white marble, the lateral voussoirs of purple; and these are the only coloured stones in the whole building which are sculptured; but they are sculptured in a way which more satisfactorily proves that the principle above stated was understood by the builders, than if they had been left blank. The object, observe, was to make the archivolt as rich as possible; eight of the white sculptured marbles were used upon it in juxtaposition. Had the purple marbles been left altogether plain, they would have been out of harmony with the elaboration of the rest. It became necessary to touch them with sculpture as a mere sign of carefulness and finish, but at the same time destroying their coloured surface as little as possible. *The ornament is merely outlined upon them with a fine incision*, as if it had been etched out on their surface preparatory to being carved. In two of them it is composed merely of three concentric lines, parallel with the sides of the triangle; in the third, it is a wreath of beautiful design, which I have drawn of larger size in Figure 2, Plate IV, that the reader may see how completely the surface is left undestroyed by the delicate incisions of the chisel, and may compare the method of working with that employed on the white stones, two of which are given in [*Figures 4 and 5*]. The keystone, of which we have not yet spoken, is the only white stone worked with the

J. Ruskin. R. E. Cuff.

Ruskin's drawing of the sculptured triangles in the apse of S. Donato (Volume II, Plate IV).

light incision; its design not being capable of the kind of workmanship given to the floral ornaments, and requiring either to be carved in complete relief, or left as we see it. It is given in [*Figure 1*] of Plate IV. The sun and moon on each side of the cross are, as we shall see [*elsewhere*], constantly employed on the keystones of Byzantine arches.

Ruskin then considers further details of the marble work of the arches with speculations about the intentions of the craftsmen.

XXXI. Above the first story of the apse runs ... a gallery under open arches, protected by a light balustrade. This balustrade is worked on the *outside* with mouldings, of which I shall only say at present that they are of exactly the same school as the greater part of the work of the existing church. But the great horizontal pieces of stone which form the top of this balustrade are fragments of an older building turned inside out. They are covered with sculptures on the back, only to be seen by mounting into the gallery. They have once had an arcade of low wide arches traced on their surface, the spandrils filled with leafage, and archivolts enriched with studded chainwork and with crosses in their centres. These pieces have been used as waste marble by the architect of the existing apse. The small arches of the present balustrade are cut mercilessly through the old work, and the profile of the balustrade is cut out of what was once the back of the stone; only some respect is shown for the crosses in the old design, the blocks are cut so that these shall be not only left uninjured, but come in the centre of the balustrades.

XXXII. Now let the reader observe carefully that this balustrade of Murano is a fence of other things than the low gallery round the deserted apse. It is a barrier between two great schools of early architecture. On one side it was cut by Romanesque workmen of the early Christian ages, and furnishes us with a distinct type of a kind of ornament which, as we meet with other examples of it, we shall be able to describe in generic terms, and to throw back behind this balustrade, out of our way. The *front* of the balustrade presents us with a totally different condition of design, less rich, more graceful, and here shown in its simplest possible form. From the outside of this bar of marble we shall commence our progress in the study of existing Venetian architecture. The only question is, do we begin from the tenth or from the twelfth century?

XXXIII. I was in great hopes once of being able to determine this positively; but the alterations in all the early buildings of Venice are so numerous, and the foreign fragments introduced so innumerable, that I was obliged to leave the question doubtful. But one circumstance must be noted, bearing upon it closely.

Ruskin then illustrates two archivolts: the first, less elaborately cut, from St Mark's; the second, deep and richly moulded, from Murano. This second archivolt is acknowledged by historians to be twelfth-century work. However, Ruskin argues, all other twelfth-century archivolts in Venice are, without exception, on the model of the one from St Mark's, varying only in detail of decoration and sculpture. 'There is not one which resembles that of Murano.' Ruskin continues:

But the deep mouldings of Murano are almost exactly similar to those of S. Michele of Pavia, and other Lombard churches built, some as early as the seventh, others in the eighth, ninth, and tenth centuries.

On this ground it seems to me probable that the existing apse of Murano is part of the original earliest church, and that the inscribed fragments used in it have been brought from the mainland. The balustrade, however, may still be later than the rest. . . .

XXXIV. [*In the interior is*] a range of shafts whose bases are concealed by wooden panelling, and which sustain arches decorated in the most approved style of Renaissance upholstery, with stucco roses in squares under the soffits, and egg and arrow mouldings on the architraves, gilded, on a ground of spotty black and green, with a small pink-faced and black-eyed cherub on every keystone. . . .

In the shadow of the apse our more careful glance shows us a Greek Madonna, pictured on a field of gold; and we feel giddy at the first step we make on the pavement, for it, also, is of Greek mosaic, waved like the sea, and dyed like a dove's neck. [*The mosaic is described in more detail later.*]

XXXV. Nor are the original features of the rest of the edifice altogether indecipherable; the entire series of shafts marked in the ground plan on each side of the nave from the western entrance to the apse, are nearly un-injured; and I believe the stilted arches they sustain are those of the original fabric, though the masonry is covered by the Renaissance stucco mouldings. Their capitals, for a wonder, are left bare, and appear to have sustained no further injury than has resulted from the insertion of a large brass chandelier into each of their abaci, each chandelier carrying a sublime wax candle two inches thick, fastened with wire to the wall above. The due arrangement of these appendages, previous to festa days, can only be effected from a ladder set against the angle of the abacus; and ten minutes before I wrote this sentence I had the privilege of watch-ing the candlelighter at his work, knocking his ladder about the heads of the capitals as if they had given him personal offence. He at last succeeded in breaking away one of the lamps altogether, with a bit of the marble of

the abacus; the whole falling in ruin to the pavement, and causing much consultation and clamour among a tribe of beggars who were assisting the sacristan with their wisdom respecting the festal arrangements.

XXXVI. It is fortunate that the capitals themselves, being somewhat rudely cut, can bear this kind of treatment better than most of those in Venice. They are all founded on the Corinthian type, but the leaves are in every one different: those of the eastern-most capital of the southern range are the best, and very beautiful, but presenting no features of much interest, their workmanship being inferior to most of the imitations of Corinthian common at the period; much more to the rich fantasies which we have seen at Torcello.

XXXVII. The pavement [*of the apse*] ... is of infinite interest, although grievously distorted and defaced. For whenever a new chapel has been built, or a new altar erected, the pavement has been broken up and re-adjusted so as to surround the newly inserted steps or stones with some appearance of symmetry; portions of it either covered or carried away, others mercilessly shattered or replaced by modern imitations, and those of very different periods, with pieces of the old floor left here and there in the midst of them, and worked round so as to deceive the eye into acceptance of the whole as ancient. The portion, however, which occupies the western extremity of the nave, and the parts immediately adjoining it in the aisles, are, I believe, in their original positions, and very little injured: they are composed chiefly of groups of peacocks, lions, stags, and griffins—two of each in a group, drinking out of the same vase, or shaking claws together—enclosed by interlacing bands, and alternating with chequer or star patterns, and here and there an attempt at representation of architecture, all worked in marble mosaic. The floors of Torcello and of St Mark's are executed in the same manner; but what remains at Murano is finer than either, in the extraordinary play of colour obtained by the use of variegated marbles. At St Mark's the patterns are more intricate, and the pieces far more skilfully set together; but each piece is there commonly of one colour: at Murano every fragment is itself variegated, and all are arranged with a skill and feeling not to be taught, and to be observed with deep reverence, for that pavement is not dateless, like the rest of the church; it bears its date on one of its central circles, 1140, and is, in my mind, one of the most precious monuments in Italy, showing thus early, and in those rude chequers which the bared knee of the Murano fisher wears in its daily bending, the beginning of that mighty spirit of Venetian colour, which was to be consummated in Titian. ...

XXXIX. . . . An old wooden tablet, carved into a rude effigy of S. Donato, which occupies the central niche in the lower part of the tribune, has an interest of its own, but is unconnected with the history of the older church. The faded frescoes of saints, which cover the upper tier of the wall of the apse, are also of comparatively recent date, much more the piece of Renaissance workmanship, shaft and entablature, above the altar, which has been thrust into the midst of all, and has cut away part of the feet of the Madonna. Nothing remains of the original structure but the semi-dome itself, the cornice whence it springs, which is the same as that used on the exterior of the church, and the border and face-arch which surround it. The ground of the dome is of gold, unbroken except by the upright Madonna, and [*an*] inscription. . . . The figure wears a robe of blue, deeply fringed with gold, which seems to be gathered on the head and thrown back on the shoulders, crossing the breast, and falling in many folds to the ground. The under robe, shown beneath it where it opens at the breast, is of the same colour; the whole, except the deep gold fringe, being simply the dress of the women of the time. . . .

Round the dome there is a coloured mosaic border; and on the edge of its arch, legible by the whole congregation, this inscription:

'QUOS EVA CONTRIVIT, PIA VIRGO MARIA REDEMIT; HANC CUNCTI LAUDENT, QUI CRISTI MUNERE GAUDENT.'

[*'Whom Eve destroyed, the pious Virgin Mary redeemed;*
All praise her, who rejoice in the grace of Christ.']

The large mosaic floor of S. Donato is being restored by the American International Fund for Monuments. Some earlier work has been done by the Italian Fondazione Ercole Varzi, together with restoration of the frescoes.

D'ORO, CASA. A noble pile of very quaint Gothic, once superb in general effect, but now destroyed by restorations. I saw the beautiful slabs of red marble, which formed the bases of its balconies, and were carved into noble spiral mouldings of strange sections, half a foot deep, dashed to pieces when I was last in Venice, its glorious interior staircase, by far the most interesting Gothic monument of the kind in Venice, had been carried away, piece by piece, and sold for waste marble, two years before. Of what remains, the most beautiful portions are, or were, when I last saw them, the capitals of the windows in the upper story, most glorious sculpture of the fourteenth century. The fantastic window traceries are, I think, later; but the rest of the architecture of this palace is

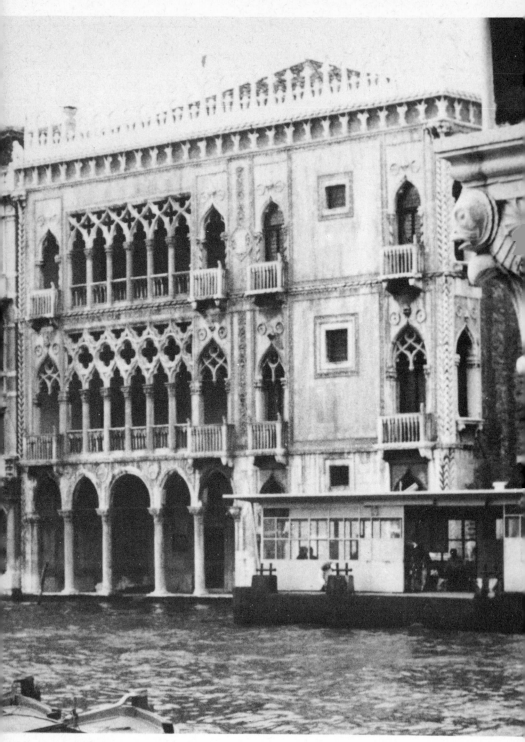

Ca' d'Oro on the Grand Canal, seen from the Fish Market opposite.

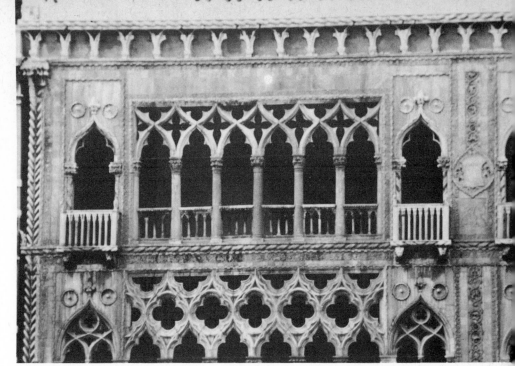

Ca' d'Oro: view of Gothic tracery on the second floor.

anomalous, and I cannot venture to give any decided opinion respecting it. Parts of its mouldings are quite Byzantine in character, but look somewhat like imitations.

The architects of the Ca' d'Oro were Matteo Raverti and Giovanni and Bartolomeo Bon who built the palace in 1424–1436. The Bon brothers were possibly among the architects of the Gothic parts of the Ducal Palace.

The palace was acquired by Baron Giorgio Franchetti, in 1896, who restored the building and formed a collection of paintings, sculpture and other works of art. He bequeathed the palace and his collection to the city.

The Ca' d'Oro is being extensively restored with the assistance of the American International Fund for Monuments and the Association France-Italie.

DUCAL PALACE.
Ruskin devotes an entire chapter (VIII) to the palace in Volume II, and also refers to particular aspects elsewhere, as indicated in the following references. Extracts from the key sections have been given below.

Architectural dating, I–I–XLIV; history of, II–VIII–I et seq,

III–Appendix 1; aescription of, II–VIII–XXXIV et seq; capitals, II–VIII–LXV et seq; spandrels, I–XXVI–IX, I–Appendix 20, shafts, I–Appendix 20; traceries derived from those of the Frari, II–VII–III; angles, II–VII–XI, II–VIII–XXXV et seq; main balcony, II–VII–XVIII; base, III–Appendix 5; Rio façade, III–I–XXXVIII, paintings in, II–VIII–CXXXIV et seq.

History

The Ducal Palace, which was the great work of Venice, was built successively in the three styles. There was a Byzantine Ducal Palace, a Gothic Ducal Palace, and a Renaissance Ducal Palace. The second superseded the first totally: a few stones of it (if indeed so much) are all that is left. But the third superseded the second in part only, and the existing building is formed by the union of the two.

Ruskin gives a brief history of the development of the palace through these three periods, giving the sources for his information. Modern research has generally confirmed his conclusions. A brief summary of the main facts is given below (from II–VIII–IX to XXIX).

The first palace was built by Doge Angelo (or Agnello) Participazo in 813. This palace was injured by fire in 1106 and restored in 1116. 'Between 1173 and the close of the century, it seems to have been again repaired and much enlarged by the Doge Sebastiano Ziani.' Ruskin quotes Francesco Sansovino as saying that Ziani 'enlarged it in every direction' and cites the Chronicle of Pietro Doffino of 1422 which says the 'palace, of which half remains to this day, was built, as we now see it, by Sebastiano Ziani.'

In 1301, as recorded by Sansovino, 'another saloon was begun on the Rio del Palazzo under the Doge Gradenigo, and finished in 1309, in which year the Grand Council first sat in it'. It was in 1301 that, according to the evidence, the Gothic Palace was begun, and this included a new Council Chamber on the Grand Canal (sanctioned in 1340) but it was not completed until 1423 when the Grand Council sat in it for the first time. Although parts of the old Byzantine Palace remained in rather a decayed state, it was largely replaced by the new Gothic Palace completed in 1423, which thus took 122 years to build.

One rather amusing incident occurred in 1422. In 1419 a fire injured parts of the palace. However, so pleased was the Senate apparently with their palace that it issued a decree stating that the old palace should not be rebuilt and that, in addition, no one should propose rebuilding it under a penalty of 1,000 ducats. However in 1422 the Doge Tommaso Mocenigo proposed rebuilding the palace 'more nobly and in a way more befitting

the greatness' of the Venetian State. When making the proposal he had the penalty of 1,000 ducats brought into the Senate Chamber. His proposal was adopted and the Renaissance sections of the palace were begun shortly afterwards under the Doge Francesco Foscari who succeeded Mocenigo in 1423.

In 1574 (or 1577) the palace again suffered from fire and the opinions of fifteen eminent architects were obtained by the Signoria whether to restore the palace or pull it down and rebuild it. Giovanni Rusconi was in favour of retaining the ancient fabric. (Ruskin says he experienced 'some childish pleasure' in the accidental resemblance of his own name to one who favoured the retention of the old fabric.) Palladio, with a few others, on the contrary 'wanted to pull down the old palace, and execute designs of their own; but the best architects in Venice, and to his immortal honour, chiefly Francesco Sansovino, energetically pleaded for the Gothic pile and prevailed'.

The Renaissance sections of the Palace include the walls of the 'cortile' or inner court and the Giant's Stairway built by the architects Antonio Rizzo, Pietro Lombardo and Antonio Scarpagnino between 1485 and 1550. The façades facing the cortile are rather a mixture of styles, and although the Gothic pointed arch is used in the first floor arcading of the east side, and here and there on the north side, they are essentially Renaissance in character. The prisons were transferred to the other side of the Rio del Palazzo and the Bridge of Sighs was built in 1595 to connect the two buildings. (The prison building is now devoted to various social, political and cultural activities.)

All the southern façade facing the sea and the western façade facing the Piazzetta are therefore of the Gothic Palace, built between 1301 and 1423. Earlier, in Volume I, Ruskin discusses the problems of dating these two façades.

I–I–XLIV. . . . The Ducal Palace has two principal façades; one towards the sea, the other towards the Piazzetta. The seaward side, and, as far as its seventh main arch inclusive, the Piazzetta side, is work of the early part of the fourteenth century, some of it perhaps even earlier; while the rest of the Piazzetta side is of the fifteenth. The difference in age has been gravely disputed by the Venetian antiquaries, who have examined many documents on the subject, and quoted some which they never examined. I have myself collated most of the written documents, and one document more, to which the Venetian antiquaries never thought of referring—the masonry of the palace itself.

XLV. That masonry changes at the centre of the eighth arch from the sea angle on the Piazzetta side. It has been of comparatively small stones up to that point; the fifteenth-century work instantly begins with larger

stones, 'brought from Istria, a hundred miles away'. The ninth shaft from the sea in the lower arcade, and the seventeenth, which is above it, in the upper arcade, commence the series of fifteenth-century shafts. These two are somewhat thicker than the others and carry the party-wall of the Sala del Scrutinio. Now observe, reader. The face of the palace, from this point to the Porta della Carta, was built at the instance of that noble Doge Mocenigo . . . and in the beginning of the reign of his successor, Foscari; that is to say, circa 1424. This is not disputed; it is only disputed that the sea façade is earlier; of which, however, the proofs are as simple as they are incontrovertible: for not only the masonry, but the sculpture, changes at the ninth lower shaft, and that in the capitals of the shafts both of the upper and lower arcade: the costumes of the figures introduced in the sea façade being purely Giottesque, correspondent with those of Giotto's work in the Arena Chapel at Padua, while the costume on the other capitals is Renaissance-Classic: and the lions' heads between the arches change at the same point. And there are a multitude of other evidences in the statues of the angles, with which I shall not at present trouble the reader.

XLVI. Now, the architect who built under Foscari, in 1424 (remember my date for the decline of Venice, 1418), was obliged to follow the principal forms of the older palace. But he had not the wit to invent new capitals in the same style; he therefore clumsily copied the old ones. The palace has seventeen main arches on the sea façade, eighteen on the Piazzetta side, which in all are of course carried by thirty-six pillars; and these

Ducal Palace: detail of upper arcading on the Piazzetta façade.

pillars I shall always number from right to left, from the angle of the palace at the Ponte della Paglia to that next the Porta della Carta. I number them in this succession, because I thus have the earliest shafts first numbered. So counted, the 1st, the 18th, and the 36th, are the great supports of the angles of the palace; and the first of the fifteenth-century series, being, as above stated, the 9th from the sea on the Piazzetta side, is the 26th of the entire series, and will always in future be so numbered so that all numbers above twenty-six indicate fifteenth-century work, and all below it, fourteenth century, with some exceptional cases of restoration.

Then the copied capitals are: the 28th, copied from the 7th; the 29th, from the 9th; the 30th, from the 10th; the 31st, from the 8th; the 33rd, from the 12th; and the 34th, from the 11th; the others being dull inventions of the fifteenth century, except the 36th, which is very nobly designed. [*The capitals, including the 'copies' are discussed in greater detail on pages 76–97.*]

Layout

II–VIII–III. . . . [*Ruskin's drawing, as illustrated gives a*] ground plan of the buildings round St Mark's Place; and the following references will clearly explain their relative positions:

A. St Mark's Place
B. Piazzetta
P. V. Procuratie Vecchie
P. N. (opposite) Procuratie Nuove
P. L. Libreria Vecchia
l. Piazzetta de' Leoni
T. Tower of St Mark
F. F. Great Façade of St Mark's Church
M. St Mark's. (It is so united with the Ducal Palace, that the separation cannot be indicated in the plan, unless all the walls had been marked, which would have confused the whole.)

D. D. D. Ducal Palace g.s. Giant's Stair
C. Court of Ducal Palace J. Judgment angle
c. Porta della Carta a. Fig tree angle
p.p. Ponte della Paglia (Bridge of Straw)
S. Ponte de' Sospiri (Bridge of Sighs)
R. R. Riva de' Schiavoni

The reader will observe that the Ducal Palace is arranged somewhat in the form of a hollow square, of which one side faces the Piazzetta, B, and another the quay called the Riva de' Schiavoni, R R; the third is on the dark canal called the 'Rio del Palazzo', and the fourth joins the Church of St Mark.

Of this fourth side, therefore, nothing can be seen. Of the other three sides we shall have to speak constantly; and they will be respectively called, that towards the Piazzetta, the 'Piazzetta Façade'; that towards the

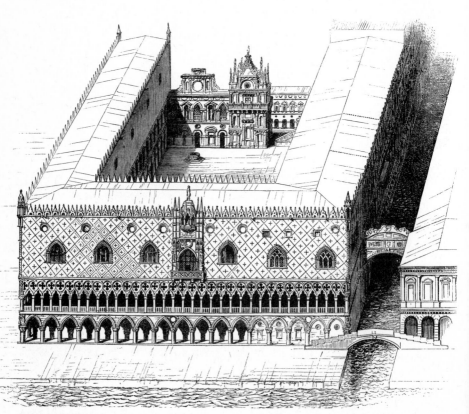

Ruskin's plan of the Piazza S. Marco and surrounding buildings,
and drawing of the Ducal Palace (Volume II, Figures XXXVI and XXXVII).

Riva de' Schiavoni, the 'Sea Façade'; and that towards the Rio del Palazzo, the 'Rio Façade'. This Rio, or canal, is usually looked upon by the traveller with great respect, or even horror, because it passes under the Bridge of Sighs. It is, however, one of the principal thorough-fares of the city; and the bridge and its canal together occupy, in the mind of a Venetian, very much the position of Fleet Street and Temple Bar in that of a Londoner—at least, at the time when Temple Bar was occasion-ally decorated with human heads. The two buildings closely resemble each other in form.

IV. We must now proceed to obtain some rough idea of the appearance and distribution of the palace itself; but its arrangement will be better understood by supposing ourselves raised some hundred and fifty feet above the point in the lagoon in front of it, so as to get a general view of the Sea Façade and Rio Façade (the latter in very steep perspective), and to look down into its interior court. [*The lower drawing*] roughly repre-sents such a view, omitting all details on the roofs, in order to avoid con-fusion. In this drawing we have merely to notice that, of the two bridges seen on the right, the uppermost, above the black canal, is the Bridge of Sighs; the lower one is the Ponte della Paglia, the regular thoroughfare from quay to quay and, I believe, called the Bridge of Straw, because the boats which brought straw from the mainland used to sell it at this place. The corner of the palace, rising above this bridge, and formed by the meet-ing of the Sea Façade and Rio Façade, will always be called the Vine angle, because it is decorated by a sculpture of the drunkenness of Noah [*see page 72*]. The angle opposite will be called the Fig-tree angle, because it is decorated by a sculpture of the Fall of Man [*see page 71*]. The long and narrow range of building, of which the room is seen in perspective behind this angle, is the part of the palace fronting the Piazzetta; and the angle under the pinnacle most to the left of the two which terminate it will be called, for a reason presently to be stated, the Judgment angle [*see page 75*]. Within the square formed by the building is seen its interior court (with one of its wells), terminated by small and fantastic buildings of the Renaissance period, which face the Giant's Stair, of which the extremity is seen sloping down on the left.

V. The great façade which fronts the spectator looks southward. Hence the two traceried windows lower than the rest, and to the right of the spectator, may be conveniently distinguished as the 'Eastern Windows'. There are two others like them, filled with tracery, and at the same level, which look upon the narrow canal between the Ponte della Paglia and the Bridge of Sighs: these we may conveniently call the 'Canal Windows'. The reader will observe a vertical line in this dark side of the palace, separating its nearer and plainer wall from a long four-storied range of

rich architecture. This more distant range is entirely Renaissance: its extremity is not indicated, because I have no accurate sketch of the small buildings and bridges beyond it, and we shall have nothing whatever to do with this part of the palace in our present inquiry. The nearer and undecorated wall is part of the older palace, though much defaced by modern opening of common windows, refittings of the brick-work, etc.

Ruskin's section through the Ducal Palace from the middle of the sea façade to the interior court (Volume II, Figure XXXVIII).

VI. It will be observed that the façade is composed of a smooth mass of wall, sustained on two tiers of pillars, one above the other. The manner in which these support the whole fabric will be understood at once by the rough section [*illustrated*] which is supposed to be taken right through the palace to the interior court, from near the middle of the Sea Façade. Here *a* and *d* are the rows of shafts, both in the inner court and on the façade, which carry the main walls; *b*, *c* are solid walls variously strengthened with pilasters. A, B, C are the three stories of the interior of the palace.

The reader sees that it is impossible for any plan to be more simple, and that if the inner floors and walls of the stories A, B were removed, there would be left merely the form of a basilica—two high walls, carried on ranges of shafts, and roofed by a low gable.

The stories A, B are entirely modernized, and divided into confused ranges of small apartments, among which what vestiges remain of ancient masonry are entirely undecipherable, except by investigations such as I have had neither the time nor, as in most cases they would involve the removal of modern plastering, the opportunity, to make. With the subdivisions of this story, therefore, I shall not trouble the reader; but those of the great upper story, C, are highly important.

VII. In the bird's-eye view above, [*as illustrated below the plan*], it will be noticed that the two windows on the right are lower than the other four of the façade. In this arrangement there is one of the most remarkable instances I know of the daring sacrifice of symmetry to convenience [*which is*] . . . one of the chief noblenesses of the Gothic schools.

The part of the palace in which the two lower windows occur, we shall find, was first built, and arranged in four stories in order to obtain the necessary number of apartments. Owing to circumstances, of which we shall presently give an account, it became necessary, in the beginning of the fourteenth century, to provide another large and magnificent chamber for the meeting of the Senate. That chamber was added at the side of the older building; but, as only one room was wanted, there was no need to divide the added portion into two stories. The entire height was given to the single chamber, being indeed not too great for just harmony with its enormous length and breadth. And then came the question how to place the windows, whether on a line with the two others, or above them.

The ceiling of the new room was to be adorned by the paintings of the best masters in Venice, and it became of great importance to raise the light near that gorgeous roof, as well as to keep the tone of illumination in the Council Chamber serene; and therefore to introduce light rather in simple masses than in many broken streams. A modern architect, terrified at the idea of violating external symmetry, would have sacrificed both the pictures and the peace of the Council. He would have placed the larger windows at the same level with the other two, and have introduced above them smaller windows, like those of the upper story in the older building, as if that upper story had been continued along the façade. But the old Venetian thought of the honour of the paintings, and the comfort of the Senate, before his own reputation. He unhesitatingly raised the large windows to their proper position with reference to the interior of the chamber, and suffered the external appearance to take care of itself. And I believe the whole pile rather gains than loses in effect by the variation thus obtained in the spaces of wall above and below the windows.

VIII. On the party wall, between the second and third windows, which faces the eastern extremity of the Great Council Chamber, is painted the Paradise of Tintoretto; and this wall will therefore be hereafter called the 'Wall of the Paradise'.

In nearly the centre of the Sea Façade, and between the first and second windows of the Great Council Chamber, is a large window to the ground, opening on a balcony, which is one of the chief ornaments of the palace, and will be called in future the 'Sea Balcony'.

The façade which looks on the Piazzetta is very nearly like this to the sea, but the greater part of it was built in the fifteenth century, when people had become studious of their symmetries. Its side windows are all on the same level. Two light the west end of the Great Council Chamber, one lights a small room anciently called the Quarantia Civil Nuova; the other three, and the central one, with a balcony like that to the Sea,

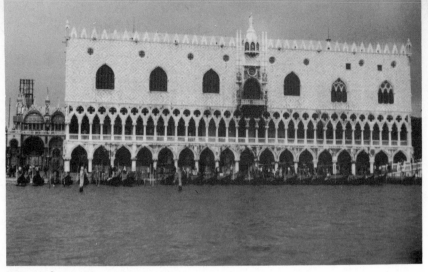

The sea façade of the Ducal Palace.

light another large chamber, called Sala del Scrutinio, or 'Hall of Inquiry', which extends to the extremity of the palace above the Porta della Carta.

The sculptured angles

II–VIII–XXXI. [*As the palace building is*] very nearly square on the ground plan, a peculiar prominence and importance [*is*] given to its angles, which rendered it necessary that they should be enriched and softened by sculpture. I do not suppose that the fitness of this arrangement will be questioned; but if the reader will take the pains to glance over any series of engravings of church towers or other four-square buildings in which great refinement of form has been attained, he will at once observe how their effect depends on some modification of the sharpness of the angle, either by groups of buttresses, or by turrets and niches rich in sculpture. It is to be noted also that this principle of breaking the angle is peculiarly Gothic, arising partly out of the necessity of strengthening the flanks of enormous buildings, where composed of imperfect materials, by buttresses or pinnacles; partly out of the conditions of Gothic warfare, which generally required a tower at the angle; partly out of the natural dislike of the meagreness of effect in buildings which admitted large surfaces of wall, if the angle were entirely unrelieved. The Ducal Palace, in its acknowledgment of this principle, makes a more definite concession to the Gothic spirit than any of the previous architecture of Venice. No angle, up to the time of its erection, had been otherwise decorated than by a narrow fluted pilaster of red marble, and the sculpture was reserved always, as in Greek and Roman work, for the plane surfaces of the building, with, as far as I recollect, two exceptions only, both in St Mark's; namely, the bold and grotesque gargoyle on its north-west angle, and the angels which project from the four inner angles under the

main cupola; both of these arrangements being plainly made under Lombardic influence. And if any other instances occur, which I may have at present forgotten, I am very sure the Northern influence will always be distinctly traceable in them.

xxxII. The Ducal Palace, however, accepts the principle in its completeness, and throws the main decoration upon its angles. The central window, which looks rich and important in the woodcut, was entirely restored in the Renaissance time, as we have seen, under the Doge Steno; so that we have no traces of its early treatment; and the principal interest of the older palace is concentrated in the angle sculpture, which is arranged in the following manner. The pillars of the two bearing arcades are much enlarged in thickness at the angles, and their capitals increased in depth, breadth, and fullness of subject: above each capital, on the angle of the wall, a sculptural subject is introduced, consisting, in the great lower arcade, of two or more figures of the size of life; in the upper arcade, of a single angel holding a scroll: above these angels rise the twisted pillars with their crowning niches, already noticed in the account of parapets [*Volume II, chapter VII*], thus forming an unbroken line of decoration from the ground to the top of the angle.

xxxIII. It was before noticed that one of the corners of the palace joins the irregular outer buildings connected with St Mark's, and is not generally seen. There remain, therefore, to be decorated, only the three angles, above distinguished as the Vine angle, the Fig-tree angle, and the Judgment angle; and at these we have, according to the arrangement just explained—
First, three great bearing capitals (lower arcade).
Secondly, three figure subjects of sculpture above them (lower arcade).
Thirdly, three smaller bearing capitals (upper arcade).
Fourthly, three angels above them (upper arcade).
Fifthly, three spiral shafts with niches.

xxxIV. I shall describe the bearing capitals hereafter, in their order, with the others of the arcade; for the first point to which the reader's attention ought to be directed is the choice of subject in the great figure sculptures above them. These, observe, are the very corner stones of the edifice, and in them we may expect to find the most important evidences of the feeling, as well as of the skill, of the builder. If he has anything to say to us of the purpose with which he built the palace, it is sure to be said here; if there was any lesson which he wished principally to teach to those for whom he built, here it is sure to be inculcated; if there was any sentiment which they themselves desired to have expressed in the principal edifice

of their city, this is the place in which we may be secure of finding it legibly inscribed.

XXXV. Now the first two angles, of the Vine and Fig-tree, belong to the old, or true Gothic, Palace; the third angle belongs to the Renaissance imitation of it: therefore, at the first two angles, it is the Gothic spirit which is going to speak to us, and, at the third, the Renaissance spirit.

The reader remembers, I trust, that the most characteristic sentiment of all that we traced in the working of the Gothic heart, was the frank confession of its own weakness; and I must anticipate, for a moment, the results of our inquiry in subsequent chapters, so far as to state that the principal element in the Renaissance spirit, is its firm confidence in its own wisdom.

Here, then, the two spirits speak for themselves.

The first main sculpture of the Gothic Palace is on what I have called the angle of the Fig-tree:

Its subject is the FALL OF MAN.

The second sculpture is on the angle of the Vine:

Its subject is the DRUNKENNESS OF NOAH.

The Renaissance sculpture is on the Judgment angle:

Its subject is the JUDGMENT OF SOLOMON.

It is impossible to overstate, or to regard with too much admiration, the significance of this single fact. It is as if the palace had been built at various epochs, and preserved uninjured to this day, for the sole purpose of teaching us the difference in the temper of the two schools.

XXXVI. I have called the sculpture on the Fig-tree angle the principal one; because it is at the central bend of the palace, where it turns to the Piazzetta (the façade upon the Piazzetta being the more important one in ancient times). The great capital, which sustains this Fig-tree angle, is also by far more elaborate than the head of the pilaster under the Vine angle, marking the pre-eminence of the former in the architect's mind. It is impossible to say which was first executed, but that of the Fig-tree angle is somewhat rougher in execution, and more stiff in the design of the figures, so that I rather suppose it to have been the earliest completed.

XXXVII. In both the subjects, of the Fall and the Drunkenness, the tree, which forms the chiefly decorative portion of the sculpture—fig in the one case, vine in the other—was a necessary adjunct. Its trunk, in both sculptures, forms the true outer angle of the palace; boldly cut separate from the stonework behind, and branching out above the figures so as to enwrap each side of the angle, for several feet, with its deep foliage. Nothing can be more masterly or superb than the sweep of this foliage on the

Ducal Palace: sculpture of Adam and Eve at the south-west corner (the 'fig-tree angle').

Ducal Palace: sculpture of the drunkenness of Noah
at the south-east corner (the 'vine angle').

Fig-tree angle; the broad leaves lapping round the budding fruit, and sheltering from sight, beneath their shadows, birds of the most graceful form and delicate plumage. The branches are, however, so strong, and the masses of stone hewn into leafage so large, that, notwithstanding the depth of the undercutting, the work remains nearly uninjured; not so at the Vine angle, where the natural delicacy of the vine-leaf and tendril having tempted the sculptor to greater effort, he has passed the proper limits of his art, and cut the upper stems so delicately that half of them have been broken away by the casualties to which the situation of the sculpture necessarily exposes it. What remains is, however, [*highly*] interesting in its extreme refinement. . . . Although half of the beauty of the composition is destroyed by the breaking away of its central masses, there is still enough in the distribution of the variously bending leaves, and in the placing of the birds on the lighter branches, to prove to us the power of the designer. I have already referred to this [*piece of sculpture*] as a remarkable instance of the Gothic Naturalism; and, indeed; it is almost impossible for the copying of nature to be carried further than in the fibres of the marble branches, and the careful finishing of the tendrils: note especially the peculiar expression of the knotty joints of the vine in the light branch which rises highest . . . [*and*] in several cases, the sculptor has shown the under sides of the leaves turned boldly to the light, and has literally *carved every rib and vein upon them in relief* [*Ruskin's italics*]; not merely the main ribs which sustain the lobes of the leaf, and actually project in nature, but the irregular and sinuous veins which chequer the membranous tissues between them, and which the sculptor has represented conventionally as relieved like the others, in order to give the vine-leaf its peculiar tessellated effect upon the eye.

XXXVIII. As must always be the case in early sculpture, the figures are much inferior to the leafage; yet so skilful in many respects, that it was a long time before I could persuade myself that they had indeed been wrought in the first half of the fourteenth century. Fortunately, the date is inscribed upon a monument in the Church of S. Simeon Grande, bearing a recumbent statue of the saint, of far finer workmanship, in every respect, than those figures of the Ducal Palace, yet so like them, that I think there can be no question that the head of Noah was wrought by the sculptor of the palace in emulation of that of the statue of St Simeon. .. . [*See* Church of S. Simeone Profeta]

XXXIX. The head of the Noah on the Ducal Palace . . . has the same profusion of flowing hair and beard, but wrought in smaller and harder curls; and the veins on the arms and breast are more sharply drawn, the sculptor being evidently more practised in keen and fine lines of vegetation than in those of the figure; so that, which is most remarkable in a

Ducal Palace: head of Noah.

Ducal Palace: sculpture
of the judgment
of Solomon at the
north-west corner
(the 'judgment angle').

workman of this early period, he has failed in telling his story plainly, regret and wonder being so equally marked on the features of all the three brothers, that it is impossible to say which is intended for Ham....

XL. It may be observed, as a further evidence of the date of the group, that, in the figures of all the three youths, the feet are protected simply by a bandage arranged in crossed folds round the angle and lower part of the limb; a feature of dress which will be found in nearly every piece of figure sculpture in Venice, from the year 1300 to 1380, and of which the traveller may see an example within three hundred yards of this very group, in the bas-reliefs on the tomb of the Doge Andrea Dandolo (in St Mark's), who died in 1354.

XLI. The figures of Adam and Eve, sculptured on each side of the Fig-tree angle, are more stiff than those of Noah and his sons, but are better fitted for their architectural service; and the trunk of the tree, with the angular body of the serpent writhed around it, is more nobly treated as a terminal group of lines than that of the vine.

The Renaissance sculptor of the figures of the Judgment of Solomon

has very nearly copied the fig-tree from this angle, placing its trunk between the executioner and the mother, who leans forward to stay his hand. But, though the whole group is much more free in design than those of the earlier palace, and in many ways excellent in itself, so that it always strikes the eye of a careless observer more than the others, it is of immeasurably inferior spirit in the workmanship; the leaves of the tree, though far more studiously varied in flow than those of the fig-tree from which they are partially copied, have none of its truth to nature; they are ill set on the stems, bluntly defined on the edges, and their curves are not those of growing leaves, but of wrinkled drapery.

XLII. Above these three sculptures are set, in the upper arcade, the statues of the archangels Raphael, Michael, and Gabriel [*with*] that of Raphael above the Vine angle. A diminutive figure of Tobit follows at his feet, and he bears in his hand a scroll with [*an inscription which in full would read*]: Effice (quæso?) fretum, Raphael reverende, quietum. [*'Oh, venerable Raphael, make thou the gulf calm, we beseech you.' The angel Raphael is traditionally credited with restraining the harmful influences of evil spirits. In this connection, Ruskin draws attention to 'the peculiar superstitions of the Venetians respecting the raising of storms by fiends, as embodied in the well-known tale of the fisherman and St Mark's ring.'*] I could not decipher the inscription on the scroll borne by the angel Michael; and the figure of Gabriel, which is by much the most beautiful feature of the Renaissance portion of the palace, has only in its hand the Annunciation lily.

XLIII. Such are the subjects of the main sculptures decorating the angles of the palace; notable, observe, for their simple expression of two feelings, the consciousness of human frailty, and the dependence upon Divine guidance and protection: this being, of course, the general purpose of the introduction of the figures of the angels; and, I imagine, intended to be more particularly conveyed by the manner in which the small figure of Tobit follows the steps of Raphael, just touching the hem of his garment. We have next to examine the course of divinity and of natural history embodied by the old sculptor in the great series of capitals which support the lower arcade of the palace; and which, being at a height of little more than eight feet above the eye, might be read, like the pages of a book, by those (the noblest men in Venice) who habitually walked beneath the shadow of this great arcade at the time of their first meeting each other for morning converse.

The arcade capitals and their sculpture
II–VIII–XLIV. The principal sculpture of the capitals consist of personifications of the Virtues and Vices, the favourite subjects of decorative art,

at this period, in all the cities of Italy ... [*Counting the capitals from left to right, the most ancient come first so that*] thus arranged, the first, which is not a shaft, but a pilaster, will be the support of the Vine angle; the eighteenth will be the great shaft of the Fig-tree angle; and the thirty-sixth, that of the Judgment angle. [*As Ruskin explains earlier—page 63 —twenty-five of the capitals belong to the period of the Gothic Palace. Eleven are Renaissance copies.*]

LXVI. All their capitals, except that of the first, are octagonal, and are decorated by sixteen leaves, differently enriched in every capital, but arranged in the same way; eight of them rising to the angles, and there forming volutes; the eight others set between them, on the sides, rising half-way up the bell of the capital; there nodding forward, and showing above them, rising out of their luxuriance, the groups or single figures which we have to examine. In some instances, the intermediate or lower leaves are reduced to eight sprays of foliage; and the capital is left dependent for its effect on the bold position of the figures. In referring to the figures on the octagonal capitals, I shall call the outer side, fronting either the Sea or the Piazzetta, the first side; and so count round from left to right; the fourth side being thus, of course, the innermost. As, however, the first five arches were walled up after the great fire, only three sides of their capitals are left visible, which we may describe as the front and the eastern and western sides of each. [*This brickwork has now been taken down and the arches are open, as the illustrations show.*]

LXVII. FIRST CAPITAL, ie., of the pilaster at the Vine angle.

In front, towards the sea. A child holding a bird before him, with its wings expanded, covering his breast.

On its eastern side. Children's heads among leaves.

On its western side. A child carrying in one hand a comb; in the other, a pair of scissors.

It appears curious, that this, the principal pilaster of the façade, should have been decorated only by these graceful grotesques, for I can hardly suppose them anything more. There may be meaning in them, but I will not venture to conjecture any, except the very plain and practical meaning conveyed by the last figure to all Venetian children, which it would be well if they would act upon. For the rest, I have seen the comb introduced in grotesque work as early as the thirteenth century, but generally for the purpose of ridiculing too great care in dressing the hair, which assuredly is not its purpose here. The children's heads are very sweet and full of life, but the eyes sharp and small.

LXVIII. SECOND CAPITAL. Only three sides of the original work are left unburied by the mass of added wall. Each side has a bird, one web-footed,

with a fish; one clawed, with a serpent, which opens its jaws, and darts its tongue at the bird's breast; the third pluming itself, with a feather between the mandibles of its bill. It is by far the most beautiful of the three capitals decorated with birds. [*All sides of the capital are now visible.*]

THIRD CAPITAL. Also has three sides only left. They have three heads, large, and very ill cut; one female, and crowned. [*All sides now free.*]

FOURTH CAPITAL. Has three children. The eastern one is defaced: the one in front holds a small bird, whose plumage is beautifully indicated, in its right hand; and with its left holds up half a walnut, showing the nut inside: the third holds a fresh fig, cut through, showing the seeds.

The hair of all three children is differently worked: the first has luxuriant flowing hair, and a double chin; the second, light flowing hair falling in pointed locks on the forehead: the third, crisp curling hair, deep cut with drill holes.

This capital has been copied on the Renaissance side of the palace, only with such changes in the ideal of the children as the workman thought expedient and natural. It is highly interesting to compare the child of the fourteenth with the child of the fifteenth century. The early heads are full of youthful life, playful, humane, affectionate, beaming with sensation and vivacity, but with much manliness and firmness also, not a little cunning, and some cruelty perhaps, beneath all; the features small and hard, and the eyes keen. There is the making of rough and great men

Ducal Palace: detail of the fourth capital of the arcading.
Ruskin did not describe this side which was walled up at the time.

in them. But the children of the fifteenth century are dull smooth-faced dunces, without a single meaning line in the fatness of their stolid cheeks; and, although, in the vulgar sense, as handsome as the other children are ugly, capable of becoming nothing but perfumed coxcombs.

FIFTH CAPITAL. Still three sides only left [*all now visible*], bearing three half-length statues of kings; this is the first capital which bears any inscription. In front, a king with a sword in his right hand points to a handkerchief embroidered and fringed, with a head on it, carved on the cavetto of the abacus. His name is written above, 'TITUS VESPASIAN IMPERATOR' [*in a contracted form*].

On the eastern side, 'TRAJANUS IMPERATOR'. Crowned, a sword in right hand, and sceptre in left.

On western, '(OCT)AVIANUS AUGUSTUS IMPERATOR'. The 'OCT' is broken away. He bears a globe in his right hand, with 'MUNDUS PACIS' upon it; a sceptre in his left, which I think has terminated in a human figure. He has a flowing beard, and a singularly high crown; the face is much injured, but has once been very noble in expression.

SIXTH CAPITAL. Has large male and female heads, very coarsely cut, hard, and bad.

LXIX. SEVENTH CAPITAL. This is the first of the series which is complete; the first open arch of the lower arcade being between it and the sixth. It begins the representation of the Virtues. [*As mentioned above, the first six capitals had been partially blocked in. The brickwork has now been removed.*]

First side. Largitas, or Liberality: always distinguished from the higher Charity. A male figure, with his lap full of money, which he pours out of his hand. The coins are plain, circular, and smooth; there is no attempt to mark device upon them. The inscription above is, 'LARGITAS ME ONORAT'.

In the copy of this design on the twenty-fifth capital, instead of showering out the gold from his open hand, the figure holds it in a plate or salver, introduced for the sake of disguising the direct imitation. The changes thus made in the Renaissance pillars are always injuries. . . .

LXX. *Second side.* Constancy; not very characteristic. An armed man with a sword in his hand, inscribed, 'CONSTANTIA SUM, NIL TIMENS'.

LXXI. *Third side.* Discord; holding up her finger, but needing the inscription above to assure us of her meaning, 'DISCORDIA SUM, DISCORDANS'. In the Renaissance copy she is a meek and nun-like person with a veil.

LXXII. *Fourth side.* Patience. A female figure, very expressive and lovely, in a hood, with her right hand on her breast, the left extended, inscribed 'PATIENTIA MANET MECUM'.

LXXIII. *Fifth side.* Despair. A female figure thrusting a dagger into her throat, and tearing her long hair, which flows down among the leaves of the capital below her knees. One of the finest figures of the series; inscribed 'DESPERACIO MOS (mortis?) CRUDELIS'. In the Renaissance copy she is totally devoid of expression, and appears, instead of tearing her hair, to be dividing it into long curls on each side.

LXXIV. *Sixth side.* Obedience: with her arms folded; meek, but rude and commonplace, looking at a little dog standing on its hind legs and begging, with a collar round its neck. Inscribed 'OBEDIENTI**'; the rest of the sentence is much defaced [*but probably read*] 'Obedientiam domino exhibeo'.

LXXV. *Seventh side.* Infidelity. A man in a turban, with a small image in his hand, or the image of a child. Of the inscription nothing but 'INFIDELITATE***' and some fragmentary letters 'ILI CERO', remain.

LXXVI. *Eighth side.* Modesty; bearing a pitcher. (In the Renaissance copy, a vase like a coffee-pot) . . .

LXXVII. EIGHTH CAPITAL. It has no inscriptions, and its subjects are not, by themselves, intelligible; but they appear to be typical of the degradation of human instincts.

First side. A caricature of Arion on his dolphin; he wears a cap ending in a long proboscis-like horn, and plays a violin with a curious twitch of the bow and wag of the head, very graphically expressed, but still without anything approaching to the power of Northern grotesque. His dolphin has a goodly row of teeth, and the waves beat over its back.

Second side. A human figure, with curly hair and legs of a bear; the paws laid, with great sculptural skill, upon the foliage. It plays a violin, shaped like a guitar, with a bent double stringed bow.

Third side. A figure with a serpent's tail and a monstrous head, founded on a Negro type, hollow-cheeked, large-lipped, and wearing a cap made of a serpent's skin holding a fir-cone in its hand.

Fourth side. A monstrous figure, terminating below in a tortoise. It is devouring a gourd, which it grasps greedily with both hands; it wears a cap ending in a hoofed leg.

Fifth side. A creature wearing a crested helmet, and holding a curved sword.

Sixth side. A knight, riding a headless horse, and wearing chain armour, with a triangular shield flung behind his back, and a two-edged sword.

Seventh side. A figure like that on the fifth, wearing a round helmet, and with the legs and tail of a horse. He bears a long mace with a top like fir-cone.

Eighth side. A figure with curly hair, and an acorn in its hand, ending below in a fish.

LXXVIII. NINTH CAPITAL. *First side.* Faith. She has her left hand on her breast, and the cross on her right. Inscribed 'FIDES OPTIMA IN DEO'.

LXXIX. *Second side.* Fortitude. A long-bearded man (Samson?) tearing open a lion's jaw. The inscription is illegible, and the somewhat vulgar personification appears to belong rather to Courage than Fortitude. On the Renaissance copy it is inscribed 'FORTITUDO SUM VIRILIS'. The Latin word has, perhaps, been received by the sculptor as merely signifying 'Strength', the rest of the perfect idea of this virtue having been given in 'Constantia' previously.

LXXX. Third side. Temperance; bearing a pitcher of water and a cup. Inscription, illegible here, and on the Renaissance copy nearly so, 'TEM-PERANTIA SUM' only left.

LXXXI. *Fourth side.* Humility; with a veil upon her head, carrying a lamb in her lap. Inscribed in the copy, 'HUMILITAS HABITAT IN ME'.

LXXXII. *Fifth side.* Charity. A woman with her lap full of loaves (?), giving one to a child, who stretches his arm out for it across a broad gap in the leafage of the capital.

LXXXIII. *Sixth side.* Justice. Crowned, and with sword. Inscribed in the copy 'REX SUM JUSTICIE'.

This idea was afterwards much amplified and adorned in the only good capital of the Renaissance series, under the Judgment angle.

LXXXIV. *Seventh Side.* Prudence. A man with a book and a pair of compasses, wearing the noble cap, hanging down towards the shoulder, and bound in a fillet round the brow, which occurs so frequently during the fourteenth century in Italy in the portraits of men occupied in any civil capacity.

This virtue [*was*] conceived under very different degrees of dignity, from mere worldly prudence up to heavenly wisdom, being opposed sometimes by Stultitia, sometimes by Ignorantia.

LXXXV. *Eighth side.* Hope. A figure full of devotional expression, holding up its hands as in prayer, and looking to a hand which is extended towards it out of sunbeams. In the Renaissance copy this hand does not appear. . . .

Ducal Palace: detail of ninth capital, second side. Fortitude, shown as a bearded man tearing open a lion's jaw.

LXXXVI. TENTH CAPITAL. *First side.* Luxury (the opposite of Chastity). A woman with a jewelled chain across her forehead, smiling as she looks into a mirror, exposing her breast by drawing down her dress with one hand. Inscribed 'LUXURIA SUM IMENSA'.

LXXXVII. *Second side.* Gluttony. A woman in a turban, with a jewelled cup in her right hand. In her left, the clawed limb of a bird, which she is gnawing. Inscribed 'GULA SINE ORDINE SUM'.

LXXXVIII. *Third side.* Pride. A knight, with a heavy and stupid face, holding a sword with three edges, his armour covered with ornaments in the form of roses, and with two ears.

LXXXIX. *Fourth side.* Anger. A woman tearing her dress open at her breast. Inscription here undecipherable; but in the Renaissance copy it is 'IRA CRUDELIS EST IN ME'.

XC. *Fifth side.* Avarice. An old woman with a veil over her forehead, and a bag of money in each hand. A figure very marvellous for power of expression. The throat is all made up of sinews with skinny channels deep between them, strained as by anxiety, and wasted by famine; the features hunger-bitten, the eyes hollow, the look glaring and intense, yet without the slightest caricature. Inscribed in the Renaissance copy, 'AVARITIA IMPLETOR'.

XCI. *Sixth side.* Idleness. 'Accidia'. A figure much broken away, having had its arms round two branches of trees.

I do not know why idleness should be represented as among trees, unless, in the Italy of the fourteenth century, forest country was considered as desert, and therefore the domain of Idleness.

XCII. *Seventh side.* Vanity. She is smiling complacently as she looks into a mirror in her lap. Her robe is embroidered with roses, and roses for her crown. Undecipherable.

XCIII. *Eighth side.* Envy. One of the noblest pieces of expression in the series. She is pointing malignantly with her finger; a serpent is wreathed about her head like a cap, another forms the girdle of her waist, and a dragon rests in her lap.

XCIV. ELEVENTH CAPITAL. Its decoration is composed of eight birds . . . all varied in form and action, but not so as to require special description. *Ruskin mistakenly refers the reader to an illustration of this given as Plate I in* The Seven Lamps of Architecture. *In fact this was sketched from the Renaissance copy—the thirty-fourth capital. Writing of the eleventh capital, Ruskin describes it as 'of the noblest period of the Venetian Gothic;*

Ducal Palace: the upper part of the eleventh capital.

and it is interesting to see the play of leafage so luxuriant, absolutely subordinated to the breadth of two masses of light and shade.'

XCV. TWELFTH CAPITAL. This has been very interesting, but is grievously defaced, four of its figures being entirely broken away, and the character of two others quite undecipherable. It is fortunate that it has been copied in the thirty-third capital of the Renaissance series, from which we are able to identify the lost figures.

First side. Misery. A man with a wan face, seemingly pleading with a child who has its hands crossed on its breast. There is a buckle at his own breast in the shape of a cloven heart. Inscribed 'MISERIA'.

The intention of this figure is not altogether apparent, as it is by no means treated as a vice: the distress seeming real, and like that of a parent in poverty mourning over his child. Yet it seems placed here as in direct opposition to the virtue of Cheerfulness, which follows next in order; rather, however, I believe, with the intention of illustrating human life, than the character of the vice which . . . Dante placed in the circle of hell.

It is to be noticed, however, that in the Renaissance copy this figure is stated to be, not Miseria, but 'Misericordia'. The contraction is a very moderate one, Misericordia being in old MS written always as 'Mia'. If this reading be right, the figure is placed here rather as the companion, than the opposite, of Cheerfulness; unless, indeed, it is intended to unite the idea of Mercy and Compassion with that of Sacred Sorrow.

XCVI. *Second side.* Cheerfulness. A woman with long flowing hair, crowned with roses, playing on a tambourine, and with open lips, as singing. Inscribed 'ALACRITAS'.

We have already met with this virtue among those especially set by Spenser to attend on Womanhood. It is inscribed in the Renaissance copy, 'ALACHRISTAS CHANIT MECUM'. Note the gutturals of the rich and fully developed Venetian dialect now affecting the Latin, which is free from them in the earlier capitals.

XCVII. *Third side.* Destroyed; but, from the copy, we find it has been Stultitia, Folly; and it is there represented simply as a man riding, a sculpture worth the consideration of the English residents who bring their horses to Venice.

XCVIII. *Fourth side.* Destroyed, all but a book, which identifies it with the 'Celestial Chastity' of the Renaissance copy; there represented as a woman pointing to a book (connecting the convent life with the pursuit of literature?).

XCIX. *Fifth side.* Only a scroll is left; but, from the copy, we find it has been Honesty or Truth. Inscribed 'HONESTATEM DILIGO'. It is very curious, that among all the Christian systems of the virtues which we have examined, we should find this one in Venice only.

C. *Sixth side.* Falsehood. An old woman leaning on a crutch; and inscribed in the copy, 'FALSITAS IN ME SEMPER EST'.

CI. *Seventh side.* Injustice. An armed figure holding a halbert; so also in the copy.

Eighth side. A man with a dagger looking sorrowfully at a child, who turns its back to him. I cannot understand this figure. It is inscribed in the copy, 'ASTINECIA (Abstinentia?) OPITIMA?'

CII. THIRTEENTH CAPITAL. It has lions' heads all round, coarsely cut.
FOURTEENTH CAPITAL. It has various animals, each sitting on its haunches. Three dogs, one a greyhound, one long-haired, one short-haired with bells about its neck; two monkeys, one with fan-shaped hair projecting on each side of its face; a noble boar, with its tusks, hoofs, and bristles sharply cut; and a lion and lioness.

CIII. FIFTEENTH CAPITAL. The pillar to which it belongs is thicker than the rest, as well as the one over it in the upper arcade.
The sculpture of this capital is also much coarser, and seems to me later than that of the rest; and it has no inscription, which is embarrassing, as its subjects have had much meaning; but I believe Selvatico is right in supposing it to have been intended for a general illustration of Idleness.

First side. A woman with a distaff; her girdle richly decorated, and fastened by a buckle.

Second side. A youth in a long mantle, with a rose in his hand.

Third side. A woman in a turban stroking a puppy, which she holds by the haunches.

Fourth side. A man with a parrot.

Fifth side. A woman in very rich costume, with braided hair, and dress thrown into minute folds, holding a rosary (?) in her left hand, her right on her breast.

Sixth side. A man with a very thoughtful face, laying his hand upon the leaves of the capital.

Seventh side. A crowned lady, with a rose in her hand.

Eighth side. A boy with a ball in his left hand, and his right laid on his breast.

CIV. SIXTEENTH CAPITAL. [*Selvatico states that these are intended to represent eight nations: Latins, Tartars, Turks, Hungarians, Greeks, Goths, Egyptians and Persians.*] It is decorated with eight large heads, partly intended to be grotesque, and very coarse and bad, except only that in the sixth side, which is totally different from all the rest, and looks like a portrait. It is thin, thoughtful, and dignified; thoroughly fine in every way. It wears a cap surmounted by two winged lions; this head is certainly meant to express the superiority of the Venetian character over that of other nations. Nothing is more remarkable in all early sculpture than its appreciation of the signs of dignity of character in the features, and the way in which it can exalt the principal figure in any subject by a few touches.

CV. SEVENTEENTH CAPITAL. This has been so destroyed by the sea wind, which sweeps at this point of the arcade round the angle of the palace,

Ducal Palace: heads from the sixteenth capital—the human race.

that its inscriptions are no longer legible, and great part of its figures are gone. Selvatico states them as fellows: Solomon, the wise; Priscian, the grammarian; Aristotle, the logician; Tully, the orator; Pythagoras, the philosopher; Archimedes, the mechanic; Orpheus, the musician; Ptolemy, the astronomer. The fragments actually remaining are the following:

First side. A figure with two books, in a robe richly decorated with circles of roses. Inscribed 'SALOMON (SAP)IENS'.

Second side. A man with one book, poring over it: he has had a long stick or reed in his hand. Of inscription only the letters 'GRAMMATIC' remain.

Third side. 'ARISTOTLE': so inscribed. He has a peaked double beard and a flat cap, from under which his long hair falls down his back.

Fourth side. Destroyed.

Fifth side. Destroyed, all but a board with three (counters?) on it.

Sixth side. A figure with compasses. Inscribed 'GEOMET**'.

Seventh side. Nothing is left but a guitar with its handle wrought into a lion's head.

Eighth side. Destroyed.

CVI. We have now arrived at the EIGHTEENTH CAPITAL, the most interesting and beautiful of the palace. It represents the planets, and the sun and moon, in those divisions of the zodiac known to astrologers as their 'houses'; and perhaps indicates, by the position in which they are placed, the period of the year at which this great corner-stone was laid. The inscriptions above have been in quaint Latin rhyme, but are now decipherable only in fragments, and that with the more difficulty because the rusty iron bar that binds the abacus has broken away, in its expansion, nearly all the upper portions of the stone, and with them the signs of contraction, which are of great importance. [*Where Ruskin has been able to offer an interpretation of the inscriptions, these have been included.*]

CVII. It should be premised that, in modern astrology, the houses of the planets are thus arranged:

The house of the	Sun	is	Leo
The house of the	Moon	is	Cancer
The house of	Mars	is	Aries and Scorpio
The house of	Venus	is	Taurus and Libra
The house of	Mercury	is	Gemini and Virgo
The house of	Jupiter	is	Sagittarius and Pisces
The house of	Saturn	is	Capricorn
The house of	Herschel	is	Aquarius

The Herschel planet being of course unknown to the old astrologers, we have only the other six planetary powers, together with the sun; and Aquarius is assigned to Saturn as his house. I could not find Capricorn at all; but this sign may have been broken away, as the whole capital is grievously defaced. The eighth side of the capital, which the Herschel planet would now have occupied, bears a sculpture of the Creation of Man: it is the most conspicuous side, the one set diagonally across the angle; or the eighth in our usual mode of reading the capitals, from which I shall not depart.

CVIII. The *first side*, then, or that towards the Sea, has Aquarius, as the house of Saturn, represented as a seated figure beautifully draped, pouring a stream of water out of an amphora over the leaves of the capital.

CIX. *Second side*. Jupiter, in his houses Sagittarius and Pisces, represented throned, with an upper dress disposed in radiating folds about his neck, and hanging down upon his breast, ornamented by small pendant trefoiled studs or bosses. He wears the drooping bonnet and long gloves; but the folds about the neck, shot forth to express the rays of the star, are the most remarkable characteristic of the figure. He raises his sceptre in his

Ducal Palace: the eighteenth capital of the arcading, at the south-west corner. Two details: first side Aquarius, and second side Jupiter and Sagittarius, represented as the centaur Chiron.

left hand over Sagittarius, represented as the centaur Chiron; and holds two thunnies in his right. Something rough, like a third fish, has been broken away below them; the more easily because this part of the group is entirely undercut, and the two fish glitter in the light, relieved on the deep gloom below the leaves. [*Ruskin discusses the inscription and gives an English version: inscription as reading: 'Then the house of Jupiter gives (or governs?) the fishes and Chiron'.*]

cx. *Third side.* Mars, in his houses Aries and Scorpio. Represented as a very ugly knight in chain mail, seated sideways on the ram, whose horns are broken away, and having a large scorpion in his left hand, whose tail is broken also, to the infinite injury of the group, for it seems to have curled across to the angle leaf, and formed a bright line of light, like the fish in the hand of Jupiter. The knight carries a shield, on which fire and water are sculptured, and bears a banner upon his lance, with the word 'DEFEROSUM', which puzzled me for some time. It should be read, I believe, 'De ferro sum'; which would be good Venetian Latin for 'I am of iron'.

cxi. *Fourth side.* The sun, in his house Leo. Represented under the figure of Apollo, sitting on the Lion, with rays shooting from his head, and the world in his hand.

cxii. *Fifth side.* Venus, in her houses Taurus and Libra. The most beautiful figure of the series. She sits upon the bull, who is deep in the dewlap, and better cut than most of the animals, holding a mirror in her right hand, and the scales in her left. Her breast is very nobly and tenderly indicated under the folds of her drapery, which is exquisitely studied in its fall.

cxiii. *Sixth side.* Mercury, represented as wearing a pendant cap, and holding a book: he is supported by three children in reclining attitudes, representing his houses Gemini and Virgo.

cxiv. *Seventh side.* The Moon, in her house Cancer. This sculpture, which is turned towards the Piazzetta, is the most picturesque of the series. The moon is represented as a woman in a boat upon the sea, who raises the crescent in her right hand, and with her left draws a crab out of the waves, up the boat's side. The moon was, I believe, represented in Egyptian sculptures as in a boat; but I rather think the Venetian was not aware of this, and that he meant to express the peculiar sweetness of the moonlight at Venice, as seen across the lagoons. Whether this was intended by putting the planet in the boat, may be questionable, but assuredly the idea was meant to be conveyed by the dress of the figure. For all the draperies of the other figures on this capital, as well as on the

rest of the façade, are disposed in severe but full folds, showing little of the forms beneath them; but the moon's drapery ripples down to her feet, so as exactly to suggest the trembling of the moonlight on the waves. This beautiful idea is highly characteristic of the thoughtfulness of the early sculptors; five hundred men may be now found who could have cut the drapery, as such, far better, for one who would have disposed its folds with this intention.

cxv. *Eighth side.* God creating man. Represented as a throned figure, with a glory round the head, laying his left hand on the head of a naked youth, and sustaining him with his right hand. The inscription puzzled me for a long time; but except the lost r and m of 'formavit', and a letter quite undefaced, but to me unintelligible, before the word Eva, in the shape of a figure of 7, I have safely ascertained the rest. [*Ruskin gives this in its full form as: 'De limo Dominus Adam, de costa fo(rm)avit Evam'. That is: 'From the dust the Lord made Adam, and from the rib Eve'.*] I imagine the whole of this capital, therefore—the principal one of the old palace—to have been intended to signify, first, the formation of the planets for the service of man upon the earth; secondly, the entire subjection of the fates and fortune of man to the will of God, as determined from the time when the earth and stars were made, and, in fact, written in the volume of the stars themselves.

Thus interpreted, the doctrines of judicial astrology were not only consistent with, but an aid to, the most spiritual and humble Christianity.

In the workmanship and grouping of its foliage, this capital is, on the whole, the finest I know in Europe. The sculptor has put his whole strength into it. . . .

cxvl. NINETEENTH CAPITAL. This is, of course, the second counting from the Sea, on the Piazzetta side of the palace, calling that of the Fig-tree angle the first.

It is the most important capital, as a piece of evidence in point of dates, in the whole palace. Great pains have been taken with it, and in some portion of the accompaying furniture or ornaments of each of its figures a small piece of coloured marble has been inlaid, with peculiar significance: for the capital represents the arts of sculpture and architecture; and the inlaying of the coloured stones (which are far too small to be effective at a distance, and are found in this one capital only of the whole series) is merely an expression of the architect's feeling of the essential importance of this art of inlaying, and of the value of colour generally in his own art.

cxvii. *First side.* 'st simplicius': so inscribed. A figure working with a pointed chisel on a small oblong block of green serpentine, about four

inches long by one wide, inlaid in the capital. The chisel is, of course, in the left hand, but the right is held up open, with the palm outwards.

Second side. A crowned figure, carving the image of a child on a small statue, with a ground of red marble. The sculptured figure is highly finished, and is in type of head much like the Ham or Japheth at the Vine angle. Inscription effaced.

Third side. An old man, uncrowned, but with curling hair, at work on a small column, with its capital complete, and a little shaft of dark red marble, spotted with paler red. The capital is precisely of the form of that found in the palace of the Tiepolos and the other thirteenth-century work of Venice. This one figure would be quite enough, without any other evidence whatever, to determine the date of this flank of the Ducal Palace as not later, at all events, than the first half of the fourteenth century. Its inscription is broken away, all but 'DISIPULO'.

Fourth side. A crowned figure; but the object on which it has been working is broken away, and all the inscription except 'ST E(N?)AS'.

Fifth side. A man with a turban and a sharp chisel, at work on a kind of panel or niche, the back of which is of red marble.

Sixth side. A crowned figure, with hammer and chisel, employed on a little range of windows of the fifth order, having roses set, instead of orbicular ornaments, between the spandrils, with a rich cornice, and a band of purple marble inserted above. This sculpture assures us of the date of the fifth order window, which it shows to have been universal in the early fourteenth century. [*See* ORDERS OF VENETIAN ARCHES.]

There are also five arches in the block on which the sculptor is working, marking the frequency of the number five in the window groups of the time.

Seventh side. A figure at work on a pilaster, with Lombardic thirteenth-century capital . . . the shaft of dark red spotted marble.

Eighth side. A figure with a rich open crown, working on a delicate recumbent statue the head of which is laid on a pillow covered with a rich chequer pattern; the whole supported on a block of dark red marble. Inscription broken away, all but 'ST SYM. (Symmachus?) TV ** ANVS'. There appear, therefore, altogether to have been five saints, two of them popes, if Simplicius is the pope of that name (three in front, two on the fourth and sixth sides), alternating with the three uncrowned workmen in the manual labour of sculpture. . . . It would be difficult to find a more interesting expression of the devotional spirit in which all great work was undertaken at this time.

CXVIII. TWENTIETH CAPITAL. It is adorned with heads of animals, and is the finest of the whole series in the broad massiveness of its effect . . . In spite of the sternness of its plan, however, it is wrought with great care

in surface detail; and the ornamental value of the minute chasing obtained by the delicate plumage of the birds, and the clustered bees on the honeycomb in the bear's mouth, opposed to the strong simplicity of its general form cannot be too much admired. There is also more grace, life, and variety in the sprays of foliage on each side of it, and under the heads, than in any other capital of the series, though the earliness of the workmanship is marked by considerable hardness and coldness in the larger heads. A Northern Gothic workman, better acquainted with bears and wolves than it was possible to become in St Mark's Place, would have put far more life into these heads, but he could not have composed them more skilfully.

CXIX. *First side.* A lion with a stag's haunch in his mouth. Observe the peculiar way in which the ear is cut into the shape of a ring, jagged or furrowed on the edge; an archaic mode of treatment peculiar, in the Ducal Palace, to the lions' heads of the fourteenth century. The moment we reach the Renaissance work, the lions' ears are smooth. Inscribed simply, 'LEO'.

Second side. A wolf with a dead bird in his mouth, its body wonderfully true in expression of the passiveness of death. The feathers are each wrought with a central quill and radiating filaments. Inscribed 'LUPUS'.

Third side. A fox, not at all like one, with a dead cock in his mouth, its comb and pendant neck admirably designed so as to fall across the great angle leaf of the capital, its tail hanging down on the other side, its long straight feathers exquisitely cut. Inscribed '(VULP?)IS'.

Fourth side. Entirely broken away.

Fifth side. 'APER' [*a boar*]. Well tusked, with a head of maize in his mouth; at least I suppose it to be maize, though shaped like a pine-cone.

Sixth side. 'CHANIS'. With a bone, very ill cut; and a bald-headed species of dog, with ugly flap ears.

Seventh side. 'MUSCIPULUS'. With a rat (?) in his mouth. [*This side represents a cat, or gryphon, with a rat—'muscipulus'—in its mouth.*]

Eighth side. 'URSUS' [*a bear*]. With a honeycomb, covered with large bees.

CXX. TWENTY-FIRST CAPITAL. Represents the principal inferior professions.

First side. An old man, with his brow deeply wrinkled, and very expressive features, beating in a kind of mortar with a hammer. Inscribed 'LAPICIDA SUM' [*I am a stonecutter*].

Second side. I believe, a goldsmith; he is striking a small flat bowl or patera, on a pointed anvil, with a light hammer. The inscription is gone.

Third side. A shoemaker, with a shoe in his hand, and an instrument

for cutting leather suspended beside him. Inscription undecipherable.

Fourth side. Much broken. A carpenter planing a beam resting on two horizontal logs. Inscribed 'CARPENTARIUS SUM'.

Fifth side. A figure shovelling fruit into a tub; the latter very carefully carved from what appears to have been an excellent piece of cooperage. Two thin laths cross each other over the top of it. The inscription, now lost, was, according to Selvatico, 'MENSURATOR'?

Sixth side. A man, with a large hoe, breaking the ground, which lies in irregular furrows and clods before him. Now undecipherable, but, according to Selvatico, 'ACRICHOLA' [*a farmer*].

Seventh side. A man, in a pendant cap, writing on a large scroll which falls over his knee. Inscribed 'NOTARIUS SUM' [*'I am a clerk'*].

Eighth side. A smith forging a sword or scythe-blade: he wears a large skull-cap; beats with a large hammer on a solid anvil; and is inscribed 'FABER SUM'.

CXXI. TWENTY-SECOND CAPITAL. The Ages of Man; and the influence of the planets on human life.

First side. The moon, governing infancy for four years, according to Selvatico. I have no note of this side, having, I suppose, been prevented from raising the ladder against it by some fruit-stall or other impediment in the regular course of my examination; and then forgotten to return to it.

Second side. A child with a tablet, and an alphabet inscribed on it. [*Ruskin reads the inscription as:* 'Mercurius dominatur pueritiæ per annos X' *or* 'VII'. *That is:* 'Mercury governs boyhood for ten (or seven) years'.]

Third side. An older youth, with another tablet, but broken.

Fourth side. A youth with a hawk on his fist. [*The inscription means:* 'The sun governs youth for nineteen years'.]

Fifth side. A man sitting, helmed, with a sword over his shoulder. [*The inscription:* 'Mars governs manhood for fifteen years'.]

Sixth side. A very graceful and serene figure, in the pendant cap, reading: 'Jupiter governs age for twelve years'.

Seventh side. An old man in a skull-cap, praying. [*Inscribed as:* 'Saturn governs decrepitude until death'.]

Eighth side. The dead body lying on a mattress: [*The inscription runs:* 'Last comes death, the penalty of sin'.]

CXXII. Shakespeare's Seven Ages are of course merely the expression of this early and well-known system. He has deprived the dotage of its devotion; but I think wisely, as the Italian system would imply that devotion was, or should be, always delayed until dotage.

TWENTY-THIRD CAPITAL. I agree with Selvatico in thinking this has been restored. It is decorated with large and vulgar heads.

CXXIII. TWENTY-FOURTH CAPITAL. This belongs to the large shaft which sustains the great party wall of the Sala del Gran Consiglio. The shaft is thicker than the rest; but the capital, though ancient, is coarse and somewhat inferior in design to the others of the series. It represents the history of marriage: the lover first seeing his mistress at a window, then addressing her, bringing her presents; then the bridal, the birth and the death of a child. But I have not been able to examine these sculptures properly, because the pillar is encumbered by the railing which surrounds the two guns set before the Austrian guard-house. [*Led by Daniele Manin, Venice had revolted against the Austrians on 22 March 1848. After a lengthy siege they were forced to capitulate.*]

CXXIV. TWENTY-FIFTH CAPITAL. We have here the employments of the months, with which we are already tolerably acquainted. There are, however, one or two varieties worth noticing in this series.

First side. March. Sitting triumphantly in a rich dress, as the beginning of the year.

Second side. April and May. April with a lamb: May with a feather fan in her hand.

Third side. June. Carrying cherries in a basket. . . . this representation of June is peculiarly Venetian.

The cherries principally grown near Venice are of a deep red colour, and large, but not of high flavour, though refreshing. They are carved upon the pillar with great care, all their stalks undercut.

Fourth side. July and August. The first reaping; the leaves of the straw being given, shooting out from the tubular stalk. August, opposite, beats (the grain?) in a basket.

Fifth side. September. A woman standing in a wine-tub, and holding a branch of vine. Very beautiful.

Sixth side. October and November. I could not make out their occupation; they seem to be roasting or boiling some root over a fire.

Seventh side. December. Killing pigs, as usual.

Eighth side. January warming his feet, and February frying fish. This last employment is again as characteristic of the Venetian winter as the cherries are of the Venetian summer.

The inscriptions are undecipherable, except a few letters here and there, and the words MARCIUS, APRILIS, and FEBRUARIUS.

This is the last of the capitals of the early palace; the next, or twenty-sixth capital, is the first of those executed in the fifteenth century under Foscari; and hence to the Judgment angle the traveller has nothing to do

but to compare the base copies of the earlier work with their originals, or to observe the total want of invention in the Renaissance sculptor, wherever he has depended on his own resources. This, however, always with the exception of the twenty-seventh and of the last capital, which are both fine.

I shall merely enumerate the subjects and point out the plagiarisms of these capitals, as they are not worth description.

cxxv. TWENTY-SIXTH CAPITAL. Copied from the fifteenth, merely changing the succession of the figures.

TWENTY-SEVENTH CAPITAL. I think it possible that this may be part of the old work displaced in joining the new palace with the old: at all events, it is well designed, though a little coarse. It represents eight different kinds of fruit, each in a basket; the characters well given, and groups well arranged, but without much care or finish. The names are inscribed above, though somewhat unnecessarily, and with certainly as much disrespect to the beholder's intelligence as the sculptor's art. . . . The 'Zuche' are the common gourds, divided into two protuberances, one larger than the other, like a bottle compressed near the neck; and the 'Moloni' are the long water-melons, which, roasted, form a stable food of of the Venetians to this day.

cxxvi. TWENTY-EIGHTH CAPITAL. Copied from the seventh.

TWENTY-NINTH CAPITAL. Copied from the ninth.

THIRTIETH CAPITAL. Copied from the tenth. The 'Accidia' is noticeable as having the inscription complete, 'ACCIDIA ME STRINGIT'; and the 'Luxuria' for its utter want of expression, having a severe and calm face, a robe up to the neck, and her hand upon her breast. The inscription is also different.

THIRTY-FIRST CAPITAL. Copied from the eighth.

THIRTY-SECOND CAPITAL. Has no inscription, only fully robed figures laying their hands, without any meaning, on their own shoulders, heads, or chins, or on the leaves around them.

THIRTY-THIRD CAPITAL. Copied from the twelfth.

THIRTY-FOURTH CAPITAL. Copied from the eleventh.

THIRTY-FIFTH CAPITAL. Has children, with birds or fruit, pretty in features, and utterly inexpressive, like the cherubs of the eighteenth century.

cxxvii. THIRTY-SIXTH CAPITAL. This is the last of the Piazzetta façade, the elaborate one under the Judgment angle. Its foliage is copied from the eighteenth at the opposite side, with an endeavour on the part of the Renaissance sculptor to refine upon it, by which he has merely lost some of its truth and force. This capital will, however, be always thought, at

first, the most beautiful of the whole series: and indeed it is very noble; its groups of figures most carefully studied, very graceful, and much more pleasing than those of the earlier work, though with less real power in them; and its foliage is only inferior to that of the magnificent Fig-tree angle. It represents, on its front or first side, Justice enthroned, seated on two lions; and on the seven other sides examples of acts of justice or good government, or figures of lawgivers, in the following order:

Second side. Aristotle, with two pupils, giving laws. [*The inscription reads: 'Aristotle who declares laws'.*]

Third side. I have mislaid my note of this side: Selvatico and Lazari call it 'Isidore'. (Can they have mistaken the ISIPIONE of the fifth side for the word Isidore?)

Fourth side. Solon with his pupils. [*Inscribed is: 'Solon, one of the seven sages of Greece, who declares laws'.*] Note, by the by, the pure Venetian dialect used in this capital, instead of the Latin in the more ancient ones. One of the seated pupils in this sculpture is remarkably beautiful in the sweep of his flowing drapery.

Fifth side. The chastity of Scipio. A soldier in a plumed bonnet presents a kneeling maiden to the seated Scipio, who turns thoughtfully away.

Sixth side. Numa Pompilius building churches. Numa, in a kind of hat with a crown above it, directing a soldier in Roman armour (note this, as contrasted with the mail of the earlier capitals). They point to a tower of three stories filled with tracery.

Ducal Palace: the thirty-sixth capital, seventh side. Detail of Moses receiving the law.

Seventh side. Moses receiving the law. Moses kneels on a rock, whence springs a beautifully fancied tree, with clusters of three berries in the centre of three leaves, sharp and quaint, like fine Northern Gothic. The half figure of the Deity comes out of the abacus, the arm meeting that of Moses, both at full stretch, with the stone tablets between.

Eighth side. Trajan doing justice to the Widow. He is riding spiritedly, his mantle blown out behind; the widow kneeling before his horse. . . .

Between 1873 and 1889 the sea and Piazzetta façades of the Ducal Palace were extensively restored and several of the arcade columns and capitals were removed and replaced by copies which were not always well executed. Some of the originals are in the Museo dell'Opera. This restoration work has been criticized by a number of people. For example, the author of the article on Venice in the ninth edition of the Encyclopaedia Britannica *speaks of it 'as a wholesale and needless restoration . . . not only of the sculpture, but also of the columns, arches and traceries, which in many cases have been wholly removed without any excuse whatsoever'. Among the capitals that were renewed are numbers 1, 2, 3, 5, 6, 17, 18, 19, 20 and 25, mostly on the sea side.*

CXXIX. We have now examined the portions of the palace which contain the principal evidence of the feeling of its builders. The capitals of the upper arcade are exceedingly various in their character; their design is formed, as in the lower series, of eight leaves, thrown into volutes at the angles, and sustaining figures at the flanks; but these figures have no inscriptions, and though evidently not without meaning, cannot be interpreted without more knowledge than I possess of ancient symbolism. Many of the capitals towards the sea appear to have been restored, and to be rude copies of the ancient ones; others, though apparently original, have been somewhat carelessly wrought; but those of them which are both genuine and carefully treated are even finer in composition than any, except the eighteenth, in the lower arcade. The traveller in Venice ought to ascend into the corridor, and examine with great care the series of capitals which extend on the Piazzetta side from the Fig-tree angle to the pilaster which carries the party wall of the Sala del Gran Consiglio. As examples of graceful composition in massy capitals meant for hard service and distant effect, these are among the finest things I know in Gothic art; and that above the fig-tree is remarkable for its sculptures of the four winds; each on the side turned towards the wind represented. Levante, the east wind: a figure with rays round its head, to show that it is always clear weather when that wind blows, raising the sun out of the sea; Hotro, the south wind: crowned, holding the sun in its right

hand; Ponente, the west wind: plunging the sun into the sea; and Tramontana, the north wind: looking up at the north star. . . . I may also especially point out the bird feeding its three young ones on the seventh pillar on the Piazzetta side; but there is no end to the fantasy of these sculptures; and the traveller ought to observe them all carefully, until he comes to the great pilaster or complicated pier which sustains the party wall of the Sala del Consiglio; that is to say, the forty-seventh capital of the whole series, counting from the pilaster of the Vine angle inclusive, as in the series of the lower arcade. The forty-eighth, forty-ninth, and fiftieth are bad work, but they are old; the fifty-first is the first Renaissance capital of the upper arcade; the first new lion's head with smooth ears, cut in the time of Foscari, is over the fiftieth capital; and that capital, with its shaft, stands on the apex of the eighth arch from the sea, on the Piazzetta side, of which one spandril is masonry of the fourteenth and the other of the fifteenth century.

CXXX. The reader who is not able to examine the building on the spot may be surprised at the definiteness with which the point of junction is ascertainable; but a glance at the lowest range of leaves [*as illustrated in Ruskin's drawing*] will enable him to judge of the grounds on which the above statement is made. Figure 12 is a cluster of leaves from the capital of the Four Winds; early work of the finest time. Figure 13 is a leaf from the great Renaissance capital at the Judgment angle, worked in imitation of the older leafage. Figure 14 is a leaf from one of the Renaissance capitals of the upper arcade, which are all worked in the natural manner of the period. It will be seen that it requires no great ingenuity to distinguish between such design as that of Figure 12 and that of Figure 14.

CXXXI. It is very possible that the reader may at first like Figure 14 the best. I shall endeavour, in the next chapter, to show why he should not [*this is the chapter on the early Renaissance*]; but it must also be noted, that Figure 12 has lost, and Figure 14 gained, both largely, under the hands of the engraver. All the bluntness and coarseness of feeling in the workmanship of Figure 14 have disappeared on this small scale, and all the subtle refinements in the broad masses of Figure 12 have vanished. They could not, indeed, be rendered in line engraving, unless by the hand of Albert Durer. [*However those who can view the originals*] will be able to judge for themselves of their perfect, pure, unlaboured naturalism; the freshness, elasticity, and softness of their leafage, united with the most noble symmetry and severe reserve—no running to waste, no loose or experimental lines, no extravagance, and no weakness. Their design is always sternly architectural; there is none of the wildness or redundance of natural vegetation, but there is all the strength, freedom,

Ruskin's drawing of leafage of the Venetian capitals (Volume II, Plate xx).

and tossing flow of the breathing leaves, and all the undulation of their surfaces, rippled, as they grew, by the summer winds, as the sands are by the sea.

CXXXII. This early sculpture of the Ducal Palace, then, represents the state of Gothic work in Venice at its central and proudest period, ie, circa 1350. After this time, all is decline. . . .

CXXXIII. And as, under the shadow of these nodding leaves, we bid farewell to the great Gothic spirit . . . for above its upper arcade there are only the four traceried windows, and one or two of the third order on the Rio Façade, which can be depended upon as exhibiting the original workmanship of the older palace. I examined the capitals of the four other windows on the façade, and of those on the Piazzetta, one by one, with great care, and I found them all to be of far inferior workmanship to those which retain their traceries: I believe the stone framework of these windows must have been so cracked and injured by the flames of the great fire, as to render it necessary to replace it by new traceries; and that the present mouldings and capitals are base imitations of the original ones. The traceries were at first, however, restored in their complete form, as the holes for the bolts which fastened the bases of their shafts are still to be seen in the window-sills, as well as the marks of the inner mouldings on the soffits. How much the stone facing of the façade, the parapets, and the shafts and niches of the angles, retain of their original masonry, it is also impossible to determine; but there is nothing in the workmanship of any of them demanding especial notice; still less in the large central windows on each façade, which are entirely of Renaissance execution. All that is admirable in these portions of the building is the disposition of their various parts and masses, which is without doubt the same as in the original fabric, and calculated, when seen from a distance, to produce the same impression.

Wall decoration

I–XXVI–IX. *In a chapter on the wall in general Ruskin discusses the particular example in the Ducal Palace of the decorated spandril—that is the triangular area between two arches. This section* might frequently be lightened with great advantage by piercing it with a circle, or with a group of circles. . . . Sometimes the circle is entirely pierced; at other times it is merely suggested by a mosaic or light tracery on the wall surface [*as in the Ducal Palace*].

Ruskin writes elsewhere of these spandrils (I–Appendix 20): The mass of the building being of Istrian stone, a depth of about two inches is left within the mouldings of the arches, rough hewn, to receive the slabs of

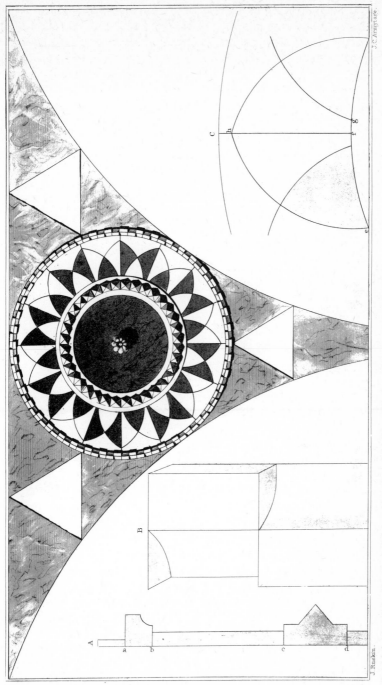

Ruskin's drawing of spandril decoration from the Ducal Palace (Volume I, Plate xiv).

fine marble composing the patterns. I cannot say whether the design was
never completed, or the marbles have been since removed, but there are
now only two spandrils retaining their fillings, and vestiges of them in a
third. The two complete spandrils are on the sea façade ... The white
portions of [*the spandril illustrated in Vol. I Plate XIV*] are all white
marble, the dental band surrounding the circle is in coarse sugary marble,
which I believe to be Greek, and never found in Venice, to my recollec-
tion, except in work at least anterior to the fifteenth century. The
shaded fields charged with the three white triangles are of red Verona
marble; the inner disc is green serpentine, and the dark pieces of the
radiating leaves are grey marble. The three triangles are equilateral. ...

The marbles are, in both [*spandrils*], covered with a rusty coating,
through which it is excessively difficult to distinguish the colours (another
proof of the age of the ornament). But the white marbles are certainly, in
places (except only the sugary dentil), veined with purple, and the grey
seems warmed with green.

A trace of another of those ornaments may be seen over the 21st capital;
but I doubt if the marbles have ever been inserted in the other spandrils,
and their want of ornament occasions the slight meagreness in the effect
of the lower story, which is almost the only fault of the building.

This decoration by discs, or shield-like ornaments, is a marked charac-
teristic of Venetian architecture in its earlier ages, and is carried into
later times by the Byzantine Renaissance, already distinguished from the
more corrupt forms of Renaissance [*in Vol. I–Appendix 6*].... here we
have, on the Ducal Palace, the most characteristic of all, because likest to
the shield, which was probably the origin of the same ornament among the
Arabs, and assuredly among the Greeks. In [*a*] restoration of the gate
of the treasury of Atreus [*carried out in Ruskin's time*], this ornament
is conjecturally employed, and it occurs constantly on the Arabian build-
ings of Cairo.

The Renaissance side of the Ducal Palace

III–I–XXXVIII. The Rio Façade of the Ducal Palace, though very
sparing in colour, is yet, as an example of finished masonry in a vast
building, one of the finest things, not only in Venice, but in the world.
It differs from other work of the Byzantine Renaissance, in being on a
very large scale; and it still retains one pure Gothic character, which adds
not a little to its nobleness, that of perpetual variety. There is hardly one
window of it, or one panel, that is like another; and this continual change
so increases its apparant size by confusing the eye, that, though present-
ing no bold features, or striking masses of any kind, there are few things
in Italy more impressive than the vision of it overhead, as the gondola
glides from beneath the Bridge of Sighs. And lastly (unless we are to

blame these buildings for some pieces of very childish perspective), they are magnificently honest, as well as perfect. I do not remember even any gilding upon them; all is pure marble, and of the finest kind.

III–Appendix 5. In passing along the Rio del Palazzo the traveller ought especially to observe the base of the Renaissance building, formed by alternately depressed and raised pyramids, the depressed portions being casts of the projecting ones, which are truncated on the summits. The work cannot be called rustication, for it is cut as sharply and delicately as a piece of ivory, but it thoroughly answers the end which rustication proposes, and misses: it gives the base of the building a look of crystalline hardness, actually resembling, and that very closely, the appearance presented by the fracture of a piece of cap quartz; while yet the light and shade of its alternate recesses and projections are so varied as to produce the utmost possible degree of delight to the eye attainable by a geometrical pattern so simple. Yet, with all this high merit, it is not a base which could be brought into general use. Its brilliancy and piquancy are here set off with exquisite skill by its opposition to mouldings, in the upper part of the building, of an almost effeminate delicacy, and its complexity is rendered delightful by its contrast with the ruder bases of the other buildings of the city; but it would look meagre if it were employed to sustain bolder masses above, and would become wearisome if the eye were once thoroughly familiarized with it by repetition.

The interior
II–VIII–CXXXIV. . . . All vestige of the earlier modes of decoration was here, of course, destroyed by the fires; and the severe and religious work of Guariento and Bellini has been replaced by the wildness of Tintoretto and the luxury of Veronese. But in this case, though widely different in temper, the art of the renewal was at least intellectually as great as that which had perished: and though the halls of the Ducal Palace are no more representative of the character of the men by whom it was built, each of them is still a colossal casket of priceless treasure; a treasure whose safety has till now depended on its being despised, and which at this moment, and as I write, is piece by piece being destroyed for ever.

Some of the paintings are still rather dark and hard to distinguish fully. However, Ruskin's remarks may well have been prompted by the fact that, when Venice was under siege from the Austrians and shells were damaging a number of buildings, the pictures in the great hall of the Ducal Palace were taken down for safety and, according to Edmund Flagg (Venice, 1853), had still not been replaced in 1850 when Ruskin took his wife, Effie, to see them.

The 'Index' proper continues: The multitude of works by various masters
which cover the walls of this palace is so great that the traveller is in
general merely wearied and confused by them. He had better refuse all
attention except to the following works:

1. *Paradise,* by Tintoretto; at the extremity of the Great Council-
chamber. I found it impossible to count the number of figures in this
picture, of which the grouping is so intricate; that at the upper part it
is not easy to distinguish one figure from another; but I counted 150
important figures in one half of it alone; so that, as there are nearly as
many in subordinate positions, the total number cannot be under 500.
I believe this is, on the whole, Tintoretto's *chef-d'œuvre:* though it is so
vast that no one takes the trouble to read it, and therefore less wonderful
pictures are preferred to it. I have not myself been able to study except
a few fragments of it, all executed in his finest manner; but it may assist
a hurried observer to point out to him that the whole composition is
divided into concentric zones, represented one above another like the
stories of a cupola, round the figures of Christ and the Madonna, at the
central and highest point: both these figures are exceedingly dignified and
beautiful. Between each zone or belt of the nearer figures, the white
distances of heaven are seen filled with floating spirits. The picture is on
the whole wonderfully preserved, and the most precious thing that Venice
possesses. She will not possess it long; for the Venetian academicians,
finding it exceedingly unlike their own works, declare it to want harmony,
and are going to retouch it to their own ideas of perfection.

2. *Siege of Zara [also by Tintoretto]*: the first picture on the right on
entering the Sala del Scrutinio. It is a mere battle piece, in which the
figures, like the arrows, are put in by the score. There are high merits
in the thing, and so much invention that it is possible Tintoretto may
have made the sketch for it; but, if executed by him at all, he has done
it merely in the temper in which a sign-painter meets the wishes of an
ambitious landlord. He seems to have been ordered to represent all the
events of the battle at once; and to have felt that, provided he gave men,
arrows, and ships enough, his employers would be perfectly satisfied. The
picture is a vast one, some thirty feet by fifteen.

Various other pictures will be pointed out by the custode, in these
two rooms, as worthy of attention, but they are only historically, not
artistically, interesting. The works of Paul Veronese on the ceiling have
been repainted; and the rest of the pictures on the walls are by second-
rate men. The traveller must, once for all, be warned against mistaking the
works of Domenico Robusti (Domenico Tintoretto), a very miserable
painter, for those of his illustrious father, Jacopo.

3. *The Doge Grimani kneeling before Faith,* by Titian; in the Sala

delle quattro Porte. To be observed with care, as one of the most striking examples of Titian's want of feeling and coarseness of conception. As a work of mere art, it is, however, of great value. The traveller who has been accustomed to deride Turner's indistinctness of touch ought to examine carefully the mode of painting the Venice in the distance at the bottom of this picture.

4. *Frescoes on the roof of the Sala delle quattro Porte*, by Tintoretto. Once magnificent beyond description, now mere wrecks (the plaster crumbling away in large flakes), but yet deserving of the most earnest study.

5. *Christ taken down from the Cross*, by Tintoretto; at the upper end of the Sala dei Pregadi. One of the most interesting mythic pictures of Venice, two Doges being represented beside the body of Christ, and a most noble painting; executed, however, for distant effect, and seen best from the end of the room.

6. *Venice, Queen of the Sea*, by Tintoretto. Central compartment of the ceiling, in the Sala dei Pregadi. Notable for the sweep of its vast green surges, and for the daring character of its entire conception, though it is wild and careless, and in many respects unworthy of the master. Note the way in which he has used the fantastic forms of the sea-weeds. . . .

7. *The Doge Loredano in prayer to the Virgin*, by Tintoretto; in the same room. Sickly and pale in colour, yet a grand work; to be studied, however, more for the sake of seeing what a great man does 'to order', when he is wearied of what is required from him, than for its own merit.

8. *St George and the Princess*. There are, besides the 'Paradise', only six pictures in the Ducal Palace, as far as I know, which Tintoretto painted carefully, and those are all exceedingly fine: the most finished of these are in the Anti-Collegio; but those that are most majestic and characteristic of the master are two oblong ones, made to fill the panels of the walls in the Anti-Chiesetta; these two, each, I suppose, about eight feet by six, are in his most quiet and noble manner. There is excessively little colour in them, their prevalent tone being a greyish brown opposed with grey, black, and a very warm russet. They are thinly painted, perfect in tone, and quite untouched. The first of them is 'St George and the Dragon', the subject being treated in a new and curious way. The principal figure is the princess, who sits astride on the dragon's neck, holding him by a bridle of silken riband; St George stands above and behind her, holding his hands over her head as if to bless her, or to keep the dragon quiet by heavenly power; and a monk stands by on the right, looking gravely on. There is no expression or life in the dragon, though the white flashes in its eye are very ghastly; but the whole thing is entirely typical; and the princess is not so much represented riding on the dragon, as

supposed to be placed by St George in an attitude of perfect victory over her chief enemy. She has a full rich dress of dull red, but her figure is somewhat ungraceful. St George is in grey armour and grey drapery, ~nd has a beautiful face; his figure entirely dark against the distant sky. There is a study for this picture in the Manfrini Palace.

9. *St Andrew and St Jerome* [*by Tintoretto*]. This, the companion picture, has even less colour than its opposite. It is nearly all brown and grey; the fig-leaves and olive-leaves brown, the faces brown, the dresses brown, and St Andrew holding a great brown cross. There is nothing that can be called colour, except the grey of the sky, which approaches in some places a little to blue, and a single piece of dirty brick-red in St Jerome's dress; and yet Tintoretto's greatness hardly ever shows more than in the management of such sober tints. I would rather have these two small brown pictures, and two others in the Academy perfectly brown also in their general tone—the 'Cain and Abel' and the 'Adam and Eve'—than all the other small pictures in Venice put together which he painted in bright colours for altar pieces; but I never saw two pictures which so nearly approached grisailles as these, and yet were delicious pieces of colour. I do not know if I am right in calling one of the saints St Andrew. He stands holding a great upright wooden cross against the sky. St Jerome reclines at his feet, against a rock over which some glorious fig-leaves and olive branches are shooting; every line of them studied with the most exquisite care, and yet cast with perfect freedom.

10. *Bacchus and Ariadne.* The most beautiful of the four careful pictures by Tintoretto, which occupy the angles of the Anti-Collegio. Once one of the noblest pictures in the world, but now miserably faded, the sun being allowed to fall on it all day long. The design of the forms of the leafage round the head of the Bacchus, and the floating grace of the female figure above, will, however, always give interest to this picture, unless it be repainted.

The other three Tintorettos in this room are careful and fine, but far inferior to the 'Bacchus'; and the 'Vulcan and the Cyclops' is a singularly meagre and vulgar study of common models.

11. *Europa*, by Paul Veronese; in the same room. One of the very few pictures which both possess, and deserve, a high reputation.

12. *Venice enthroned*, by Paul Veronese; on the roof of the same room. One of the grandest pieces of frank colour in the Ducal Palace.

13. *Venice, and the Doge Sebastian Venier*; at the upper end of the Sala del Collegio. An unrivalled Paul Veronese, far finer even than the 'Europa'.

14. *Marriage of St Catherine*, by Tintoretto; in the same room. An inferior picture, but the figure of St Catherine is quite exquisite. Note

how her veil falls over her form, showing the sky through it, as an alpine cascade falls over a marble rock.

There are three other Tintoretto's on the walls of this room, but all inferior, though full of power. Note especially the painting of the lion's wings, and of the coloured carpet, in the one nearest the throne, the Doge Alvise Mocenigo adoring the Redeemer.

The roof is entirely by Paul Veronese, and the traveller who really loves painting ought to get leave to come to this room whenever he chooses; and should pass the sunny summer mornings there again and again, wandering now and then into the Anti-Collegio and Sala dei Pregadi, and coming back to rest under the wings of the couched lion at the feet of the Mocenigo'. He will not otherwise enter so deeply into the heart of Venice.

E

E M O, P A L A Z Z O, on the Grand Canal. Of no interest.
The Palazzo Emo is a seventeenth-century building on the Grand Canal, with little distinction.

E R I Z Z O, P A L A Z Z O, near the Arsenal, II–VII–XL. *In a section on window orders of Gothic Palaces (see also* ORDERS OF VENETIAN ARCHES*) Ruskin cites the Erizzo Palace as showing an example of the fifth order of Gothic windows:*

II–VII–XL. . . . in its early purity. The ornaments appear to be actually of Greek workmanship (except, perhaps, the two birds over the central arch, which are bolder, and more free in treatment), and built into the Gothic fronts; showing, however, the early date of the whole by the manner of their insertion, corresponding exactly with that employed in the Byzantine palaces, and by the covering of the intermediate spaces with sheets of marble, which, however, instead of being laid over the entire wall, are now confined to the immediate spaces between and above the windows, and are bounded by a dentil moulding.

E R I Z Z O, P A L A Z Z O, on the Grand Canal, nearly opposite the Fondaco de' Turchi. A Gothic palace, with a single range of windows founded on the Ducal traceries, and bold capitals. It has been above referred to in the notice of tracery bars [*Volume III, Appendix 10, section VI on traceries*].

EUFEMIA, CHURCH OF S. A small and defaced, but very curious, early Gothic church on the Giudecca. Not worth visiting, unless the traveller is seriously interested in architecture.

Founded in the ninth century, the Church of S. Eufemia has been frequently restored. It has capitals and columns of the eleventh century.

EUROPA, ALBERGO ALL'. Once a Giustiniani palace. Good Gothic, circa 1400, but much altered.

A number of famous people have stayed in this hotel, among them Chateaubriand, George Eliot and Wagner.

EVANGELISTI, CASA DEGLI, II–VII–XLIII. *Discussing the development of Gothic Palaces, Ruskin examines the experiments made to enrich the space between arches, left blank once Byzantine sculpture was abandoned. One of the most important examples of this infilling is 'at the Ponte del Forner, at S. Cassano, a noble house in which the spandrils of the windows are filled by the emblems of the four Evangelists [hence the name], sculptured in deep relief, and touching the edges of the arches with their expanded wings'. The other example is the Palazzo Cicogna (qv).*

F

FACANON, PALAZZO (ALLA FAVA). A fair example of the fifteenth-century Gothic, founded on Ducal Palace.

FALIER, PALAZZO, at the Apostoli. *Here Ruskin draws attention to the windows, which are shown in his own illustration given opposite. These windows,* with the arcade beneath them, are the remains of the palace once belonging to the unhappy doge, Marino Faliero [*who was beheaded for treason in 1335*].

The balcony is, of course, modern, and the series of windows has been of greater extent, once terminated by a pilaster on the left hand, as well as on the right; but the terminal arches have been walled up. What remains, however, is enough, with its sculptured birds and dragons, to give the reader a very distinct idea of the second order window in its perfect form.

Ruskin's drawing illustrating windows of the second order of Venetian
Gothic arches, in the Palazzo Falier (Volume II, Plate xv).

For further details of Ruskin's classification of window arches, and of the second order in particular, see ORDERS OF VENETIAN ARCHES.

FANTINO, CHURCH OF S. Said to contain a John Bellini. Otherwise of no importance.

S. Fantino is a notable early Renaissance church designed in the early sixteenth century by Antonio Scarpagnino (1490–1549). It has interesting groined vaulting. The choir was designed by Jacopo Sansovino in 1549.

FARSETTI, PALAZZO, on the Grand Canal, II–V–VIII. *Ruskin quotes the Palazzo Farsetti as an example of the subtle and harmonious proportions of Byzantine palaces. For further details on proportions and dimensions see* BYZANTINE PALACES *above.*

In Volume II, Appendix 11 Ruskin describes the view from the Grand Canal of what he styles the 'Casa Farsetti'.

We have now to reascend the Grand Canal, and approach the Rialto. As soon as we have passed the Casa Grimani, the traveller will recognize, on his right, two rich and extensive masses of building, which form important objects in almost every picturesque view of the noble bridge. Of these, the first, that farthest from the Rialto, retains great part of its ancient materials in a dislocated form. It has been entirely modernized in its upper stories, but the ground door and first door have nearly all their original shafts and capitals, only they have been shifted hither and

Two Byzantine palaces on the Grand Canal: right the Palazzo Farsetti, and left the Palazzo Loredan.

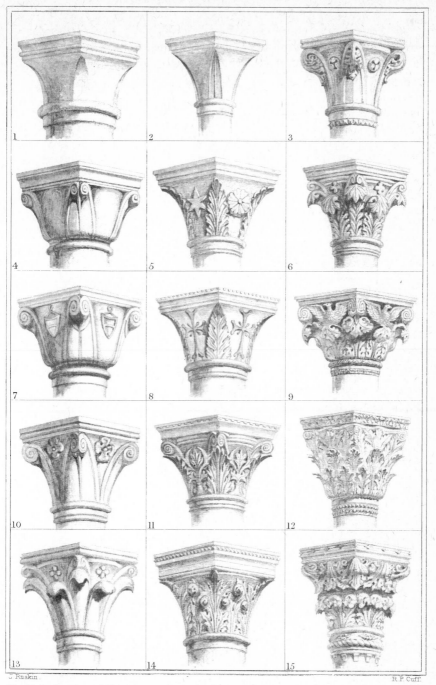

Ruskin's drawing of Gothic capitals, including examples from the Palazzi Falier (Figure 5), Querini (Figure 10) and Soranzo, Campo S. Polo (Figure 12) and from an unnamed palace at the Apostoli (Figure 7), (Volume III, Plate II).

thither to give room for the introduction of various small apartments, and present, in consequence, marvellous anomalies in proportion. This building is known in Venice as the Casa Farsetti.

The Palazzo Farsetti has been used for municipal offices since 1898.

FAVA, CHURCH OF S. Of no importance.
S. Maria della Fava is an eighteenth-century Renaissance church, built to the designs of A. Gaspari and G. Massari. It contains an altarpiece by Tiepolo of St Anne, St Joachim and the Virgin.

FELICE, CHURCH OF S. Said to contain a Tintoretto which if untouched, I should conjecture from Lazari's statement of its subject, St Demetrius armed, with one of the Ghisi family in prayer, must be very fine. Otherwise the church is of no importance.

The church was founded in the tenth century and was rebuilt in the middle sixteenth century. It has a Greek cross plan with cupola. The Tintoretto mentioned by Ruskin is of 'San Demetrio armed, and a Worshipper' and is now confirmed as a genuine early work of 1547. It occupies a side altar to the right.

FENICE THEATRE, LA. *Though not mentioned by Ruskin, the opera house has the reputation of being one of the largest and most beautiful in Europe. It was built to the design of Giannantonio Selva in 1790–1792. In 1836 it was entirely destroyed by fire except for the façade, but was rebuilt mainly as it was before.*
 The first opera house in Venice was the Teatro di S. Cassiano, built at the end of the sixteeenth century, but now demolished. Another theatre, the chief one before La Fenice was built, was the Teatro di S. Benedetto, renamed Rossini in 1875, and again demolished. A cinema now stands on the site.

FERRO, PALAZZO, on the Grand Canal. Fifteenth-century Gothic, very hard and bad.

The Palazzo Ferro became the Grand Hotel.

FLANGINI, PALAZZO, on the Grand Canal. Of no importance.
This is a late Renaissance palace and was possibly designed by Baldassare Longhena or by Giuseppe Sardi (the latter possibly continuing the work of the former). It is also known as the Palazzo Clery.

FONDACO DEI TEDESCHI. A huge and ugly building near the

Rialto, rendered, however, peculiarly interesting by remnants of the frescoes by Giorgione with which it was once covered.

The Fondaco dei Tedeschi, or 'German warehouse', was rebuilt after a fire in 1505, and was provided by the Venetians as a set of offices and warehouses for German merchants, who conducted considerable business with Venice. The merchants were obliged to live and work in this building and could only trade via the brokers allotted to them. These received a percentage on every deal, though by the end of the fourteenth century the position of broker had become a sinecure.

The design of the building has been attributed variously to Girolamo Tedesco, Giorgio Spavento and Antonio Abbondi, also known as Scarpagnino. Its façades were originally decorated with frescoes by Giorgione and Titian. Only fragments of the Giorgione remain, the only documented work by Giorgione to survive, and these are now housed in the Accademia.

The Fondaco dei Tedeschi was restored at the beginning of this century and now serves as the Post Office.

FONDACO DEI TURCHI.
Built on the Grand Canal as a private house in the mid-thirteenth century, this was handed over to Turkish merchants as a warehouse ('fondaco') in 1621. When Ruskin saw it, it was in a pitiful state.

II–V–III. It is a ghastly ruin; whatever is venerable or sad in its wreck being disguised by attempts to put it to present uses of the basest kind. It has been composed of arcades borne by marble shafts, and walls of brick faced with marble: but the covering stones have been torn away from it like the shroud from a corpse; and its walls, rent into a thousand chasms, are filled and refilled with fresh brickwork, and the seams and hollows are choked with clay and whitewash, oozing and trickling over the marble—itself blanched into dusty decay by the frosts of centuries. Soft grass and wandering leafage have rooted themselves in the rents, but they are not suffered to grow in their own wild and gentle way, for the place is in a sort inhabited; rotten partitions are nailed across its corridors, and miserable rooms contrived in its western wing; and here and there the weeds are indolently torn down, leaving their haggard fibres to struggle again into unwholesome growth when the spring next stirs them: and thus, in contest between death and life, the unsightly heap is festering to its fall.

Of its history little is recorded, and that little futile. That it once belonged to the dukes of Ferrara, and was bought from them in the sixteenth century [*sic*], to be made a general receptacle for the goods of the Turkish merchants, whence it is now generally known as the

Fondaco, or Fontico, de' Turchi, are facts just as important to the antiquary, as that, in the year 1852, the municipality of Venice allowed its lower story to be used for a 'deposito di Tabacchi'. Neither of this, nor of any other remains of the period, can we know anything but what their own stones will tell us.

The Fondaco dei Turchi was completely restored in 1869. It now houses the Museum of Natural History.

Elsewhere Ruskin examines certain details of the building when discussing the development of Venetian architecture (see I–XXVII–XLII on the capital, and II–V–VI and II–VII–VII on the proportions of Byzantine architecture, part of which is given under BYZANTINE PALACES*).*

FORMOSA, CHURCH OF S. MARIA.
S. Maria Formosa, or 'the Beautiful' *(though the word hardly expresses the full meaning of the Italian), was traditionally founded, as Ruskin explains (III–III–IV), by the* Bishop of Uderzo, driven by the Lombards from his bishopric, [*who*] as he was praying, beheld in a vision the Virgin Mother, who ordered him to found a church in her honour, in the

Fondaco dei Turchi, on the Grand Canal. See also Ruskin's drawing on p. 28 of part of the elevation, made with the intention of showing the subtle proportioning of the arches. This building has been extensively restored: restoration that has been criticised for its harshness.

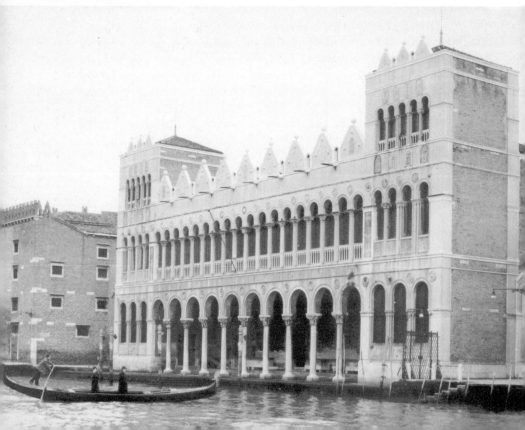

place where he should see a white cloud rest. And when he went out, the white cloud went before him; and on the place where it rested he built a church, and it was called the Church of St Mary the Beautiful, from the loveliness of the form in which she had appeared in the vision.

The church was later connected with another legend. In 944 a number of young girls were on their way to be married at the cathedral church of S. Pietro di Castello, when they were surprised by a hoard of Slavs who carried them off. However Cassellieri, a maker of marriage coffers, followed and rescued the girls. Ruskin quotes Sansovino as saying that the success of the chase was due to the 'ready help and hard fighting of the men of the district of S. Maria Formosa, for the most part trunk-makers'. Ruskin continues with the story:

III–III–X. . . . they, having been presented after the victory to the Doge and the Senate, were told to ask some favour for their reward. The good men then said that they desired the Prince, with his wife and the Signory, to visit every year the church of their district, on the day of its feast. And the Prince asking them, 'Suppose it should rain?' they answered, 'We will give you hats to cover you; and if you are thirsty we will give you to drink.'

Thus it was that every year at Candlemas, until 1797, the Doge processed to S. Maria Formosa where he was presented with a straw hat (one of which can still be seen in the Museo Correr, qv) and a glass of wine.
 Having dwelt on 'the fair images of the ancient festival', Ruskin turns to the grotesque which he considers 'one of many hundreds which disgrace the latest buildings of the city'.

III–III–XV. A head—huge, inhuman and monstrous—leering in bestial degradation, too foul to be either pictured or described, or to be beheld for more than an instant: yet let it be endured for that instant; for in that head is embodied the type of the evil spirit to which Venice was abandoned. . . .

Further on, Ruskin again selects the church as an example of what he sees as another case of the decline in Venetian architecture:

XVII. . . . first exemplified in the very façade of Santa Maria Formosa, which is flanked by the grotesque head to which our attention has just been directed. This façade, whose architect is unknown, consists of a pediment, sustained on four Corinthian pilasters, and is, I believe, the earliest in Venice which appears *entirely destitute of every religious symbol, sculpture, or inscription* [*Ruskin's italics*]; unless the cardinal's hat upon the shield in the centre of the pediment be considered a religious symbol. The entire façade is nothing else than a monument to the

Church of S. Maria Formosa

One of two circular trophies on façade,
'just as valueless in a military as in an
ecclesiastical point of view'. (*Above*)

Grotesque above a doorway in the campanile,
'too foul to be either pictured or described'.
(*Left*).

Admiral Vincenzo Cappello. Two tablets, one between each pair of flanking pillars, record his acts and honours; and, on the corresponding spaces upon the base of the church, are two circular trophies, composed of halberts, arrows, flags, tridents, helmets, and lances: sculptures which are just as valueless in a military as in an ecclesiastical point of view; for, being all copied from the forms of Roman arms and armour, they cannot even be referred to for information respecting the costume of the period. Over the door, as the chief ornament of the façade, exactly in the spot which in the 'barbarous' St Mark's is occupied by the figure of Christ, is the statue of Vincenzo Cappello, in Roman armour. He died in 1542; and we have, therefore, the latter part of the sixteenth century fixed as the period when, in Venice, churches were first built to the glory of man, instead of the glory of God.

Ruskin says that the architect of the church is unknown. The Renaissance façade is now ascribed to Mauro Coducci; the dome was restored in 1668 and again in 1921.

F O S C A, C H U R C H O F S. at Torcello. See TORCELLO.

F O S C A, C H U R C H O F S. Notable for its exceedingly picturesque campanile, of late Gothic, but uninjured by restorations, and peculiarly Venetian in being crowned by the cupola instead of the pyramid, which would have been employed at the same period in any other Italian city.

This is an eighteenth-century church in the district of Cannaregio and should not be confused with the Church of Fosca at Torcello.

F O S C A R I, P A L A Z Z O, on the Grand Canal. The noblest example in Venice of the fifteenth-century Gothic, founded on the Ducal Palace, but lately restored and spoiled, all but the stonework of the main windows. The restoration was necessary, however: for, when I was in Venice in 1845, this palace was a foul ruin; its great hall a mass of mud, used as the back receptacle of a stone-mason's yard; and its rooms white-washed, and scribbled over with indecent caricatures. It has since been partially strengthened and put in order; but as the Venetian municipality have now given it to the Austrians to be used as barracks, it will probably soon be reduced to its former condition. The lower palaces at the side of this building are said by some to have belonged to the younger Foscari. See GIUSTINIANI.

The Palazzo Foscari is now used as the headquarters of the University.

F R A N C E S C O D E L L A V I G N A, C H U R C H O F S. Base Renaissance but must be visited in order to see the John Bellini in the Cappella Santa. The late sculpture, in the Cappella Giustiniani, appears from Lazari's statement to be deserving of careful study. This church is said also to contain two pictures by Paul Veronese.

The main structure was designed by Jacapo Sansovino and Francesco di Giorgio in 1534; the façade was designed by Palladio in 1568 but was not completed until 1634. The picture by Giovanni Bellini is of 'The Madonna and Four Saints'. There is also an 'Adoration of the Magi' by Veronese. The marble sculpture in the Giustiniani chapel is fifteenth-century work by Pietro Lombardo and his pupils.

F R A R I, C H U R C H O F T H E. Founded in 1250, and continued at various subsequent periods. The apse and adjoining chapels are the earliest portions, and their traceries have been above noticed [*II–VII–III*] as the origin of those of the Ducal Palace. The best view of the apse, which is a very noble example of Italian Gothic, is from the door of the Scuola di S. Rocco.

Reference II–VII–III occurs in the chapter on Gothic palaces.

The real root of the Ducal Palace is the apse of the Church of the Frari. The traceries of that apse, though earlier and ruder in workmanship, are nearly the same in mouldings, and precisely the same in treatment (especially in the placing of the lions' heads), as those of the great Ducal Arcade; and the originality of thought in the architect of the Ducal Palace consists in his having adapted those traceries, in a more highly developed and finished form, to civil uses. In the apse of the church they form narrow and tall window lights, somewhat more massive than those of Northern Gothic, but similar in application: the thing to be done was to adapt these traceries to the forms of domestic building necessitated by national usage. The early palaces consisted, as we have seen, of arcades sustaining walls faced with marble, rather broad and long than elevated. This form was kept for the Ducal Palace; but instead of round arches from shaft to shaft, the Frari traceries were substituted, with two essential modifications. Besides being enormously increased in scale and thickness, that they might better bear the superincumbent weight, the quatrefoil, which in the Frari windows is above the arch, as at *a* [*see Ruskin's illustration*], was, in the Ducal Palace, put between the arches, as at *b*; the main reason for this alteration being that the bearing power of the arches, which was now to be trusted with the weight of a wall forty feet high, was thus thrown *between* the quatrefoils, instead of under them, and thereby applied at far better advantage. And, in the second place, the joints of the masonry were changed. In the Frari (as often also in St John and Paul's), the tracery is formed of two simple cross bars or slabs of stone, pierced into the requisite forms, and

separated by a horizontal joint, just on a level with the lowest cusp of the quatrefoils, as seen [*in 'a'*]. But at the Ducal Palace the horizontal joint is in the centre of the quatrefoils, and two others are introduced beneath it at right angles to the run of the mouldings, as seen in *b*.

a　　　　　*b*

The Venetian Index continues: The doors of the church are all later than any other portion of it, very elaborate Renaissance Gothic. The interior is good Gothic, but not interesting, except in its monuments.

Ruskin examines a number of the Frari monuments elsewhere in the text and the relevant sections are included below. A general comment on tomb sculpture may serve as a useful introduction. Ruskin is speaking of the changes in the treatment of Renaissance tombs.

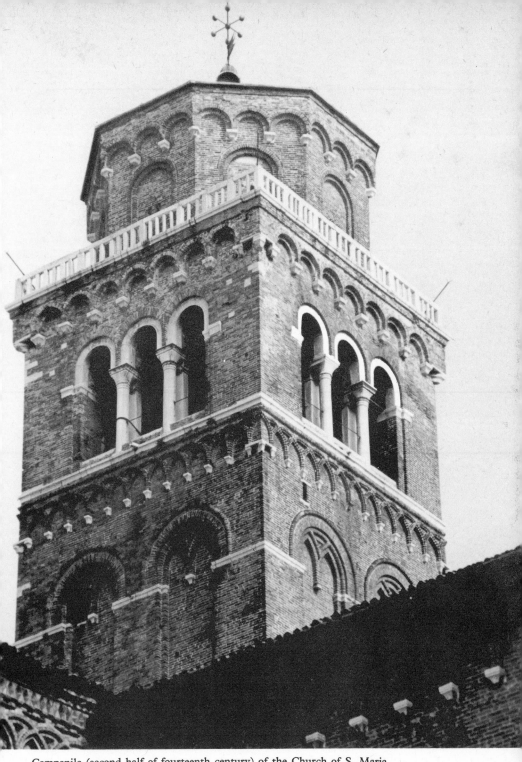

Campanile (second half of fourteenth century) of the Church of S. Maria Gloriosa dei Frari.

III–II–LXXIX. . . . The most significant change in the treatment of these tombs . . . is in the form of the sarcophagus. It was above noted that, exactly in proportion to the degree of the pride of life expressed in any monument, would be also the fear of death; and therefore, as these tombs increased in splendour, in size, and beauty of workmanship, we perceive a gradual desire to *take away from the definite character of the sarcophagus* [*Ruskin's italics*]. In the earliest times, as we have seen, it was a gloomy mass of stone; gradually it became charged with religious sculpture; but never with the slightest desire to disguise its form, until towards the middle of the fifteenth century. It then becomes enriched with flower-work and hidden by the Virtues; and, finally, losing its four-square form, it is modelled on graceful types of ancient vases, made as little like a coffin as possible, and refined away in various elegancies, till it becomes, at last, a mere pedestal or stage for the portrait statue. This statue, in the meantime, has been gradually coming back to life, through a curious series of transitions. The Vendramin monument [*in the Church of SS. Giovanni e Paolo*] is one of the last which shows or pretends to show, the recumbent figure laid in death. A few years later, this idea became disagreeable to polite minds; and lo! the figures, which before had been laid at rest upon the tomb pillow, raised themselves on their elbows, and began to look round them. The soul of the sixteenth century dared not contemplate its body in death.

LXXX. The reader cannot but remember many instances of this form of monument, England being peculiarly rich in examples of them; although, with her, tomb sculpture after the fourteenth century, is altogether imitative, and in no degree indicative of the temper of the people. It was from Italy that the authority for the change was derived; and in Italy only, therefore, that it is truly correspondent to the change in the national mind. . . .

LXXXI. The statue, however, did not long remain in this partially recumbent attitude. Even the expression of peace became painful to the frivolous and thoughtless Italians, and they required the portraiture to be rendered in a manner that should induce no memory of death. The statue rose up, and presented itself in front of the tomb, like an actor upon a stage, surrounded now not merely, or not at all, by the Virtues, but by allegorical figures of Fame and Victory, by genii and muses, by personifications of humbled kingdoms and adoring nations, and by every circumstance of pomp, and symbol of adulation, that flattery could suggest, or insolence could claim.

Monuments in the Church of the Frari

III–II–LVII. . . . In the second chapel counting from right to left, at the west end of the Church of the Frari, there is a very early fourteenth, or perhaps late thirteenth-century tomb, another exquisite example of the perfect Gothic form. It is a knight's; but there is no inscription upon it, and his name is unknown. It consists of a sarcophagus supported on bold brackets against the chapel wall, bearing the recumbent figure, protected by a simple canopy in the form of a pointed arch, pinnacled by the knight's crest; beneath which the shadowy space is painted dark blue, and strewn with stars. The statue itself is rudely carved; but its lines as seen from the intended distance, are both tender and masterly. The knight is laid in his mail, only the hands and face being bare. The hauberk and helmet are of chain-mail, the armour for the limbs of jointed steel; a tunic, fitting close to the breast, and marking the noble swell of it by two narrow embroidered lines, is worn over the mail; his dagger is at his right side; his long cross-belted sword, not seen by the spectator from below, at his left. His feet rest on a hound (the hound being his crest), which looks up towards its master. In general, in tombs of this kind, the face of the statue is slightly turned towards the spectator; in this monument, on the contrary, it is turned away from him, towards the depth of the arch: for there, just above the warrior's breast, is carved a small image of St Joseph bearing the infant Christ, who looks down upon the resting figure; and to this image its countenance is turned. The appearance of the entire tomb is as if the warrior had seen the vision of Christ in his dying moments, and had fallen back peacefully upon his pillow, with his eyes still turned to it, and his hands clasped in prayer.

LVIII. On the opposite side of this chapel is another very lovely tomb, to Duccio degli Alberti, a Florentine ambassador at Venice; noticeable chiefly as being the first in Venice on which any images of the Virtues appear. . . .

LXVI. . . . Its small lateral statues of Justice and Temperance are exquisitely beautiful, and were, I have no doubt, executed by a Florentine sculptor; the whole range of artistical power and religious feeling being in Florence full half a century in advance of that of Venice.

In the same chapter (III–II–LVIII) Ruskin mentions that the tomb of the Doge Francesco Dandolo was also housed at one time in the church.

But, as if there were not room enough, nor waste houses enough, in the desolate city to receive a few convent papers, the monks, wanting an 'archivio', have separated the tomb into three pieces: the canopy, a simple arch sustained on brackets, still remains on the blank walls of the

desecrated chamber; the sarcophagus has been transported to a kind of museum of antiquities, established in what was once the cloister of S. Maria della Salute; and the painting which filled the lunette behind it is hung far out of sight, at one end of the sacristy of the same church.

Another tomb in the church is that of Jacopo Pesaro.

III–II–LXXX. There are many monuments in Venice of [*the*] semi-animate type, most of them carefully sculptured, and some very admirable as portraits, and for the casting of the drapery, especially those in the Church of San Salvador [*qv*]: but I shall only direct the reader to one, that of Jacopo Pesaro, Bishop of Paphos, in the Church of the Frari; notable not only as a very skilful piece of sculpture, but for the epitaph, singularly characteristic of the period, and confirmatory of all that I have alleged against it:

'James Pesaro, Bishop of Paphos, who conquered the Turks in war, himself in peace, transported from a noble family among the Venetians to a nobler among the angels, laid here, expects the noblest crown, which the just Judge shall give to him in that day. He lived the years of Plato. He died 24th March, 1547.'

The mingled classicism and carnal pride of this epitaph surely need no comment. The crown is expected as a right from the justice of the Judge, and the nobility of the Venetian family is only a little lower than that of the angels. The quaint childishness of the 'Vixit annos Platonicos' is also very notable.

The tomb of Doge Giovanni Pesaro is also in the Frari. Ruskin considers, it an example of 'the last and most gross' of the Renaissance monumental types.

III–II–LXXXII. It is to be observed that we have passed over a considerable interval of time; we are now in the latter half of the seventeenth century; the progress of corruption has in the meantime been incessant, and sculpture has here lost its taste and learning as well as its feeling. The monument is a huge accumulation of theatrical scenery in marble: four colossal negro caryatides, grinning and horrible, with faces of black marble and white eyes, sustain the first story of it; above this, two monsters, long-necked, half dog and half dragon, sustain an ornamental sarcophagus, on the top of which the full-length statue of the Doge in robes of state stands forward with its arms expanded, like an actor courting applause, under a huge canopy of metal, like the roof of a bed, painted crimson and gold; on each side of him are sitting figures of genii, unintelligible personifications gesticulating in Roman armour; below, between the negro caryatides, are two ghastly figures in bronze,

half corpse, half skeleton, carrying tablets on which is written the eulogium: but in large letters, graven in gold, the following words are the first and last that strike the eye; the first two phrases, one on each side, on tablets in the lower story, the last under the portrait statue above:

VIXIT ANNOS LXX DEVIXIT ANNO MDCLIX
'HIC REVIXIT ANNO MDCLXIX'

We have here, at last, the horrible images of death in violent contrast with the defiant monument, which pretends to bring the resurrection down to earth, 'Hic revixit'; and it seems impossible for false taste and base feeling to sink lower.

Besides these tombs, the traveller ought to notice carefully that of Pietro Bernardo, a first-rate example of Renaissance work; nothing can be more detestable or mindless in general design, or more beautiful in execution. Examine especially the griffins, fixed in admiration of bouquets at the bottom. The fruit and flowers which arrest the attention of the griffins may well arrest the traveller's also; nothing can be finer of their kind. The tomb of Canova, *by* Canova, cannot be missed; consummate in science, intolerable in affectation, ridiculous in conception, null and void to the uttermost in invention and feeling. The equestrian statue of Paolo Savelli is spirited; the monument of the Beato Pacifico, a curious example of Renaissance Gothic with wild crockets (all in terra cotta). There are several good Vivarinis in the church, but its chief pictorial treasure is the John Bellini in the sacristy, the most finished and delicate example of the master in Venice.

Titian's famous 'Assumption of the Virgin' has now been returned to the Frari from the Accademia, where Ruskin saw it, and under which head he briefly describes it (qv).

There he argues that the picture attracts undue attention because of the brightness of the colouring. However, in a later work published in 1877 (Guide to the Principal Pictures in the Academy of Fine Arts), *he modifies this. Ruskin writes: 'the fault of this picture, as I read it now is in not being bright enough. A large piece of scarlet, two large pieces of crimson, and some very beautiful blue, occupy about a fifth part of it, but the rest is mostly fox colour or dark brown: the majority of the apostles under total eclipse of brown. St John, there being nobody else handsome to look at, is therefore seen to advantage; also St Peter and his beard; but the rest of the lower canvas is filled with little more than flourishing of arms and flingings of cloaks, in shadow and light.*

'However, as a piece of oil painting, and what artists call "composition",

with entire grasp and knowledge of the action of the human body, the perspectives of the human face, and the relations of shade to colour in expressing form, the picture is deservedly held unsurpassable.'

Ruskin adds in the Guide: *'In general Titian is ill represented in his own Venice. The best example of him, by far, is the portrait group of the Pesaro family in the Frari'.*

G

GEREMIA, CHURCH OF S. Of no importance.
San Geremia is a late Renaissance church of about 1755. The campanile, however, is of the twelfth or thirteenth century and is one of the oldest in Venice.

GESUATI, CHURCH OF THE. Of no importance.
The Church of S. Maria del Rosario, known as the Gesuati, is situated on the Zattere and should not be confused with a church with a similar name, the Gesuiti (which Ruskin describes under JESUITI*), which is the Jesuit church of S. Maria Assunta near the Fondamente Nuove, to the north of Venice.*

The Church of the Gesuati was named after the order of Poveri Gesuati. It was built in 1730–1740 in the late Renaissance style, and was designed by Giorgio Massari. The ceiling of the church was painted by Tiepolo. These frescoes have been restored by the German Stifterverband für die Deutsche Wissenschaft and by the French Comité français pour la Sauvegarde de Venise.

GESUITI, CHURCH OF THE. See JESUITI.

GIACOMO DE LORIO, CHURCH OF S. [*or* DELL'ORIO], a most interesting church, of the early thirteenth century, but grievously restored. Its capitals have been already noticed as characteristic of the earliest Gothic; and it is said to contain four works of Paul Veronese, but I have not examined them. The pulpit is admired by the Italians, but is utterly worthless. The verd-antique pillar, in the south transept, is a very noble example of the 'Jewel Shaft'. [*This is discussed in Volume II.*]

II–IV–XXXIII. . . . Although, as we have said, it is impossible to cover the walls of a large building with colour, except on the condition of dividing the stone into plates, there is always a certain appearance of meanness and niggardliness in the procedure. It is necessary that the builder should

justify himself from this suspicion; and prove that it is not in mere economy or poverty, but in the real impossibility of doing otherwise, that he has sheeted his walls so thinly with the precious film. Now the shaft is exactly the portion of the edifice in which it is fittest to recover his honour in this respect. For if blocks of jasper or porphyry be inserted in the walls, the spectator cannot tell their thickness, and cannot judge of the costliness of the sacrifice. But the shaft he can measure with his eye in an instant, and estimate the quantity of treasure both in the mass of its existing substance, and in that which has been hewn away to bring it into its perfect and symmetrical form. And thus the shafts of all buildings of this kind are justly regarded as an expression of their wealth, and a form of treasure, just as much as the jewels or gold in the sacred vessels; they are, in fact, nothing else than large jewels, the block of precious serpentine or jasper being valued according to its size and brilliancy of colour, like a large emerald or ruby; only the bulk required to bestow value on the one is to be measured in feet and tons, and on the other in lines and carats. The shafts must therefore be, without exception, of one block in all buildings of this kind; for the attempt in any place to incrust or joint them would be a deception like that of introducing a false stone among jewellery (for a number of joints of any precious stone are of course not equal in value to a single piece of equal weight), and would put an end at once to the spectator's confidence in the expression of wealth in any portion of the structure, or of the spirit of sacrifice in those who raised it.

The Church of S. Giacomo dell'Orio, as it is more usually called, is thought to derive its name from the word for laurel—'del lauro' or 'd'allora'. Inside is a ceiling painting of the 'Triumph of Faith' surrounded by four paintings of 'Fathers of the Church'. Berenson ascribes three of these to Veronese—Laurence, Jerome and Prosper—and not the centre panel (see bibliography).

GIACOMO DI RIALTO, CHURCH OF S. A picturesque little church, on the Piazza di Rialto. It has been grievously restored, but the pillars and capitals of its nave are certainly of the eleventh century; those of its portico are of good central Gothic; and it will surely not be left unvisited, on this ground, if on no other, that it stands on the site, and still retains the name, of the first church ever built on that Rialto which formed the nucleus of future Venice, and became afterwards the mart of her merchants.

GIGLIO, S. MARIA DEL. See ZOBENIGO, CHURCH OF S. MARIA.

GIOBBE, CHURCH OF S., near the Canna Reggio. Its principal entrance is a very fine example of early Renaissance sculpture. Note in it, especially, its beautiful use of the flower of the convolvulus. There are said to be still more beautiful examples of the same period, in the interior. The cloister, though much defaced, is of the Gothic period, and worth a glance.

The Church of S. Giobbe was began in 1451 and designed in the Gothic style by Antonio Gambello. The work appears to have been abandoned for a time, but later it was resumed in 1471 by Pietro Lombardo who designed it in the Renaissance style. Extensive restoration of this church was being done in 1974 by the America–Italy Society of Philadelphia.

GIORGIO DEGLI GRECI, CHURCH OF S. The Greek Church. It contains no valuable objects of art, but its service is worth attending by those who have never seen the Greek ritual.

This Greek church was erected in the middle of the sixteenth century and was designed in the Renaissance style by Sante Lombarde.

GIORGIO DE' SCHIAVONI, CHURCH OF S. Said to contain a very precious series of paintings by Vittor Carpaccio. Otherwise of no interest.

Ruskin speaks highly of these paintings by Carpaccio and describes them in another work, St Mark's Rest. There are nine—three on the theme of St George, three on the theme of St Jerome, and the other middle three being 'St Tryphonius and the Basilisk', 'Agony in the Garden' and 'The Calling of St Matthew'.

St George, St Jerome and St Tryphonius were the protectors of the Dalmatian Brotherhood, a fraternity who in 1452 built itself a small oratory. At the end of the century this was rebuilt as the Scuola di S. Giorgio degli Schiavoni, by which name it is now known. Much needed restoration work was carried out in 1970–1 by the Comitato Italiano per Venezia.

GIORGIO IN ALGA (St George in the seaweed), CHURCH OF S. Unimportant in itself, but the most beautiful view of Venice at sunset is from a point at about two-thirds of the distance from the city to the island [*of the same name—the island lies south-west of the Guidecca*].

GIORGIO MAGGIORE, CHURCH OF S. A building which owes its interesting effect chiefly to its isolated position, being seen over a great space of lagoon. The traveller should especially notice in its façade

the manner in which the central Renaissance architects (of whose style this church is a renowned example) endeavoured to fit the laws they had established to the requirements of their age. Churches were required with aisles and clerestories, that is to say, with a high central nave and lower wings; and the question was, how to face this form with pillars of one proportion. The noble Romanesque architects built story above story, as at Pisa and Lucca; but the base Palladian architects dared not do this. They must needs retain some image of the Greek temple; but the Greek temple was all of one height, a low gable roof being borne on ranges of equal pillars. So the Palladian builders raised first a Greek temple with pilasters for shafts; and, *through the middle of its roof, or horizontal beam*, that is to say, of the cornice which externally represented this beam, they lifted another temple on pedestals, adding these barbarous appendages to the shafts, which otherwise would not have been high enough; fragments of the divided cornice or tie-beam being left between the shafts, and the great door of the church thrust in between the pedestals. It is impossible to conceive a design more gross, more barbarous, more childish in conception, more servile in plagiarism, more insipid in result, more contemptible under every point of rational regard.

Observe, also, that when Palladio had got his pediment at the top of the church, he did not know what to do with it: he had no idea of decorating it except by a round hole in the middle. (The traveller should compare, both in construction and decoration, the Church of the Redentore with this of S. Giorgio.) Now a dark penetration is often a most precious assistance to a building dependent upon colour for its effect; for a cavity is the only means in the architect's power of obtaining certain and vigorous shadow; and for this purpose, a circular penetration, surrounded by a deep russet marble moulding, is beautifully used in the centre of the white field on the side of the portico of St Mark's. But Palladio had given up colour, and pierced his pediment with a circular cavity, merely because he had not wit enough to fill it with sculpture. The interior of the church is like a large assembly room, and would have been undeserving of a moment's attention, but that it contains some most precious pictures, namely:

1. *Gathering the Manna.* (On the left hand of the high altar.) One of Tintoretto's most remarkable landscapes. A brook flowing through a mountainous country, studded with thickets and palm trees: the congregation have been long in the wilderness, and are employed in various manufactures much more than in gathering the manna. One group is forging, another grinding manna in a mill, another making shoes, one woman making a piece of dress, some washing; the main purpose of Tintoretto being evidently to indicate the *continuity* of the supply of heavenly food. Another painter would have made the congregation

'Gathering the Manna' by Tintoretto in the Church of S. Giorgio Maggiore.

hurrying to gather it, and wondering at it; Tintoretto at once makes us remember that they have been fed with it 'by the space of forty years'. It is a large picture, full of interest and power, but scattered in effect, and not striking except from its elaborate landscape.

2. *The Last Supper.* (Opposite the former.) These two pictures have been painted for their places, the subjects being illustrative of the sacrifice of the mass. This latter is remarkable for its entire homeliness in the general treatment of the subject; the entertainment being represented like any large supper in a second-rate Italian inn, the figures being all comparatively uninteresting: but we are reminded that the subject is a sacred one, not only by the strong light shining from the head of Christ, but because the smoke of the lamp which hangs over the table turns, as it rises, into a multitude of angels, all painted in grey, the colour of the smoke; and so writhed and twisted together that the eye hardly at first distinguishes them from the vapour out of which they are formed, ghosts of countenances and filmy wings filling up the intervals between the completed heads. The idea is highly characteristic of the master. The picture has been grievously injured, but still shows miracles of skill in the expression of candle-light mixed with twilight; variously reflected rays, and half tones of the dimly lighted chamber, mingled with the beams of

'The Last Supper' by Tintoretto in the Church of S. Giorgio Maggiore.

the lantern and those from the head of Christ, flashing along the metal and glass upon the table, and under it along the floor, and dying away into the recesses of the room.

3. *Martyrdom of various Saints.* (Altar piece of the third altar in the south aisle.) A moderately sized picture, and now a very disagreeable one, owing to the violent red into which the colour that formed the glory of the angel at the top is changed. It has been hastily painted, and only shows the artist's power in the energy of the figure of an executioner drawing a bow, and in the magnificent ease with which the other figures are thrown together in all manner of wild groups and defiances of probability. Stones and arrows are flying about in the air at random.

4. *Coronation of the Virgin.* (Fourth altar in the same aisle.) Painted more for the sake of the portraits at the bottom, than of the Virgin at the top. A good picture, but somewhat tame for Tintoretto and much injured. The principal figure, in black, is still, however, very fine.

5. *Resurrection of Christ.* (At the end of the north aisle, in the chapel beside the choir.) Another picture painted chiefly for the sake of the included portraits, and remarkably cold in general conception; its colour has, however, been gay and delicate, lilac, yellow, and blue being largely used in it. The flag which our Saviour bears in his hand, has been once as

bright as the sail of a Venetian fishing-boat, but the colours are now all chilled, and the picture is rather crude than brilliant; a mere wreck of what it was, and all covered with droppings of wax at the bottom.

6. *Martyrdom of St Stephen.* (Altar piece in the north transept.) The saint is in a rich prelate's dress, looking as if he had just been saying mass, kneeling in the foreground, and perfectly serene. The stones are flying about him like hail, and the ground is covered with them as thickly as if it were a river bed. But in the midst of them, at the saint's right hand, there is a book lying, crushed, but open, two or three stones which have torn one of its leaves lying upon it. The freedom and ease with which the leaf is crumpled is just as characteristic of the master as any of the grander features; no one but Tintoretto could have so crushed a leaf, but the idea is still more characteristic of him, for the book is evidently meant for the Mosaic History which Stephen had just been expounding, and its being crushed by the stones shows how the blind rage of the Jews was violating their own law in the murder of Stephen. In the upper part of the picture are three figures—Christ, the Father, and St Michael. Christ of course at the right hand of the Father, as Stephen saw Him standing; but there is little dignity in this part of the conception. In the middle of the picture, which is also the middle distance, are three or four men throwing stones, with Tintoretto's usual vigour of gesture, and behind them an immense and confused crowd; so that, at first, we wonder where St Paul is; but presently we observe that, in the front of this crowd, and *almost exactly in the centre of the picture,* there is a figure seated on the ground, very noble and quiet, and with some loose garments thrown across its knees. It is dressed in vigorous black and red. The figure of the Father in the sky above is dressed in black and red also, and these two figures are the centres of colour to the whole design. It is almost impossible to praise too highly the refinement of conception which withdrew the unconverted St Paul into the distance, so as entirely to separate him from the immediate interest of the scene, and yet marked the dignity to which he was afterwards to be raised, by investing him with the colours which occurred nowhere else in the picture except in the dress which veils the form of the Godhead. It is also to be noted as an interesting example of the value which the painter put upon colour only; another composer would have thought it necessary to exalt the future apostle by some peculiar dignity of action or expression. The posture of the figure is indeed grand, but inconspicuous; Tintoretto does not depend upon it, and thinks that the figure is quite ennobled enough by being made a keynote of colour.

It is also worth observing how boldly imaginative is the treatment which covers the ground with piles of stones, and yet leaves the martyr apparently unwounded. Another painter would have covered him with

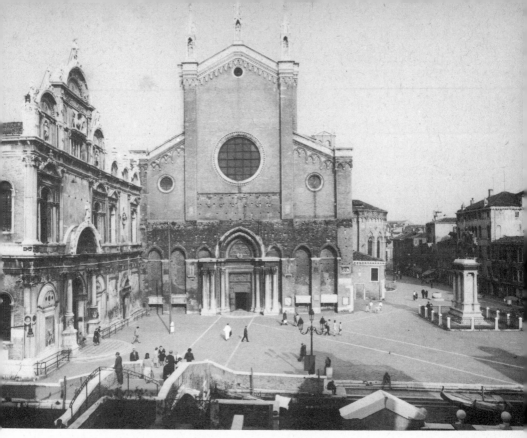

Church of SS. Giovanni e Paolo, with the Scuola di S. Marco on left and Verrocchio's equestrian statue of Colleoni on right.

blood, and elaborated the expression of pain upon his countenance. Tintoretto leaves us under no doubt as to what manner of death he is dying; he makes the air hurtle with the stones, but he does not choose to make his picture disgusting, or even painful. The face of the martyr is serene, and exulting; and we leave the picture, remembering only how 'he fell asleep'.

The Church of S. Giorgio Maggiore was built in 1565–76 to the design of Palladio, who spoke of it in 1567 as 'a building which I direct and I hope to achieve some honour by it'. The façade was not completed until 1607– 11. In more recent times the monastery buildings were restored by Count Vittorio Cini, in memory of his son, and they now house the Fondazione Giorgio Cini, an international cultural centre.

GIOVANELLI, PALAZZO, at the Ponte di Noale. A fine example of fifteenth-century Gothic, founded on the Ducal Palace.

GIOVANNI E PAOLO, CHURCH OF SS. III–II–LI. [*Also known by its contracted name of S. Zanipolo.*]

The foundation of the Church of St John and Paul was laid by the Dominicans about 1234, under the immediate protection of the Senate and the Doge Giacomo Tiepolo, accorded to them in consequence of a miraculous vision appearing to the Doge; of which the following account is given in popular tradition:

'In the year 1226, the Doge Giacomo Tiepolo dreamed a dream; and in his dream he saw the little oratory of the Dominicans, and, behold, the ground all around it (now occupied by the church) was covered with roses of the colour of vermilion, and the air was filled with their fragrance. And in the midst of the roses, there were seen flying to and fro a crowd of white doves, with golden crosses upon their heads. And while the Doge looked, and wondered, behold, two angels descended from heaven with golden censers, and passing through the oratory, and forth among the flowers, they filled the place with the smoke of their incense. Then the Doge heard suddenly a clear and loud voice which proclaimed, "This is the place that I have chosen for my preachers"; and having heard it, straightway he awoke, and went to the Senate, and declared to them the vision. Then the Senate decreed that forty paces of ground should be given to enlarge the monastery; and the Doge Tiepolo himself made a still larger grant afterwards.'

The Index describes the church as an impressive church, though none of its Gothic is comparable with that of the North, or with that of Verona. The western door is interesting as one of the last conditions of Gothic design passing into Renaissance, very rich and beautiful of its kind, especially the wreath of fruit and flowers which forms its principal moulding. The statue of Bartolomeo Colleone, in the little square beside the church, is certainly one of the noblest works in Italy. I have never seen anything approaching it in animation, in vigour of portraiture, or nobleness of line. The reader will need Lazari's Guide [*see bibliography at the end of this book*] in making the circuit of the church, which is full of interesting monuments: but I wish especially to direct his attention to two pictures, besides the celebrated Peter Martyr. [*A guide is available from the church itself giving the layout of the various tombs.*]

Here Ruskin discusses two works by Tintoretto—'The Crucifixion' and 'Our Lady with the Camerlenghi', the latter now known as 'The Madonna with the Treasurers'. Both paintings are now housed in the Accademia and Ruskin's examination of them is included under that heading.

The Index continues: The reader ought especially to study the sculpture round the altar of the Cappella del Rosario, as an example of the abuse

Equestrian statue of Bartolomeo Colleoni by Andrea Verrochio
in the Campo dei SS. Giovanni e Paolo.

of the sculptor's art; every accessory being laboured out with much ingenuity and intense effort to turn sculpture into painting, the grass, trees, and landscape being as far realized as possible, and in alto-relieve. These bas-reliefs are by various artists, and therefore exhibit the folly of the age, not the error of in individual.

Ruskin then lists the tombs which he has described elsewhere in The Stones of Venice.

> *Cavalli, Jacopo, III–II–LXIX*
> *Cornaro, Marco, III–I–XV*
> *Dolfin, Giovanni, III–II–LXII*
> *Giustiniani, Marco, I–XXVIII–XXI*
> *Mocenigo, Giovanni, III–II–LXXVIII*
> *Mocenigo, Pietro, III–II–LXXVIII*
> *Mocenigo, Tomaso, I–I–V, I–I–XL, III–II–LXX*
> *Morosini, Michele, III–II–LXV*
> *Steno, Michele, III–II–LXX*
> *Vendramin, Andrea, I–I–XLI, III–II–LXXVIII*

III–II–LXIX. [*The tomb of Jacopo Cavalli*] is peculiarly rich in religious imagery, adorned by boldly cut types of the four evangelists, and of two saints, while, on projecting brackets in front of it, stood three statues of Faith, Hope, and Charity, now lost, but drawn in Zanotto's work. It is all rich in detail, and its sculptor has been proud of it, thus recording his name below the epitaph:

> 'QST OPERA DINTALGIO E FATTO IN PIERA,
> UNVENICIAN LAFE CHANOME POLO,
> NATO DI JACHOMEL CHATAIAPIERA.'

> This work of sculpture is done in stone;
> A Venetian did it, named Paul,
> Son of Jachomel the stone cutter.

Jacopo Cavalli died in 1384. He was a bold and active Veronese soldier, did the state much service, was therefore ennobled by it, and became the founder of the house of the Cavalli; but I find no especial reason for the images of the Virtues, especially that of Charity, appearing at his tomb, unless it be this: that at the siege of Feltre, in the war against Leopold of Austria, he refused to assault the city because the senate would not grant his soldiers the pillage of the town. The feet of the recumbent figure, which is in full armour, rest on a dog, and its head on two lions; and these animals (neither of which form any part of the knight's bearings) are said by Zanotto to be intended to symbolize his bravery and

fidelity. If, however, the lions are meant to set forth courage, it is a pity they should have been represented as howling.

III–I–XV. . . . the tomb of the *Doge Marco Cornaro,* who died in 1367 . . . is rich and fully developed Gothic, with crockets and finials, but not yet attaining any extravagant development.

A further note on this tomb is given in Vol. III–II–LXV. . . . very noble monument was placed on the north side of the choir of St John and Paul, to the Doge Marco Cornaro, chiefly, with respect to our present subject, noticeable for the absence of religious imagery from the sarcophagus, which is decorated with roses only; three very beautiful statues of the Madonna and two saints, are however, set in the canopy above.

This tomb is being restored with the assistance of funds provided by the American–Italy Society of Philadelphia.

After describing Doge Andrea Dandolo's tomb in St Mark's Ruskin says: III–II–LXII. Of much ruder workmanship, though still most precious, and singularly interesting from its quaintness, is a sarcophagus in the northernmost chapel, beside the choir of St John and Paul, charged with two bas-reliefs and many figures, but which bears no inscription. It has, however, a shield with three dolphins on its brackets; and, as at the feet of the Madonna in its centre there is a small kneeling figure of a Doge, we know it to be the tomb of the *Doge Giovanni Dolfino,* who came to the throne in 1356.

He was chosen Doge while, as provveditore, he was in Treviso, defending the city against the King of Hungary. The Venetians sent to the besiegers, praying that their newly elected Doge might be permitted to pass the Hungarian lines. Their request was refused, the Hungarians exulting that they held the Doge of Venice prisoner in Treviso. But Dolfino, with a body of two hundred horse, cut his way through their lines by night, and reached Mestre (Malghera) in safety, where he was met by the Senate. His bravery could not avert the misfortunes which were accumulating on the republic. The Hungarian war was ignominiously terminated by the surrender of Dalmatia; the Doge's heart was broken, his eyesight failed him, and he died of the plague four years after he had ascended the throne.

LXIII. It is perhaps on this account, perhaps in consequence of later injuries, that the tomb has neither effigy nor inscription: that it has been subjected to some violence is evident from the dentil which once crowned its leaf-cornice being now broken away, showing the whole front. But,

fortunately, the sculpture of the sarcophagus itself is little injured.

There are two saints, male and female, at its angles, each in a little niche; a Christ, enthroned in the centre, the Doge and Dogaressa kneeling at His feet; in the two intermediate panels, on one side the Epiphany, on the other the Death of the Virgin; the whole supported, as well as crowned, by an elaborate leaf-plinth. The figures under the niches are rudely cut, and of little interest. Not so the central group. Instead of a niche, the Christ is seated under a square tent, or tabernacle, formed by curtains running on rods; the idea, of course, as usual, borrowed from the Pisan one, but here ingeniously applied. The curtains are opened in front, showing those at the back of the tent, behind the seated figure; the perspective of the two retiring sides being very tolerably suggested. Two angels, of half the size of the seated figure, thrust back the near curtains, and look up reverently to the Christ; while again, at their feet, about one-third of *their* size, and half-sheltered, as it seems, by their garments, are the two kneeling figures of the Doge and Dogaressa, though so small and carefully cut, full of life. The Christ raising one hand as to bless, and holding a book upright and open on the knees, does not look either towards them or to the angels, but forward; and there is a very noticeable effort to represent Divine abstraction in the countenance: the idea of the three magnitudes of spiritual being—the God, the Angel, and the Man—is also to be observed, aided as it is by the complete subjection of the angelic power to the Divine; for the angels are in attitudes of the most lowly watchfulness of the face of Christ, and appear unconscious of the presence of the human beings who are nestled in the folds of their garments.

Ruskin devotes a chapter in Volume I of The Stones of Venice *to the cornice and capital. In discussing the transition from the Byzantine to the Gothic cornice he says:*

I–XXVII–XXI. The fifth example was cut in 1347; it is from the tomb of *Marco Giustiniani*, in the church of St John and Paul, and it exhibits the character of the central Venetian Gothic fully developed. The lines are now soft and undulatory, though elastic; the sharp incisions have become deeply-gathered folds; the hollow of the leaf is expressed completely beneath, and its edges are touched with light, and incised into several lobes, and their ribs deliberately drawn above. (The flower between is only accidentally absent; it occurs in most cornices of the time.)

After describing the tomb of Doge Andrea Vendramin Ruskin says:
III–II–LXXVIII. Of far other workmanship are the tombs of *Pietro* and *Giovanni Mocenigo*, in St John and Paul; and of Pietro Bernardo in the Frari; in all which the details are as full of exquisite fancy, as they are

perfect in execution: and in the two former, and several others of similar feeling, the old religious symbols return; the Madonna is again seen enthroned under the canopy, and the sarcophagus is decorated with legends of the saints.

I–I–XL. [*The tomb of Doge Tomaso Mocenigo is*] wrought by a Florentine; but it is of the same general type and feeling as all the Venetian tombs of the period, and it is one of the last which retains it. The classical element enters largely into its details, but the feeling of the whole is as yet unaffected. Like all the lovely tombs of Venice and Verona, it is a sarcophagus with a recumbent figure above, and this figure is a faithful but tender portrait, wrought as far as it can be without painfulness, of the doge as he lay in death. He wears his ducal robe and bonnet—his head is laid slightly aside upon his pillow—his hands are simply crossed as they fall. The face is emaciated, the features large, but so pure and lordly in their natural chiselling, that they must have looked like marble even in their animation. They are deeply worn away by thought and death; the veins on the temples branched and starting; the skin gathered in sharp folds; the brow high-arched and shaggy; the eye-ball magnificently large; the curve of the lips just veiled by the light moustache at the side; the beard short, double, and sharp-pointed: all noble and quiet; the white sepulchral dust marking like light the stern angles of the cheek and brow.

This tomb was sculptured in 1424, and is thus described by one of the most intelligent of the recent writers who represent the popular feeling respecting Venetian art [*Selvatico*, Architettura di Venezia].

'Of the Italian school is also the rich but ugly (ricco ma non bel) sarcophagus in which repose the ashes of Tomaso Mocenigo. It may be called one of the last links which connect the declining art of the Middle Ages with that of the Renaissance, which was in its rise. We will not stay to particularize the defects of each of the seven figures of the front and sides, which represent the cardinal and theological virtues; nor will we make any remarks upon those which stand in the niches above the pavilion, because we consider them unworthy both of the age and reputation of the Florentine school, which was then with reason considered the most notable in Italy.'

It is well, indeed, not to pause over these defects; but it might have been better to have paused a moment beside that noble image of a king's mortality.

For further reference to the tomb of Tomaso Mocenigo see below under Michele Steno.

After refuting accusations of avarice against the Doge Michele Morosini Ruskin says:

III–II–LXVIII. . . . The occurrence of the Virtues upon his tomb, for the first time in Venetian monumental work, and so richly and conspicuously placed, may partly have been in public contradiction of such a floating rumour. But the face of the statue is a more explicit contradiction still; it is resolute, thoughtful, serene, and full of beauty; and we must, therefore, for once, allow the somewhat boastful introduction of the Virtues to have been perfectly just: though the whole tomb is most notable, as furnishing not only the exactly intermediate condition in style between the pure Gothic and its final Renaissance corruption, but, at the same time, the exactly intermediate condition of *feeling* between the pure calmness of early Christianity, and the boastful pomp of the Renaissance faithlessness; for here we have still the religious humility remaining in the mosaic of the canopy, which shows the Doge kneeling before the cross, while yet this tendency to self-trust is shown in the surrounding of the coffin by the Virtues.

For further details of the character of Morosini see under PALAZZO MOROSINI.

III–II–LXX. We must next pause for an instant beside the tomb of *Michael Steno*, now in the northern aisle of St John and Paul, having been removed there from the destroyed church of the Servi: first, to note its remarkable return to the early simplicity, the sarcophagus being decorated only with two crosses in quatrefoils, though it is of the fifteenth century, Steno dying in 1413; and, in the second place, to observe the peculiarity of the epitaph, which eulogizes Steno as having been 'amator justitie, pacis, et ubertatis', 'A lover of justice, peace, and plenty'. In the epitaphs of ths period, the virtues which are made most account of in public men are those which were most useful to their country. We have already seen one example in the epitaph on Simon Dandolo; and similar expressions occur constantly in laudatory mentions of their later Doges by the Venetian writers.

I–I–XLI. In the choir of the same church, SS. Giovanni e Paolo, is another tomb, that of the *Doge Andrea Vendramin*. This doge died in 1478, after a short reign of two years, the most disastrous in the annals of Venice. He died of a pestilence which followed the ravage of the Turks, carried to the shores of the lagoons. He died, leaving Venice disgraced by sea and land, with the smoke of hostile devastation rising in the blue distances of Friuli; and there was raised to him the most costly tomb ever bestowed on her monarchs. . . .

It is unanimously declared the chef d'œuvre of Renaissance sepulchral work, and pronounced by Cicognara (also quoted by Selvatico): 'Il vertice a cui l' arti Veneziane si spinsero col ministero del scalpello'— 'The very culminating point to which the Venetian arts attained by ministry of the chisel'.

To this culminating point, therefore, covered with dust and cobwebs, I attained, as I did to every tomb of importance in Venice, by the ministry of such ancient ladders as were to be found in the sacristan's keeping. I was struck at first by the excessive awkwardness and want of feeling in the fall of the hand towards the spectator, for it is thrown off the middle of the body in order to show its fine cutting. Now the Mocenigo hand, severe and even stiff in its articulations, has its veins finely drawn, its sculptor having justly felt that the delicacy of the veining expresses alike dignity and age and birth. The Vendramin hand is far more laboriously cut, but its blunt and clumsy contour at once makes us feel that all the care has been thrown away, and well it may be, for it has been entirely bestowed in cutting gouty wrinkles about the joints. Such as the hand is, I looked for its fellow. At first I thought it had been broken off, but on clearing away the dust, I saw the wretched effigy had only *one* hand, and was a mere block on the inner side. The face, heavy and disagreeable in its features, is made monstrous by its semi-sculpture. One side of the forehead is wrinkled elaborately, the other left smooth; one side only of the doge's cap is chased; one cheek only is finished, and the other blocked out and distorted besides; finally, the ermine robe, which is elaborately imitated to its utmost lock of hair and of ground hair on the one side, is blocked out only on the other: it having been supposed throughout the work that the effigy was only to be seen from below, and from one side.

It was indeed to be so seen by nearly every one; and I do not blame—I should, on the contrary, have praised—the sculptor for regulating his treatment of it by its position; if that treatment had not involved, first, dishonesty, in giving only half a face, a monstrous mask, when we demanded true portraiture of the dead; and, secondly, such utter coldness of feeling, as could only consist with an extreme of intellectual and moral degradation: Who, with a heart in his breast, could have stayed his hand as he drew the dim lines of the old man's countenance—unmajestic once, indeed, but at least sanctified by the solemnities of death—could have stayed his hand, as he reached the bend of the grey forehead and measured out the last veins of it at so much the zecchin?

I do not think the reader, if he has feeling, will expect that much talent should be shown in the rest of his work, by the sculptor of this base and senseless lie. The whole monument is one wearisome aggregation of that species of ornamental flourish, which, when it is done with a pen, is called penmanship, and when done with a chisel, should be

called chiselmanship; the subject of it being chiefly fat-limbed boys sprawling on dolphins, dolphins incapable of swimming, and dragged along the sea by expanded pocket-handkerchiefs.

But now, reader, comes the very gist and point of the whole matter. This lying monument to a dishonoured doge, this culminating pride of the Renaissance art of Venice, is at least veracious, if in nothing else, in its testimony to the character of its sculptor. *He was banished from Venice for forgery* in 1487 [*Ruskin's italics*].

Elsewhere Ruskin writes:
III–II–LXXVII. The most celebrated monument of this period is that to the Doge Andrea Vendramin, in the Church of St John and Paul, sculptured about 1480, and before alluded to in the first chapter of the first volume. It has attracted public admiration, partly by its costliness, partly by the delicacy and precision of its chiselling; being otherwise a very base and unworthy example of the school, and showing neither invention nor feeling. It has the Virtues, as usual, dressed like heathen goddesses, and totally devoid of expression, though graceful and well studied merely as female figures. The rest of its sculpture is all of the same kind; perfect in workmanship, and devoid of thought. Its dragons are covered with marvellous scales, but have no terror nor sting in them; its birds are perfect in plumage, but have no song in them; its children lovely of limb, but have no childishness in them.

Much restoration work was recently carried out on the Church of SS. Giovanni e Paolo with the assistance of funds provided by the American Committee to Rescue Italian Art.

GIOVANNI ELEMOSINARIO, CHURCH OF S. Said to contain a Titian and a Bonifazio. Of no other interest.

The original church to St John the Almsgiver was destroyed by fire in 1413 and was rebuilt in 1528 by Antonio Abbondi, alias Scarpagnino. It has a Greek cross plan, with barrel vaulting. Ruskin adds in the 1877 abridgement, quoting from Selvatico: 'Its campanile is the most interesting piece of central Gothic remaining comparatively intact in Venice. It stands on four detached piers; a greengrocer's shop in the space between them, the stable tower for its roof. There are three lovely bits of heraldry, carved on three square stones, on its side towards the Rialto. Selvatico gives no ground for his date; I believe 1298–1310 more probable' (Selvatico: Archittura di Venezia, Venice 1847).

Ruskin also says: 'The Titian, only visible to me by the sacristan's single candle, seems languid and affected.' The work by Titian in the chancel is of 'S. Giovanni Elemosinario giving alms to a Beggar'. The

Bonifazio, much damaged on the wall of the apse chapel, is of 'Sts Peter, Paul and the Virgin in Glory'.

GIOVANNI GRISOSTOMO, CHURCH OF S. One of the most important in Venice. It is early Renaissance, containing some good sculpture, but chiefly notable as containing a noble Sebastian del Piombo [*St John Chrysastom enthroned with other Saints*], and a John Bellini [*Sts Jerome, Augustine and Christopher, a late work of 1513*] which a few years hence, unless it be 'restored', will be esteemed one of the most precious pictures in Italy, and among the most perfect in the world. John Bellini is the only artist who appears to me to have united, in equal and magnificent measures, justness of drawing, nobleness of colouring, and perfect manliness of treatment, with the purest religious feeling. He did, as far as it is possible to do it, instinctively and unaffectedly, what the Caracci only pretended to do. Titian colours better, but has not his piety. Leonardo draws better, but has not his colour. Angelico is more heavenly, but has not his manliness, far less his powers of art.

S. Giovanni Grisostimo was built in about 1500 by Moro Coducci. Restoration work is being done with the assistance of the American Save Venice Inc.

GIOVANNI IN BRAGORA, CHURCH OF S. A Gothic church of the fourteenth century, small, but interesting, and said to contain some precious works by Cima da Conegliano, and one by John Bellini.

This church, behind the Riva degli Schiavoni, does indeed contain two works by Cima: 'The Emperor Constantine and St Helen' in the chancel, and a 'Baptism of Christ' behind the high altar. Also in the church is the well-known picture by Alvise Vivarini of 'The Resurrection'. The painting of the 'Madonna and Child', sometimes ascribed to Giovanni Bellini is considered by Crowe and Cavalcaselle (see bibliography) to be the work of Alvise Vivarini.

GIOVANNI NUOVO, CHURCH OF S. Of no importance.
This church, founded in the tenth century, was rebuilt in 1762 by Matteo Lucchesi in the Palladian style.

GIOVANNI, SCUOLA DI S. A fine example of the Byzantine Renaissance, mixed with remnants of good late Gothic. The little exterior cortile is sweet in feeling, and Lazari praises highly the work of the interior staircase.

A note on the constitution of the Venetian scuoli is given under Scuola di S. Rocco. The Scuola Grande di S. Giovanni Evangelista was the second of the six scuoli and was founded in 1201. The building as it now stands is partly Byzantine, partly Gothic but mainly Renaissance. The handsome interior double staircase was designed by Mauro Coducci and was built in 1498. In common with the other Venetian scuoli, it was closed by Napoleon in 1806. In 1855–57 it was extensively restored and became the home of the Societa per le Arti Edificatorie. It suffered from the flooding of 1966, and since 1969 work of restoration has been carried out by the International Fund for Monuments, which it is hoped to complete in 1976–77. It functions as an information centre for tourists and students.

GIUDECCA. The crescent-shaped island (or series of islands), which forms the most northern [*although 'northern' is given in all editions, it is obviously an error: it should read 'southern'*] extremity of the city of Venice, though separated by a broad channel from the main city. Commonly said to derive its name from the number of Jews who lived upon it; but Lazari derives it from the word 'judicato', in Venetian dialect 'zudegà', it having been in old time 'adjudged' as a kind of prison territory to the more dangerous and turbulent citizens. It is now inhabited only by the poor, and covered by desolate groups of miserable dwellings, divided by stagnant canals.

Its two principal churches, the Redentore and S. Eufemia, are named in their alphabetical order.

GIULIANO, CHURCH OF S. Of no importance.
S. Giuliano is a Renaissance church designed by Jacopo Sansovino and built in 1554 It contains a ceiling painting by Palma Giovane, together with two other works by the same artist—'The Assumption' and 'The Agony in the Garden'—two works by Antonio Zanchi—'A Miracle of St Julian' and 'The Martyrdom of St Julian—and a Pietà by Veronese.

GIUSEPPE DI CASTELLO, CHURCH OF S. Said to contain a Paul Veronese: otherwise of no importance.

The picture by Veronese is the 'Adoration of the Shepherds' and is behind the high altar. The church is of Renaissance design, having been rebuilt in the sixteenth century. It was originally a convent church for Augustinian nuns and was then used by the Salesian order.

GIUSTINA, CHURCH OF S. Of no importance.
This church is, or was, in a derelict state and was closed in 1810. Part of it has since been used as an office.

GIUSTINIANI, PALAZZO, on the Grand Canal, now Albergo all'
Europa [*see under* EUROPA]. Good late-fourteenth-century Gothic, but
much altered.

GIUSTINIANI, PALAZZO, next the Casa Foscari, on the Grand
Canal. Lazari, I knew not on what authority, says that this palace was
built by the Giustiniani family before 1428. It is one of those founded
directly on the Ducal Palace, together with the Casa Foscari at its side:
and there could have been no doubt of their date on this ground; but it
would be interesting, after what we have seen of the progress of the Ducal
Palace, to ascertain the exact year of the erection of any of these imitations.
This palace contains some unusually rich detached windows, full of tracery,
of which the profiles are given in [*Volume III Appendix 10, Plate XI—
this plate is not reproduced*], under the title of the Palace of the Younger
Foscari, it being popularly reported to have belonged to the son of the
Doge.

*Historical notices, wrongly interpreted, spoke of a building in the area,
which belonged to the Giustinian family and was sold in 1428. This gave
rise to an earlier date being placed on the building than was in fact
accurate. In 1863, however, Tassini established that building commenced
in 1452 (see Edoardo Arslan,* Gothic Architecture in Venice).

The Palazzi Foscari (right) and Giustiniani (left), fifteenth-century
Gothic palaces on the Grand Canal.

GIUSTINIAN LOLIN, PALAZZO, on the Grand Canal. Of no importance.

The Palazzo Giustinian Lolin is a Baroque-Renaissance building erected about 1625 and designed by Baldassare Longhena.

GOLDONI THEATRE. *Built in the seventeenth century by the Vendramin family, it was variously called the San Luca and the San Salvatore, later the Apollo. In the 1870s it was altered considerably and in 1875 was renamed after the famous Venetian playright Carlo Goldoni. Ruskin does not include the theatre in his index.*

GRASSI, PALAZZO, on the Grand Canal, now Albergo all'Imperator d'Austria. Of no importance.

The Palazzo Grassi was designed by Giorgio Massari in the Renaissance style and erected in the early eighteenth century. It is no longer a hotel, and now serves as the headquarters of the Centro Internazionale delle Arti e del Costume.

GREGORIO, CHURCH OF S., on the Grand Canal. An important church of the fourteenth century, now desecrated, but still interesting. Its apse is on the little canal crossing from the Grand Canal to the Giudecca, beside the Church of the Salute, and is very characteristic of the rude ecclesiastical Gothic contemporary with the Ducal Palace. The entrance to its cloisters, from the Grand Canal, is somewhat later; a noble square door, with two windows on each side of it, the grandest examples in Venice of the late window of the fourth order [*for further details see under* ORDERS OF VENETIAN ARCHES].

The cloister, to which this door gives entrance, is exactly contemporary with the finest work of the Ducal Palace, circa 1350. It is the loveliest cortile I know in Venice; its capitals consummate in design and execution; and the low wall on which they stand showing remnants of sculpture unique, as far as I know, in such application.

The Church of S. Gregorio no longer serves as a church but as a laboratory for the cleaning and restoration of paintings.

GRIMANI, PALAZZO, on the Grand Canal, III–II–I.
There are several other palaces in Venice belonging to this family, but none of any architectural interest.

Ruskin opens the chapter entitled 'Roman Renaissance' with a description of the Palazzo Grimani.

Palazzo Grimani, now the Court of Appeal; considered by many to be Sanmicheli's masterpiece. To the right is the Palazzo Cavalli; to the immediate left the Palazzo Corner-Valmarana, and then the Palazzo Corner-Martinengo.

III–II–I. Of all the buildings in Venice, later in date than the final additions to the Ducal Palace, the noblest is, beyond all question, that which, having been condemned by its proprietor, not many years ago, to be pulled down and sold for the value of its materials, was rescued by the Austrian Government, and appropriated—the Government officers having no other use for it—to the business of the Post-Office [*no longer used as such—see below*]; though still known to the gondolier by its ancient name, the Casa Grimani. It is composed of three stories of the Corinthian order, at once simple, delicate, and sublime; but on so colossal a scale, that the three-storied palaces on its right and left only reach to the cornice which marks the level of its first floor. Yet it is not at first perceived to be so vast; and it is only when some expedient is employed to hide it from the eye, that by the sudden dwarfing of the whole reach of the Grand Canal, which it commands, we become aware that it is to the majesty of the Casa Grimani that the Rialto itself, and the whole group of neighbouring buildings, owe the greater part of their impressiveness. Nor is the finish of its details less notable than the grandeur of their scale. There is not an erring line, nor a mistaken proportion, throughout its noble front; and the exceeding fineness of the chiselling gives an

appearance of lightness to the vast blocks of stone out of whose perfect union that front is composed. The decoration is sparing but delicate: the first story only simpler than the rest, in that it has pilasters instead of shafts, but all with Corinthian capitals, rich in leafage, and fluted delicately; the rest of the walls flat and smooth, and their mouldings sharp and shallow, so that the bold shafts look like crystals of beryl running through a rock of quartz.

II. This palace is the principal type at Venice, and one of the best in Europe, of the central architecture of the Renaissance schools.

The palace was designed by Michele Sanmicheli and it is considered by many to be his masterpiece. It is now used as the Court of Appeal. There are two other Palazzi Grimani on the Grand Canal: one the Palazzo Grimani della Vida, a sixteenth-century Renaissance building, possibly also designed by Sanmicheli; the other a late-Renaissance palazzo at S. Tomà. Yet another Palazzo Grimani is to be found near the Campo S. Maria Formosa, a Renaissance design (1539) probably by Sebastiano Serlio.

GRITTI, PALAZZO *(or Pisani-Gritti), a fifteenth-century Gothic palace on the Grand Canal by the Campo S. Maria del Giglio, which was occupied by Ruskin and his wife in 1851–52. It was here that Ruskin returned to continue his work on the second and third volumes of* The Stones of Venice. *The palace had been acquired by Baroness Wetzlar, from whom the Ruskins rented most of the first floor. It was then known as the Palazzo Wetzlar; it is now a hotel.*

J

JESUITI, CHURCH OF THE. The basest Renaissance; but worth a visit in order to examine the imitations of curtains in white marble inlaid with green.

It contains a Tintoretto, 'The Assumption', which I have not examined; and a Titian, 'The Martyrdom of St Lawrence', originally, it seems to me, of little value, and now, having been restored, of none.

This church, generally known as the Church of the Gesuiti, and not to be confused with the Church of the Gesuati (qv), was built for the Jesuits between 1714–1729.

L

LABIA, PALAZZO, on the Canna Reggio. Of no importance.
The Palazzo Labia is a late Renaissance building designed by Andrea
Cominelli in the second quarter of the eighteenth century. It has frescoes
by Tiepolo in the principal hall of the first floor.

LIBRERIA VECCHIA. A graceful building of the central Renais-
sance, designed by Sansovino, 1536, and much admired by all architects
of the school. It was continued by Scamozzi, down the whole side of St
Mark's Place, adding another story above it, which modern critics blame
as destroying the 'eurithmia'; never considering that had the two low
stories of the Library been continued along the entire length of the Piazza,
they would have looked so low that the entire dignity of the square would
have been lost. As it is, the Library is left in its originally good propor-
tions and the larger mass of the Procuratie Nuove forms a more majestic,
though less graceful, side for the great square.

But the real faults of the building are not in the number of stories,
but in the design of the parts. It is one of the grossest examples of the
base Renaissance habit of turning *keystones* into *brackets* [*Ruskin's
italics*], throwing them out in bold projection (not less than a foot and
a half) beyond the mouldings of the arch; a practice utterly barbarous,
inasmuch as it evidently tends to dislocate the entire arch, if any real
weight were laid on the extremity of the keystone; and it is also a very
characteristic example of the vulgar and painful mode of filling spandrils
by naked figures in *alto-relievo*, leaning against the arch on each side,
and appearing as if they were continually in danger of slipping off. Many
of these figures have, however, some merit in themselves; and the whole
building is graceful and effective of its kind. The continuation of the
Procuratie Nuove, at the western extremity of St Mark's Place (together
with various apartments in the great line of the Procuratie Nuove), forms
the 'Royal Palace', the residence of the Emperor when at Venice. This
building is entirely modern, built in 1810, in imitation of the Procuratie
Nuove, and on the site of Sansovino's Church of S. Geminiano.

In this range of buildings, including the Royal Palace, the Procuratie
Nuove, the old Library, and the 'Zecca' [*'mint'*] which is connected
with them (the latter being an ugly building of very modern date, not
worth notice architecturally), there are many most valuable pictures,
among which I would especially direct attention, first to those in the
Zecca, namely, a beautiful and strange Madonna, by Benedetto Diana;
two noble Bonifazios; and two groups, by Tintoretto, of the Provveditori

della Zecca, by no means to be missed, whatever may be sacrificed to see them, on account of the quietness and veracity of their unaffected portraiture, and the absolute freedom from all vanity either in the painter or in his subjects.

Next, in the 'Antisala' of the old Library, observe the 'Sapienza' of Titian, in the centre of the ceiling; a most interesting work in the light brilliancy of its colour, and the resemblance to Paul Veronese. Then, in the great hall of the old Library, examine the two large Tintorettos, 'St Mark saving a Saracen from drowning', and the 'Stealing his Body from Constantinople', both rude, but great (note in the latter the dashing of the rain on the pavement, and running of the water about the feet of the figures): then, in the narrow spaces between the windows, there are some magnificent single figures by Tintoretto, among the finest things of the kind in Italy, or in Europe. Finally, in the gallery of pictures in the Palazzo Reale, among other good works of various kinds, are two of the most interesting Bonifazios in Venice, the 'Children of Israel in their Journeyings', in one of which, if I recollect right, the quails are coming in flights across a sunset sky, forming one of the earliest instances I know of a thoroughly natural and Turneresque effect being felt and rendered by the old masters. The picture struck me chiefly from this circumstance; but the notebook in which I had described it and its companion having been lost on my way home, I cannot now give a more special account of them, except that they are long, full of crowded figures, and peculiarly light in colour and handling as compared with Bonifazio's work in general.

See also under PROCURATIE NUOVE.

The library houses the Biblioteca Marciana, Venice's chief public library; and the Archaeological Museum of classical works, together with a small collection of Assyrian reliefs.

The Museo Correr occupies most of the Procuratie Nuove (see also under CORRER, RACCOLTA) *and includes not only paintings and objects of historic interest from the city (such as official robes) but also the Museum of the Risorgimento.*

LIO, CHURCH OF S. Of no importance, but said to contain a spoiled Titian.

The Church was originally built in the fifteenth century, but has been considerably restored, finally in 1783 in the Renaissance style. The Titian to which Ruskin refers is of the Apostle James, but is badly preserved. There is another picture, 'The Coronation of the Virgin and Saints', which may have been by Titian, but again this is badly preserved.

L I O, S A L I Z Z A D A D I S., windows in, II–VII–XXVIII, XXXIV. *'Salizzada' means 'paved street'. Ruskin selects this particular street as offering examples of the second and fourth order of Gothic windows which he illustrates and discusses in the sections mentioned above. See also under* ORDERS OF VENETIAN ARCHES.

L O G G E T T A. *(Not included by Ruskin in the Index.) The Loggetta, designed by Jacopo Sansovino and built in 1537–1540 at the base of the Campanile of S. Marco, was largely destroyed when the companile collapsed in 1902. It was, however successfully rebuilt shortly after, as it was before, with the assistance of many of the recovered fragments. It is an ornate, beautifully proportioned, Renaissance two-storied structure. In the intervals of the three main arches on the lower story bronze statues of Minerva, Apollo, Mercury and Peace occupy niches, and in the upper story are marble relief panels. A considerable variety of marbles, mainly from Istria and Verona, have been used in the building, which has recently been restored by members of the staff of the Victoria and Albert Museum and Italian craftsmen. The work was largely financed by the British Venice in Peril Fund.*

L O R E D A N, P A L A Z Z O, on the Grand Canal near the Rialto, II–V–VII, II–Appendix 11. Another palace of this name, on the Campo S. Stefano, is of no importance.

The first reference refers to the chapter on Byzantine palaces, in which Ruskin cites the Palazzo Loredan, together with its neighbour, the Palazzo Farsetti, as an example of fine Byzantine proportions (see above, under BYZANTINE PALACES).

II–Appendix 11. The one next to it, though not conspicuous, and often passed with neglect, will, I believe, be felt at last, by all who examine it carefully, to be the most beautiful palace in the whole extent of the Grand Canal. It has been restored often, once in the Gothic, once in the Renaissance times—some writers say, even rebuilt; but, if so, rebuilt in its old form. The Gothic additions harmonize exquisitely with its Byzantine work, and it is easy, as we examine its lovely central arcade, to forget the Renaissance additions which encumber it above. It is known as the Casa Loredan.

The Palazzo Loredan, together with Palazzo Forsetti, are now municipal offices.

L O R E N Z O, C H U R C H O F S. Of no importance.
This is a sixth-century foundation of Benedictine nuns. The church as it

now stands was completed in the late sixteenth century, but was subse-quently turned into a poor house and is the property of the city council. It was damaged in the First World War and is in the process of restoration.

LUCA, CHURCH OF S. Its campanile is of very interesting and quaint early Gothic, and it is said to contain a Paul Veronese, 'St Luke and the Virgin'. In the little Campiello S. Luca, close by, is a very pre-cious Gothic door, rich in brickwork of the thirteenth century; and in the foundations of the houses on the same side of the square, but at the other end of it are traceable some shafts and arches closely resembling the work of the Cathedral of Murano, and evidently having once belonged to some most interesting building.

LUCIA, CHURCH OF S. Of no importance.
This was a Palladian church which was, however, demolished to make way for the railway station which takes its name from the church. A bronze statue of S. Lucia is placed in a small garden near the station to com-memorate the church.

M

MADDALENA, CHURCH OF S. MARIA. Of no importance.
This is a late eighteenth-century church, built by Tommaso Temanza. It was closed and may not be reopened.

MALIPIERO, PALAZZO, on the Campo S. Maria Formosa facing the canal at its extremity. A very beautiful example of the Byzantine Renaissance. Note the management of colour in its inlaid balconies.

This palace was built in the early sixteenth century and designed by Sante Lombardo.

MANFRINI, PALAZZO. The architecture is of no interest, and as it is in contemplation to allow the collection of pictures to be sold. I shall take no note of them. But, even if they should remain, there are few of the churches in Venice where the traveller had not better spend his time than in this gallery; as, with the exception of Titian's 'Entombment', one or two Giorgiones, and the little John Bellini (St Jerome), the pictures are all of a kind which may be seen elsewhere.

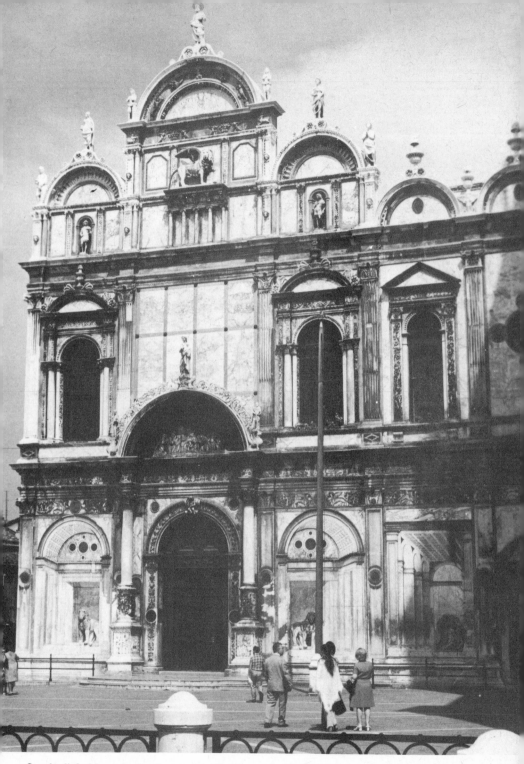

Scuola di S. Marco in the Campo dei SS. Giovanni e Paolo. This late fifteenth-century façade was designed by Pietro Lombardo and Giovanni Buora and completed by Mauro Coducci. It is now the civic hospital.

This palace is the Palazzo Venier-Priuli-Manfrini, to give it its full title, situated on the Cannaregio. The item itself is really only of historical interest, since the collection of paintings mentioned by Ruskin was indeed broken up shortly afterwards.

The 1847 edition of Murray's Hand-book for the Traveller in Northern Italy *(the established guide before Baedeker) speaks of the paintings as 'the best collection of paintings in Venice, after that of the Academy' and describes a number of works by G. Bellini, Giorgione, Titian ('The Queen of Cyprus' and a 'Portrait of Ariosto'), Veronese and others. However, by the time the 1877 edition was published Murray had to report that all the best works had been sold in 1856.*

MANGILLI-VALMARANA, PALAZZO, on the Grand Canal. Of no importance.

The Palazzo Mangilli-Valmarana has a Renaissance façade erected in 1760 to the design of Andrea Visentini.

MANIN, PALAZZO, on the Grand Canal. Of no importance.
This Renaissance building is the work of Jacopo Sansovino. This was formerly the home of the last doge of Venice, Ludovico Manin (1788–1797). It is now the Banca d'Italia.

MANZONI, PALAZZO, on the Grand Canal, near the Church of the Carità. A perfect and very rich example of Byzantine Renaissance: its warm yellow marbles are magnificent.

MARCILIAN, CHURCH OF ST. (*Also known as Marziale.*) Said to contain a Titian, 'Tobit and the Angel': otherwise of no importance.

The Titian in this church is above an altar in the first chapel on the left. The church also contains a Tintoretto of St Marcilian with Sts Peter and Paul.

MARIA, CHURCHES OF S. See FORMOSA, MATER DOMINI, MIRACOLI, ORTO, SALUTE, and ZOBENIGO.

MARCO, SCUOLA DI S., III–I–XXIII.
Ruskin cites the Scuola di S. Marco, together with such buildings as the Palazzo Contarini delle Figure (qv), as one of the 'two most refined buildings' in Venice which combine Byzantine and Renaissance characteristics (III–I–XXIII). For a general note on the Venetian 'scuole', see under SCUOLA DI S. ROCCO.

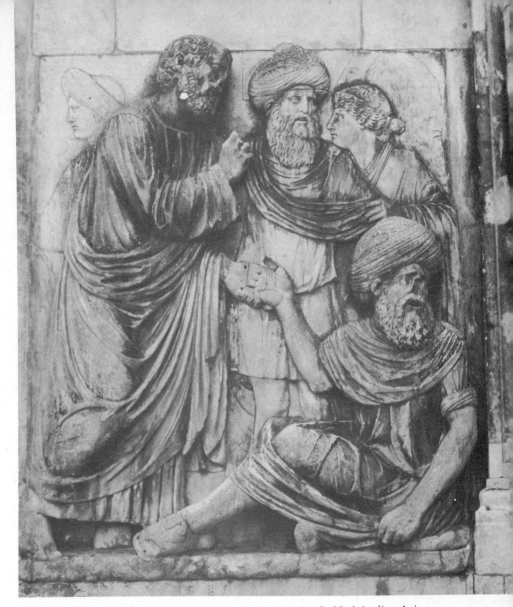

One of the 'trompe l'oeil' reliefs by Tullio Lombardo, showing St Mark healing Anianus on the façade of the Scuola di S. Marco

MARK, CHURCH OF ST.

Ruskin treats the Doges' church in detail in the chapter 'St Mark's' in Volume II. Below are references to passages on specific aspects of the church, both in this chapter and elsewhere in The Stones of Venice.

History, II–IV–III et seq; approach to, II–IV–XII et seq; dimensions of façade, II–V–XII; balustrades, II–VII–XVII, XXI; cornices,

I–XXVII–XIV; horseshoe arches, II–VII–XXV; entrances, II–VII–L, LI, III–Appendix, 10–11, shafts II–Appendix 9; base in baptistery I–XXV–XVIII, mosaics in atrium, II–IV–LXV et seq; III–IV–X; 'lily' capitals II–V–XXIII et seq; illustrations, Vol II–Plates VI, VII, VIII, IX, XI and Vol III–Plate III. These sections are given in a somewhat different sequence below in order to gather all the relevant material for, say, mosaics under one head.

Before considering details of the church, a description of the approach to St Mark's is given and then of the interior itself, in one of the most famous prose passages in the English language, and one that has appeared in numerous anthologies.

II–IV–X. And now I wish that the reader, before I bring him into St Mark's Place, would imagine himself for a little time in a quiet English cathedral town, and walk with me to the west front of its cathedral. Let us go together up the more retired street, at the end of which we can see the pinnacles of one of the towers, and then through the low grey gateway, with its battlemented top and small latticed window in the centre, into the inner private-looking road or close, where nothing goes in but the carts of the tradesmen who supply the bishop and the chapter, and where there are little shaven grass-plots, fenced in by neat rails, before old-fashioned groups of somewhat diminutive and excessively trim houses, with little oriel and bay windows jutting out here and there, and deep wooden cornices and eaves painted cream colour and white, and small porches to their doors in the shape of cockle-shells, or little, crooked, thick, indescribable wooden gables warped a little on one side; and so forward till we come to larger houses, also old-fashioned, but of red brick, and with gardens behind them, and fruit walls, which show here and there, among the nectarines, the vestiges of an old cloister arch or shaft, and looking in front on the cathedral square itself, laid out in rigid divisions of smooth grass and gravel walk, yet not uncheerful, especially on the sunny side, where the canons' children are walking with their nurserymaids. And so, taking care not to tread on the grass, we will go along the straight walk to the west front, and there stand for a time, looking up at its deep-pointed porches and the dark places between their pillars where there were statues once, and where the fragments, here and there, of a stately figure are still left, which has in it the likeness of a king, perhaps indeed a king on earth, perhaps a saintly king long ago in heaven, and so higher and higher up to the great mouldering wall of rugged sculpture and confused arcades, shattered, and grey, and grisly with heads of dragons and mocking fiends, worn by the rain and swirling winds into yet unseemlier shape, and coloured on their stony scales by

the deep russet-orange lichen, melancholy gold; and so, higher still, to the bleak towers, so far above that the eye loses itself among the bosses of their traceries, though they are rude and strong, and only sees like a drift of eddying black points, now closing, now scattering, and now settling suddenly into invisible places among the bosses and flowers, the crowd of restless birds that fill the whole square with that strange clangour of theirs, so harsh and yet so soothing, like the cries of birds on a solitary coast between the cliffs and sea.

XI. Think for a little while of that scene, and the meaning of all its small formalisms, mixed with its serene sublimity. Estimate its secluded, continuous, drowsy felicities, and its evidence of the sense and steady performance of such kind of duties as can be regulated by the cathedral clock; and weigh the influence of those ark towers on all who have passed through the lonely square at their feet for centuries, and on all who have seen them rising far away over the wooded plain, or catching on their square masses the last rays of the sunset, when the city at their feet was indicated only by the mist at the bend of the river. And then let us quickly recollect that we are in Venice, and land at the extremity of the Calle Lunga S. Moisè, which may be considered as there answering to the secluded street that led us to our English cathedral gateway.

XII. We find ourselves in a paved alley, some seven feet wide where it is widest, full of people, and resonant with cries of itinerant salesmen—a shriek in their beginning, and dying away into a kind of brazen ringing, all the worse for its confinement between the high houses of the passage along which we have to make our way. Overhead an inextricable confusion of rugged shutters, and iron balconies and chimney flues pushed out on brackets to save room, and arched windows with projecting sills of Istrian stone, and gleams of green leaves here and there where a fig-tree branch escapes over a lower wall from some inner cortile, leading the eye up to the narrow stream of blue sky high over all. On each side, a row of shops, as densely set as may be, occupying, in fact, intervals between the square stone shafts, about eight feet high, which carry the first floors: intervals of which one is narrow and serves as a door; the other is, in the more respectable shops, wainscotted to the height of the counter and glazed above, but in those of the poorer tradesmen left open to the ground, and the wares laid on benches and tables in the open air, the light in all cases entering at the front only, and fading away in a few feet from the threshold into a gloom which the eye from without cannot penetrate, but which is generally broken by a ray or two from a feeble lamp at the back of the shop, suspended before a print of the Virgin.

The less pious shopkeeper sometimes leaves his lamp unlighted, and is contented with a penny print; the more religious one has his print coloured and set in a little shrine with a gilded or figured fringe, with perhaps a faded flower or two on each side, and his lamp burning brilliantly. Here at the fruiterer's, where the dark-green water melons are heaped upon the counter like cannon balls, the Madonna has a tabernacle of fresh laurel leaves; but the pewterer next door has let his lamp out, and there is nothing to be seen in his shop but the dull gleam of the studded patterns on the copper pans, hanging from his roof in the darkness. Next comes a 'Vendita Frittole e Liquori', where the Virgin, enthroned in a very humble manner beside a tallow candle on a back shelf, presides over certain ambrosial morsels of a nature too ambiguous to be defined or enumerated. But a few steps farther on, at the regular wine-shop of the calle, where we are offered 'Vino Nostrani a Soldi 28·32', the Madonna is in great glory, enthroned above ten or a dozen large red casks of three-year-old vintage, and flanked by goodly ranks of bottles of Maraschino, and two crimson lamps; and for the evening, when the gondoliers will come to drink out, under her auspices, the money they have gained during the day, she will have a whole chandelier.

XIII. A yard or two father, we pass the hostelry of the Black Eagle, and glancing as we pass through the square door of marble, deeply moulded, in the outer wall, we see the shadows of its pergola of vines resting on an ancient well, with a pointed shield carved on its side; and so presently emerge on the bridge and Campo S. Moisè, whence to the entrance into St Mark's Place, called the Bocca di Piazza (mouth of the square), the Venetian character is nearly destroyed, first by the frightful façade of S. Moisè, which we will pause at another time to examine, and then by the modernizing of the shops as they near the piazza, and the mingling with the lower Venetian populace of lounging groups of English and Austrians. We will push fast through them into the shadow of the pillars at the end of the 'Bocca di Piazza', and then we forget them all; for between those pillars there opens a great light, and, in the midst of it, as we advance slowly, the vast tower of St Mark seems to lift itself visibly forth from the level field of chequered stones; and, on each side, the countless arches prolong themselves into ranged symmetry, as if the rugged and irregular houses that pressed together above us in the dark alley had been struck back into sudden obedience and lovely order, and all their rude casements and broken walls had been transformed into arches charged with goodly sculpture, and fluted shafts of delicate stone.

XIV. And well may they fall back, for beyond those troops of ordered arches there rises a vision out of the earth, and all the great square seems to have opened from it in a kind of awe, that we may see it far away;

a multitude of pillars and white domes, clustered into a long low pyramid of coloured light; a treasureheap, it seems, partly of gold, and partly of opal and mother-of-pearl, hollowed beneath into five great vaulted porches, ceiled with fair mosaic, and beset with sculpture of alabaster, clear as amber and delicate as ivory—sculpture fantastic and involved, of palm leaves and lilies, and grapes and pomegranates, and birds clinging and fluttering among the branches, all twined together into an endless network of buds and plumes; and, in the midst of it, the solemn forms of angels, sceptred, and robed to the feet, and leaning to each other across the gates, their figures indistinct among the gleaming of the golden ground through the leaves beside them, interrupted and dim, like the morning light as it faded back among the branches of Eden, when first its gates were angel-guarded long ago. And round the walls of the porches there are set pillars of variegated stones, jasper and porphyry, and deep-green serpentine spotted with flakes of snow, and marbles, that half refuse and half yield to the sunshine, Cleopatra-like, 'their bluest veins to kiss'—the shadow, as it steals back from them, revealing line after line of azure undulation, as a receding tide leaves the waved sand; their capitals rich with interwoven tracery, rooted knots of herbage, and drifting leaves of acanthus and vine, and mystical signs, all beginning and ending in the Cross; and above them, in the broad archivolts, a continuous chain of language and of life—angels, and the signs of heaven, and the labours of men, each in its appointed season upon the earth; and above these, another range of glittering pinnacles, mixed with white arches edged with scarlet flowers, a confusion of delight, amidst which the breasts of the Greek horses are seen blazing in their breadth of golden strength, and the St Mark's lion, lifted on a blue field covered with stars, until at last, as if in ecstasy, the crests of the arches break into a marble foam, and toss themselves far into the blue sky in flashes and wreaths of sculptured spray, as if the breakers on the Lido shore had been frost-bound before they fell, and the sea-nymphs had inlaid them with coral and amethyst.

Between that grim cathedral of England and this, what an interval! There is a type of it in the very birds that haunt them; for, instead of the restless crowd, hoarse-voiced and sable-winged, drifting on the bleak upper air, the St Mark's porches are full of doves, that nestle among the marble foliage, and mingle and soft iridescence of their living plumes, changing at every motion, with the tints, hardly less lovely, that have stood unchanged for seven hundred years.

xv. And what effect has this splendour on those who pass beneath it? You may walk from sunrise to sunset, to and fro, before the gateway of St Mark's, and you will not see an eye lifted to it, nor a countenance

brightened by it. Priest and layman, soldier and civilian, rich and poor, pass by it alike regardlessly. Up to the very recesses of the porches, the meanest tradesmen of the city push their counters; nay, the foundations of its pillars are themselves the seats—not 'of them that sell doves' for sacrifice, but of the vendors of toys and caricatures. Round the whole square in front of the church there is almost a continuous line of cafés, where the idle Venetians of the middle classes lounge, and read empty journals; in its centre the Austrian bands play during the time of vespers, their martial music jarring with the organ notes, the march drowning the miserere, and the sullen crowd thickening round them, a crowd, which, if it had its will, would stiletto every soldier that pipes to it. And in the recesses of the porches, all day long, knots of men of the lowest classes, unemployed and listless, lie basking in the sun like lizards; and unregarded children, every heavy glance of their young eyes full of desperation and stony depravity, and their throats hoarse with cursing, gamble, and fight, and snarl, and sleep, hour after hour, clashing their bruised centesimi upon the marble ledges of the church porch. And the images of Christ and His angels look down upon it continually.

That we may not enter the church out of the midst of the horror of this, let us turn aside under the portico which looks towards the sea, and passing round within the two massive pillars brought from St Jean d'Acre, we shall find the gate of the Baptistery; let us enter there. The heavy door closes behind us instantly, and the light and the turbulence of the Piazzetta are together shut out by it.

XVI. We are in a low vaulted room; vaulted, not with arches, but with small cupolas starred with gold, and chequered with gloomy figures: in the centre is a bronze font charged with rich bas-reliefs, a small figure of the Baptist standing above it in a single ray of light that glances across the narrow room, dying as it falls from a window high in the wall, and the first thing that it strikes, and the only thing that it strikes brightly, is a tomb. . . .

It is [*of*] the Doge Andrea Dandolo, a man early great among the great of Venice; and early lost. She chose him for her king in his 36th year; he died ten years later, leaving behind him that history to which we owe half of what we know of her former fortunes. . . .

Through the heavy door whose bronze network closes the place of his rest, let us enter the church itself. It is lost in still deeper twilight, to which the eye must be accustomed for some moments before the form of the building can be traced; and then there opens before us a vast cave, hewn out into the form of a Cross, and divided into shadowy aisles by many pillars. Round the domes of its roof the light enters only through narrow apertures like large stars; and here and there a ray or two from

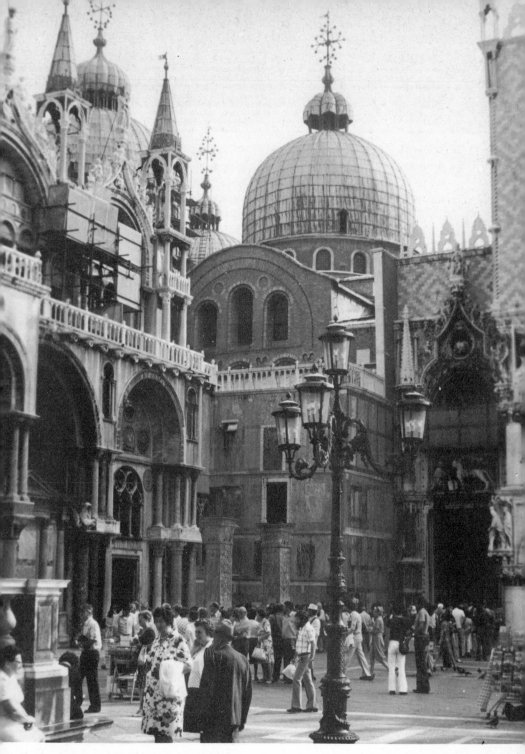

South-west view of St Mark's Basilica and of the entrance
to the Ducal Palace, the Porta della Carta.

some far-away casement wanders into the darkness, and casts a narrow phosphoric stream upon the waves of marble that heave and fall in a thousand colours along the floor. What else there is of light is from torches, or silver lamps, burning ceaselessly in the recesses of the chapels; the roof sheeted with gold, and the polished walls covered with alabaster, give back at every curve and angle some feeble gleaming to the flames; and the glories round the heads of the sculptured saints flash out upon us as we pass them, and sink again into the gloom. Under foot and over head, a continual succession of crowded imagery, one picture passing into another, as in a dream; forms beautiful and terrible mixed together; dragons and serpents, and ravening beasts of prey, and graceful birds that in the midst of them drink from running fountains and feed from vases of crystal; the passions and the pleasures of human life symbolized together, and the mystery of its redemption; for the mazes of interwoven lines and changeful pictures lead always at last to the Cross, lifted and carved in every place and upon every stone; sometimes with the serpent of eternity wrapt round it, sometimes with doves beneath its arms, and sweet herbage growing forth from its feet; but conspicuous most of all on the great rood that crosses the church before the altar, raised in bright blazonry against the shadow of the apse. And although in the recesses of the aisles and chapels, when the mist of the incense hangs heavily, we may see continually a figure traced in faint lines upon their marble, a woman standing with her eyes raised to heaven, and the inscription above her, 'Mother of God', she is not here the presiding deity. It is the Cross that is first seen, and always burning in the centre of the temple; and every dome and hollow of its roof has the figure of Christ in the utmost height of it, raised in power, or returning in judgment.

XIX. Nor is this interior without effect on the minds of the people. At every hour of the day there are groups collected before the various shrines, and solitary worshippers scattered through the darker places of the church, evidently in prayer both deep and reverent, and, for the most part, profoundly sorrowful. The devotees at the greater number of the renowned shrines of Romanism may be seen murmuring their appointed prayers with wandering eyes and unengaged gestures; but the step of the stranger does not disturb those who kneel on the pavement of St Mark's; and hardly a moment passes, from early morning to sunset, in which we may not see some half-veiled figure enter beneath the Arabian porch, cast itself into long abasement on the floor of the temple, and then rising slowly with more confirmed step, and with a passionate kiss and clasp of the arms given to the feet of the crucifix, by which the lamps burn always in the northern aisle, leave the church, as if comforted.

Historical background

II–IV–IV. . . . in the year 813, when the seat of government was finally removed to the Rialto, a Ducal Palace, built on the spot where the present one stands, with a Ducal Chapel beside it gave a very different character to the Square of St Mark; and fifteen years later, the acquisition of the body of the Saint, and its deposition in the Ducal Chapel, perhaps not yet completed, occasioned the investiture of that Chapel with all possible splendour. St Theodore was deposed from his patronship, and his church destroyed, to make room for the aggrandizement of the one attached to the Ducal Palace, and thenceforward known as 'St Mark's'.

v. This first church was however destroyed by fire, when the Ducal Palace was burned in the revolt against Candiano, in 976. It was partly rebuilt by his successor, Pietro Orseolo, on a larger scale; and, with the assistance of Byzantine architects, the fabric was carried on under successive Doges for nearly a hundred years; the main building being completed in 1071, but its incrustation with marble not till considerably later. It was consecrated on the 8th of October 1085 according to Sansovino and the author of the 'Chiesa Ducale di S. Marco', in 1094 according to Lazari, but certainly between 1084 and 1096, those years being the limits of the reign of Vital Falier; I incline to the supposition that it was soon after his accession to the throne in 1085, though Sansovino writes, by mistake, Ordelafo instead of Vital Falier. But, at all events, before the close of the eleventh century the great consecration of the church took place. It was again injured by fire in 1106, but repaired, and from that time to the fall of Venice there was probably no Doge who did not in some slight degree embellish or alter the fabric, so that few parts of it can be pronounced boldly to be of any given date. Two periods of interference are, however, notable above the rest: the first, that in which the Gothic school had superseded the Byzantine towards the close of the fourteenth century, when the pinnacles, upper archivolts, and window traceries were added to the exterior, and the great screen, with various chapels and tabernacle-work, to the interior; the second, when the Renaissance school superseded the Gothic, and the pupils of Titian and Tintoretto substituted, over one half of the church, their own compositions for the Greek mosaics with which it was originally decorated; happily, though with no goodwill, having left enough to enable us to imagine and lament what they destroyed. Of this irreparable loss we shall have more to say hereafter; meantime, I wish only to fix in the reader's mind the succession of periods of alterations as firmly and simply as possible.

vi. We have seen that the main body of the church may be broadly stated to be of the eleventh century, the Gothic additions of the fourteenth, and the restored mosaics of the seventeenth. There is no difficulty

in distinguishing at a glance the Gothic portions from the Byzantine; but there is considerable difficulty in ascertaining how long, during the course of the twelfth and thirteenth centuries, additions were made to the Byzantine church, which cannot be easily distinguished from the work of the eleventh century, being purposely executed in the same manner. . . .

IX. This, however, I only wish him to recollect in order that I may speak generally of the Byzantine architecture of St Mark's without leading him to suppose the whole church to have been built and decorated by Greek artists. Its later portions, with the single exception of the seventeenth-century mosaics, have been so dexterously accommodated to the original fabric that the general effect is still that of a Byzantine building; and I shall not, except when it is absolutely necessary, direct attention to the discordant points, or weary the reader with anatomical criticism. Whatever in St Mark's arrests the eye, or affects the feelings, is either Byzantine, or has been modified by Byzantine influence; and our inquiry into its architectural merits need not therefore be disturbed by the anxieties of antiquarianism, or arrested by the obscurities of chronology.

St Mark's as Byzantine architecture

Whilst his travels have not enabled Ruskin to examine Byzantine architecture in the same detail as the Gothic and Renaissance styles, nevertheless he argues that St Mark's can be seen as exemplifying most of the leading features and motifs of the Byzantine style. This is particularly evident in its most salient characteristic—incrustation.

II–IV–XXIV. Now the first broad characteristic of the building, and the root nearly of every other important peculiarity in it, is its confessed incrustation. It is the purest example in Italy of the great school of architecture in which the ruling principle is the incrustation of brick with more precious materials; and it is necessary, before we proceed to criticize any one of its arrangements, that the reader should carefully consider the principles which are likely to have influenced, or might legitimately influence, the architects of such a school, as distinguished from those whose designs are to be executed in massive materials.

It is true, that among different nations, and at different times, we may find examples of every sort and degree of incrustation, from the mere setting of the larger and more compact stones by preference at the outside of the wall, to the miserable construction of that modern brick cornice with its coating of cement, which, but the other day in London, killed its unhappy workmen in its fall. . . .

[*There are a variety of examples but basically*] two families of buildings: the one in which the substance is alike throughout, and the forms

and conditions of the ornament assume or prove that it is so, as in the best Greek buildings, and for the most part in our early Norman and Gothic; and the other, in which the substance is of two kinds, one internal, the other external, and the system of decoration is founded on this duplicity, as pre-eminently in St Mark's.

xxv. I have used the word duplicity in no depreciatory sense. In [*The Seven Lamps of Architecture*] I especially guarded this incrusted school from the imputation of insincerity, and I must do so now at greater length. It appears insincere at first to a Northern builder, because, accustomed to build with solid blocks of freestone, he is in the habit of supposing the external superficies of a piece of masonry to be some criterion of its thickness. But, as soon as he gets acquainted with the incrusted style, he will find that the Southern builders had no intention to deceive him. He will see that every slab of facial marble is fastened to the next by a confessed rivet and that the joints of the armour are . . . visibly and openly accommodated to the contours of the substance within . . .

Ruskin ascribes this incrusted style to three main causes. Firstly the situation of Venice meant that it had no easy access to quarries (relations with the mainland were precarious). As shipping stone was a costly business, the cargoes tended to be of the more valuable types of stone.

xxvi. . . . Out of this supply of marble, partly composed of pieces of so precious a quality that only a few tons of them could be on any terms obtained, and partly of shafts, capitals, and other portions of foreign buildings, the island architect has to fashion, as best he may, the anatomy of his edifice. It is at his choice either to lodge his few blocks of precious marble here and there among his masses of brick, and to cut out of the sculptured fragments such new forms as may be necessary for the observance of fixed proportions in the new building; or else to cut the coloured stones into thin pieces, of extent sufficient to face the whole surface of the walls, and to adopt a method of construction irregular enough to admit the insertion of fragmentary sculptures; rather with a view of displaying their intrinsic beauty, than of setting them to any regular service in the support of the building.

The Venetians also developed the practice of inserting older fragments into modern buildings. This Ruskin sees as the work of exiles 'accustomed to build with their ruins'.

xxvii. . . . The practice which began in the affections of a fugitive nation, was prolonged in the pride of a conquering one; and beside the memorials of departed happiness, were elevated the trophies of returning victory.

The ship of war brought home more marble in triumph, than the merchant vessel in speculation; and the front of St Mark's became rather a shrine at which to dedicate the splendour of miscellaneous spoil, than the organized expression of any fixed architectural law, or religious emotion.

Thirdly, Ruskin argues, St Mark's owes its incrusted style to the Venetians' sense of colour, unique in Western Europe.

XXVIII. . . . The perception of colour is a gift just as definitely granted to the one person, and denied to another, as an ear for music; and the very first requisite for true judgment of St Mark's, is the perfection of that colour-faculty which few people ever set themselves seriously to find out whether they possess or not. For it is on its value as a piece of perfect and unchangeable colouring, that the claims of this edifice to our respect are finally rested; and a deaf man might as well pretend to pronounce judgment on the merits of a full orchestra, as an architect trained in the composition of form only, to discern the beauty of St Mark's. It possesses the charm of colour in common with the greater part of the architecture, as well as of the manufactures, of the East; but the Venetians deserve especial note as the only European people who appear to have sympathized to the full with the great instinct of the Eastern races. They indeed were compelled to bring artists from Constantinople to design the mosaics of the vaults of St Mark's, and to group the colours of its porches; but they rapidly took up and developed, under more masculine conditions, the system of which the Greeks had shown them the example: while the burghers and barons of the North were building their dark streets and grisly castles of oak and sandstone, the merchants of Venice were covering their palaces with porphyry and gold; and at last, when her mighty painters had created for her a colour more priceless than gold or porphyry, even this, the richest of her treasures, she lavished upon walls whose foundations were beaten by the sea; and the strong tide, as it runs beneath the Rialto, is reddened to this day by the reflection of the frescoes of Giorgione.

XXIX. If, therefore, the reader does not care for colour, I must protest against his endeavour to form any judgment whatever of this church of St Mark's. But, if he both cares for and loves it, let him remember that the school of incrusted architecture is *the only one in which perfect and permanent chromatic decoration is possible* [*Ruskin's italics*]; and let him look upon every place of jasper and alabaster given to the architect as a cake of very hard colour, of which a certain portion is to be ground down or cut off, to paint the walls with.

The mosaics

Ruskin then considers whether this use of colour is truly suited to the purpose of St Mark's. Not only did colour play an important part but so, too, did pictorial decoration, for a Byzantine church 'requires expression and interesting decoration over vast plane surfaces' (II–IV–LVII). This was provided, above all in St Mark's, by mosaics. But Ruskin also saw the mosaics as playing a more important role. They transformed the church into:

II–IV–LXII. . . . a great Book of Common Prayer; the mosaics were its illuminations, and the common people of the time were taught their Scripture history by means of them . . .

LXIII. . . . they covered the walls and roofs of the churches with inevitable lustre· they could not be ignored or escaped from; their size rendered them majestic, their distance mysterious, their colour attractive. They did not pass into confused or inferior decorations; neither were they adorned with any evidence of skill or science, such as might withdraw their attention from their subjects. They were before the eyes of the devotee at every interval of his worship; vast shadowings forth of scenes to whose realization he looked forward, or of spirits whose presence he invoked.

Ruskin then examines the mosaics in detail and considers their significance for the early worshippers in St Mark's.

II–IV–LXV. A large atrium or portico is attached to two sides of the church, a space which was especially reserved for unbaptized persons and new converts. It was thought right that, before their baptism, these persons should be led to contemplate the great facts of the Old Testament history; the history of the Fall of Man, and of the lives of Patriarchs up to the period of the Covenant by Moses: the order of the subjects in this series being very nearly the same as in many Northern churches, but significantly closing with the Fall of the Manna, in order to mark to the catechumen the insufficiency of the Mosaic covenant for salvation—'Our fathers did eat manna in the wilderness, and are dead'—and to turn his thoughts to the true Bread of which that manna was the type.

LXVI. Then, when after his baptism he was permitted to enter the church, over its main entrance he saw, on looking back, a mosaic of Christ enthroned, with the Virgin on one side and St Mark on the other, in attitudes of adoration. Christ is represented as holding a book open upon his knee, on which is written:

'I AM THE DOOR; BY ME IF ANY MAN ENTER IN,
HE SHALL BE SAVED.'

On the red marble moulding which surrounds the mosaic is written:

'I AM THE GATE OF LIFE; LET THOSE WHO ARE
MINE ENTER BY ME.'

Above, on the red marble fillet which forms the cornice of the west end of the church, is written, with reference to the figure of Christ below:

'WHO HE WAS, AND FROM WHOM HE CAME, AND AT
WHAT PRICE HE REDEEMED THEE, AND WHY HE
MADE THEE, AND GAVE THEE ALL THINGS,
DO THOU CONSIDER.'

LXVII. . . . In the centre of the cupola is the Dove, enthroned in the Greek manner, as the Lamb is enthroned, when the Divinity of the Second and Third Persons is to be insisted upon, together with their peculiar offices. From the central symbol of the Holy Spirit twelve streams of fire descend upon the heads of the twelve apostles, who are represented standing around the dome; and below them, between the windows which are pierced in its walls, are represented, by groups of two figures for each separate people, the various nations who heard the apostles speak, at Pentecost, every man in his own tongue. Finally, on the vaults, at the four angles which support the cupola, are pictured four angels each bearing a tablet upon the end of a rod in his hand: on each of the tablets of the three first angels is inscribed the word 'Holy'; on that of the fourth is written 'Lord'; and the beginning of the hymn being thus put into the mouths of the four angels, the words of it are continued around the border of the dome, uniting praise to God for the gift of the Spirit, with welcome to the redeemed soul received into His Church:

'HOLY, HOLY, HOLY, LORD GOD OF SABAOTH:
HEAVEN AND EARTH ARE FULL OF THY GLORY.
HOSANNA IN THE HIGHEST:
BLESSED IS HE THAT COMETH IN THE NAME
OF THE LORD!'

LXVIII. . . . On the vault between the first and second cupolas are represented the crucifixion and resurrection of Christ, with the usual series of intermediate scenes—the treason of Judas, the judgment of Pilate, the crowning with thorns, the descent into Hades, the visit of the women to the Sepulchre, and the apparition to Mary Magdalene. The second cupola itself, which is the central and principal one of the church, is entirely occupied by the subject of the Ascension. At the highest point of it Christ is represented as rising into the blue heaven, borne up by

four angels, and throned upon a rainbow, the type of reconciliation. Beneath him, the twelve apostles are seen upon the Mount of Olives, with the Madonna, and, in the midst of them, the two men in white apparel who appeared at the moment of the Ascension, above whom, as uttered by them, are inscribed the words, 'Ye men of Galilee, why stand ye gazing up into heaven? This Christ, the Son of God, as He is taken from you, shall so come, the arbiter of the earth, trusted to do judgment and justice.'

LXIX. Beneath the circle of the apostles, between the windows of the cupola, are represented the Christian virtues, as sequent upon the crucifixion of the flesh, and the spiritual ascension together with Christ. Beneath them, on the vaults which support the angles of the cupola, are placed the four Evangelists, because on their evidence our assurance of the fact of the Ascension rests and, finally, beneath their feet, as symbols of the sweetness and fulness of the Gospel which they declared, are represented the four rivers of Paradise, Pison, Gihon, Tigris, and Euphrates.

LXX. The third cupola, that over the altar, represents the witness of the Old Testament to Christ; showing him enthroned in its centre, and surrounded by the patriarchs and prophets. But this dome was little seen by the people; their contemplation was intended to be chiefly drawn to that of the centre of the church.

Elsewhere Ruskin discussess the mosaic in the central cupola which depicts the Apostles on the Mount of Olives, with an olive tree seperating each from the other (III–IV–X). He stresses the stylised presentation of this scene, which he sees as a Byzantine characteristic, in strong contrast to the naturalism of Renaissance pictorialization (a similar stylization occurs in the Ravenna mosaics and in those in the cathedral at Torcello—qv).

Ruskin argues that the Byzantine mosaicist was more concerned with the innate nature of the olive, than with a naturalistic presentation of it, and he discusses the significance of the olive for Italy, comparing it with the elm and oak in England.

The west portal
In the chapter 'Byzantine Palaces' (Volume II), extracts of which are given under that head, Ruskin considers the 'singular and minute harmonies of proportion' which are expressed in the Byzantine use of arches in Venice. He cites the west portal of St Mark's as an example.

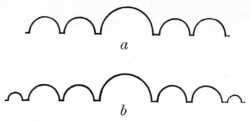

Ruskin's outline of the ground floor arches of the west façade of St Mark's at *b; a* shows a more typical arrangement (Volume II, Figure v).

II–V–XII. The doors actually employed for entrance in the western façade are as usual five, arranged as at *a* in [*Ruskin's illustration*] but the Byzantine builder could not be satisfied with so simple a group, and he therefore introduced two minor arches at the extremities, as at *b*, by adding two small porticos which are of *no use whatever* [*Ruskin's italics*] except to consummate the proportions of the façade, and themselves to exhibit the most exquisite proportions in arrangements of shaft and archivolt with which I am acquainted in the entire range of European architecture.

Elsewhere in the volume, in the chapter on Gothic palaces, Ruskin discusses the sculptural decoration of the main western archivolt.

II–VII–L. the great outer entrance of St Mark's, which appears to have been completed some time after the rest of the fabric, differs from all [*other entrances*] in presenting a series of subjects altogether Gothic in feeling, selection, and vitality of execution, and which show the occult entrance of the Gothic spirit before it had yet succeeded in effecting any modification of the Byzantine forms. These sculptures represent the months of the year employed in the avocations usually attributed to them throughout the whole compass of the Middle Ages, in northern architecture and manuscript calendars, and at last exquisitely versified by Spenser. For the sake of the traveller in Venice, who should examine this archivolt carefully, I shall enumerate these sculptures in their order, noting such parallel representations as I remember in other works.

Ruskin draws on traditional representations from northern manuscripts and sculptural programmes, as well as from Spenser's allegorical poetry. (A number of the Spenserian references and quotations have been excluded.) Ruskin considers the typically Gothic work of this sculpture to be the 'first expression of that spirit which is to be found in Venice'.

St Mark's Basilica: central arch of west front, detail of carving of second archivolt. Female figures with scrolls.

LI. There are four successive archivolts, one within the other, forming the great central entrance of St Mark's. The first is a magnificent external arch, forced of obscure figures mingled among masses of leafage, as in ordinary Byzantine work; within this there is a hemispherical dome, covered with modern mosaic; and at the back of this recess the other three archivolts follow consecutively, two sculptured, one plain; the one with which we are concerned is the outermost.

It is carved both on its front and under surface or soffit; on the front are seventeen female figures bearing scrolls, from which the legends are unfortunately effaced. These figures were once gilded on a dark blue ground, as may still be seen in Gentile Bellini's picture of St Mark's in the Accademia delle Belle Arti. The sculptures of the months are on the under-surface, beginning at the bottom on the left hand of the spectator as he enters, and following in succession round the archivolt; separated, however, into two groups, at its centre, by a beautiful figure of the youthful Christ, sitting in the midst of a slightly hollowed sphere covered with stars to represent the firmament, and with the attendant sun and moon, set one on each side, to rule over the day and over the night.

LII. The months are personified as follows:

I. JANUARY. *Carrying home a noble tree on his shoulders, the leafage of which nods forward, and falls nearly to his feet.* Superbly cut. This is a rare representation of him. More frequently he is represented as the two-headed Janus, sitting at a table, drinking at one mouth and eating at the other. Sometimes as an old man, warming his feet at a fire, and drinking from a bowl; though this type is generally reserved for February. . . .

His sign, Aquarius, is obscurely indicated in the archivolt by some wavy lines representing water, unless the figure has been broken away.

2. FEBRUARY. *Sitting in a carved chair, warming his bare feet at a blazing fire.* Generally, when he is thus represented, there is a pot hung over the fire, from the top of the chimney. Sometimes he is pruning trees . . .

Not unfrequently, in the calendars, this month is represented by a female figure carrying candles, in honour of the Purification of the Virgin.

His sign, Pisces, is prominently carved above him.

3. MARCH. Here, as almost always in Italy, *a warrior*: the Mars of the Latins being of course, in mediaeval work, made representative of the military power of the place and period; and thus, at Venice, having the winged Lion painted upon his shield. In Northern work, however, I think March is commonly employed in pruning trees; or, at least, he is so when that occupation is left free for him by February's being engaged with the ceremonies of Candlemas. Sometimes, also, he is reaping a low and scattered kind of grain . . .

His sign, the Ram, is very superbly carved above him in the archivolt.

4. APRIL. Here, *carrying a sheep upon his shoulder.* A rare representation of him. In Northern work he is almost universally gathering flowers, or holding them triumphantly in each hand. . . .

5. MAY *is seated, while two young maidens crown him with flowers.* A very unusual representation, even in Italy; where as in the North, he is almost always riding out hunting or hawking, sometimes playing on a

St Mark's Basilica: central arch of west front, second archivolt carving
of November and December.

musical instrument. In Spenser, this month is personified as 'the fayrest mayd on ground', borne on the shoulders of the Twins.

In this archivolt there are only two heads to represent the zodiacal sign.

The summer and autumnal months are always represented in a series of agricultural occupations, which, of course, vary with the locality in which they occur; but generally in their order only. Thus, if June is mowing, July is reaping; if July is mowing, August is reaping; and so on. . . .

6. JUNE. *Reaping.* The corn and sickle sculptured with singular care and precision, in bold relief, and the zodiacal sign, the Crab, above, also worked with great spirit. Spenser puts plough irons into his hand. Sometimes he is sheep shearing; and, in English and northern French manuscripts, carrying a kind of fagot or barrel, of the meaning of which I am not certain.

7. JULY. *Mowing.* A very interesting piece of sculpture, owing to the care with which the flowers are wrought out among the long grass. I do not remember ever finding July but either reaping or mowing. . . .

8. AUGUST. Peculiarly represented in this archivolt, *sitting in a chair, with his head upon his hand, as if asleep; the Virgin* (the zodiacal sign) *above him, lifting up her hand.* This appears to be a peculiarly Italian version of the proper employment of August. In Northern countries he is generally threshing, or gathering grapes. . . .

9. SEPTEMBER. *Bearing home grapes in a basket.* Almost always sowing, in Northern work. By Spenser, with his usual exquisite ingenuity, employed in gathering in the general harvest, and *portioning it out with the Scales,* his zodiacal sign.

10. OCTOBER. *Wearing a conical hat, and digging busily with a long spade.* In Northern work he is sometimes a vintager, sometimes beating the acorns out of an oak to feed swine. When September is vintaging, October is generally sowing. Spenser employs him in the harvest both of vine and olive.

11. NOVEMBER. *Seems to be catching small birds in a net.* I do not remember him so employed elsewhere. He is nearly always killing pigs; sometimes beating the oak for them; with Spenser, fatting them.

12. DECEMBER. *Killing swine.* It is hardly ever that this employment is not given to one or other of the terminal months of the year. If not so engaged, December is usually putting new loaves into the oven; sometimes killing oxen. Spenser properly makes him feasting and drinking instead of January.

Balustrades
In the chapter on Gothic palaces Ruskin discusses parapets and balconies.
He classifies three kinds (II–VII–XVI):

(1) of solid stone, decorated, if at all, by mere surface sculpture as in the uppermost example in [*Ruskin's drawing*]; or (2) pierced into some kind of tracery, as in the second; or (3) composed of small pillars carrying a level bar of stone, as in the third . . .

XVII. Of these three kinds, the first, which is employed for the pulpit at Torcello [*qv*] and in the nave of St Mark's, whence the uppermost example is taken, is beautiful when sculpture so rich can be employed upon it; but it is liable to objection, first, because it is heavy and unlike a parapet when seen from below; and, secondly, because it is inconvenient in use. The position of leaning over a balcony becomes cramped and painful if long continued, unless the foot can be sometimes advanced *beneath* the ledge on which the arm leans, *i.e.*, between the balusters or traceries, which of course cannot be done in the solid parapet: it is also more agreeable to be able to see partially down through the penetrations, than to be obliged to lean far over the edge. The solid parapet was rarely used in Venice after the earlier ages.

After considering other forms of parapet—the second type, traceried (XVIII), and the third type, the baluster (XIX)—Ruskin cites examples of the latter in the churches of Torcello, Murano, and St Mark's.

Ruskin's drawing of three balconies or parapets.
The topmost example is from the nave of St Mark's;
the second from the Palazzo Contarini Fasan;
the third example, of a baluster parapet, is not
ascribed to a particular building
(Volume II, Figure XXIV).

XXI. . . . At Murano, between the pillars of the apse, a beautiful balustrade is employed . . . and at St Mark's, a noble round-arched parapet, with small pillars of precisely the same form as those at Murano, but shorter, and bound at the angles into groups of four by the serpentine knot so often occurring in Lombardic work, runs round the whole exterior of the lower story of the church, and round a great part of its interior galleries, alternating with a more fantastic form.

Cornices

On two plates (Volume I Plates XV and XVI, not illustrated) Ruskin shows sections or profiles and decorations of Byzantine and Gothic cornices in Venice, which are clearly derived from ancient Greek and Roman models. Many of these examples are from St Mark's.

Ruskin traces the stages of evolution from the 'pure root of cornices', through the transition from Byzantine to Gothic, to the fully developed Venetian Gothic, founded on Byzantine tradition, and then to the Lombardic-Gothic cornice, founded on the Pisan Romanesque traditions. Ruskin considers this 'the perfect cornice of the highest order' (I–XXVII–XIV).

Horseshoe arches

Ruskin divides arches, like windows, into a series of orders. Further details of the orders, together with an illustration of them, are given under the separate heading ORDERS OF VENETIAN ARCHES. *St Mark's has a number of fine examples of the first order.*

II–VII–XXV. We shall now be able, without any difficulty, to follow the course of transition, beginning with the first order, 1 and 1 *a* [*see Ruskin's illustration on page 191*], in the second row. The horse-shoe arch, 1*b*, is the door-head commonly associated with it, and the other three in the same row occur in St Mark's exclusively; 1 *c* being used in the nave, in order to give a greater appearance of lightness to its great lateral arcades, which at first the spectator supposes to be round-arched, but he is struck by a peculiar grace and elasticity in the curves for which he is unable to account, until he ascends into the galleries whence the true form of the arch is discernible. The other two—1 *d*, from the door of the southern transept, and 1 *c*, from that of the treasury—sufficiently represent a group of fantastic forms derived from the Arabs, and of which the exquisite decoration is one of the most important features in St Mark's. Their form is indeed permitted merely to obtain more fantasy in the curves of this decoration. The reader can see in a moment, that, as pieces of masonry,

or bearing arches, they are infirm or useless, and therefore never could be employed in any building in which dignity of structure was the primal object. It is just because structure is *not* the primal object in St Mark's, because it has no severe weights to bear, and much loveliness of marble and sculpture to exhibit, that they are therein allowable. They are of course, like the rest of the building, built of brick and faced with marble, and their inner masonry, which must be very ingenious, is therefore not discernible. They have settled a little, as might have been expected, and the consequence is, that there is in every one of them, except the upright arch of the treasury, a small fissure across the marble of the flanks.

XXVI. Though, however, the Venetian builders adopted these Arabian forms of arch where grace of ornamentation was their only purpose, they saw that such arrangements were unfit for ordinary work; and there is no instance, I believe, in Venice, of their having used any of them for a dwelling-house in the truly Byzantine period. But so soon as the Gothic influence began to be felt, and the pointed arch forced itself upon them, their first concession to its attack was the adoption, in preference to the round arch, of the form 3 *a* [*on page 191*]; the point of the Gothic arch forcing itself up, as it were, through the top of the semicircle which it was soon to supersede.

Shafts

II–Appendix 9. The principal pillars which carry the nave and transepts, fourteen in number, are of white alabaster veined with grey and amber; each of a single block, 15 ft high, and 6 ft 2 in round at the base. I in vain endeavoured to ascertain their probable value. Every sculptor whom I questioned on this subject told me there were no such pieces of alabaster in the market, and that they were to be considered as without price.

On the façade of the church alone are two great ranges of shafts, seventy-two in the lower range, and seventy-nine in the upper; all of porphyry, alabaster, and verd-antique or fine marble; the lower about 9 ft, the upper about 7 ft high, and of various circumferences, from 4 ft 6 in to 2 ft round.

. . . first, we ought to note the relations of the shafts and wall, the latter being first sheeted with alabaster, and then the pillars set within two or three inches of it, forming such a grove of golden marble that the porches open before us as we enter the church like glades in a deep forest. The reader may perhaps at first question the propriety of placing the wall so close behind the shafts that the latter have nearly as little work to do as the statues in a Gothic porch; but the philosophy of this arrangement is briefly deducible from the principles stated in the text. The builder had

at his disposal shafts of a certain size only, not fit to sustain the whole weight of the fabric above. He therefore turns just as much of the wall veil into shaft as he has strength of marble at his disposal, and leaves the rest in its massive form. And that there may be no dishonesty in this, nor any appearance in the shafts of doing more work than is really allotted to them, many are left visibly with half their capitals projecting beyond the archivolts they sustain, showing that the wall is very slightly dependent on their co-operation, and that many of them are little more than mere bonds or connecting rods between the foundation and cornices. If any architect ventures to blame such an arrangement, let him look at our much vaunted early English piers in Salisbury Cathedral or Westminster Abbey, where the small satellitic shafts are introduced in the same gratuitous manner, but with far less excuse or reason: for these small shafts have nothing but their delicacy and purely theoretical connection with the archivolt mouldings to recommend them; but the St Mark's shafts have an intrinsic beauty and value of the highest order, and the object of the whole system of architecture, as above stated, is in great part to set forth the beauty and value of the shaft itself. Now, not only is this accomplished by withdrawing it occasionally from servile work, but the position here given to it, within three or four inches of a wall from which it nevertheless stands perfectly clear all the way up, is exactly that which must best display its colour and quality. When there is much vacant space left behind a pillar, the shade against which it is relieved is comparatively indefinite, the eye passes by the shaft, and penetrates into the vacancy. But when a broad surface of wall is brought near the shaft, its own shadow is, in almost every effect of sunshine, so sharp and dark as to throw out its colours with the highest possible brilliancy; if there be no sunshine, the wall veil is subdued and varied by the most subtle gradations of delicate half shadow, hardly less advantageous to the shaft which it relieves. . . .

It was assuredly not in the builder's power, even had he been so inclined, to obtain shafts high enough to sustain the whole external gallery, as it is sustained in the nave, on one arcade. He had, as above noticed, a supply of shafts of every sort and size, from which he chose the largest for his nave shafts; the smallest were set aside for windows, jambs, balustrades, supports of pulpits, niches, and such other services, every conceivable size occurring in different portions of the building; and the middle-sized shafts were sorted into two classes, of which on the average one was about two-thirds the length of the other, and out of these the two stories of the façade and sides of the church are composed, the smaller shafts of course uppermost, and more numerous than the lower, according to the ordinary laws of superimposition adopted by all the Romanesque builders, and observed also in a kind of architecture

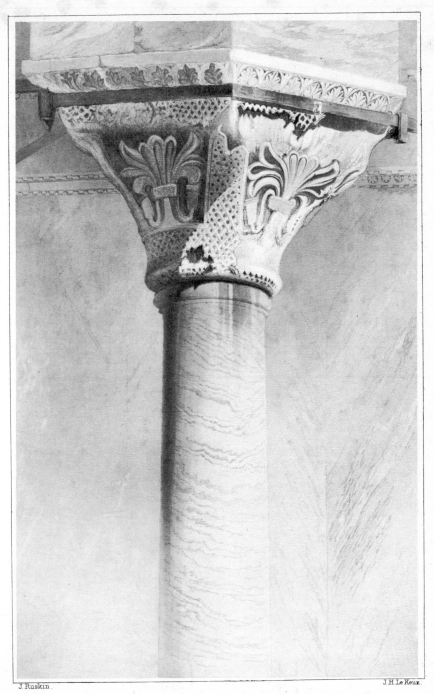

J. Ruskin.

J.H. Le Keux.

Ruskin' drawing of the lily capital in St Mark's Basilica (Volume II, Plate ix).

quite as beautiful as any we are likely to invent, that of forest trees. . . .

Not that the idea of the Byzantine superimposition was taken from trees, any more than that of Gothic arches. Both are simply compliances with laws of nature, and, therefore, approximations to the forms of nature.

There is, however, one very essential difference between tree structure and the shaft structure in question, namely, that the marble branches, having no vital connection with the stem, must be provided with a firm tablet or second foundation whereon to stand. This intermediate plinth or tablet runs along the whole façade at one level, is about eighteen inches thick, and left with little decoration, as being meant for hard service. The small porticos, already spoken of as the most graceful pieces of composition with which I am acquainted, are sustained on detached clusters of four or five columns, forming the continuation of those of the upper series, and each of these clusters is balanced on one grand detached shaft; as much trust being thus placed in the pillars here, as is withdrawn from them elsewhere. The northern portico has only one detached pillar at its outer angle, which sustains three shafts and a square pilaster; of these shafts the one at the outer angle of the group is the thickest (so as to balance the pilaster on the inner angle), measuring 3 ft 2 in round, while the others measure only 2 ft 10 in and 2 ft 11 in; and in order to make this increase of diameter and the importance of the shaft, more manifest to the eye, the old builders made the shaft *shorter* as well as thicker, increasing the depth both of its capital and the base, with what is to the thoughtless spectator ridiculous incongruity, and to the observant one a most beautiful expression of constructive science.

Base in the baptistery of St Mark's

I–XXV–XVIII. . . . The most beautiful base I ever saw, on the whole, is a Byzantine one in the Baptistery of St Mark's . . . the spur profile is formed by a cherub, who sweeps downwards on the wing. His two wings, as they half close, form the upper part of the spur, and the rise of it in the front is formed by exactly the action of Alichino, swooping on the pitched lake. . . . But it requires noble management to confine such a fancy within such limits. The greater number of best bases are formed of leaves; and the reader may amuse himself as he will by endless inventions of them, from types which he may gather among weeds at the nearest roadside.

The 'lily' capitals

One of the features Ruskin considers in his chapter of Byzantine palaces is capitals, which he divides into two categories: concave and convex. He relates these standard forms to their natural equivalent—the concave form to the convulvulus, the convex to the lily. He adds: 'There was no intention in the Byzantine architects to imitate either one or the other of

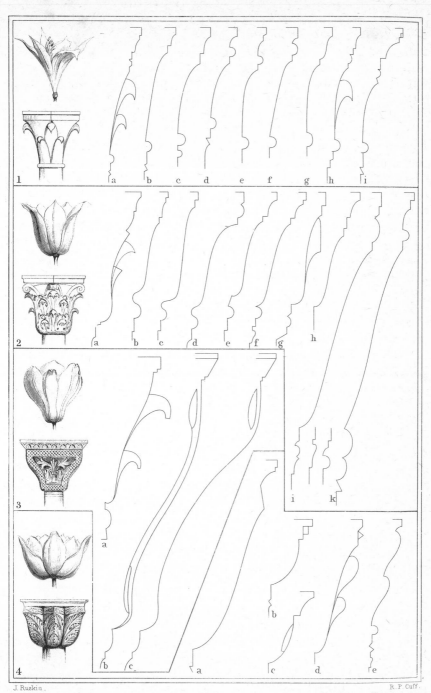

J. Ruskin.

R. P. Cuff.

Ruskin's drawing of the four Venetian 'flower orders' (Volume II, Plate x). Figure 1*a*, the profile of a pure concave capital, based on a trumpet-flower shape. Figure 2*a*, from a Byzantine capital, lower arcade of the Fondaco dei Turchi, essentially concave. Figure 3*a*, from a capital in the nave of St Mark's, essentially Byzantine in its convex form, though with some suggestion of the Corinthian bell. Figure 4*a*, pure convex.

*these flowers; but, as I have already so often repeated, all beautiful works
of art must either intentionally imitate or accidentally resemble natural
forms' (II–V–XIV).*

*Both forms occur in St Mark's, the capitals of which 'alone would form a
volume', as Ruskin comments. He examines particularly the lily capital,
remarking on its purity of line and on its other main characteristic, the
patterning of chequers.*

II–V–XXIII. . . . the capitals which show [*this patterning*] most definitely
are those already so often spoken of as the lily capitals of St Mark's, of
which the northern one is carefully drawn in [*Ruskin's illustration as
shown*].

XXIV. These capitals, called barbarous by our architects, are without
exception the most subtle pieces of composition in broad contour which
I have ever met with in architecture. Their profile is given in [*Ruskin's
second plate*]; the inner line in the figure being that of the stone behind
the lily, the outer that of the external network, taken through the side
of the capital; while Figure 3 *c* is the outer profile at its angle: and the
reader will easily understand that the passing of the one of these lines
into the other is productive of the most exquisite and wonderful series of
curvatures possible within such compass, no two views of the capital
giving the same contour. Upon these profoundly studied outlines, as
remarkable for their grace and complexity as the general mass of the
capital is for solid strength and proportion to its necessary service, the
braided work is wrought with more than usual care; perhaps, as suggested
by the Marchese Selvatico, with some idea of imitating those 'nets of
chequer work and wreaths of chainwork' on the chapiters of Solomon's
temple, which are, I suppose, the first instances on record of an orna-
mentation of this kind thus applied. The braided work encloses on each
of the four sides of the capital a flower whose form [*is*] derived from that
of the lily, though as usual modified, in every instance of its occurrence,
in some minor particulars . . . but no amount of illustration or eulogium
would be enough to make the reader understand the perfect beauty of the
thing itself, as the sun steals from interstice to interstice of its marble veil,
and touches with the white lustre of its rays at midday the pointed leaves
of its thirsty lilies.

MARK, SQUARE OF ST (Piazza di S. Marco), anciently a garden,
II–IV–III; general effect of, II–IV–XIII, LXXI; plan of, II-Figure
XXXVI [*Ruskin's plan is reproduced in the section on the* DUCAL
PALACE—*see page 64*].

II–IV–III. . . . A church erected to this Saint is said to have occupied, before the ninth century, the site of St Mark's; and the traveller, dazzled by the brilliancy of the great square, ought not to leave it without endeavouring to imagine its aspect in that early time when it was a green field, cloister-like and quiet, divided by a small canal, with a line of trees on each side; and extending between the two churches of St Theodore and St Gemanium, as the little piazza of Torcello lies between its 'palazzo' and cathedral.

Ruskin also quotes the writer, Galliciolli, who describes the square at that period as ' "partly covered by turf, and planted with a few trees; and on account of its pleasant aspect called Brollo or Broglio, that is to say, Garden". The canal passed through it, over which is built the bridge of the Malpassi.'

II–IV–XIII. *The description of the general effect of St Mark's and the square is included in the lengthy extract given under* MARK, CHURCH OF ST *(see pages 154–8).*

MATER DOMINO, CHURCH OF S. MARIA. It contains two important pictures: one over the second altar on the right, 'St Christina', by Vincenzo Catena, a very lovely example of the Venetian religious school; and, over the north transept door, the 'Finding of the Cross', by Tintoretto, a carefully painted and attractive picture, but by no means a good specimen of the master, as far as regards power of conception. He does not seem to have entered into his subject. There is no wonder, no rapture, no entire devotion in any of the figures. They are only interested and pleased in a mild way; and the kneeling woman who hands the nails to a man stooping forward to receive them on the right hand, does so with the air of a person saying, 'You had better take care of them; they may be wanted another time.' This general coldness in expression is much increased by the presence of several figures on the right and left, introduced for the sake of portraiture merely; and the reality, as well as the feeling, of the scene is destroyed by our seeing one of the youngest and weakest of the women with a huge cross lying across her knees, the whole weight of it resting upon her. As might have been expected, where the conception is so languid, the execution is little delighted in: it is throughout steady and powerful, but in no place affectionate, and in no place impetuous. If Tintoretto had always painted in this way, he would have sunk into a mere mechanist. It is, however, a genuine and tolerably well preserved specimen, and its female figures are exceedingly graceful; that of St Helena very queenly, though by no means agreeable in feature. Among the male portraits on the left there is one different from the usual types which occur either in Venetian paintings or

Venetian populace; it is carefully painted, and more like a Scotch Presbyterian minister than a Greek. The background is chiefly composed of architecture, white, remarkably uninteresting in colour, and still more so in form. This is to be noticed as one of the unfortunate results of the Renaissance teaching at this period. Had Tintoretto backed his Empress Helena with Byzantine architecture, the picture might have been one of the most gorgeous he ever painted.

The Church of Maria Mater Domini, in the Renaissance style, was designed by Giovanni Buora, with a façade by Jacopo Sansovino, and was built in 1510–40. The plan is a Greek cross with a central dome.

M A T E R D O M I N I, C A M P O D I S. M A R I A, II–VII–XXXIX. A most interesting little piazza, surrounded by early Gothic houses, once of singular beauty; the arcade at its extremity, of fourth order windows, drawn in my folio work, is one of the earliest and loveliest of its kind in Venice; and in the houses at the side is a group of second order windows with their intermediate crosses, all complete, and well worth careful examination.

For further details of Ruskin's window orders, see under ORDERS OF VENETIAN ARCHES. *Section II–VII–XXXIX, referred to above, mentions one particular window in the campo which is illustrated in Figure 6 of Ruskin's drawing, given on page 267. Ruskin selects this example as demonstrating a development in Gothic window form: just as, originally, the round arch yielded 'to the Gothic, by allowing a point to emerge at its summit' so now 'we have the Gothic conceding something to the form which had been assumed by the round; and itself slightly altering its outline so as to meet the condescension of the round arch half way'. This particular window in the 'campo' is an example 'where the reversed curve at the head of the pointed arch is just perceptible and no more'.*

M I C H E L E I N I S O L A, C H U R C H O F S. On the island between Venice and Murano. The little Cappella Emiliana at the side of it has been much admired, but it would be difficult to find a building more feelingless or ridiculous. It is more like a German summer-house, or angle turret, than a chapel, and may be briefly described as a bee-hive set on a low hexagonal tower, with dashes of stonework about its windows like the flourishes of an idle penman.

The cloister of this church is pretty; and the attached cemetery is worth entering, for the sake of feeling the strangeness of the quiet sleeping ground in the midst of the sea.

In spite of Ruskin's adverse criticism, the group of buildings still has its

admirers. The Camaldulensian church of S. Michele was designed by Mauro Coducci and built in 1470–1475. The hexagonal Cappella Emiliana by its side was built a little later in 1530 to the design of Guglielmo Bergamasco. It was restored in 1560 by Jacopo Sansovino. The interior was completely restored in 1971–1974 by the Comitato Italiano per Venezia.

MICHIEL DELLE COLONNE, PALAZZO. Of no importance. *The Palazzo Michiel delle Colonne has had several names—Grimani, Donà dalle Rose—and was originally a Gothic structure but was rebuilt in the Renaissance style in the seventeenth century.*

MINELLI, PALAZZO. In the Corte del Maltese, at St Paternian. It has a spiral external staircase, very picturesque, but of the fifteenth century, and without merit.

This palace, which Ruskin calls the Palazzo Minelli, is generally known as the Palazzo Contarini dal Bovolo (qv) and a more detailed note is given under that heading. Ruskin there dismisses the palace even more curtly.

MIRACOLI, CHURCH OF S. MARIA DEI. The most interesting and finished example in Venice of the Byzantine Renaissance, and one of the most important in Italy of the cinque-cento style. All its sculptures should be examined with great care, as the best possible examples of a bad style. Observe, for instance, that in spite of the beautiful work on the square pillars which support the gallery at the west end, they have no more architectural effect than two wooden posts. The same kind of failure in boldness of purpose exists throughout; and the building is, in fact, rather a small museum of unmeaning, though refined sculpture, than a piece of architecture.

Its grotesques are admirable examples of the base Raphaelesque design examined above, III–III–XXXIX. Note especially the children's heads tied up by the hair, in the lateral sculptures at the top of the altar steps. A rude workman, who could hardly have carved the head at all, might have been allowed this or any other mode of expressing discontent with his own doings; but the man who could carve a child's head so perfectly must have been wanting in all human feeling, to cut it off, and tie it by the hair to a vine leaf. Observe, in the Ducal Palace, though far ruder in skill, the heads always *emerge* from the leaves, they are never *tied* to them [*Ruskin's italics*].

III–III–XXXIX. *Ruskin writes disapprovingly of the treatment of the grotes-que 'which developed itself among the enervated Romans, and which was brought to the highest perfection of which it was capable, by Raphael, in the arabesques of the Vatican. It may generally be described as an elaborate and luscious form of nonsense.'*

The church was designed by Pietro Lombardo and built in 1481–1489. It has been much admired. There are several drawings—plans, sections and elevations—of it in Banister Fletcher's History of Architecture *(17th edition 1961, p. 735). The roof, masonry and ceiling paintings were restored in 1970 by the West German Stifterverband für die Deutsche Wissenshaft.*

MISERICORDIA, CHURCH OF. The church itself is nothing, and contains nothing worth the traveller's time; but the Albergo de' Confratelli della Misericordia at its side is a very interesting and beautiful relic of the Gothic Renaissance. Lazari says [*of the fourteenth century*], but I believe it to be later. Its traceries are very curious and rich, and the sculpture of its capitals very fine for the late time. Close to it, on the right-hand side of the canal, which is crossed by the wooden bridge, is one of the richest Gothic doors in Venice, remarkable for the appearance of antiquity in the general design and stiffness of its figures, though it bears its date, 1505. Its extravagant crockets are almost the only features which, but for this written date, would at first have confessed its lateness; but, on examination, the figures will be found as bad and spiritless as they are apparently archaic, and completely exhibiting the Renaissance palsy of imagination.

The general effect is, however, excellent, the whole arrangement having been borrowed from earlier work.

The action of the statue of the Madonna, who extends her robe to shelter a group of diminutive figures, representative of the Society for whose house the sculpture was executed, may be also seen in most of the later Venetian figures of the Virgin which occupy similar situations. The image of Christ is placed in a medallion on her breast, thus fully, though conventionally, expressing the idea of self support which is so often partially indicated by the great religious painters in their representations of the infant Jesus.

The Scuola della Misericordia (or 'albergo de' confratelli' as Ruskin calls it) was the third of the six 'scuole grande' and was also known as the Scuola S. Maria Valverde. (For further details of the scuole, see under SCUOLA DI S. ROCCO.*) There are in fact two scuole buildings though this is not immediately apparent from Ruskin's description.*

The older, the Scuola Vecchia, is situated alongside the church and is

indeed more recent than Lazari's dating suggests. The façade was built in the first half of the fifteenth century; the relief of the Madonna and members of the guild, discussed by Ruskin, originally formed a tympanum over a door in the façade. It was the work of Bartolomeo Bon. It is now in the Victoria and Albert Museum, London, and all that remains of the relief on the scuola itself are two small angels.

Across a bridge, on the opposite side of the canal, stands the Scuola Nuova, the so-called 'new school', which was started in 1532 to a design by Sansovino. It is now used as a sports association.

M O I S É , C H U R C H O F S., III–III–XIX. Notable as one of the basest examples of the basest school of the Renaissance.

III–III–XIX. Ruskin is criticizing the vainglory of men such as Vincenzo Cappello, for whom—Ruskin argues—the entire façade of S. Maria Formosa (qv) was a memorial. He continues:

Having taken sufficient note of all the baseness of mind which these facts indicate in the people, we shall not be surprised to find immediate signs of dotage in the conception of their architecture. The churches raised throughout this period are so grossly debased, that even the Italian critics of the present day, who are partially awakened to the true state of art in Italy, though blind, as yet, to its true cause, exhaust their terms of reproach upon these last efforts of the Renaissance builders. The two churches of S. Moisé and S. Maria Zobenigo, which are among the most remarkable in Venice for their manifestation of insolent atheism, are characterized by Lazari, the one as 'culmine d' ogni follia architettonica', [*the height of architectural folly*], the other as 'orrido ammasso di pietra d'Istria [*a hideous pile of Istrian stone*], with added expressions of contempt, as just as it is unmitigated.

XX. Now both these churches, which I should like the reader to visit in succession, if possible, after that of S. Maria Formosa, agree with that church, and with each other, in being totally destitute of religious symbols, and entirely dedicated to the honour of two Venetian families. In San Moisè, a bust of Vincenzo Fini is set on a tall narrow pyramid above the central door, with this marvellous inscription:

'O M N E F A S T I G I V M
V I R T V T E I M P L E T
V I N C E N T I V S F I N I .'

It is very difficult to translate this; for 'fastigium', besides its general sense, has a particular one in architecture, and refers to the part of the building occupied by the bust; but the main meaning of it is that 'Vincenzo

Church of S. Moisè: façade showing the memorials to three members of the Fini family.
To the right is the modern façade of the Bauer-Grünwald Hotel.

'Christ washing the Disciples' Feet' by Tintoretto, in the Church of S. Moisé.

Fini fills all height with his virtue . The inscription goes on into further praise, but this example is enough. Over the two lateral doors are two other laudatory inscriptions of younger members of the Fini family, the dates of death of the three heroes being 1660, 1685, and 1726, marking thus the period of consummate degradation.

The highly decorated Baroque façade of S. Moisè, which Ruskin did not like, was designed by Alessandro Tremignon in 1668. The roof was restored in 1967 with funds provided by the American Committee to Rescue Italian Art. This organization also provided funds for the restoration of its paintings.

The Index continues on S. Moisè: It contains one important picture, namely, 'Christ Washing the Disciples' Feet', by Tintoretto; on the left side of the chapel, north of the choir. This picture has been originally dark, is now much faded—in parts, I believe, altogether destroyed—and is hung in the worst light of a chapel, where, on a sunny day at noon, one could not easily read without a candle. I cannot, therefore, give much information respecting it; but it is certainly one of the least successful of the painter's works, and both careless and unsatisfactory in its composition as well as its colour. One circumstance is noticeable, as in a considerable degree detracting from the interest of most of Tintoretto's representations of our Saviour with His disciples. He never loses sight of the fact that all were poor; and the latter ignorant; and while he never paints a senator or a saint, once thoroughly canonized, except as a gentleman, he is very careful to paint the Apostles, in their living intercourse with the Saviour, in such a manner that the spectator may see in an instant, as the Pharisee did of old, that they were unlearned and ignorant men; and, whenever we find them in a room, it is always such a one as

would be inhabited by the lower classes. There seems some violation of this practice in the dais, or flight of steps, at the top of which the Saviour is placed in the present picture; but we are quickly reminded that the guests' chamber or upper room ready prepared was not likely to have been in a palace, by the humble furniture upon the floor, consisting of a tub with a copper saucepan in it, a coffee-pot, and a pair of bellows, curiously associated with a symbolic cup with a wafer, which, however, is in an injured part of the canvas, and may have been added by the priests. I am totally unable to state what the background of the picture is or has been; and the only point further to be noted about it is the solemnity, which, in spite of the familiar and homely circumstances above noticed, the painter has given to the scene, by placing the Saviour, in the act of washing the feet of Peter, at the top of a circle of steps, on which the other Apostles kneel in adoration and astonishment.

M O R O, P A L A Z Z O. See OTHELLO.

M O R O S I N I, P A L A Z Z O, near the Ponte dell'Ospedaletto, at SS. Giovanni e Paolo. Outside it is not interesting, though the gateway shows remains of brickwork of the thirteenth century. Its interior court is singularly beautiful; the staircase of early fourteenth century Gothic has originally been superb, and the window in the angle above is the most perfect that I know in Venice of the kind; the lightly sculptured coronet is exquisitely introduced at the top of its spiral shaft.

This palace still belongs to the Morosini family, to whose present representative, the Count Carlo Morosini, the reader is indebted for the note on the character of his ancestors, [*see Volume III, Appendix 6*].

In this appendix Ruskin quotes at length from a letter he received from Count Carlo Morosini indicating the character of the Doge Michele Morosini.

After criticizing historians, commentators and others who have derided the doge, the count cites an authentic manuscript, belonging to the Venieri family, saying that Michele Morosini 'was elected Doge to the delight and joy of all men'. The letter further states that Morosini 'was not elected Doge until after he had been entrusted with many honourable embassies to the Genoese and Carrarese, as well as to the King of Hungary and Amadeus of Savoy'.

According to F. C. Hodgson (Venice in the Thirteenth and Fourteenth Centuries, London 1910) Morosini was the victim of a misprint in Sanudo's Lives of the Doges. As the text stood, it read that Morosini wished to fare well by the country's misfortunes, whereas the correct version was that he did not wish to fare well.

The tomb of Doge Morosini is in the Church of SS. Giovanni e Paolo and is described by Ruskin under that heading.

MOROSINI, PALAZZO, at S. Stefano. Of no importance.
The Palazzo Morosini-Gatterburg, as it is sometimes known, was once the home of Doge Francesco Morosini (1688–94). It overlooks the canal called the Rio del Santissimo di S. Stefano and is now used partly as offices and partly as private flats.

MURANO. *See* ANGELI, DONATO *and* PIETRO, CHURCHES.

N

NANI-MOCENICO, PALAZZO. A glorious example of the central Gothic, nearly contemporary with the finest parts of the Ducal Palace. Though less impressive in effect than the Casa Foscari or Casa Bernardo, it is of purer architecture than either; and quite unique in the delicacy of the form of the cusps in the central group of windows, which are shaped like broad scimitars, the upper foil of the windows, being very small. If the traveller will compare these windows with the neighbouring traceries of the Ducal Palace, he will easily perceive the peculiarity.

NICOLÓ DEL LIDO, CHURCH OF S. Of no importance.
There are three churches in Venice dedicated to St. Nicholas: S. Nicoló del Lido, S. Nicoló da Tolentino and S. Nicoló dei Mendicoli.

The first named is a mediaeval church near the Porta di Lido. (The island was once called the Lido of St Nicholas and the name was given to its airport.)

S. Nicoló da Tolentino is to the west of the city, near the Rio di Croce (more details are given under TOLENTINO).

The church of S. Nicoló dei Mendicoli was founded in the seventh century, rebuilt in the Romanesque-Byzantine style in the eleventh century, much of which remains, and enlarged and partly reconstructed in the Gothic style in the fourteenth century. The church contains paintings by pupils and followers of Veronese, including those by Dal Friso in the nave and ceiling paintings by Montemezzano. Work of restoration of the church has been in hand since 1972, undertaken by the British Venice in Peril Fund in collaboration with the Soprintendenza alle Gallerie.

O

ORDERS OF VENETIAN ARCHES. *Throughout the Index Ruskin makes a number of references to 'orders' of Venetian arches. For the developing form of window and door arches provides a graphic indicator of the wider-scale transitions which took place in the architecture of Gothic palaces in Venice.*

The Gothic style developed in a distinctive form in Venice. In the chapter devoted to Gothic palaces Ruskin writes:

II–VII–XXIII . . . It has already been repeatedly stated, that the Gothic style had formed itself completely on the main land, while the Byzantines still retained their influence at Venice; and that the history of early Venetian Gothic is therefore not that of a school taking new forms independently of external influence, but the history of the struggle of the Byzantine manner with a contemporary style quite as perfectly organized as itself, and far more energetic. And this struggle is exhibited partly in the gradual change of the Byzantine architecture into other forms, and partly by isolated examples of genuine Gothic, taken prisoner, as it were, in the contest; or rather entangled among the enemy's forces, and maintaining their ground till their friends came up to sustain them. Let us first follow the steps of the gradual change, and then give some brief account of the various advanced guards and forlorn hopes of the Gothic attacking force.

XXIV. The uppermost shaded series of six forms of windows [*see Ruskin's illustration*] represents, at a glance, the modifications of this feature in Venetian palaces, from the eleventh to the fifteenth century. Figure 1 is Byzantine, of the eleventh and twelfth centuries; Figures 2 and 3 transitional, of the thirteenth and early fourteenth centuries; Figures 4 and 5 pure Gothic, of the thirteenth, fourteenth and early fifteenth; and Figure 6 late Gothic of the fifteenth century, distinguished by its added finial. Figure 4 is the longest-lived of all these forms: it occurs first in the thirteenth century; and, sustaining modifications only in its mouldings, is found also in the middle of the fifteenth.

I shall call these the six orders of Venetian windows.

Ruskin adds the note:

I found it convenient in my own memoranda to express them simply as fourths, seconds, etc. But 'order' is an excellent word for any known group of forms, whether of windows, capitals, bases, mouldings, or any other architectural feature, provided always that it be not understood

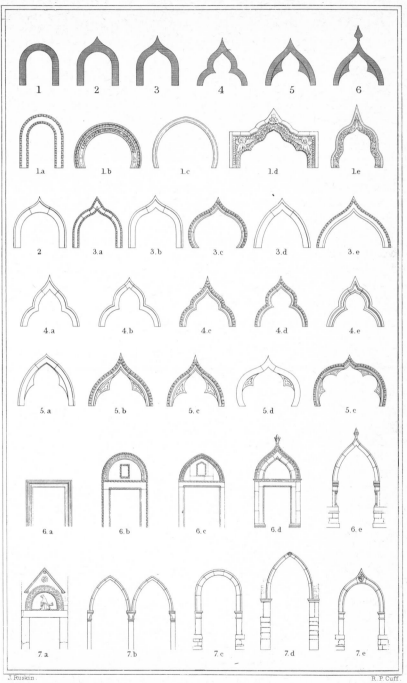

Ruskin's orders of Venetian arches (Volume II, Plate XIV). The top series shows the six basic orders. Then follow four rows of variations on these basic types, each related to its particular type by the relevant number. The final two series, showing a range of orders, are all door arches (as are 1b, 1d and 1e).

in any wise to imply pre-eminence or isolation in these groups. Thus I may rationally speak of the six orders of Venetian windows, provided I am ready to allow a French architect to speak of the six or seven, or eight, or seventy or eighty, orders of Norman windows, if so many are distinguishable; and so also we may rationally speak, for the sake of intelligibility, of the five orders of Greek pillars, provided only we understand that there may be five millions of orders, as good or better, of pillars *not* Greek.

O R O, C A' D'. See under D'ORO.

O R T O, C H U R C H O F S. M A R I A D E L L'. An interesting example of Renaissance Gothic, the traceries of the windows being very rich and quaint.

This church was originally called St Christopher but the name was later changed to Madonna dell'Orto, by which it is now generally known, because of an image of the Virgin, found in a neighbouring garden, that was reputed to have worked miracles. This is now in the church. A statue of St Christopher is above the entrance to the church. Although dating from the twelfth century the church was rebuilt in the Gothic style in the early fifteenth century.

It contains four most important Tintorettos. 'The Last Judgment', 'The Worship of the Golden Calf', 'The Presentation of the Virgin', and 'Martyrdom of St Agnes' [*not in fact a martyrdom but showing the saint raising Licinius to life*]. The first two among his largest and mightiest works, but grievously injured by damp and neglect; and unless the traveller is accustomed to decipher the thoughts in a picture patiently, he need not hope to derive any pleasure from them. But no pictures will better reward a resolute study. The following account of the 'Last Judgment', given in the second volume of *Modern Painters* [*another work by Ruskin*], will be useful in enabling the traveller to enter into the meaning of the picture, but its real power is only to be felt by patient examination of it.

'By Tintoretto only has this unimaginable event (the Last Judgment) been grappled with in its Verity; not typically nor symbolically, but as they may see it who shall not sleep, but be changed. Only one traditional circumstance he has received, with Dante and Michelangelo, the Boat of the Condemned; but the impetuosity of his mind bursts out even in the adoption of this image; he has not stopped at the scowling ferryman of the one, nor at the sweeping blow and demon dragging of the other, but, seized Hylas-like by the limbs, and tearing up the earth in his agony, the victim is dashed into his destruction; nor is it the sluggish Lethe,

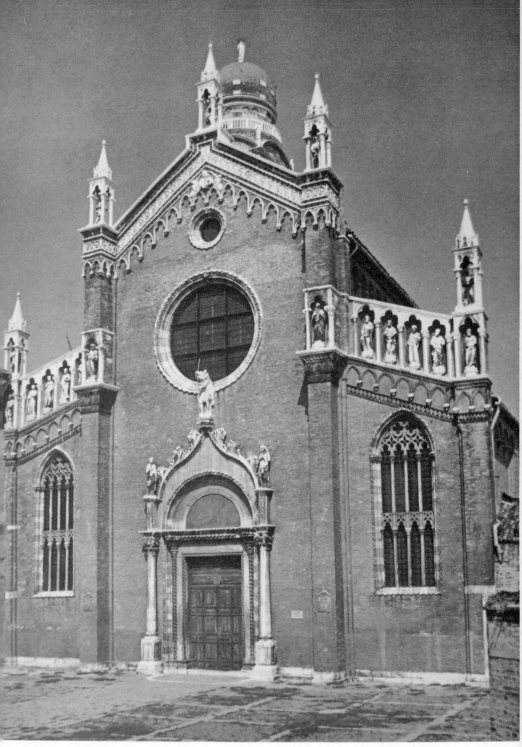

Church of S. Maria dell'Orto: the restored 'west' front. Formerly known as the Church of St Christopher, whose statue is above the central portico. To the left is the former Scuola dei Mercanti.

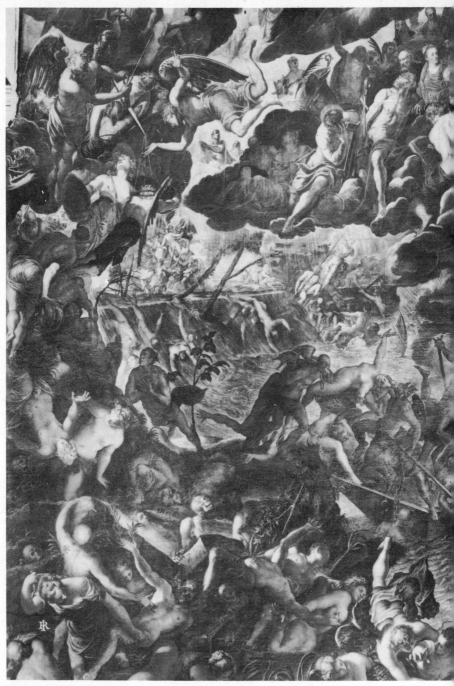

'The Last Judgment' by Tintoretto in the Church of S. Maria dell'Orto. Tintoretto lived near this church (3399 Fondamenta dei Mori) in the last twenty years of his life, and was buried there.

nor the fiery lake, that bears the cursed vessel, but the oceans of the earth and the waters of the firmament gathered into one white, ghastly cataract; the river of the wrath of God, roaring down into the gulf where the world has melted with its fervent heat, choked with the ruins of nations, and the limbs of its corpses tossed out of its whirling, like water-wheels. Bat-like, out of the holes and caverns and shadows of the earth, the bones gather, and the clay heaps heave, rattling and adhering into half-kneaded anatomies, that crawl, and startle, and struggle up among the putrid weeds, with the clay clinging to their clotted hair, and their heavy eyes sealed by the earth darkness yet, like his of old who went his way unseeing to the Siloam Pool; shaking off one by one the dreams of the prison-house, hardly hearing the clangour of the trumpets of the armies of God, blinded yet more, as they awake, by the white light of the new Heaven, until the great vortex of the four winds bears up their bodies to the judgment-seat; the Firmament is all full of them, a very dust of human souls, that drifts, and floats, and falls into the interminable, inevitable light; the bright clouds are darkened with them as with thick snow, currents of atom life in the arteries of heaven, now soaring up slowly, and higher and higher still, till the eye and the thought can follow no farther, borne up, wingless, by their inward faith and by the angel powers invisible, now hurled in countless drifts of horror before the breath of their condemnation.'

Note in the opposite picture the way the clouds are wrapped about the distant Sinai.

The figure of the little Madonna in the 'Presentation' should be compared with Titian's in his picture of the same subject in the Academy. I prefer Tintoretto's infinitely; and note how much finer is the feeling with which Tintoretto has relieved the glory round her head against the pure sky, than that which influenced Titian in encumbering his distance with architecture.

The 'Martyrdom of St Agnes' *was* a lovely picture. It has been 'restored' since I saw it.

In the 1879 abridgement Ruskin adds with regard to the 'Presentation' that, 'the whole picture has now been daubed over—chiefly this lovely bit of sky, and is a ghastly ruin and eternal disgrace to modern Venice'. The church and its paintings were restored in 1968–1972 by the United Kingdom Italian Art and Archives Rescue Fund. I think Ruskin would have been much delighted with the result.

O SPEDALETTO, CHURCH OF THE. The most monstrous example of the Grotesque Renaissance which there is in Venice; the

sculptures on its façade representing masses of diseased figures and swollen fruit.

It is almost worth devoting an hour to the successive examination of five buildings, as illustrative of the last degradation of the Renaissance. S. Moisè is the most clumsy, S. Maria Zobenigo the most impious, S. Eustachio the most ridiculous, the Ospedaletto the most monstrous, and the head at S. Maria Formosa the most foul.

The Ospedaletto Church was built by Baldassare Longhena in 1674. It is usually classified as a Baroque church.

OTHELLO, H OUSE OF, at the CARMINI. The researches of Mr Brown into the origin of the play of 'Othello' have, I think, determined that Shakespeare wrote on definite historical grounds; and that Othello may be in many points identified with Christopher Moro, the lieutenant of the republic at Cyprus in 1508. See *Ragguagli su Maria Sanuto*, i. 226.

His palace was standing till very lately, a Gothic building of the fourteenth century, of which Mr Brown possesses a drawing. It is now destroyed, and a modern square-windowed house built on its site. A statue, said to be a portrait of Moro, but a most paltry work, is set in a niche in the modern wall.

The house at No 2615, also known as the Palazzo Moro, is traditionally associated with Shakespeare's Othello. Rawdon Brown, a friend of Ruskin, spent much of his life in Venice on research in the State Archives (see also BUSINELLO).

P

PANTALEONE, CHURCH OF S. Said to contain a Paul Veronese; otherwise of no importance.

This church was originally built in the thirteenth century, but was rebuilt in the Palladian Renaissance style by Francesco Comino in 1668–1675. It has a large ceiling painting of the 'Martyrdom and Glory of St Pantaleon' by Giannantonio Fumiani (1700). The picture by Veronese is of 'St Pantaleon healing a Sick Boy', painted in 1587. Restoration of the ceiling was carried out in 1970–1971 with the assistance of the American Committee to Rescue Italian Art.

PATERNIAN, CHURCH OF ST. Its little leaning tower forms an interesting object, as the traveller sees it from the narrow canal which

passes beneath the Ponte S. Paternian. The two arched lights of the belfry appear of very early workmanship, probably of the beginning of the thirteenth century.

James Morris in his book Venice *notes that the church of S. Paternian was pulled down to make way for the statue in the Campo Manin.*

PESARO, PALAZZO, on the Grand Canal. The most powerful and impressive in effect of all the palaces of the Grotesque Renaissance. The heads upon its foundation are very characteristic of the period, but there is more genius in them than usual. Some of the mingled expressions of faces and grinning casques are very clever.

PIAZZETTA, pillars of, see [*Volume III*] Final Appendix, under head 'Capitals'. The two magnificent blocks of marble brought from St Jean d'Acre, which form one of the principal ornaments of the Piazzetta, are Greek sculpture of the sixth century, and will be described in my folio work.

The pillars to which Ruskin refers here are those on the so-called Piazzetta façade of the Ducal Palace (see plan given under DUCAL PALACE*). He makes some reference to them in the third section on capitals in the final appendix of Volume III.*

Ruskin does not in fact appear to have included the Piazzetta pillars in his folio work, which consisted of the large plates from Stones of Venice *issued separately in a planned twelve-volume series, entitled* Examples of Architecture in Venice. *As the first volume of* Stones *did not sell well at first, only three volumes of the folio work were ever published.*

The richly carved pillars were brought back from Acre by Lorenzo Tripoli in 1258 after the Venetians had conquered thet port.

These should not be confused with the free-standing columns at the lagoon end of the Piazzetta. These are of granite and were brought back from Constantinople or Syria and erected in Venice in 1180. One is sur-mounted by what became the winged lion of St Mark, the other by St Theodore on a crocodile, patron of the ancient republic. The site near these columns was the place of public executions. It was here that, in 1300, the conspirator Mario Bocconco and ten confederates were hung between the columns.

PIETA, CHURCH OF THE. Of no importance.
The Church of the Pietà is a Renaissance church designed by Giorgio Massari and built in the mid-eighteenth century. It is elliptical on plan and has ceiling frescoes by Tiepolo: 'The Coronation of the Virgin' and 'The Cardinal Virtues'. The restoration of these paintings was made in

1970–1972 with the assistance of the American International Fund for Monuments.

PIETRO, CHURCH OF S., at Murano. Its pictures, once valuable, are now hardly worth examination, having been spoiled by neglect.

The church contains two works by Giovanni Bellini—'The Madonna with Doge Barbarigo' and an 'Assumption'—and two by Veronese—'St Agatha in Prison' and 'St Jerome in the Wilderness'.

PIETRO DI CASTELLO, CHURCH OF S, I–I–IX, I–Appendix 4. It is said to contain a Paul Veronese, and I suppose the so-called 'Chair of St Peter' must be worth examining.

In a general discussion of the character of Venice, Ruskin remarks on the city's 'entire subjection of private piety to national policy'. This he sees symbolized in physical terms, in particular by the position of the one-time cathedral church of S. Pietro di Castello:

I–I–IX. . . . I am aware of no other city of Europe in which its cathedral was not the principal feature. But the principal church in Venice was the chapel attached to the palace of her prince, and called the 'Chiesa Ducale'. The patriachal church, inconsiderable in size and mean in decoration, stands on the outermost islet of the Venetian group, and its name, as well as its site, are probably unknown to the greater number of travellers passing hastily through the city.

Elsewhere (in Volume I Appendix 4) Ruskin gives a brief, if rather caustic description of the founding of the church.

It is credibly reported to have been founded in the seventh century, and (with somewhat less of credibility) in a place where the Trojans, conducted by Antenor, had, after the destruction of Troy, built 'un castello, chiamato prima Troja, poscia Olivolo, interpretato, luogo pieno' ['*a castle, at first called Troy, afterwards 'Olivolo', rendered a place of perfection'*]. It seems that St Peter appeared in person to the Bishop of Heraclea, and commanded him to found, in his honour, a church in that spot of the rising city on the Rialto: 'ove avesse veduto una mandra di buoi e di pecore pascolare unitamente. Questa fu la prodigiosa origine della Chiesa di San Pietro, che poscia, o rinovata, o ristaurata, da Orso Participazio IV Vescovo Olivolense, divenne la Cattedrale della Nuova citta.' (Notizie Storiche delle Chiese e Monasteri di Venezia. Padua, 1758) ['*where a herd of bulls and sheep were seen grazing together. This was the miraculous origin of the Church of St Peter that, after being renovated by Orso Participazio IV, the Olivolense bishop, became the*

cathedral of the new city' (*'Historical Notes of the Church and Monastery of Venice', Padua 1758*)]. What there was so prodigious in oxen and sheep feeding together, we need St Peter, I think, to tell us. The title of Bishop of Castello was first taken in 1091: St Mark's was not made the cathedral church till 1807. It may be thought hardly fair to conclude the small importance of the old S. Pietro di Castello from the appearance of the wretched modernizations of 1620. But these modernizations are spoken of as improvements; and I find no notice of peculiar beauties in the older building, either in the work above quoted, or by Sansovino; who only says that when it was destroyed by fire (as everything in Venice was, I think, about three times in a century), in the reign of Vital Michele, it was rebuilt 'with good thick walls, maintaining, *for all that*, the order of its arrangement taken from the Greek mode of building'. This does not seem the description of a very enthusiastic effort to rebuild a highly ornate cathedral. The present church is among the least interesting in Venice; a wooden bridge, something like that of Battersea on a small scale, connects its island, now almost deserted, with a wretched suburb of the city behind the arsenal; and a blank level of lifeless grass, rotted away in places rather than trodden, is extended before its mildewed façade and solitary tower.

S. Pietro of Castello, a foundation of the seventh century, was rebuilt in the Renaissance style in the late sixteenth and early seventeenth centuries. The design of the façade was by F. Smeraldi following a design by Palladio. The large and impressive altar was designed in 1649 by Baldassare Longhena. The work by Veronese, which Ruskin mentions in passing, is of Sts John, Peter and Paul. Restoration of the church was carried out in 1971–1973 with the assistance of the American International Fund for Monuments.

P I S A N I, P A L A Z Z O, on the Grand Canal. The latest Venetian Gothic, just passing into Renaissance. The capitals of the first-floor windows are, however, singularly spirited and graceful, very daringly undercut, and worth careful examination. The Paul Veronese, once the glory of this palace, is, I believe, not likely to remain in Venice. The other picture in the same room, the 'Death of Dairus', is of no value.

In the 1879 abridgement Ruskin adds a footnote with reference to the Paul Veronese 'not likely to remain in Venice. It is "The Family of Darius at the feet of Alexander after the battle of Issus". It was purchased in 1857 by the English Government, and now hangs in London in the National Gallery.' The other work, the 'Death of Darius', is by Giovan Battista Paizzetta and is now in the Ca' Rezzonico.

The palace is more commonly known by the fuller name of Pisani-Moretta.

PISANI, PALAZZO, at S. Stefano. Late Renaissance, and of no merit, but grand in its colossal proportions, especially when seen from the narrow canal at its side, which, terminated by the apse of the Church of S. Stefano, is one of the most picturesque and impressive little pieces of water scenery in Venice.

PISANI-GRITTI, PALAZZO. See GRITTI, PALAZZO.

POLO, CHURCH OF S. Of no importance, except as an example of the advantages accruing from restoration. M. Lazari says of it, 'Before this church was modernized, its principal chapel was adorned with mosaics, and possessed a pala of silver gilt, of Byzantine workmanship, which is now lost.'

This church has a campanile of the fourteenth century. In 1972 the paintings in the church were restored by the American Committee to Rescue Italian Art.

Campo S. Polo: the Gothic palaces noted by Ruskin. Although having three separate doorways, the block originally consisted of only two palazzi, both called Soranzo. The older of the two is on the left, distinguished by the 'archaic' rectangular doorways. The later palace can be distinguished by the richer use of decorative circles, over the single as well as the multi-light windows.

P O L O, S Q U A R E O F S. (Campo S. Polo). A large and important square, rendered interesting chiefly by three palaces on the side of it opposite the church, of central Gothic (1360), and fine of their time, though small. [*One of the capitals is illustrated by Ruskin as Figure 12 of Plate II, on page 111.*] They are remarkable as being decorated with sculptures of the Gothic time, in imitation of the Byzantine ones; the period being marked by the dog-tooth, and cable being used instead of the dentil round the circles.

P O L O, P A L A Z Z O, at S. G. Grisostomo (the house of Marco Polo), II–V–XXV. Its interior court is full of interest, showing fragments of the old building in every direction, cornices, windows, and doors, of almost every period, mingled among modern rebuilding and restoration of all degrees of dignity.

II–V–XXV. *Ruskin is referring to the ranges of archivolt, or undercurve of an arch, to be found in Byzantine palaces and says that they* ... are for the most part very simple, with dentilled mouldings; and all the ornamental effect is entrusted to pieces of sculpture set in the wall above or between the arches [*see* FALIER, *page 109, for an illustration of this by Ruskin*]. These pieces of sculpture are either crosses, upright oblongs, or circles [*see the illustration by Ruskin over page, showing all these forms*]. The cross was apparently an invariable ornament, placed either in the centre of the archivolt of the doorway, or in the centre of the first story above the windows; on each side of it the circular and oblong ornaments were used in various alternation. In too many instances the wall marbles have been torn away from the earliest Byzantine palaces, so that the crosses are left on their archivolts only. The best examples of the cross set above the windows are found in houses of the transitional period: one in the Campo S. Maria Formosa; another, in which a cross is placed between every window, is still well preserved in the Campo S. Maria Mater Domini; another, on the Grand Canal, in the parish of the Apostoli, has two crosses, one on each side of the first story, and a bas-relief of Christ enthroned in the centre; and finally, that from which the larger cross [*see Ruskin's illustration*] was taken is the house once belonging to Marco Polo, at S. Giovanni Grisostomo.

XXVI. This cross, though graceful and rich, and given because it happens to be one of the best preserved, is uncharacteristic in one respect; for, instead of the central rose at the meeting of the arms, we usually find a hand raised in the attitude of blessing, between the sun and moon, as in the two smaller crosses seen in the Plate.

This is not now considered to be Marco Polo's house, although the court

which Ruskin mentions—the Corte del Milion—recalls, by its name, Marco Polo's books of travels Il Milione. The house which is now thought to have been his is to be found through the second courtyard, the Corte Seconda del Milion, on the fondamenta beyond, and is marked with a plaque.

PORTA DELLA CARTA, II–VIII–XXVI. *This gateway divides the Ducal Palace from St Mark's and was the work of Giovanni and Bartolomeo Bon, who were also responsible for such works as the Ca' d'Oro. Ruskin mentions that the existing façade of the Ducal Palace to the Piazzetta was built:*

II–VIII–XXVI. so as to continue and resemble, in most particulars, the work of the Great Council Chamber. It was carried back from the sea as far as the Judgment angle; beyond which is the Porta della Carta, begun in 1439, and finished in two years, under the Doge Foscari; the interior buildings connected with it were added by the Doge Christopher Moro (the Othello of Shakespeare) in 1462.

PRIULI, PALAZZO. A most important and beautiful early Gothic palace, at S. Severo; the main entrance is from the Fondamento S. Severo, but the principal façade is on the other side, towards the canal. The entrance has been grievously defaced, having had winged lions filling the spandrils of its pointed arch, of which only feeble traces are now left; the façade has very early fourth order windows in the lower story [*see under* ORDERS OF VENETIAN ARCHES *for further details*], and, above, the beautiful range of fifth order windows drawn at the bottom of [*the plate on page 265*], where the heads of the fourth order range are also seen (note their inequality, the larger one at the flank). This palace has two most interesting traceried angle windows also, which, however, I believe are later than those on the façade; and, finally, a rich and bold interior staircase.

PROCURATIE NUOVE, see 'LIBRERIA'. VECCHIE: A graceful series of buildings, of late fifteenth-century design, forming the northern side of St Mark's, but of no particular interest.

Under 'LIBRERIA' Ruskin refers to and briefly describes the buildings that form the north, south and west sides of St Mark's Square. At the risk of repetition, but to make the information quite clear, I should add that the north side of the square is the Procuratie Vecchie built in 1480–1517 and designed by Pietro Lombardo, Bartolomeo Bon and Guglielmo Bergamasco; the south side is the Procuratie Nuove begun by

J. Ruskin.

J. H. Le Keux.

Ruskin's drawings of Byzantine wall sculpture, Figure 4 being taken from the Palazzo Polo (Volume II, Plate XI).

Vincenzo Scamozzi in 1584, and the west side the Procuratie Novissime (or the Atrio, or Nuova Fabbrica) built in 1810 and formerly, as Ruskin mentions, the Royal Palace. Restoration work is being carried out (1974) on the Procuratie Nuove with the assistance of the International Fund for Monuments.

Q

QUERINI, PALAZZO, now the Beccherie, II–VII–XXXII, III–Appendix 10.

The Palazzo Querini is in the Campo delle Beccarie, literally the public slaughter houses. In more recent times the area became the fish market. The Palazzo Querini was restored in 1908. It should not be confused with the Querini-Stampalia Gallery, near S. Maria Formosa.

II–VII–XXXII. *Ruskin selects this palace as showing the finest example of what he classifies as the third order of Venetian window arches (for an illustration and further details of all six orders, see under* ORDER OF VENETIAN ARCHES)*:*

The most perfect examples of the third order in Venice are the windows of the ruined palace of Marco Querini, the father-in-law of Bajamonte Tiepolo, in consequence of whose conspiracy against the government this palace was ordered to be razed in 1310; but it was only partially ruined, and was afterwards used as the common shambles. The Venetians have now made a poultry market of the lower story (the shambles being removed to a suburb), and a prison of the upper, though it is one of the most important and interesting monuments in the city, and especially valuable as giving us a secure date for the central form of these very rare transitional windows. For, as it was the palace of the father-in-law of Bajamonte, and the latter was old enough to assume the leadership of a political faction in 1280, the date of the accession to the throne of the Doge Pietro Gradenigo, we are secure of this place having been built not later than the middle of the thirteenth century.

III–Appendix 10. *This reference occurs in an appendix on capitals and refers the reader to an illustration of one of the capitals in the Palazzo Querini, given in Volume III, Plate II, Figure 10 (see page 111).*

R

RAFFAELLE, CHIESA DELL'ANGELO. Said to contain a Bonifazio: otherwise of no importance.

The church contains a series of paintings on the balcony of the organ loft, probably by one or both of the Guardi brothers, Giovanni Antonio and Francesco. They depict a number of scenes from the story of Tobias and the Angel and are noted for their brilliant colours. The work by Bonifazio is 'The Last Supper'.

RAILWAY STATION. *This was erected in 1955 to the design of Perilli Dott. Paolo. It is in the modern idiom and although a contrast to the Byzantine, Gothic and Renaissance buildings that form the architectural character of Venice, it is visually pleasing and does not strike an inharmonious note. The long horizontal façade and the spacious forecourt spreading to the Grand Canal are impressive, and suggest that a few more such modern buildings might give here and there a life and openness to Venice.*

REDENTORE, CHURCH OF THE. II-Appendix 2. It contains three interesting John Bellinis, and also, in the sacristy, a most beautiful Paul Veronese.

II-Appendix 2. *Ruskin compares this church, dedicated to the Redeemer, with S. Maria della Salute. The passage is given in full under that head*

Venice's railway station the Ferrovia S. Lucia, built about 1955. Although in the modern idiom, it does not, with its spacious forecourt extending to the Grand Canal, strike an inharmonious note.

Church of the Redentore, Guidecca, built in 1577–92 by Palladio.

(qv). Ruskin concludes that the grandeur of the latter, compared with the former, presents 'an accurate index of the relative importance of the ideas of the Madonna and of Christ, in the modern Italian mind'.

The Church of the Redentore was built in 1577–1592 by Palladio. It contains two well-known paintings of Tintoretto: 'The Scourging of Christ' and 'The Ascension'. Two other works in the church which are attributed to Tintoretto are 'Christ bearing the Cross' and 'Descent from the Cross'.

Ruskin mentions three Bellinis in the sacristy; these are all of the Madonna though are now attributed to the school of Bellini, rather than the master himself. One of them, the Madonna in red, is thought to be the work of Alvise Vivarini. The painting by Veronese is a 'Baptism of Christ'.

REMER, CORTE DEL, *house in* II–VII–XXVII. *Ruskin's eye for detail observes a number of interesting points about the architecture of one particular house in this 'corte' (literally 'courtyard'):*

II–VII–XXVII. The woodcut [*illustrated*], represents the door and two of the lateral windows of a house in Corte del Remer, facing the Grand

Ruskin's drawing of the door and two windows of a house
in the Corte del Remer (Volume II, Figure XXVI).

Canal, in the parish of the Apostoli. It is remarkable as having its great
entrance on the first floor, attained by a bold flight of steps, sustained on
pure *pointed* arches wrought in brick. I cannot tell if these arches are
contemporary with the building, though it must always have had an
access of the kind. The rest of its aspect is Byzantine, except only that the
rich sculptures of its archivolt show in combats of animals, beneath the
soffit, a beginning of the Gothic fire and energy. The moulding of its
plinth is of a Gothic profile, and the windows are pointed, not with a
reversed curve, but in a pure straight gable, very curiously contrasted with
the delicate bending of the pieces of marble armour cut for the shoulders
of each arch. There is a two-lighted window, such as that seen in the
vignette, on each side of the door, sustained in the centre by a basket-
worked Byzantine capital: the mode of covering the brick archivolt with
marble, both in the windows and doorway, is precisely like that of the
true Byzantine palaces.

REZZONICO, PALAZZO, on the Grand Canal. Of the Grotesque
Renaissance time, but less extravagant than usual.

*The Palazzo Rezzonico was built by Baldassare Longhena in 1680 and
in 1745 the top story was added by Giovanni Massari. It has ceiling
paintings by Giordano, Tiepolo and Crosato. Robert Browning lived in
this palace and died here in 1889.*

*It now houses eighteenth-century pieces from the Correr collection,
including furniture and paintings.*

RIALTO, BRIDGE OF THE. The best building raised in the time
of the Grotesque Renaissance; very noble in its simplicity, in its propor-

tions, and in its masonry. Note especially the grand way in which the oblique archstones rest on the butments of the bridge, safe, palpably both to the sense and eye: note also the sculpture of the Annunciation on the southern side of it; how beautifully arranged, so as to give more lightness and grace to the arch—*the dove, flying towards the Madonna, forming the keystone* [*Ruskin's italics*]—and thus the whole action of the figures being parallel to the curve of the arch, while all the masonry is at right angles to it. Note, finally, one circumstance which gives peculiar firmness to the figure of the angel, and associates itself with the general expression of strength in the whole building; namely, that the sole of the advanced foot is set perfectly level, as if placed on the ground, instead of being thrown back behind like a heron's, as in most modern figures of this kind.

The sculptures themselves are not good; but these pieces of feeling in them are very admirable [*sic*]. The two figures on the other side, St Mark and St Theodore, are inferior, though all by the same sculptor, Girolamo Campagna.

The bridge was built by Antonio da Ponte, in 1588. It was anciently of wood, with a drawbridge in the centre, a representation of which may be seen in one of Carpaccio's pictures at the Accademia delle Belle Arti: and the traveller should observe that the interesting effect, both of this and the Bridge of Sighs, depends in great part on their both being *more* than bridges; the one a covered passage, the other a row of shops, sustained on an arch. No such effect can be produced merely by the masonry of the roadway itself.

Left Rialto Bridge, built by Antonio da Ponte in 1588; in the foreground a vaporetto.

Right Angel of the Annunciation on the south side of the Rialto Bridge.

RIO DEL PALAZZO, II–VIII–III. *In this chapter on the Ducal Palace Ruskin writes:* This Rio, or canal, is usually looked upon by the traveller with great respect, or even horror, because it passes under the Bridge of Sighs. It is, however, one of the principal thoroughfares of the city; and the bridge and its canal together occupy, in the mind of a Venetian, very much the position of Fleet Street and Temple Bar in that of a Londoner—at least, at the time when the Temple Bar was occasionally decorated with human heads. The two buildings closely resemble each other in form.

The Temple Bar was dismantled in 1878 and was re-erected at Theobalds Park in Hertfordshire. Its position on the boundary of Fleet Street is marked by a monument.

ROCCO, CAMPIELLO DI S., windows in, II–VII–XXXV *Ruskin refers to this little square in the chapter on Gothic palaces:*
The little Campiello S. Rocco is entered by a sotto-portico behind the Church of the Frari. Looking back, the upper traceries of the magnificent apse are seen towering above the irregular roofs and chimneys of the little square; and our lost Prout [*Samuel Prout, English watercolourist, 1783–1852*] was enabled to bring the whole subject into an exquisitely picturesque composition, by the fortunate occurrence of four quaint trefoiled windows in one of the houses on the right. Those trefoils are among the most ancient efforts of Gothic art in Venice. I have given a rude sketch of them [*see first illustration*]. They are built entirely of brick, except the central shaft and capital, which are of Istrian stone. Their structure is the simplest possible; the trefoils being cut out of the radiating bricks which form the pointed arch, and the edge or upper limit of that pointed arch indicated by a roll moulding formed of cast bricks, in

Two of Ruskin's drawings of details in the Campiello di S. Rocco. On the left, trefoiled window arches; on the right the rolled mouldings of these arches (Volume II, Figures XXXIII and XXXIV).

length of about a foot, and ground at the bottom so as to meet in one, as in [*the second illustration*]. The capital of the shaft is one of the earliest transitional forms; and observe the curious following out, even in this minor instance, of the great law of centralization above explained with respect to the Byzantine palaces. There is a central shaft, a pilaster on each side, and then the wall. The pilaster has, by way of capital, a square flat brick, projecting a little, and cast, at the edge, into the form of the first type of all cornices [*Ruskin refers the reader to Chapter VI on the wall cornice in Volume I*]; and the shafts and pilasters all stand, without any added bases, on a projecting plinth of the same simple profile. These windows have been much defaced; but I have not the least doubt that their plinths are the original ones: and the whole group is one of the most valuable in Venice, as showing the way in which the humblest houses, in the noble times, followed out the system of the larger palaces, as far as they could, in their rude materials. It is not often that the dwellings of the lower orders are preserved to us from the thirteenth century.

R o c c o, C h u r c h o f S. Notable only for the most interesting pictures by Tintoretto which it contains, namely:

1. *S. Rocco before the Pope.* (On the left of the door as we enter.) A delightful picture in his best manner, but not much laboured; and, like several other pictures in this church, it seems to me to have been executed at some period of the painter's life when he was either in ill-health, or else had got into a mechanical way of painting, from having made too little reference to nature for a long time. There is something stiff and forced

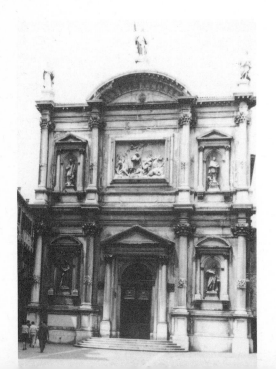

Renaissance-Baroque façade
of the Church of S. Rocco.

in the white draperies on both sides, and a general character about the whole which I can feel better than I can describe; but which, if I had been the painter's physician, would have immediately caused me to order him to shut up his painting-room, and take a voyage to the Levant and back again. The figure of the Pope is, however, extremely beautiful, and is not unworthy, in its jewelled magnificence, here dark against the sky, of comparison with the figure of the high priest in the 'Presentation', in the Scuola di S. Rocco.

2. *Annunciation.* (On the other side of door, on entering.) A most disagreeable and dead picture, having all the faults of the age, and none of the merits of the painter. It must be a matter of future investigation to me, what could cause the fall of his mind from a conception so great and so fiery as that of the 'Annunciation' in the Scuola di S. Rocco, to this miserable reprint of an idea worn out centuries before. One of the most inconceivable things in it, considered as the work of Tintoretto, is that where the angel's robe drifts away behind his limb: one cannot tell by the character of the outline, or by the tones of the colour, whether the cloud comes in before the robe, or whether the robe cuts upon the cloud. The Virgin is uglier than that of the Scuola, and not half so real; and the draperies are crumpled in the most commonplace and ignoble folds. It is a picture well worth study, as an example of the extent to which the greatest mind may be betrayed by the abuse of its powers, and the neglect of its proper food in the study of nature.

3. *Pool of Bethesda.* (On the right side of the church, in its centre, the lowest of the two pictures which occupy the wall.) A noble work, but eminently disagreeable, as must be all pictures of this subject; and with the same character in it of undefinable want, which I have noticed in the two preceding works. The main figure in it is the cripple, who has taken up his bed; but the whole effect of this action is lost by his not turning to Christ, but flinging it on his shoulder like a triumphant porter with a huge load; and the corrupt Renaissance architecture, among which the figures are crowded, is both ugly in itself, and much too small for them. It is worth noticing, for the benefit of persons who find fault with the perspective of the Pre-Raphaelites, that the perspective of the brackets beneath these pillars is utterly absurd; and that, in fine, the presence or absence of perspective has nothing to do with the merits of a great picture: not that the perspective of the Pre-Raphaelites *is* false in any case that I have examined, the objection being just as untenable as it is rediculous.

4. *S. Rocco in the Desert.* (Above the last-named picture.) A single recumbent figure in a not very interesting landscape, deserving less attention than a picture of St Martin just opposite to it—a noble and knightly figure on horseback by Pordenone, to which I cannot pay a greater compli-

ment than by saying that I was a considerable time in doubt whether or not it was another Tintoretto.

5. *S. Rocco in the Hospital.* (On the right-hand side of the altar.) There are four vast pictures by Tintoretto in the dark choir of this church, not only important by their size (each being some twenty-five feet long by ten feet high), but also elaborate compositions; and remarkable, one for its extraordinary landscape, and the other as the most studied picture in which the painter has introduced horses in violent action. . . . This picture, which I have called 'S. Rocco in the Hospital', shows him, I suppose, in his general ministrations at such places, and is one of the usual representations of disgusting subjects from which neither Orcagna nor Tintoretto seems ever to have shrunk. It is a very noble picture, carefully composed and highly wrought; but to me gives no pleasure, first, on account of its subject, secondly, on account of its dull brown tone all over—it being impossible, or nearly so, in such a scene, and at all events inconsistent with its feeling, to introduce vivid colour of any kind. So it is a brown study of diseased limbs in a close room.

6. *Cattle Piece.* (Above the picture last described.) I can give no other name to this picture, whose subject I can neither guess nor discover, the picture being in the dark, and the guide-books leaving me in the same position. All I can make out of it is, that there is a noble landscape, with cattle and figures. It seems to me the best landscape of Tintoretto's in Venice, except the 'Flight into Egypt'; and is even still more interesting from its savage character, the principal trees being pines, something like Titian's in his 'St Francis receiving the Stigmata', and chestnuts on the slopes and in the hollows of the hills: the animals also seem first-rate. But it is too high, too much faded, and too much in the dark to be made out. It seems never to have been rich in colour, rather cool and grey, and very full of light.

7. *Finding of Body of S. Rocco.* (On the left-hand side of the altar.) An elaborate, but somewhat confused picture, with a flying angel in a blue drapery; but it seemed to me altogether uninteresting, or, perhaps, requiring more study than I was able to give it.

8. *S. Rocco in Campo d'Armata.* So this picture is called by the sacristan. I could see no S. Rocco in it; nothing but a wild group of horses and warriors in the most magnificent confusion of fall and flight ever painted by man. They seem all dashed different ways as if by a whirlwind; and a whirlwind there must be, or a thunderbolt, behind them, for a huge tree is torn up and hurled into the air beyond the central figure, as if it were a shivered lance. Two of the horses meet in the midst, as if in a tournament; but in madness of fear, not in hostility: on the horse to the right is a standard-bearer, who stoops as from some foe behind him, with the lance laid across his saddle-bow, level, and the flag

stretched out behind him as he flies, like the sail of a ship drifting from its mast; the central horseman, who meets the shock, of storm, or enemy, whatever it be, is hurled backwards from his seat, like a stone from a sling; and this figure, with the shattered tree trunk behind it, is the most noble part of the picture. There is another grand horse on the right, however, also in full action. Two gigantic figures on foot, on the left, meant to be nearer than the others, would, it seems to me, have injured the picture, had they been clearly visible; but time has reduced them to perfect subordination.

The Church of S. Rocco, the patron saint of plague victims, was built in 1490, in the Renaissance style, to the design of Bartolomeo Bon. It was largely rebuilt in 1725 by Giovanni Scalfarotto and later, in 1771, a new Renaissance-Baroque façade was added by Bernardino Maccaruzzi.

R O C C O , S C U O L A D I S., bases of, I–XXV–XVIII, I–Appendix 24; soffit ornaments of I–XXVIII–VIII.

The Venetian 'scuole', or lay confraternities, had much in common with other European guilds, although they flourished longer. Membership was based on a common craft or nationality, a particular religious cult, or a charity to which the members devoted themselves.

Members were bound by their scuola's code of rules, pledging them-selves, in particular, to come to the aid of fellow members in distress. An annual subscription provided the necessary funds, and where a surplus was available this was frequently put towards refurbishing the premises. Many of Venice's leading artists contributed to this end and thus the scuole came to play a very important role as patrons of the arts. The scuole were all closed down by Napoleon but two were later reopened: the Scuola di S. Rocco and the Scuola di S. Giorgio degli Schiavoni.

The building of the Scuola di S. Rocco was begun in 1517, planned on Renaissance principles by Bartolomeo Bon, the master mason from S. Marco. The work was continued by Scarpagnino (Antonio Abbondi) and was partially completed for occupation by 1536. Further work was continued under Giovanni Giacomo dei Grisi up to 1560. An idea of its principal façade can be obtained from Canaletto's picture of the Doge visiting the scuola in 1735. The picture is now housed in the National Gallery in London and is reproduced here.

Ruskin's general appraisal of the Scuola S. Rocco is of an 'interesting building of the early Renaissance (1517), passing into Roman Renais-sance. The wreaths of leafage about its shafts are wonderfully delicate and fine, though misplaced.' In Appendix 24 (Volume I) Ruskin discusses this decoration in greater detail:

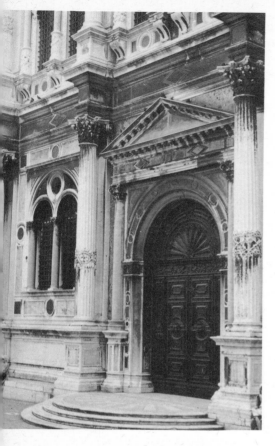

(*left*) Main entrance of the Scuola di S. Rocco showing the marble inlay and wreaths round the columns mentioned by Ruskin.

(*right*) Picture by Canaletto of 'The Doge visiting the Chiesa and Scuola di S. Rocco' 1730–43 (by courtesy of the Trustees of the National Gallery, London). The scuola façade is the same today as in this picture, but the church on the right is as it was before the new Renaissance façade, still to be seen today (see p. 210). It was designed by Bernardino Maccanozzi and erected in 1771.

The Scuola di S. Rocco is one of the most interesting examples of Renaissance work in Venice. Its fluted pillars are surrounded each by a wreath, one of vine, another of laurel, another of oak, not indeed arranged with the fantasticism of early Gothic; but, especially the laurel, reminding one strongly of the laurel sprays, powerful as well as beautiful, of Veronese and Tintoretto. Their stems are curiously and richly interlaced —the last vestige of the Byzantine wreathed work—and the vine-leaves are ribbed on the surfaces, I think, nearly as fine as those of the Noah [*one of the sculptured 'angles' on the Ducal Palace—qv*], though more injured by time. The capitals are far the richest Renaissance in Venice, less corrupt and more masculine in plan than any other, and truly suggestive of support, though of course showing the tendency to error in this respect; and finally, at the angles of the pure Attic bases, on the square plinth, are set couchant animals; one, an elephant four inches high, very curiously and cleverly cut, and all these details worked with a spirit, finish, fancy, and affection quite worthy of the middle ages. But

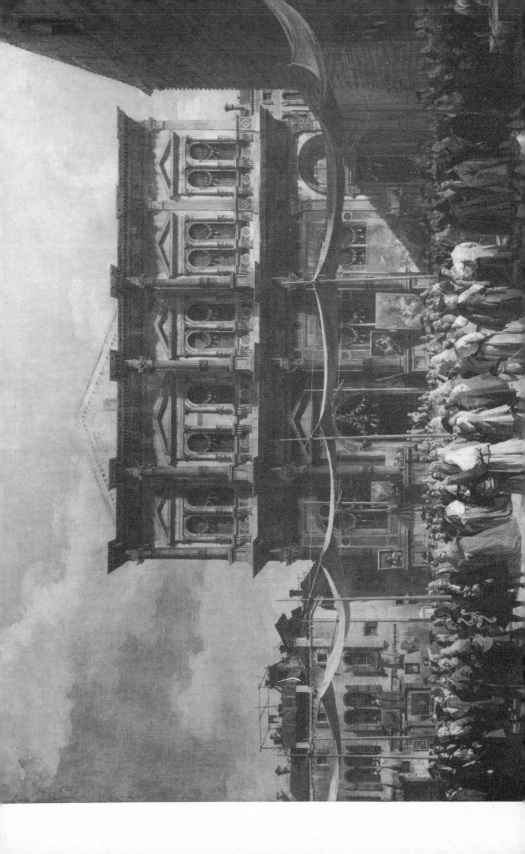

they have all the marked fault of being utterly detached from the architecture. The wreaths round the columns look as if they would drop off the next moment, and the animals at the bases produce exactly the effect of mice who had got there by accident: one feels them ridiculously diminutive, and utterly useless.

The effect of diminutiveness is, I think, chiefly owing to there being no other groups or figures near them, to accustom the eye to the proportion, and to the needless choice of the largest animals, elephants, bears, and lions, to occupy a position so completely insignificant, and to be expressed on so contemptible a scale—not in a bas-relief or pictorial piece of sculpture, but as independent figures. The whole building is a most curious illustration of the appointed fate of the Renaissance architects—to caricature whatever they imitated, and misapply whatever they learned.

Elsewhere (I–XXV–XVIII) Ruskin criticizes the architect of the Scuola di S. Rocco who, 'imitating the mediaeval base, which he did not understand, has put an elephant, four inches high, in the same position'.

Ruskin discusses another architectural detail of the Scuola, the soffit, or underside of a window, vault, lintel, etc. These conform to the general rule which he states as follows:

I–XXVIII–VIII. . . . while the outside or vertical surface may properly be decorated, and yet the soffit or under surface left plain, the soffit is never to be decorated, and the outer surface left plain. Much beautiful sculpture is, in the best Byzantine buildings, half lost by being put under soffits; but the eye is led to discover it, and even to demand it, by the rich chasing of the outside of the voussoirs. It would have been an hypocrisy to carve them externally only. But there is not the smallest excuse for carving the soffit, and not the outside; for, in that case, we approach the building under the idea of its being perfectly plain; we do not look for the soffit decoration, and, of course, do not see it; or, if we do, it is merely to regret that it should not be in a better place. In the Renaissance architects, it may, perhaps, for once, be considered a merit, that they put their bad decoration systematically in the places where we should least expect it, and can seldomest see it:—Approaching the Scuola di S. Rocco, you probably will regret the extreme plainness and barrenness of the window traceries; but, if you will go very close to the wall beneath the windows, you may, on sunny days, discover a quantity of panel decorations which the ingenious architect has concealed under the soffits.

The Index itself continues on the Scuola di S. Rocco:

As regards the pictures which it contains, it is one of the three most precious buildings in Italy; buildings, I mean, consistently decorated with a series of paintings at the time of their erection, and still exhibiting that

series in its original order. I suppose there can be little question but that the three most important edifices of this kind in Italy, are the Sistine Chapel, the Campo Santo of Pisa, and the Scuola di S. Rocco at Venice: the first painted by Michelangelo; the second by Orcagna, Benozzo Gozzoli, Pietro Laurati, and several other men whose works are as rare as they are precious; and the third by Tintoretto.

Whatever the traveller may miss in Venice, he should, therefore, give unembarrassed attention and unbroken time to the Scuola di S. Rocco; and I shall, accordingly, number the pictures, and note in them, one by one, what seemed to me most worthy of observation.

They are sixty-two in all, but eight of these are merely of children or children's heads, and two of unimportant figures. The number of valuable pictures is fifty-two; arranged on the walls and ceilings of three rooms, so badly lighted, in consequence of the admirable arrangements of the Renaissance architect, that it is only in the early morning that some of the pictures can be seen at all, nor can they ever be seen but imperfectly. They were all painted, however, for their places in the dark, and, as compared with Tintoretto's other works, are therefore, for the most part, nothing more than vast sketches, made to produce, under a certain degree of shadow, the effect of finished pictures. Their treatment is thus to be considered as a kind of scene-painting; differing from ordinary scene-painting only in this, that the effect aimed at is not *that of a natural scene*, but *of a perfect picture* [*Ruskin's italics*]. They differ in this respect from all other existing works; for there is not, as far as I know, any other instance in which a great master has consented to work for a room plunged into almost total obscurity. It is probable that none but Tintoretto would have undertaken the task, and most fortunate that he was forced to it. For in this magnificent scene-painting we have, of course, more wonderful examples, both of his handling and knowledge of effect, than could ever have been exhibited in finished pictures; while the necessity of doing much with few strokes keeps his mind so completely on the stretch throughout the work (while yet the velocity of production prevented his being wearied), that no other series of his works exhibits powers so exalted. On the other hand, owing to the velocity and coarseness of the painting, it is more liable to injury through drought or damp; and as the walls have been for years continually running down with rain, and what little sun gets into the place contrives to fall all day right on one or other of the pictures, they are nothing but wrecks of what they were; and the ruins of paintings originally coarse are not likely ever to be attractive to the public mind. Twenty or thirty years ago they were taken down to be retouched; but the man to whom the task was committed providentially died, and only one of them was spoiled. I have found traces of his work upon another, but not to an extent very seriously

destructive. The rest of the sixty-two, or, at any rate, all that are in the upper room, appear entirely intact.

The process of cleaning and restoring all the pictures in the Scuola di S. Rocco was begun in 1969 and is now near to completion. The work is being done with the assistance of the International Fund for Monuments (USA). About two-thirds were completed in 1974 when I inspected them. The cleaning has revealed considerable richness of colour which probably can now be more fully appreciated than when Ruskin saw them. The illustrations of Tintoretto's pictures shown here were taken after cleaning.

All these paintings by Tintoretto were done on canvas which, like all woven textiles, was manufactured in standard sizes according to the width of the loom. A common width of canvas in Venice at the time of Tintoretto was about 110 cm, sometimes a little more, so that for large pictures like those in the Scuola di S. Rocco several widths would be sewn together.

Whilst the cleaning and restoration of a number of Tintorettos was in hand, both in this Scuola, and in the Accademia, the Madonna dell' Orto and the National Gallery, London, an examination of some of them was carried out by Joyce Plester of the Scientific Department of the National Gallery, and Lorenzo Lazzarini, of the Laboratory of S. Gregorio in Venice, the results of which were given in a paper on the 'Technique and Materials of Tintoretto'. They found that in the picture of the 'Adoration of the Shepherds' (No. 10 below), along the line of the dividing floor, several small strips of canvas seemed to have been inserted as though the upper and lower halves of the picture had been painted separately then joined together, with the upraised hand of the shepherd painted over the jambs.

Although, as compared with his other works, they are all very scenic in execution, there are great differences in their degrees of finish; and, curiously enough, some on the ceilings and others in the darkest places in the lower room are very nearly finished pictures, while the 'Agony in the Garden', which is in one of the best lights in the upper room, appears to have been painted in a couple of hours with a broom for a brush.

For the traveller's greater convenience I shall give a rude plan of the arrangement, and list of the subjects, of each group of pictures before examining them in detail.

1. *The Annunciation.* This, which first strikes the eye, is a very just representative of the whole group, the execution being carried to the utmost limits of boldness consistent with completion. It is a well-known picture, and need not therefore be specially described, but one or two points in it require notice. The face of the Virgin is very disagreeable

First group. On the walls of the room on the ground floor

1. Annunciation
2. Adoration of Magi
3. Flight into Egypt
4. Massacre of Innocents

5. The Magdalen
6. St Mary of Egypt
7. Circumcision
8. Assumption of Virgin

At the turn of the stairs leading to the upper room:
9. Visitation

to the spectator from below, giving the idea of a woman about thirty, who had never been handsome. If the face is untouched, it is the only instance I have ever seen of Tintoretto's failing in an intended effect, for, when seen near, the face is comely and youthful, and expresses only surprise, instead of the pain and fear of which it bears the aspect in the distance. I could not get near enough to see whether it had been retouched. It looks like Tintoretto's work, though rather hard; but, as there are unquestionable marks of the re-touching of this picture, it is possible that some slight restoration of lines supposed to be faded, entirely alter the distant expression of the face. One of the evident pieces of repainting is the scarlet of the Madonna's lap, which is heavy and lifeless. A far more injurious one is the strip of sky seen through the doorway by which the angel enters, which has originally been of the deep golden colour of the distance on the left, and which the blundering restorer has daubed over with whitish blue, so that it looks like a bit of the wall; luckily he has not touched the outlines of the angel's black wings, on which the whole expression of the picture depends. This angel and the group of small cherubs above form a great swinging chain, of which the dove representing the Holy Spirit forms the bend. The angels in their flight seem to be attached to this as the train of fire is to a rocket; all of them appearing to have swooped down with the swiftness of a falling star.

2. *Adoration of the Magi.* The most finished picture in the Scuola except the 'Crucifixion', and perhaps the most delightful of the whole. It unites every source of pleasure that a picture can possess: the highest elevation of principal subject, mixed with the lowest detail of picturesque incident; the dignity of the highest ranks of men, opposed to the simplicity of the lowest; the quietness and serenity of an incident in cottage life, contrasted with the turbulence of troops of horsemen and the spiritual power of angels. The placing of the two doves as principal points of light in the front of the picture, in order to remind the spectator of the poverty of the mother whose child is receiving the offerings and adoration of three monarchs, is one of Tintoretto's master touches; the whole scene, indeed, is conceived in his happiest manner. Nothing can be at once more humble or more dignified than the bearing of the kings; and there is a sweet reality given to the whole incident by the Madonna's stooping forward and lifting her hand in admiration of the vase of gold which has been set before the Christ, though she does so with such gentleness and quietness that her dignity is not in the least injured by the simplicity of the action. As if to illustrate the means by which the Wise Men were brought from the East, the whole picture is nothing but a large star, of which the

'Adoration of the Magi' by Tintoretto. Scuola di S. Rocco.

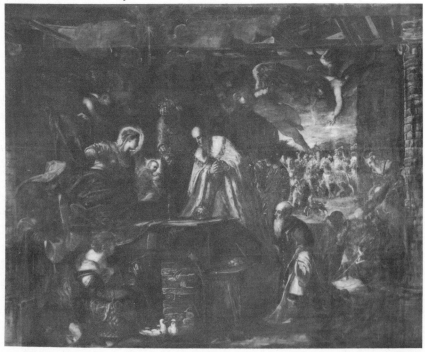

Christ is the centre; all the figures, even the timbers of the roof, radiate from the small bright figure on which the countenances of the flying angels are bent, the star itself, gleaming through the timbers above, being quite subordinate. The composition would almost be too artificial were it not broken by the luminous distance where the troop of horsemen are waiting for the kings. These, with a dog running at full speed, at once interrupt the symmetry of the lines, and form a point of relief from the over-concentration of all the rest of the action.

Ruskin made a careful watercolour copy of this picture which is testimony of his admiration. It hangs in the Ruskin Galleries, Bembridge.

3. *Flight into Egypt*. One of the principal figures here is the donkey. I have never seen any of the nobler animals—lion, or leopard, or horse, or dragon—made so sublime as this quiet head of the domestic ass, chiefly owing to the grand motion in the nostril and writhing in the ears. The space of the picture is chiefly occupied by lovely landscape, and the Madonna and St Joseph are pacing their way along a shady path upon the banks of a river at the side of the picture. I had not any conception, until I got near, how much pains had been taken with the Virgin's head; its expression is as sweet and as intense as that of any of Raphael's, its reality far greater. The painter seems to have intended that everything should be subordinate to the beauty of this single head; and the work is

'Flight into Egypt' by Tintoretto, Scuola di S. Rocco.

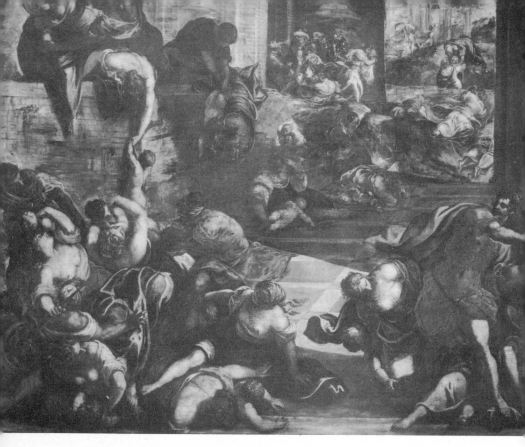

'Massacre of the Innocents' by Tintoretto, Scoula di S. Rocco.

a wonderful proof of the way in which a vast field of canvas may be made conducive to the interest of a single figure. This is partly accomplished by slightness of painting, so that on close examination, while there is everything to astonish in the masterly handling and purpose, there is not much perfect or very delightful painting; in fact, the two figures are treated like the living figures in a scene at the theatre, and finished to perfection, while the landscape is painted as hastily as the scenes, and with the same kind of opaque size colour. It has, however, suffered as much as any of the series, and it is hardly fair to judge of its tones and colours in its present state.

4. *Massacre of the Innocents*. The following account of this picture, given in *Modern Painters* [*also by Ruskin*], may be useful to the traveller, and is therefore here repeated. 'I have before alluded to the painfulness of Raphael's treatment of the Massacre of the Innocents. Fuseli affirms of it, that "in dramatic gradation he disclosed all the mother through every image of pity and of terror". If this be so, I think the philosophical spirit has prevailed over the imaginative. The imagination never errs; it sees

all that is, and all the relations and bearings of it; but it would not have confused the mortal frenzy of maternal terror with various development of maternal character. Fear, rage, and agony, at their utmost pitch, sweep away all character: humanity itself would be lost in maternity, the woman would become the mere personification of animal fury or fear. For this reason all the ordinary representations of this subject are, I think, false and cold: the artist has not heard the shrieks, nor mingled with the fugitives; he has sat down in his study to convulse features methodically, and philosophize over insanity. Not so Tintoretto. Knowing, or feeling, that the expression of the human face was, in such circumstances, not to be rendered, and that the effort could only end in an ugly falsehood, he denies himself all aid from the features, he feels that if he is to place himself or us in the midst of that maddened multitude, there can be no time allowed for watching expression. Still less does he depend on details of murder or ghastliness of death; there is no blood, no stabbing or cutting, but there is an awful substitute for these in the chiaroscuro. The scene is the outer vestibule of a palace, the slippery marble floor is fearfully barred across by sanguine shadows, so that our eyes seem to become bloodshot and strained with strange horror and deadly vision; a lake of life before them, like the burning seen of the doomed Moabite on the water that came by the way of Edom: a huge flight of stairs, without parapet, descends on the left; down this rush a crowd of women mixed with the murderers; the child in the arms of one has been seized by the limbs; she hurls herself over the edge, and falls head downmost, dragging the child out of the grasp by her weight; she will be dashed dead in a second; close to us is the great struggle; a heap of the mothers, entangled in one mortal writhe with each other and the swords; one of the murderers dashed down and crushed beneath them, the sword of another caught by the blade and dragged at by a woman's naked hand; the youngest and fairest of the women, her child just torn away from a death grasp, and clasped to her breast with the grip of a steel vice, falls backwards, helplessly over the heap, right on the sword points; all knit together and hurled down in one hopeless, frenzied, furious abandonment of body and soul in the effort to save. Far back, at the bottom of the stairs, there is something in the shadow like a heap of clothes. It is a woman, sitting quiet—quite quiet—still as any stone; she looks down steadfastly on her dead child, laid along on the floor before her, and her hand is pressed softly upon her brow.'

I have nothing to add to the above description of this picture, except that I believe there may have been some change in the colour of the shadow that crosses the pavement. The chequers of the pavements are, in the light, golden white and pale grey; in the shadow, red and dark grey, the white in the sunshine becoming red in the shadow. I formerly

supposed that this was meant to give greater horror to the scene, and it is very like Tintoretto, if it be so; but there is a strangeness and discordance in it which makes me suspect the colours may have changed.

5. *The Magdalen*. This and the picture opposite to it, 'St Mary of Egypt', have been painted to fill up narrow spaces between the windows which were not large enough to receive compositions, and yet in which single figures would have looked awkwardly thrust into the corner. Tintoretto has made these spaces as large as possible by filling them with landscapes, which are rendered interesting by the introduction of single figures of very small size. He has not, however, considered his task, of making a small piece of wainscot look like a large one, worth the stretch of his powers, and has painted these two landscapes just as carelessly and as fast as an upholsterer's journeyman finishing a room at a railroad hotel. The colour is for the most part opaque, and dashed or scrawled on in the manner of a scene-painter; and as during the whole morning the sun shines upon the one picture, and during the afternoon upon the other, hues, which were originally thin and imperfect, are now dried in many places into mere dirt upon the canvas. With all these drawbacks the pictures are of very high interest, for although, as I said, hastily and carelessly, they are not languidly painted; on the contrary, he has been in his hottest and grandest temper; and in this first one (Magdalen) the laurel-tree, with its leaves driven hither and thither among flakes of fiery cloud, has been probably one of the greatest achievements that his hand performed in landscape: its roots are entangled in underwood, of which every leaf seems to be articulated, yet all is as wild as if it had grown there instead of having been painted; there has been a mountain distance, too, and a sky of stormy light, of which I infinitely regret the loss, for though its masses of light are still discernible, its variety of hue is all sunk into a withered brown. There is a curious piece of execution in the striking of the light upon a brook which runs under the roots of the laurel in the foreground: these roots are traced in shadow against the bright surface of the water; another painter would have drawn the light first, and drawn the dark roots over it. Tintoretto has laid in a brown ground which he has left for the roots, and painted the water through their interstices with a few mighty rolls of his brush laden with white.

6. *St Mary of Egypt*. This picture differs but little, in the plan, from the one opposite, except that St Mary has her back towards us, and the Magdalen her face, and that the tree on the other side of the brook is a palm instead of a laurel. The brook (Jordan ?) is, however, here, much more important; and the water painting is exceedingly fine. Of all painters that I know, in old times, Tintoretto is the fondest of running water; there was a sort of sympathy between it and his own impetuous spirit. The

rest of the landscape is not of much interest, except so far as it is pleasant to see trunks of trees drawn by single strokes of the brush.

7. *The Circumcision of Christ.* The custode has some story about this picture having been painted in imitation of Paul Veronese. I much doubt if Tintoretto ever imitated anybody; but this picture is the expression of his perception of what Veronese delighted in, the nobility that there may be in mere golden tissue and coloured drapery. It is, in fact, a picture of the moral power of gold and colour; and the chief use of the attendant priest is to support upon his shoulders the crimson robe, with its square tablets of black and gold; and yet nothing is withdrawn from the interest or dignity of the scene. Tintoretto has taken immense pains with the head of the high priest. I know not any existing old man's head so exquisitely tender, or so noble in its lines. He receives the infant Christ in his arms kneeling, and looking down upon the child with infinite veneration and love; and the flashing of golden rays from its head is made the centre of light and all interest. The whole picture is like a golden charger to receive the Child; the priest's dress is held up behind him, that it may occupy larger space; the tables and floor are covered with chequer-work; the shadows of the temple are filled with brazen lamps; and above all are hung masses of curtains, whose crimson folds are strewn over with golden flakes. Next to the 'Adoration of the Magi' this picture is the most laboriously finished of the Scuola di S. Rocco, and it is unquestionably the highest existing type of the sublimity which may be thrown into the treatment of accessories of dress and decoration.

8. *Assumption of the Virgin.* On the tablet or panel of stone which forms the side of the tomb out of which the Madonna rises is, this inscription, in large letters, R E S T. A N T O N I U S F L O R I A N, 1834. Exactly in proportion to a man's idiocy is always the size of the letters in which he writes his name on the picture that he spoils. The old mosaicists in St Mark's have not, in a single instance, as far as I know, signed their names; but the spectator who wishes to know who destroyed the effect of the nave, may see his name inscribed, twice over, in letters half a foot high, B A R T O L O M E O B O Z Z A. I have never seen Tintoretto's name signed, except in the great 'Crucifixion'; but this Antony Florian, I have no doubt, repainted the whole side of the tomb that he might put his name on it. The picture is, of course, ruined wherever he touched it, that is to say, half over: the circle of cherubs in the sky is still pure; and the design of the great painter is palpable enough yet in the grand flight of the horizontal angel, on whom the Madonna half leans as she ascends. It has been a noble picture, and is a grievous loss; but, happily, there are so many pure ones, that we need not spend time in gleaning treasures out of the ruins of this.

9. *Visitation.* A small picture, painted in his very best manner; exquisite in its simplicity, unrivalled in vigour, well preserved, and, as a piece of painting, certainly one of the most precious in Venice. Of course, it does not show any of his high inventive powers; nor can a picture of four middle-sized figures be made a proper subject of comparison with large canvases containing forty or fifty; but it is, for this very reason, painted with such perfect ease, and yet with no slackness either of affection or power, that there is no picture that I covet so much. It is, besides, altogether free from the Renaissance taint of dramatic effect. The gestures are as simple and natural as Giotto's, only expressed by grander lines, such as none but Tintoretto ever reached. The draperies are dark, relieved against a light sky, the horizon being excessively low, and the outlines of the drapery so severe that the intervals between the figures look like ravines between great rocks, and have all the sublimity of an alpine valley at twilight. This precious picture is hung about thirty feet above the eye, but by looking at it in a strong light, it is discoverable that the St Elizabeth is dressed in green and crimson, the Virgin in the peculiar red which all great colourists delight in—a sort of glowing brick colour or brownish scarlet, opposed to a rich golden brownish black; and both have white kerchiefs, or drapery, thrown over their shoulders. Zacharias leans on his staff behind them in a black dress with white sleeves. The stroke of brilliant white light, which outlines the knee of St Elizabeth, is a curious instance of the habit of the painter to relieve his dark forms by a sort of halo of more vivid light, which, until lately, one would have been apt to suppose a somewhat artificial and unjustifiable means of effect. The daguerreotype has shown—what the naked eye never could—that the instinct of the great painter was true, and that there is actually such a sudden and sharp line of light round the edges of dark objects relieved by luminous space.

Opposite this picture is a most precious Titian, the 'Annunciation', full of grace and beauty. I think the Madonna one of the sweetest figures he ever painted. But if the traveller has entered at all into the spirit of Tintoretto, he will immediately feel the comparative feebleness and conventionality of the Titian. Note especially the mean and petty folds of the angels' drapery, and compare them with the draperies of the opposite picture. The larger pictures at the sides of the stairs by Zanchi and Negri are utterly worthless.

10. *The Adoration of the Shepherds.* This picture commences the series of the upper room, which, as already noticed, is painted with far less care than that of the lower. It is one of the painter's inconceivable caprices that the only canvases that are in good light should be covered in this hasty manner, while those in the dungeon below, and on the ceiling above, are all highly laboured. It is, however, just possible that the covering of

Second group. On the walls of the upper room

10. Adoration of Shepherds
11. Baptism
12. Resurrection
13. Agony in Garden
14. Last Supper
15. Altar piece: S. Rocco

16. Miracle of Loaves

17. Resurrection of Lazarus
18. Ascension
19. Pool of Bethesda
20. Temptation
21. S. Rocco
22. St Sebastian

these walls may have been an after-thought, when he had got tired of his work. They are also, for the most part, illustrative of a principle of which I am more and more convinced every day, that historical and figure pieces ought not to be made vehicles for effects of light. The light which is fit for a historical picture is that tempered semi-sunshine of which, in general, the works of Titian are the best examples, and of which the picture we have just passed, 'The Visitation', is a perfect example from the hand of one greater than Titian; so also the three 'Crucifixions', of S. Rocco, S. Cassano, and St John and Paul; the 'Adoration of the Magi' here; and, in general, the finest works of the master; but Tintoretto was not a man to work in any formal or systematic manner; and, exactly like Turner, we find him recording every effect which Nature herself displays. Still, he seems to regard the pictures which deviate from the great general principle of colourists rather as 'tours de force' than as sources of pleasure; and I do not think there is any instance of his having worked out one of these tricky pictures with thorough affection, except only in the case of the 'Marriage of Cana'. By tricky pictures, I mean those which display light entering in different directions, and attract the eye to the effects rather than to the figure which displays them. Of this treatment, we have already had a marvellous instance in the candlelight picture of the 'Last Supper' in S. Giorgio Maggiore. This 'Adoration of the Shepherds' has probably

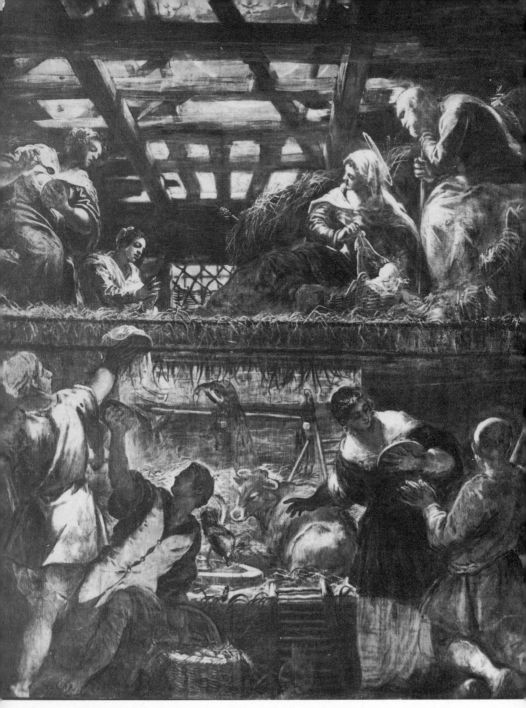

'Adoration of the Shepherds' by Tintoretto, Scuola di S. Rocco.

been nearly as wonderful when first painted: the Madonna is seated on a kind of hammock floor, made of rope netting, covered with straw; it divides the picture into two stories, of which the uppermost contains the Virgin, with two women who are adoring Christ, and shows light entering from above through the loose timbers of the roof of the stable, as well as through the bars of a square window; the lower division shows this light falling behind the netting upon the stable floor, occupied by a cock and a cow, and against this light are relieved the figures of the shepherds, for the most part in demi-tint, but with flakes of more vigorous sunshine falling here and there upon them from above. The optical illusion has originally been as perfect as in one of Hunt's best interiors: but it is most curious that no part of the work seems to have been taken any pleasure in by the painter; it is all by his hand, but it looks as if he had been bent only on getting over the ground. It is literally a piece of scene-painting, and is exactly what we might fancy Tintoretto to have done, had he been forced to paint scenes at a small theatre at a shilling a day. I cannot think that the whole canvas, though fourteen feet high and ten wide, or thereabouts, could have taken him more than a couple of days to finish: and it is very noticeable that exactly in proportion to the brilliant effects of light is the coarseness of the execution, for the figures of the Madonna, and of the women above, which are not in any strong effect, are painted with some care, while the shepherds and the cow are alike slovenly; and the latter, which is in full sunshine, is recognizable for a cow more by its size and that of its horns, than by any care given to its form. It is interesting to contrast this slovenly and mean sketch with the ass's head in the 'Flight into Egypt', on which the painter exerted his full power; as an effect of light, however, the work is, of course, most interesting. One point in the treatment is especially noticeable: there is a peacock in the rack beyond the cow; and, under other circumstances, one cannot doubt that Tintoretto would have liked a peacock in full colour, and would have painted it green and blue with great satisfaction. It is sacrificed to the light, however, and is painted in warm grey, with a dim eye or two in the tail: this process is exactly analogous to Turner's taking the colours out of the flags of his ships in the 'Gosport'. Another striking point is the litter with which the whole picture is filled in order more to confuse the eye: there is straw sticking from the roof, straw all over the hammock floor, and straw struggling hither and thither all over the floor itself; and, to add to the confusion, the glory round the head of the infant, instead of being united and serene, is broken into little bits, and is like a glory of chopped straw. But the most curious thing, after all, is the want of delight in any of the principal figures, and the comparative meanness and commonplaceness of even the folds of the drapery. It seems as if Tintoretto had determined to make the shepherds as uninteresting

as possible; but one does not see why their very clothes should be ill painted, and their disposition unpicturesque. I believe, however, though it never struck me until I had examined this picture, that this is one of the painter's fixed principles: he does not, with German sentimentality, make shepherds and peasants graceful or sublime, but he purposely vulgarizes them, not by making their actions or their faces boorish or disagreeable, but rather by painting them ill, and composing their draperies tamely. As far as I recollect at present, the principle is universal with him; exactly in proportion to the dignity of character is the beauty of the painting. He will not put out his strength upon any man belonging to the lower classes; and, in order to know what the painter is, one must see him at work on a king, a senator, or a saint. The curious connection of this with the aristocratic tendencies of the Venetian nation, when we remember that Tintoretto was the greatest man whom that nation produced, may become very interesting, if followed out. I forgot to note that, though the peacock is painted with great regardlessness of colour, there is a feature in it which no common painter would have observed—the peculiar flatness of the back, and undulation of the shoulders: the bird's body is all there, though its feathers are a good deal neglected; and the same thing is noticeable in a cock who is pecking among the straw near the spectator, though in other respects a shabby cock enough. The fact is, I believe he had made his shepherds so commonplace that he dared not paint his animals well, otherwise one would have looked at nothing in the picture but the peacock, cock, and cow. I cannot tell what the shepherds are offering; they look like milk-bowls, but they are awkwardly held up, with such twistings of body as would have certainly spilt the milk. A woman in front has a basket of eggs; but this I imagine to be merely to keep up the rustic character of the scene, and not part of the shepherds' offerings.

11. *Baptism.* There is more of the true picture quality in this work than in the former one, but still very little appearance of enjoyment or care. The colour is for the most part grey and uninteresting, and the figures are thin and meagre in form, and slightly painted; so much so, that, of the nineteen figures in the distance, about a dozen are hardly worth calling figures, and the rest are so sketched and flourished in that one can hardly tell which is which. There is one point about it very interesting to a landscape painter: the river is seen far into the distance, with a piece of copse bordering it; the sky beyond is dark, but the water nevertheless receives a brilliant reflection from some unseen rent in the clouds, so brilliant, that when I was first at Venice, not being accustomed to Tintoretto's slight execution, or to see pictures so much injured, I took this piece of water for a piece of sky. The effect, as Tintoretto has arranged it, is indeed somewhat unnatural, but it is valuable as showing

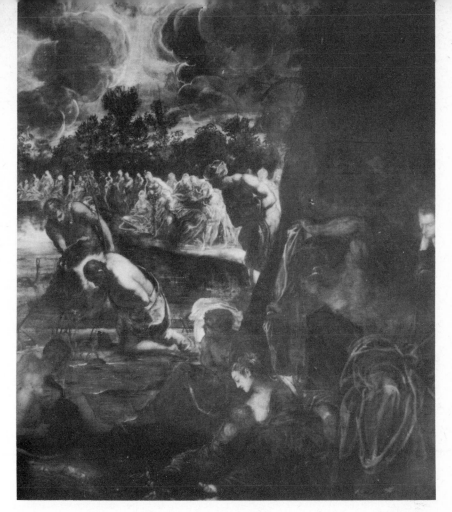

'Baptism of Christ' by Tintoretto, Scuola di S. Rocco.

his recognition of a principle unknown to half the historical painters of the present day—that the reflection seen in water is totally different from the object seen above it, and that it is very possible to have a bright light in reflection where there appears nothing but darkness to be reflected. The clouds in the sky itself are round, heavy, and lightless, and in a great degree spoil what would otherwise be a fine landscape distance. Behind the rocks on the right a single head is seen, with a collar on the shoulders: it seems to be intended for a portrait of some person connected with the picture.

12. *Resurrection.* Another of the 'effect of light' pictures, and not a very striking one, the best part of it being the two distant figures of the Maries seen in the dawn of the morning. The conception of the Resurrection itself is characteristic of the worst points of Tintoretto. His impetuosity is here in the wrong place: Christ bursts out of the rock like a

thunderbolt, and the angels themselves seem likely to be crushed under the rent stones of the tomb. Had the figure of Christ been sublime, this conception might have been accepted; but, on the contrary, it is weak, mean, and painful; and the whole picture is languidly or roughly painted, except only the fig-tree at the top of the rock, which, by a curious caprice, is not only drawn in the painter's best manner, but has golden ribs to all its leaves, making it look like one of the beautiful crossed or chequered patterns, of which he is so fond in his dresses; and leaves themselves being a dark olive brown.

13. *The Agony in the Garden.* I cannot at present understand the order of these subjects; but they may have been misplaced. This, of all the S. Rocco pictures, is the most hastily painted, but it is not, like those we have been passing, *clodly* painted; it seems to have been executed altogether with a hearth-broom, and in a few hours. It is another of the 'effects' and a very curious one; the angel who bears the cup to Christ is surrounded by a red halo; yet the light which falls upon the shoulders of the sleeping disciples, and upon the leaves of the olive-trees, is cool and silvery, while the troop coming up to seize Christ are seen by torch-light. Judas, who is the second figure, points to Christ, but turns his head away as he does so, as unable to look at him. That is a noble touch; the foliage is also exceedingly fine, though what kind of olive-tree bears such leaves I know not, each of them being about the size of a man's hand. If there be any which bear such foliage, their olives must be of the size of coconuts. This, however, is true only of the underwood, which is, perhaps, not meant for olive. There are some taller trees at the top of the picture, whose leaves are of a more natural size. On closely examining the figures of the troop on the left, I find that the distant ones are concealed, all but the limbs, by a sort of arch of dark colour, which is now so injured, that I cannot tell whether it was foliage or ground: I suppose it to have been a mass of close foliage, through which the troop is breaking its way; Judas rather showing them the path, than actually pointing to Christ, as it is written, 'Judas, who betrayed Him, knew the place'. St Peter, as the most zealous of the three disciples, the only one who was to endeavour to defend his Master, is represented as wakening and turning his head towards the troop, while James and John are buried in profound slumber, laid in magnificent languor among the leaves. The picture is singularly impressive, when seen far enough off, as an image of thick forest gloom amidst the rich and tender foliage of the South; the leaves, however, tossing as in disturbed night air, and the flickering of the torches, and of the branches, contrasted with the steady flame which from the angel's presence is spread over the robes of the disciples. The strangest feature in the whole is that the Christ also is represented as sleeping. The angel seems to appear to Him in a dream.

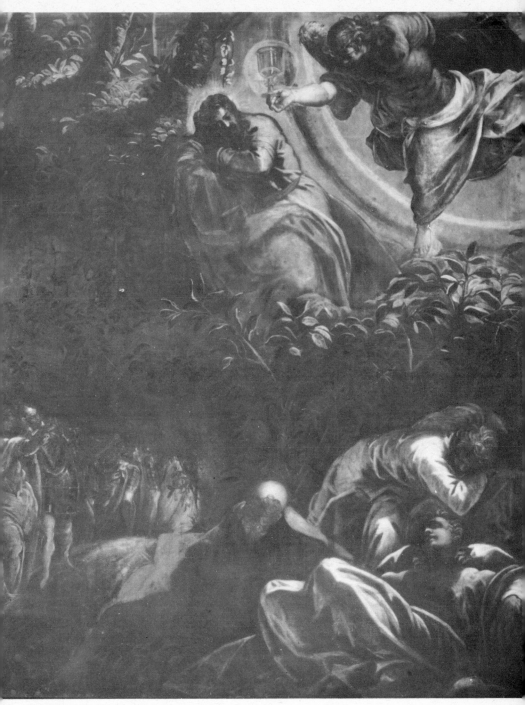

'Agony in the Garden' by Tintoretto, Scuola di S. Rocco.

14. *The Last Supper.* A most unsatisfactory picture; I think about the worst I know of Tintoretto's, where there is no appearance of retouching. He always makes the disciples in this scene too vulgar; they are here not only vulgar, but diminutive, and Christ is at the end of the table, the smallest figure of them all. The principal figures are two mendicants sitting on steps in front, a kind of supporters, but I suppose intended to be waiting for the fragments: a dog, in still more earnest expectation, is watching the movements of the disciples, who are talking together, Judas having but just gone out. Christ is represented as giving what one at first supposes is the sop to Judas, but as the disciple who receives it has a glory, and there are only eleven at table, it is evidently the sacramental bread. The room in which they are assembled is a sort of large kitchen, and the host is seen employed at a dresser in the background. This picture has not only been originally poor, but is one of those exposed all day to the sun, and is dried into mere dusty canvas: where there was once blue, there is now nothing.

15. *S. Rocco in Glory.* One of the worst order of Tintorettos, with apparent smoothness and finish, yet languidly painted, as if in illness or fatigue; very dark and heavy in tone also; its figures, for the most part, of an awkward middle size, about five feet high, and very uninteresting. S. Rocco ascends to Heaven, looking down upon a crowd of poor and sick persons who are blessing and adoring him. One of these, kneeling at the bottom, is very nearly a repetition, though a careless and indolent one, of that of St Stephen, in S. Giorgio Maggiore, and of the central figure in the 'Paradise' of the Ducal Palace. It is a kind of lay figure, of which he seems to have been fond; its clasped hands are here shockingly painted —I should think unfinished. It forms the only important light at the bottom, relieved on a dark ground; at the top of the picture, the figure of S. Rocco is seen in shadow against the light of the sky, and all the rest is in confused shadow. The commonplaceness of this composition is curiously connected with the languor of thought and touch throughout the work.

16. *Miracle of the Loaves.* Hardly anything but a fine piece of landscape is here left; it is more exposed to the sun than any other picture in the room, and its draperies having been, in great part, painted in blue, are now mere patches of the colour of starch; the scene is also very imperfectly conceived. The twenty-one figures, including Christ and His disciples, very ill represent a crowd of seven thousand; still less is the marvel of the miracle expressed by the perfect ease and rest of the reclining figures in the foreground, who do not so much as look surprised: considered merely as reclining figures, and as pieces of effect in half light, they have once been fine. The landscape, which represents the slope of a woody hill, has a very grand and far-away look. Behind it is a great

space of streaky sky, almost prismatic in colour, rosy and golden clouds covering up its blue, and some fine vigorous trees thrown against it; painted in about ten minutes each, however, by curly touches of the brush, and looking rather more like sea-weed than foliage.

17. *Resurrection of Lazarus.* Very strangely, and not impressively, conceived. Christ is half reclining, half sitting, at the bottom of the picture, while Lazarus is disencumbered of his grave-clothes at the top of it; the scene being the side of a rocky hill, and the mouth of the tomb probably once visible in the shadow on the left; but all that is now discernible is a man having his limbs unbound, as if Christ were merely ordering a prisoner to be loosed. There appears neither awe nor agitation, nor even much astonishment, in any of the figures of the group; but the picture is more vigorous than any of the three last mentioned, and the upper part of it is quite worthy of the master, especially its noble fig-tree and laurel, which he has painted, in one of his usual fits of caprice, as carefully as that in the 'Resurrection of Christ', opposite. Perhaps he has some meaning in this; he may have been thinking of the verse, 'Behold the fig-tree, and all the trees; when they now shoot forth', etc. In the present instance, the leaves are dark only, and have no golden veins. The uppermost figures also come dark against the sky, and would form a precipitous mass, like a piece of the rock itself, but that they are broken in upon by one of the limbs of Lazarus, bandaged and in full light, which, to my feeling, sadly injures the picture, both as a disagreeable object, and a light in the wrong place. The grass and weeds are, throughout, carefully painted, but the lower figures are of little interest, and the face of the Christ a grievous failure.

18. *The Ascension.* I have always admired this picture, though it is very slight and thin in execution, and cold in colour; but it is remarkable for its thorough effect of open air, and for the sense of motion and clashing in the wings of the angels which sustain the Christ: they owe this effect a good deal to the manner in which they are set, edge on; all seem like sword-blades cutting the air. It is the most curious in conception of all the pictures in the Scuola, for it represents, beneath the Ascension, a kind of epitome of what took place before the Ascension. In the distance are two apostles walking, meant, I suppose, for the two going to Emmaus; nearer are a group round a table, to remind us of Christ appearing to them as they sat at meat; and in the foreground is a single reclining figure of, I suppose, St Peter, because we are told that 'He was seen of Cephas, then of the twelve': but this interpretation is doubtful; for why should not the vision by the Lake of Tiberias be expressed also? And the strange thing of all is the scene, for Christ ascended from the Mount of Olives; but the disciples are walking, and the table is set, in a little marshy and grassy valley, like some of the bits near Maison Neuve on the Jura, with

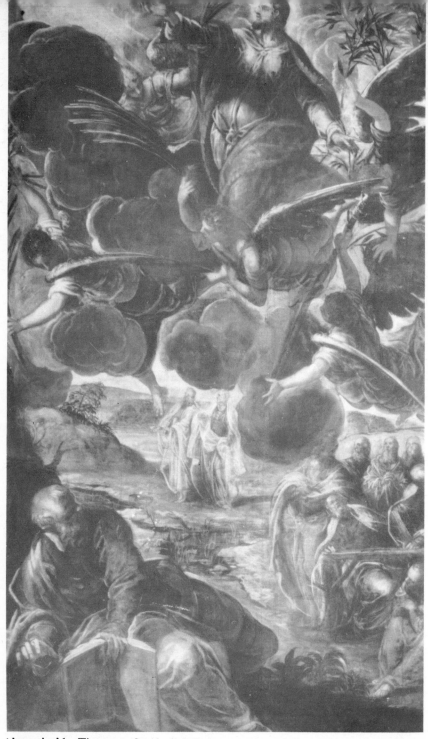

'Ascension' by Tintoretto, Scuola di S. Rocco.

a brook running through it, so capitally expressed, that I believe it is this which makes me so fond of the picture. The reflections are as scientific in the diminution, in the image, of large masses of bank above, as any of Turner's, and the marshy and reedy ground looks as if one would sink into it; but what all this has to do with the Ascension I cannot see. The figure of Christ is not undignified, but by no means either interesting or sublime.

The Ascension was among the pictures examined by Joyce Plester and Lorenzo Lazzarini, and they made a very interesting discovery. In their report (see page 218) they say that with 'any picture of appreciable age, we have to remind ourselves that the colours may have changed in course of time. This lesson was forcibly brought home to us when the "Ascension" at the Scuola di S. Rocco was taken out of its architectural framework. Strips of paint a few centimetres wide at the top and right-hand edges of the canvas had been covered by the gilded wood moulding which surrounded them. Among these protected edges practically all the colours were brighter and more intense. Samples were taken from the various colours on the protected strips of paint and from adjacent areas on the exposed, and presumably faded, main area of the picture. The details of the changes which exist between colours in the exposed and protected areas have not yet been fully worked out, but they include fading and browning of red lake pigments and browning of green-copper pigments. In the exposed area at the top of the picture the sky round Christ's head is a reddish-brown, while in the protected strip above it is mid-blue. This change was so striking that it was first supposed that an organic blue dyestuff, such as indigo, must have faded, but microscopical and chemical examination showed that the blue pigment in both areas was small, and the discoloration was an extreme form of a disorder which sometimes occurs when this pigment is used in oil medium . . . the only colour which showed virtually no difference between the exposed and protected areas was Christ's halo which proved to be painted in lead-tin yellow.'

19. *Pool of Bethesda.* I have no doubt the principal figures have been repainted; but as the colours are faded, and the subject disgusting, I have not paid this picture sufficient attention to say how far the injury extends; nor need any one spend time upon it, unless after having first examined all the other Tintorettos in Venice. All the great Italian painters appear insensible to the feeling of disgust at disease; but this study of the population of an hospital is without any points of contrast, and I wish Tintoretto had not condescended to paint it. This and the six preceding paintings have all been uninteresting—I believe chiefly owing to the observance in them of Sir Joshua's rule for the heroic, 'that drapery is to be mere drapery, and not silk, nor satin, nor brocade' [*Sir Joshua*

Reynolds: Discourses]. However wise such a rule may be when applied to works of the purest religious art, it is anything but wise as respects works of colour. Tintoretto is never quite himself unless he has fur or velvet, or rich stuff of one sort or the other, or jewels, or armour, or something that he can put play of colour into, among his figures, and not dead folds of linsey-woolsey [*a mixture of linen and wool*], and I believe that even the best pictures of Raphael and [*Fra*] Angelico are not a little helped by their hems of robes, jewelled crowns, priests' copes, and so on; and the pictures that have nothing of this kind in them, as for instance the 'Transfiguration', are to my mind not a little dull.

20. *Temptation.* This picture singularly illustrates what has just been observed; it owes great part of its effect to the lustre of the jewels in the armlet of the evil angel, and to the beautiful colours of his wings. These are slight accessories apparently, but they enhance the value of all the rest, and they have evidently been enjoyed by the painter. The armlet is seen by reflected light, its stones shining by inward lustre, this occult fire being the only hint given of the real character of the Tempter, who is otherways represented in the form of a beautiful angel, though the face is sensual: we can hardly tell how far it was intended to be therefore expressive of evil; for Tintoretto's good angels have not always the purest features; but there is a peculiar subtlety in this telling of the story by so slight a circumstance as the glare of the jewels in the darkness. It is curious to compare this imagination with that of the mosaics in St Mark's, in which Satan is a black monster, with horns, and head, and tail, complete. The whole of the picture is powerfully and carefully painted, though very broadly; it is a strong effect of light, and therefore, as usual, subdued in colour. The painting of the stones in the foreground I have always thought, and still think, the best piece of rock drawing before Turner, and the most amazing instance of Tintoretto's perceptiveness afforded by any of his pictures.

21. *S. Rocco.* Three figures occupy the spandrils of the windows above this and the following picture, painted merely in light and shade, two larger than life, one rather smaller. I believe these to be by Tintoretto; but as they are quite in the dark, so that the execution cannot be seen, and very good designs of the kind have been furnished by other masters, I cannot answer for them. The figure of S. Rocco, as well as its companion, St Sebastian, is coloured; they occupy the narrow intervals between the windows, and are of course invisible under ordinary circumstances. By a great deal of straining of the eyes, and sheltering them with the hand from the light, some little idea of the design may be obtained. The 'S. Rocco' is a fine figure, though rather coarse, but, at all events, worth as much light as would enable us to see it.

22. *St Sebastian.* This, the companion figure, is one of the finest things

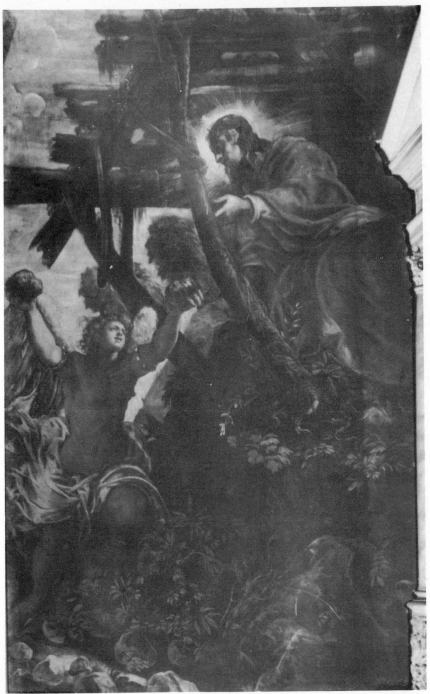

'Temptation of Christ' by Tintoretto, Scuola di S. Rocco.

Third group. On the roof of the upper room

23. Moses striking the Rock
24. Plague of Serpents
25. Fall of Manna
26. Jacob's Dream

27. Ezekial's Vision
28. Fall of Man
29. Elijah
30. Jonah
31. Joshua

32. Sacrifice of Isaac
33. Elijah at the Brook
34. Paschal Feast
35. Elisha feeding the People

in the whole room, and assuredly the most majestic St Sebastian in existence, as far as mere humanity can be majestic, for there is no effort at any expression of angelic or saintly resignation; the effort is simply to realize the fact of the martyrdom, and it seems to me that this is done to an extent not even attempted by any other painter. I never saw a man die a violent death, and therefore cannot say whether this figure be true or not, but it gives the grandest and most intense impression of truth. The figure is dead, and well it may be, for there is one arrow through the forehead and another through the heart; but the eyes are open, though glazed, and the body is rigid in the position in which it last stood, the left arm raised and the left limb advanced, something in the attitude of a soldier sustaining an attack under his shield, while the dead eyes are still turned in the direction from which the arrows came: but the most characteristic feature is the way these arrows are fixed. In the common martyrdoms of St Sebastian they are stuck into him here and there like pins, as if they had been shot from a great distance and had come faltering down, entering the flesh but a little way, and rather bleeding the saint to death than mortally wounding him; but Tintoretto had no such ideas about archery. He must have seen bows drawn in battle, like that of Jehu when he smote Jehoram between the harness: all the arrows in the saint's body lie straight in the same direction, broad-feathered and strong-shafted, and sent apparently with the force of thunderbolts; every one of them has gone through him like a lance, two through the limbs, one through the arm, one through the heart, and the last has crashed through the forehead, nailing his head to the tree behind, as if it had been dashed in by a sledge-hammer. The face, in spite of its ghastliness, is beautiful, and has been serene; and the light which enters first and glistens on the plumes of

the arrows, dies softly away upon the curling hair, and mixes with the glory upon the forehead. There is not a more remarkable picture in Venice, and yet I do not suppose that one in a thousand of the travellers who pass through the Scuola so much as perceive there is a picture in the place which it occupies.

23. *Moses striking the Rock.* We now come to the series of pictures upon which the painter concentrated the strength he had reserved for the upper room; and in some sort wisely, for, though it is not pleasant to examine pictures on a ceiling, they are at least distinctly visible without straining the eyes against the light. They are carefully conceived, and thoroughly well painted in proportion to their distance from the eye. This carefulness of thought is apparent at a glance: the 'Moses striking the Rock' embraces the whole of the seventeenth chapter of Exodus, and even something more, for it is not from that chapter, but from parallel passages that we gather the facts of the impatience of Moses and the wrath of God at the waters of Meribah; both which facts are shown by the leaping of the stream out of the rock half-a-dozen ways at once, forming a great arch over the head of Moses, and by the partial veiling of the countenance of the Supreme Being. This latter is the most painful part of the whole picture, at least as it is seen from below; and I believe that in some repairs of the roof this head must have been destroyed and repainted. It is one of Tintoretto's usual fine thoughts that the lower part of the figure is veiled, not merely by clouds, but in a kind of watery sphere, showing the Deity coming to the Israelities at that particular moment as the Lord of the Rivers and of the Fountain of the Waters. The whole figure, as well as that of Moses, and the greater number of those in the foreground, is at once dark and warm, black and red being the prevailing colours, while the distance is bright gold touched with blue, and seems to open into the picture like a break of blue sky after rain. How exquisite is this expression, by mere colour, of the main force of the fact represented! that is to say, joy and refreshment after sorrow and scorching heat. But, when we examine of what this distance consists, we shall find still more cause for admiration. The blue in it is not the blue of sky, it is obtained by blue stripes upon white tents glowing in the sunshine; and in front of these tents is seen that great battle with Amalek of which the account is given in the remainder of the chapter, and for which the Israelites received strength in the streams which ran out of the rock in Horeb. Considered merely as a picture, the opposition of cool light to warm shadow is one of the most remarkable pieces of colour in the Scuola, and the great mass of foliage which waves over the rocks on the left appears to have been elaborated with his highest power and his most sublime invention. But this noble passage is much injured, and now hardly visible.

'Moses striking the Rock' by Tintoretto, Scuola di S. Rocco.

24. *Plague of Serpents*. The figures in the distance are remarkably important in this picture, Moses himself being among them; in fact, the whole scene is filled chiefly with middle-size figures, in order to increase the impression of space. It is interesting to observe the difference in the treatment of this subject by the three great painters, Michelangelo, Rubens, and Tintoretto. The first two, equal to the latter in energy, had less love of liberty: they were fond of binding their compositions into knots, Tintoretto of scattering his far and wide: they all alike preserve the unity of composition, but the unity in the first two is obtained by

binding, and that of the last by springing from one source; and, together with this feeling, comes his love of space, which makes him less regard the rounding and form of objects themselves than their relations of light and shade and distance. Therefore Rubens and Michelangelo made the fiery serpents huge boa-constrictors, and knotted the sufferers together with them. Tintoretto does not like to be so bound; so he makes the serpents little flying and fluttering monsters, like lampreys with wings; and the children of Israel, instead of being thrown into convulsed and writhing groups, are scattered, fainting in the fields, far away in the distance. As usual, Tintoretto's conception, while thoroughly characteristic of himself, is also truer to the words of Scripture. We are told that 'the Lord sent fiery serpents among the people, and they *bit* the people'; we are not told that they crushed the people to death. And, while thus the truest, it is also the most terrific conception. Michelangelo's would be terrific if one could believe in it: but our instinct tells us that boa-constrictors do not come in armies; and we look upon the picture with as little emotion as upon the handle of a vase, or any other form worked out of serpents, where there is no probability of serpents actually occurring. But there is a probability in Tintoretto's conception. We feel that it is not impossible that there should come up a swarm of these small winged reptiles; and their horror is not diminished by their smallness: not that they have any of the grotesque terribleness of German invention; they might have been made infinitely uglier with small pains, but it is their *veritableness* which makes them awful. They have triangular heads with sharp beaks or muzzles; and short, rather thick bodies, with bony processes down the back like those of sturgeons; and small wings spotted with orange and black; and round glaring eyes, not very large, but very ghastly, with an intense delight in biting expressed in them. (It is observable that the Venetian painter has got his main idea of them from the sea-horses and small reptiles of the Lagoons.) These monsters are fluttering and writhing about everywhere, fixing on whatever they come near with their sharp venomous heads; and they are coiling about on the ground, and all the shadows and thickets are full of them, so that there is no escape any-where: and, in order to give the idea of greater extent to the plague, Tintoretto has not been content with one horizon; I have before mentioned the excessive strangeness of this composition, in having a cavern open in the right of the foreground, through which is seen another sky and another horizon. At the top of the picture, the Divine Being is seen borne by angels, apparently passing over the congregation in wrath, involved in masses of dark clouds; while, behind, an angel of mercy is descending towards Moses, surrounded by a globe of white light. This globe is hardly seen from below; it is not a common glory, but a transparent sphere, like a bubble, which not only envelopes the angel, but

crosses the figure of Moses, throwing the upper part of it into a subdued pale colour, as if it were crossed by a sunbeam. Tintoretto is the only painter who plays these tricks with transparent light, the only man who seems to have perceived the effects of sunbeams, mists, and clouds in the far-away atmosphere, and to have used what he saw on towers, clouds, or mountains, to enhance the sublimity of his figures. The whole upper part of this picture is magnificent, less with respect to individual figures, than for the drift of its clouds, and originality and complication of its light and shade; it is something like Raphael's 'Vision of Ezekiel', but far finer. It is difficult to understand how any painter, who could represent floating clouds so nobly as he has done here, could ever paint the odd, round, pillowy masses which so often occur in his more carelessly designed sacred subjects. The lower figures are not so interesting, and the whole is painted with a view to effect from below, and gains little by close examination.

25. *Fall of Manna.* In none of these three large compositions has the painter made the slightest effort at expression in the human countenance; everything is done by gesture, and the faces of the people who are drinking from the rock, dying from the serpent-bites, and eating the manna, are all alike as calm as if nothing was happening; in addition to this, as they are painted for distant effect, the heads are unsatisfactory and coarse when seen near, and perhaps in this last picture the most so, and yet the story is exquisitely told. We have seen in the Church of S. Giorgio Maggiore another example of his treatment of it, where, however, the gathering of manna is a subordinate employment, but here it is principal. Now, observe, we are told of the manna, that it was found in the morning; that then there lay round about the camp a small round thing like the hoar-frost, and that 'when the sun waxed hot it melted'. Tintoretto has endeavoured, therefore, first of all, to give the idea of coolness; the congregation are reposing in a soft green meadow, surrounded by blue hills, and there are rich trees above them, to the branches of one of which is attached a great grey drapery to catch the manna as it comes down. In any other picture such a mass of drapery would assuredly have had some vivid colour, but here it is grey; the fields are cool frosty green, the mountains cold blue, and, to complete the expression and meaning of all this, there is a most important point to be noted in the form of the Deity, seen above, through an opening in the clouds. There are at least ten or twelve other pictures in which the form of the Supreme Being occurs, to be found in the Scuola di S. Rocco alone; and in every one of these instances it is richly coloured, the garments being generally red and blue, but in this picture of the manna the figure is *snow white.* Thus the painter endeavours to show the Deity as the Giver of Bread, just as in the 'Striking of the Rock' we saw that he represented Him as the Lord of the Rivers, the Fountains, and the Waters. There is one other very sweet incident at the bottom of the

'Fall of Manna' by Tintoretto, Scuola di S. Rocco

picture; four or five sheep, instead of pasturing, turn their heads aside to catch the manna as it comes down, or seem to be licking it off each other's fleeces. The tree above, to which the drapery is tied, is the most delicate and delightful piece of leafage in all the Scuola; it has a large sharp leaf, something like that of a willow, but five times the size.

26. *Jacob's Dream.* A picture which has good effect from below, but gains little when seen near. It is an embarrassing one for any painter, because angels always look awkward going up and down stairs; one does not see the use of their wings. Tintoretto has thrown them into buoyant and various attitudes, but has evidently not treated the subject with delight; and it is seen to all the more disadvantage because just above the painting of the 'Ascension', in which the full fresh power of the painter is developed. One would think this latter picture had been done just after a walk among hills, for it is full of the most delicate effects of transparent

cloud, more or less veiling the faces and forms of the angels, and covering with white light the silvery sprays of the palms, while the clouds in the 'Jacob's Dream' are the ordinary rotundities of the studio.

27. *Ezekiel's Vision.* I suspect this has been repainted, it is so heavy and dead in colour; a fault, however, observable in many of the smaller pictures on the ceiling, and perhaps the natural result of the fatigue of such a mind as Tintoretto's. A painter who threw such intense energy into some of his works can hardly but have been languid in others in a degree never experienced by the more tranquil minds of less powerful workmen; and when this languor overtook him whilst he was at work on pictures where a certain space had to be covered by mere force of arm, this heaviness of colour could hardly but have been the consequence: it shows itself chiefly in reds and other hot hues, many of the pictures in the Ducal Palace also displaying it in a painful degree. This 'Ezekiel's Vision' is, however, in some measure worthy of the master, in the wild and horrible energy with which the skeletons are leaping up about the prophet; but it might have been less horrible and more sublime, no attempt being made to represent the space of the Valley of Dry Bones, and the whole canvas being occupied only by eight figures, of which five are half skeletons. It is strange that, in such a subject, the prevailing hues should be red and brown.

28. *Fall of Man.* The two canvases last named are the most considerable in size upon the roof, after the centre pieces. We now come to the smaller subjects which surround the 'Striking the Rock'; of these, this 'Fall of Man' is the best, and I should think it very fine anywhere but in the Scuola di S. Rocco: there is a grand light on the body of Eve, and the vegetation is remarkably rich, but the faces are coarse, and the composition uninteresting. I could not get near enough to see what the grey object is upon which Eve appears to be sitting, nor could I see any serpent. It is made prominent in the picture of the Academy of this same subject, so that I suppose it is hidden in the darkness, together with much detail which it would be necessary to discover in order to judge the work justly.

29. *Elijah* (?). A prophet holding down his face, which is covered with his hand. God is talking with him, apparently in rebuke. The clothes on his breast are rent, and the action of the figures might suggest the idea of the scene between the Deity and Elijah at Horeb: but there is no suggestion of the past magnificent scenery—of the wind, the earthquake, or the fire; so that the conjecture is good for very little. The painting is of small interest; the faces are vulgar, and the draperies have too much vapid historical dignity to be delightful.

30. *Jonah.* The whale here occupies fully one half of the canvas; being correspondent in value with a landscape background. His mouth is as large

as a cavern, and yet, unless the mass of red colour in the foreground be a piece of drapery, his tongue is too large for it. He seems to have lifted Jonah out upon it, and not yet drawn it back, so that it forms a kind of crimson cushion for him to kneel upon in his submission to the Deity. The head to which this vast tongue belongs is sketched in somewhat loosely, and there is little remarkable about it except its size, nor much in the figures, though the submissiveness of Jonah is well given. The great thought of Michelangelo renders one little charitable to any less imaginative treatment of this subject.

31. *Joshua* (?). This is a most interesting picture, and it is a shame that its subject is not made out, for it is not a common one. The figure has a sword in its hand, and looks up to a sky full of fire, out of which the form of the Deity is stooping, represented as white and colourless. On the other side of the picture there is seen among the clouds a pillar apparently falling, and there is a crowd at the feet of the principal figure, carrying spears. Unless this be Joshua at the fall of Jericho, I cannot tell what it means; it is painted with great vigour, and worthy of a better place.

32. *Sacrifice of Isaac.* In conception, it is one of the least worthy of the master in the whole room, the three figures being thrown into violent attitudes, as inexpressive as they are strained and artificial. It appears to have been vigorously painted, but vulgarly; that is to say, the light is concentrated upon the white beard and upturned countenance of Abraham, as it would have been in one of the dramatic effects of the French school, the result being that the head is very bright and very conspicuous, and perhaps, in some of the late operations upon the roof, recently washed and touched. In consequence, everyone who comes into the room is first invited to observe the 'bella testa di Abramo' ['*the fine head of Abraham*']. The only thing characteristic of Tintoretto is the way in which the pieces of ragged wood are tossed hither and thither in the pile upon which Isaac is bound, although this scattering of the wood is inconsistent with the scriptural account of Abraham's deliberate procedure, for we are told of him that 'he set the wood in order'. But Tintoretto had probably not noticed this, and thought the tossing of the timber into the disordered heap more like the act of the father in his agony.

33. *Elijah at the Brook Cherith* (?). I cannot tell if I have rightly interpreted the meaning of this picture, which merely represents a noble figure couched upon the ground, and an angel appearing to him; but I think that between the dark tree on the left, and the recumbent figure, there is some appearance of a running stream; at all events, there is of a mountainous and stony place. The longer I study this master, the more I feel the strange likeness between him and Turner, in our never knowing what subject it is that will stir him to exertion. We have lately had him treating

Jacob's dream, Ezekiel's Vision, Abraham's Sacrifice, and Jonah's Prayer (all of them subjects on which the greatest painters have delighted to expend their strength), with coldness, carelessness, and evident absence of delight; and here, on a sudden, in a subject so indistinct that one cannot be sure of its meaning, and embracing only two figures, a man and an angel, forth he starts in his full strength. I believe he must somewhere or another, the day before, have seen a kingfisher; for this picture seems entirely painted for the sake of the glorious downy wings of the angel—white clouded with blue, as the bird's head and wings are with green—the softest and most elaborate in plumage that I have seen in any of his works: but observe also the general sublimity obtained by the mountainous lines of the drapery of the recumbent figure, dependent for its dignity upon these forms alone, as the face is more than half hidden, and what is seen of it expressionless.

34. *The Paschal Feast.* I name this picture by the title given in the guide-books; it represents merely five persons watching the increase of a small fire lighted on a table or altar in the midst of them. It is only because they have all staves in their hands that one may conjecture this fire to be that kindled to consume the Paschal offering. The effect is of course a firelight; and, like all mere firelights that I have even seen, totally devoid of interest.

35. *Elisha feeding the People.* I again guess at the subject; the picture only represents a figure casting down a number of loaves before a multitude; but, as Elisha has not elsewhere occurred, I suppose that these must be the barley-loaves brought from Baal-shalisha. In conception and manner of painting, this picture and the last, together with the others above-mentioned, in comparison with the 'Elijah at Cherith', may be generally described as 'dregs of Tintoretto': they are tired, dead, dragged out upon the canvas apparently in the heavy-hearted state which a man falls into when he is both jaded with toil and sick of the work he is employed upon. They are not hastily painted; on the contrary, finished with considerably more care than several of the works upon the walls; but those, as, for instance, the 'Agony in the Garden', are hurried sketches with the man's whole heart in them, while these pictures are exhausted fulfilments of an appointed task. Whether they were really amongst the last painted, or whether the painter had fallen ill at some intermediate time, I cannot say; but we shall find him again in his utmost strength in the room which we last enter.

36. to 39. *Four Children's Heads*, which it is much to be regretted should be thus lost in filling small vacuities of the ceiling.

40. *S. Rocco in Heaven.* The central picture of the roof, in the inner room. From the well-known anecdote respecting the production of this picture, whether in all its details true or not, we may at least gather that,

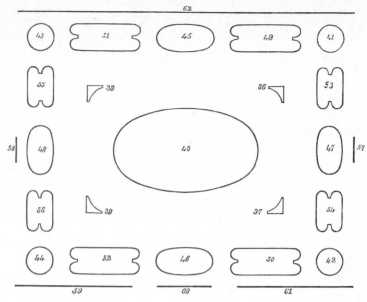

Fourth group. Inner room on the upper floor

On the roof

36–39. Children's heads	41–44. Children
40. S. Rocco in Heaven	45–46. Allegorical figures

On the walls

57. Figure in niche	60. Ecce Homo
58. Figure in niche	61. Christ before his Cross
59. Christ before Pilate	62. The Crucifixion

having been painted in competition with Paul Veronese and other power-ful painters of the day, it was probably Tintoretto's endeavour to make it as popular and showy as possible. It is quite different from his common works; bright in all its tints and tones; the faces carefully drawn, and of an agreeable type; the outlines firm, and the shadows few; the whole resembling Correggio more than any Venetian painter. It is, however, an example of the danger, even to the greatest artist, of leaving his own style; for it lacks all the great virtues of Tintoretto, without obtaining the lusciousness of Correggio. One thing, at all events, is remarkable in it—that, though painted while the competitors were making their sketches, it shows no sign of haste or inattention.

41. to 44. *Figures of Children*, merely decorative.

45. to 56. *Allegorical Figures on the Roof.* If these were not in the same room with the 'Crucifixion', they would attract more public atten-tion than any works in the Scuola, as there are here no black shadows, nor extravagances of invention, but very beautiful figures richly and delicately coloured, a good deal resembling some of the best works of Andrea del

Sarto. There is nothing in them, however, requiring detailed examination. The two figures between the windows are very slovenly, if they are his at all; and there are bits of marbling and fruit filling the cornices, which may or may not be his: if they are, they are tired work, and of small importance.

59. *Christ before Pilate.* A most interesting picture, but, which is unusual, best seen on a dark day, when the white figure of Christ alone draws the eye, looking almost like a spirit; the painting of the rest of the picture being both somewhat thin and imperfect. There is a certain meagreness about all the minor figures, less grandeur and largeness in the limbs and draperies, and less solidity, it seems, even in the colour, although its arrangements are richer than in many of the compositions above described. I hardly know whether it is owing to this thinness of colour, or on purpose, that the horizontal clouds shine through the crimson flag in the distance; though I should think the latter, for the effect is most beautiful. The passionate action of the Scribe in lifting his hand to dip the pen into the ink-horn is, however, affected and over-strained, and the Pilate is very mean; perhaps intentionally, that no reverence might be withdrawn from the person of Christ. In work of the thirteenth and fourteenth centuries, the figures of Pilate and Herod are always intentionally made contemptible.

60. *Ecce Homo.* As usual, Tintoretto's own peculiar view of the subject. Christ is laid fainting on the ground, with a soldier standing on one side of him; while Pilate, on the other, withdraws the robe from the scourged and wounded body, and points it out to the Jews. Both this and the picture last mentioned resemble Titian more than Tintoretto in the style of their treatment.

61. *Christ bearing His Cross.* Tintoretto is here recognizable again in undiminished strength. He has represented the troops and attendants climbing Calvary by a winding path of which two turns are seen, the figures on the uppermost ledge, and Christ in the centre of them, being relieved against the sky; but, instead of the usual simple expedient of the bright horizon to relieve the dark masses, there is here introduced, on the left, the head of a white horse, which blends itself with the sky in one broad mass of light. The power of the picture is chiefly in effect, the figure of Christ being too far off to be very interesting, and only the malefactors being seen on the nearer path; but for this very reason it seems to me more impressive, as if one had been truly present at the scene, though not exactly in the right place for seeing it.

62. *The Crucifixion.* I must leave this picture to work its will on the spectator; for it is beyond all analysis, and above all praise.

Having looked with much admiration at this great painting I turned

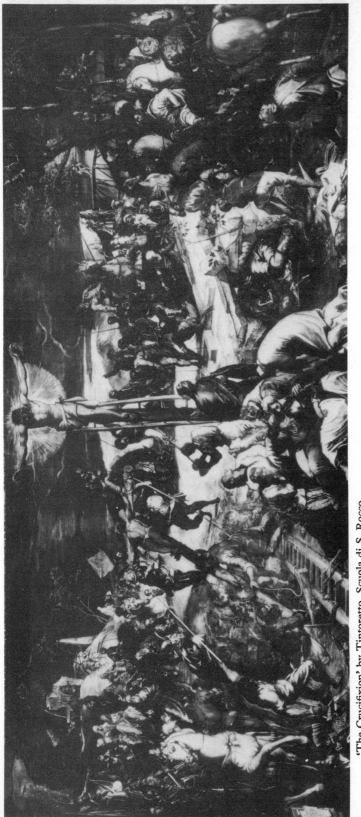

'The Crucifixion' by Tintoretto, Scuola di S. Rocco.

expectantly to the Venetian Index *for Ruskin's comments. Although his brief laudatory comment is understandable, I was disappointed. I imagine the average visitor thrilled by Tintoretto's paintings in the Scuola di S. Rocco would also be disappointed. I remembered, however, some account he gave of the picture in* Modern Painters *(Volume II) and I give it here:*

But the most exquisite instance of this imaginative power occurs in an incident in the background of the Crucifixion. I will not insult this marvellous picture by an effort at a verbal account of it. I would not whitewash it with praise, and I refer to it only for the sake of two thoughts peculiarly illustrative of the intellectual faculty immediately under discussion. In the common and most Catholic treatment of the subject, the hand is either painfully directed to the bodily agony, coarsely expressed by outward anatomical signs, or else it is permitted to rest on that countenance inconceivable by man at any time, but chiefly so in this its consummated humiliation. In the first case, the representation is revolting; in the second, inefficient, false, and sometimes blasphemous. None even of the greatest religious painters have ever, so far as I know, succeeded here: Giotto and [Fra] Angelico were cramped by the traditional treatment, and the latter especially, as before observed, is but too apt to indulge in those points of vitiated feeling which attained their worst development among the Byzantines. Perugino fails in his Christ in almost every instance: of other men than these, after them, we need not speak. But Tintoretto here, as in all other cases, penetrating into the root and deep places of his subject, despising all outward and bodily appearances of pain, and seeking for some means of expressing, not the rack of nerve or sinew, but the fainting of the deserted Son of God before His Eloi cry, and yet feeling himself utterly unequal to the expression of this by the countenance, has, on the one hand, filled his picture with such various and impetuous muscular exertion, that the body of the Crucified is, by comparison, in perfect repose, and, on the other, has cast the countenance altogether into shade. But the Agony is told by this, and by this only; that, though there yet remains a chasm of light on the mountain horizon where the earthquake darkness closes upon the day, the broad and sunlike glory about the head of the Redeemer has become wan, and of the colour of ashes.

But the great painter felt he had something more to do yet. Not only that Agony of the Crucified, but the tumult of the people, that rage which invoked His blood upon them and their children. Not only the brutality of the soldier, the apathy of the Centurion, or any other merely instrumental cause of the Divine suffering, but the fury of His own people,

Palazzo Sagredo on the Grand Canal. Gothic of the fourteenth century.

the noise against Him of those for whom He died, were to be set before the eye of the understanding, if the power of the picture was to be complete. This rage, be it remembered, was one of disappointed pride; and the disappointment dated essentially from the time when, but five days before, the King of Zion came, and was received with hosannahs, riding upon an ass, and a colt the foal of an ass. To this time, then, it was necessary to direct the thoughts, for therein are found both the cause and the character, the excitement of, and the witness against, this madness of the people. In the shadow behind the cross, a man, riding on an ass colt, looks back to the multitude, while he points with a rod to the Christ crucified. The ass is feeding on the remnants of withered palm-leaves.

S

SAGREDO, PALAZZO, on the Grand Canal, II–VII–XXXIII. Much defaced, but full of interest. Its sea story is restored; its first floor has a most interesting arcade of the early thirteenth century third order windows; its upper windows are the finest fourth and fifth orders of early fourteenth century; the group of fourth orders in the centre being brought into some resemblance to the late Gothic traceries by the subsequent introduction of the quatrefoils above them.

For further details on the dates of Ruskin's window orders, see under ORDERS OF VENETIAN ARCHES. *The illustration given there includes Ruskin's outline of the third order windows in the Palazzo Sagredo (see 3b). The reference given above refers to the chapter on Gothic palaces in which Ruskin selects these third order windows for special attention as remarkable for their 'early upright form . . . with a somewhat late moulding'.*

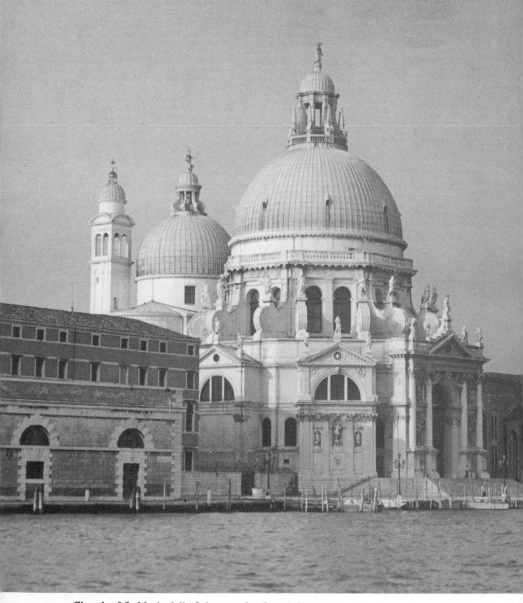

Church of S. Maria della Salute on the Grand Canal.
Designed by Baldassare Longhena and built 1631–1681.

SALUTE, CHURCH OF S. MARIA DELLA, on the Grand
II–Appendix 2. One of the earliest buildings of the Grotesque
Renaissance, rendered impressive by its position, size, and general pro-
portions. These latter are exceedingly good; the grace of the whole build-
ing being chiefly dependent on the inequality of size in its cupolas, and
pretty grouping of the two campaniles behind them. It is to be generally

observed that the proportions of buildings have nothing whatever to do with the style or general merits of their architecture. An architect trained in the worst schools, and utterly devoid of all meaning or purpose in his work, may yet have such a natural gift of massing and grouping as will render all his structures effective when seen from a distance: such a gift is very general with the late Italian builders, so that many of the most contemptible edifices in the country have good stage effect so long as we do not approach them. The Church of the Salute is further assisted by the beautiful flight of steps in front of it down to the canal; and its façade is rich and beautiful of its kind, and was chosen by Turner for the principal object in his well-known view of the Grand Canal. The principal faults of the building are the meagre windows in the sides of the cupola, and the ridiculous disguise of the buttresses under the form of colossal scrolls; the buttresses themselves being originally a hypocrisy, for the cupola is stated by Lazari to be of timber, and therefore needs none.

The appendix referred to above is appropriately inserted here. Ruskin criticizes the church for its conspicuousness.

'S. Maria Della Salute', Our Lady of Health, or of Safety, would be a more literal translation, yet not perhaps fully expressing the force of the Italian word in this case. The church was built between 1630 and 1680, in acknowledgment of the cessation of the plague—of course to the Virgin, to whom the modern Italian has recourse in all his principal distresses, and who receives his gratitude for all principal deliverances.

The hasty traveller is usually enthusiastic in his admiration of this building; but there is a notable lesson to be derived from it, which is not often read. On the opposite side of the broad canal of the Giudecca is a small church, celebrated among Renaissance architects as of Palladian design, but which would hardly attract the notice of the general observer, unless on account of the pictures by John Bellini which it contains, in order to see which the traveller may perhaps remember having been taken across the Giudecca to the church of the 'Redentore' [*qv*]. But he ought carefully to compare these two buildings with each other, the one built 'to the Virgin', the other 'to the Redeemer' (also a votive offering after the cessation of the plague of 1576): the one, the most conspicuous church in Venice, its dome, the principal one by which she is first discerned, rising out of the distant sea; the other, small and contemptible, on a suburban island, and only becoming an object of interest because it contains three small pictures! For in the relative magnitude and conspicuousness of these two buildings, we have an accurate index of the relative importance of the ideas of the Madonna and of Christ, in the modern Italian mind.

The Church of S. Maria della Salute, built in 1631–1681, is considered by many to be Baldassare Longhena's masterpiece. It was completely restored in 1970–1973 by the Comité français pour la Sauvegarde de Venise. The paintings in S. Maria della Salute are next described (Index).

The sacristy contains several precious pictures: the three on its roof by Titian, much vaunted, are indeed as feeble as they are monstrous; but the small Titian, 'St Mark, with Sts Cosmo and Damian', was, when I first saw it, to my judgment, by far the first work of Titian's in Venice. It has since been restored by the Academy, and it seemed to me entirely destroyed, but I had not time to examine it carefully.

At the end of the larger sacristy is the lunette which once decorated the tomb of the Doge Francesco Dandolo [*originally in the chapter house of the Frari but, as Ruskin relates elsewhere, the monks 'separated the tomb into three pieces: the canopy, a simple arch sustained on brackets, still remains on the blank wall of the desecrated chamber; the sarcophagus has been transported to a kind of museum of antiquities, established in what was the cloister of S. Maria della Salute; and the painting which filled the lunette behind it is hung far out of sight, at one end of the sacristy of the same church'*]; and at the side of it, one of the most highly finished Tintoretto's in Venice, namely:

The Marriage in Cana. An immense picture, some twenty-five feet long by fifteen high, and said by Lazari to be one of the few which Tintoretto signed with his name. I am not surprised at his having done so in this case. Evidently the work has been a favourite with him, and he has taken as much pains as it was ever necessary for his colossal strength to take with anything. The subject is not one which admits of much singularity or energy in composition. It was always a favourite one with Veronese, because it gave dramatic interest to figures in gay costumes and of cheerful countenances; but one is surprised to find Tintoretto, whose tone of mind was always grave, and who did not like to make a picture out of brocades and diadems, throwing his whole strength into the conception of a marriage feast; but so it is, and there are assuredly no female heads in any of his pictures in Venice elaborated so far as those which here form the central light. Neither is it often that the works of this mighty master conform themselves to any of the rules acted upon by ordinary painters; but in this instance the popular laws have been observed, and an Academy student would be delighted to see with what severity the principal light is arranged in a central mass, which is divided and made more brilliant by a vigorous piece of shadow thrust into the midst of it, and which dies away in lesser fragments and sparkling towards the extremities of the picture. This mass of light is as interesting by its composition as by its intensity. The cicerone, who escorts the stranger

round the sacristy in the course of five minutes, and allows him some forty seconds for the contemplation of a picture which the study of six months would not entirely fathom, directs his attention very carefully to the 'bell' effetto di prospettivo', the whole merit of the picture being, in the eyes of the intelligent public, that there is a long table in it, one end of which looks farther off than the other; but there is more in the 'bell' effetto di prospettivo' than the observance of the common laws of optics. The table is set in a spacious chamber, of which the windows at the end let in the light from the horizon, and those in the side wall the intense blue of an eastern sky. The spectator looks all along the table, at the farther end of which are seated Christ and the Madonna, the marriage guests on each side of it, on one side men, on the other women; the men are set with their backs to the light, which, passing over their heads and glancing slightly on the tablecloth, falls in full length along the line of young Venetian women, who thus fill the whole centre of the picture with one broad sunbeam, made up of fair faces and golden hair. Close to the spectator a woman has risen in amazement, and stretches across the table to show the wine in her cup to those opposite; her dark red dress intercepts and enhances the mass of gathered light. It is rather curious, considering the subject of the picture, that one cannot distinguish either the bride or the bridegroom; but the fourth figure from the Madonna in the line of women, who wears a white head-dress of lace and rich chains of pearls in her hair, may well be accepted for the former, and I think that between her and the woman on the Madonna's left hand the unity of the line of women is intercepted by a male figure: be this as it may, this fourth female face is the most beautiful, as far as I recollect, that occurs in the works of the painter, with the exception only of the Madonna in the 'Flight into Egypt' [*see under* SCUOLA DI S. ROCCO]. It is an ideal which occurs indeed elsewhere in many of his works, a face at once dark and delicate, the Italian cast of feature moulded with the softness and childishness of English beauty some half a century ago; but I have never seen the ideal so completely worked out by the master. The face may best be described as one of the purest and softest of Stothard's conceptions [*Thomas Stothard, 1755–1834, was an English painter and illustrator*], executed with all the strength of Tintoretto. The other women are all made inferior to this one, but there are beautiful profiles and bendings of breasts and necks along the whole line. The men are all subordinate, though there are interesting portraits among them; perhaps the only fault of the picture being that the faces are a little too conspicuous, seen like balls of light among the crowd of minor figures which fill the background of the picture. The tone of the whole is sober and majestic in the highest degree; the dresses are all broad masses of colour, and the only parts of the picture which lay claim to the expression

of wealth or splendour are the head-dresses of the women. In this respect the conception of the scene differs widely from that of Veronese, and approaches more nearly to the probable truth. Still the marriage is not an unimportant one; an immense crowd, filling the background, forming superbly rich mosaic of colour against the distant sky. Taken as a whole, the picture is perhaps the most perfect example which human art has produced of the utmost possible force and sharpness of shadow united with richness of local colour. In all the other works of Tintoretto, and much more of other colourists, either the light and shade or the local colour is predominant; in the one case the picture has a tendency to look as if painted by candlelight, in the other it becomes daringly conventional, and approaches the conditions of glass-painting. This picture unites colour as rich as Titian's with light and shade as forcible as Rembrandt's, and far more decisive.

There are one or two other interesting pictures of the early Venetian schools in this sacristy, and several important tombs in the adjoining cloister; among which that of Francesco Dandolo, transported here from the Church of the Frari, deserves especial attention [*see editor's note above*].

S A L V A T O R E, C H U R C H O F S. Base Renaissance, occupying the place of the ancient church, under the porch of which the Pope Alexander III is said to have passed the night. M. Lazari states it to have been richly decorated with mosaics; now, all is gone.

In the interior of the church are some of the best examples of Renaissance sculptural monuments in Venice.... It is said to possess an important pala of silver, of the thirteenth century, one of the objects in Venice which I much regret having forgotten to examine; besides two Titians, a Bonifazio, and a John Bellini. The latter ('The Supper at Emmaus') must, I think, have been entirely repainted: it is not only unworthy of the master, but unlike him; as far, at least, as I could see from below, for it is hung high.

Ruskin discusses the development of sculptured monuments in Volume III Chapter II (fuller extracts are given under CHURCH OF THE FRARI). *He traces the development of figures which are at first shown as recumbent and are later depicted as raising themselves on their elbows and looking round. Ruskin says: 'many monuments in Venice are of this semi-animate type, most of them carefully sculptured, and some very admirable as portraits, and for the casting of drapery, especially those in the Church of S. Salvador' (III–II–LXXX).*

S. Salvatore is a Renaissance church built by Giorgio Spavento and Tullio Lombardo in 1506–1534 with an ornate baroque façade by

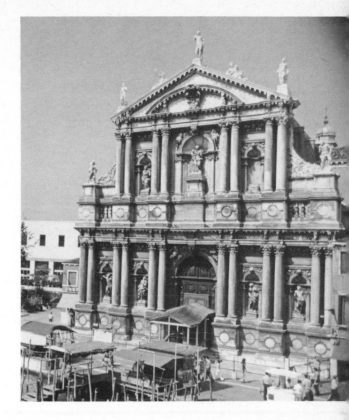

Church of the Scalzi, as seen from the bridge of the same name. To the left lies the railway station.

Giuseppe Sardi added in 1663. It was admired by Jacob Burckhardt. The Titians are the high altarpiece—the 'Transfiguration'—and a side altarpiece—the 'Annunciation', a late work admired by Crowe and Caval-caselle (History of Painting in North Italy).

S A N U D O, P A L A Z Z O. At the Miracoli. A noble Gothic palace of the fourteenth century, with Byzantine fragments and cornices built into its walls, especially round the interior court, in which the staircase is very noble. Its door, opening on the quay, is the only one in Venice entirely uninjured; retaining its wooden valve richly sculptured, its wicket for examination of the stranger demanding admittance, and its quaint knocker in the form of a fish.

This palace is often known by the rather long title, taken from the names of a number of its owners, of the Palazzo Soranzo-van Axel-Barozzi.

S C A L Z I, C H U R C H O F T H E. It possesses a fine John Bellini, and is renowned through Venice for its precious marbles. I omitted to notice above, in speaking of the buildings of the Grotesque Renaissance, that many of them are remarkable for a kind of dishonesty, even in

the use of *true* marbles, resulting not from motives of economy, but from mere love of juggling and falsehood for their own sake. I hardly know which condition of mind is meanest, that which has pride in plaster made to look like marble, or that which takes delight in marble made to look like silk. Several of the later churches in Venice, more especially those of the Jesuiti, of S. Clemente, and this of the Scalzi, rest their chief claims to admiration on their having curtains and cushions cut out of rock. The most ridiculous example is in S. Clemente, and the most curious and costly are in the Scalzi; which latter church is a perfect type of the vulgar abuse of marble in every possible way, by men who had no eye for colour, and no understanding of any merit in a work of art but that which arises from costliness of material, and such powers of imitation as are devoted in England to the manufacture of peaches and eggs out of Derbyshire spar.

The Church of the Scalzi is actually dedicated to S. Maria di Nazareth, but it is more commonly known by this first name as it served the order of Discalced Carmelite Friars ('Scalzi'). The church was designed by Baldassare Longhena and was built in the middle of the seventeenth century. A façade was added in 1683–1689, designed by Giuseppe Sardi. It has a ceiling by Tiepolo. The picture by Giovanni Bellini is of the Virgin and Child. Crowe and Cavalcaselle (see bibliography) say of it that 'it may have been originally a good picture of the master about 1500, but it has been too much cleaned and repainted to warrant a strong opinion as to its authenticity'.

SEBASTIAN, CHURCH OF S. The tomb, and of old the monument, of Paul Veronese. It is full of his noblest pictures, or of what once were such; but they seemed to me for the most part destroyed by repainting. I had not time to examine them justly, but I would especially direct the traveller's attention to the small Madonna over the second altar on the right of the nave, still a perfect and priceless treasure.

S. Sebastiano was built in 1508–1516 by Abbondi, known as Scarpagnino. The principal pictures are by Veronese: the high altar shows the 'Madonna in Glory', on the right wall of choir is the 'Martyrdom of St Sebastian and on the left the 'Martyrdom of Sts Mark and Marcellinus.' In the sacristy the ceiling paintings are by Veronese—the 'Coronation of the Virgin' and the four Evangelists. These paintings by Veronese were restored in 1967–1968 by the American Committee to Rescue Italian Art.

SERVI, CHURCH OF THE. Only two of its gates and some ruined walls are left, in one of the foulest districts of the city. It was one of the most interesting monuments of the early fourteenth-century Gothic; and

there is much beauty in the fragments yet remaining. How long they may stand I know not, the whole building having been offered me for sale, ground and all, or stone by stone, as I chose, by its present proprietor, when I was last in Venice. More real good might at present be effected by any wealthy person who would devote his resources to the preservation of such monuments wherever they exist, by freehold purchase of the entire ruin, and afterwards by taking proper charge of it, and forming a garden round it, than by any other mode of protecting or encouraging art. There is no school, no lecturer, like a ruin of the early ages.

This church, founded in the fourteenth century, was almost entirely demolished in 1862. A Gothic door from the adjoining convent still remains.

S E V E R O, F O N D A M E N T A S., palace at, II–VII–XLII. *Ruskin describes this in some detail in the chapter on Gothic palaces.*

XLII. Such, then, is the simple fact at Venice, that from the beginning of the thirteenth century there is found a singular increase of simplicity in all architectural ornamentation the rich Byzantine capitals giving place to a pure and severe type hereafter to be described, and the rich sculptures vanishing from the walls, nothing but the marble facing remaining. One of the most interesting examples of this transitional state is a palace at S. Severo, just behind the Casa Zorzi. This latter is a Renaissance building, utterly worthless in every respect, but known to the Venetian ciceroni [*or guides*]; and by inquiring for it, and passing a little beyond it down the Fondamenta S. Severo, the traveller will see, on the other side of the canal, a palace which the ciceroni never notice, but which is unique in Venice for the magnificence of the veined purple alabasters with which it has been decorated, and for the manly simplicity of the foliage of its capitals. Except in these, it has no sculpture whatever, and its effect is dependent entirely on colour. Disks of green serpentine are inlaid on the field of purple alabaster; and the pillars are alternately of red marble with white capitals, and of white marble with red capitals. Its windows appear of the third order; and the back of the palace, in a small and most picturesque court, shows a group of windows which are, perhaps, the most superb examples of that order in Venice. But the windows to the front have, I think, been of the fifth order, and their cusps have been cut away. [*See also under* ORDER OF VENETIAN ARCHES.]

S I G H S, B R I D G E O F. *See under* SOSPIRI, PONTE DE'.

S I L V E S T R O,　C H U R C H　O F　S. Of no importance in itself, but
it contains two very interesting pictures: the first, a 'St Thomas of
Canterbury with the Baptist and St Francis', by Girolamo Santa Croce,
a superb example of the Venetian religious school; the second by
Tintoretto, namely:

The Baptism of Christ. (Over the first altar on the right of the nave.)
An upright picture, some ten feet wide by fifteen high; the top of it is
arched, representing the Father supported by angels. It requires little
knowledge of Tintoretto to see that these figures are not by his hand.
By returning to the opposite side of the nave, the join in the canvas may
be plainly seen, the upper part of the picture having been entirely added
on: whether it had this upper part before it was repainted, or whether
originally square, cannot now be told, but I believe it had an upper part
which has been destroyed. I am not sure if even the dove and the two
angels which are at the top of the older part of the picture are quite
genuine. The rest of it is magnificent, though both the figures of the
Saviour and the Baptist show some concession on the part of the painter
to the imperative requirement of his age, that nothing should be done
except in an attitude; neither are there any of his usual fantastic imagina-
tions. There is simply the Christ in the water and the St John on the
shore, without attendants, disciples, or witnesses of any kind; but the power
of the light and shade, and the splendour of the landscape, which on the
whole is well preserved, render it a most interesting example. The Jordan
is represented as a mountain brook, receiving a tributary stream in a
cascade from the rocks in which St John stands: there is a rounded stone
in the centre of the current; and the parting of the water at this, as well
as its rippling among the roots of some dark trees on the left, are among
the most accurate remembrances of nature to be found in any of the works
of the great masters. I hardly know whether most to wonder at the power
of the man who thus broke through the neglect of nature which was
universal at his time; or at the evidences, visible throughout the whole
of the conception, that he was still content to paint from slight memories
of what he had seen in hill countries, instead of following out to its full
depth the fountain which he had opened. There is not a stream among the
hills of Priuli which in any quarter of a mile of its course would not
have suggested to him finer forms of cascade than those which he has
idly painted at Venice.

*The church was founded in the ninth century, built in the eleventh cen-
tury and rebuilt in the nineteenth century with a façade erected in 1919.*

S I M E O N E,　P R O F E T A,　C H U R C H　O F　S. Very important, though
small, possessing the precious statue of St Simeon, above noticed [*see*

extract given below]. The rare early Gothic capitals of the nave are only interesting to the architect; but in the little passage by the side of the church, leading out of the Campo, there is a curious Gothic monument built into the wall, very beautiful in the placing of the angels in the spandrils, and rich in the vine-leaf moulding above.

The reference above refers to the following appraisal of the sculpture. Ruskin compares this work with the sculpted figure of Noah, on the Ducal Palace (see page 73).

II–VIII–XXXVIII. . . . [*In this sculpture of St Simeon*] the face is represented in death; the mouth partly open, the lips thin and sharp, the teeth carefully sculptured beneath; the face full of quietness and majesty, though very ghastly; the hair and beard flowing in luxuriant wreaths, disposed with the most masterly freedom, yet severity, of design, far down upon the shoulders; the hands and the veins and sinews perfectly and easily expressed, yet without any attempt at extreme finish or display of technical skill. The monument bears the date of 1317, and its sculpture was justly proud of it; thus recording his name:

'CELAVIT MARCUS OPUS HOC INSIGNE
ROMANIS, LAUDIBUS NON PARCUS EST SUA
DIGNA MANUS.'

SIMEONE, PICCOLO, CHURCH OF S. One of the ugliest churches in Venice or elsewhere. Its black dome, like an unusual species of gasometer, is the admiration of modern Italian architects.

S. Simeone Piccolo was built in the early eighteenth century and designed by Giovanni Scalfarotto. It is derived in conception from the Pantheon at Rome but it has nothing like such good proportions. The portico hardly relates well to the dome which looks like a modern planetarium.

SOSPIRI, PONTE DE'. The well-known 'Bridge of Sighs', a work of no merit, and of a late period . . . owing the interest it possesses chiefly to its pretty name, and to the ignorant sentimentalism of Byron.

Elsewhere Ruskin writes of the repairs to the Ducal Palace which had to be undertaken after the great fire of 1574.

II–VIII–XXIX. The repairs necessarily undertaken at this time were however extensive, and interfere in many directions with the earlier work of the palace: still the only serious alteration in its form was the transposition of the prisons, formerly at the top of the palace, to the other side of the Rio del Palazzo; and the building of the Bridge of Sighs, to connect them with the palace, by Antonio da Ponte. The completion of this work

brought the whole edifice into its present form; with the exception of alterations in doors, partitions, and staircases among the inner apartments, not worth noticing, and such barbarisms and defacements as have been suffered within the last fifty years, by, I suppose, nearly every building of importance in Italy.

The transportation of the prisons occurred in 1597 to the palace built by Antonio da Ponte in 1571–97. Da Ponte was also responsible for designing the Rialto bridge. It is generally held however that Antonio Contino was the architect of the Bridge of Sighs, not da Ponte, as Ruskin suggests.

SPIRITO SANTO, CHURCH OF THE. Of no importance
This church was founded in the fifteenth century and built largely in the sixteenth, with several restorations. It contains an altar piece by Jacopo Bassano, much repainted; the other numerous paintings are by minor artists.

STEFANO, CHURCH OF S. An interesting building of central Gothic, the best ecclesiastical example of it in Venice. The west entrance is much later than any of the rest, and is of the richest Renaissance Gothic, a little anterior to the Porta della Carta, and first-rate of its kind. The manner of the introduction of the figure of the angel at the top of the arch is full of beauty. Note the extravagant crockets and cusp finials as signs of decline.

Originally built in the fourteenth century, this church was extensively restored in 1903–1904. It contains three paintings by Tintoretto: 'The Agony in the Garden', 'Christ washing the Disciples' Feet' and 'The Last Supper'.

STROPE, CAMPIELLO DELLA, house in, II–VII–XLIV. *Ruskin, with his eye for detail, noticed in an otherwise undistinguished quarter a fine example of an early window arch, which comes under the fifth order in his system of classifying window arches (for further details of these orders see under* ORDERS OF VENETIAN ARCHES).

II–VII–XLIV. . . . [*Ruskin's illustration shows*] examples of the fifth order window, both in its earliest and in its fully developed form, completed from base to keystone. The upper example is a beautiful group from a small house, never of any size or pretension, and now inhabited only by the poor, in the Campiello della Strope, close to the Church of S. Giacomo de Lorio. It is remarkable for its excessive purity of curve, and is of very early date, its mouldings being simpler than usual.

J. C. Armytage.

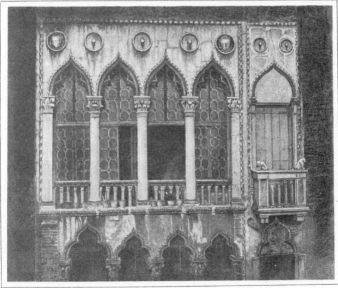

J. C. Armytage.

Ruskin's drawings of two examples of window arches of the fifth order; above in the Campiello della Strope, below in the Palazzo Priuli (Volume II, Plate XVIII).

T

TANA, windows at the, II–VII–XXXVII. *Ruskin selects these windows for their unusual construction.*

II–VII–XXXVII. . . . These windows [*Figures 1 and 2 of Ruskin's illustration shown here*] are from a narrow alley in a part of Venice now exclusively inhabited by the lower orders, close to the Arsenal; they are entirely wrought in brick, with exquisite mouldings, not cast, but *moulded in the clay by the hand* [*Ruskin's italics*], so that there is not one piece of the arch like another; the pilasters and shafts being, as usual, of stone.

Ruskin adds a note on the location of the windows: If the traveller desire to find them (and they are worth seeking), let him row from the Fondamenta S. Biagio down the Rio della Tana; and look, on his right, for a low house with windows. . . . Let him go in at the door of the portico in the middle of this house, and he will find himself in a small alley, with the windows in question on each side of him.

TEDESCHI, FONDACO DEI. See FONDACO.

TIEPOLO, PALAZZO, on the Grand Canal. Of no importance.
This is an eighteenth-century late Renaissance building named after the famous Venetian family.

TOLENTINI, CHURCH OF THE. One of the basest and coldest works of the late Renaissance. It is said to contain two Bonifazios.

The Church of S. Nicolò da Tolentino, as it is also known, actually contains three works by Bonifazio: 'The Feast of Herod', 'Herod' and 'Beheading of John the Baptist'.

TOMÀ, PONTE S. There is an interesting ancient doorway opening on the canal close to this bridge, probably of the twelfth century, and a good early Gothic door, opening upon the bridge itself.

TORCELLO, general aspect, II–II–I *et seq*; cathedral II–II–III *et seq*; its mosaics, II–II–IX, II–VI–LXV; its dimensions, II–Appendix 3; dating of cathedral, II–Appendix 4; Santa Fosca, I–IX–XXIV, II–II–III. [*Ruskin's references have been regrouped slightly in order of subject, rather than following the order of the sections as they appear in* The Stones of Venice.]

The island
II–II–I. Seven miles to the north of Venice, the banks of sand, which near

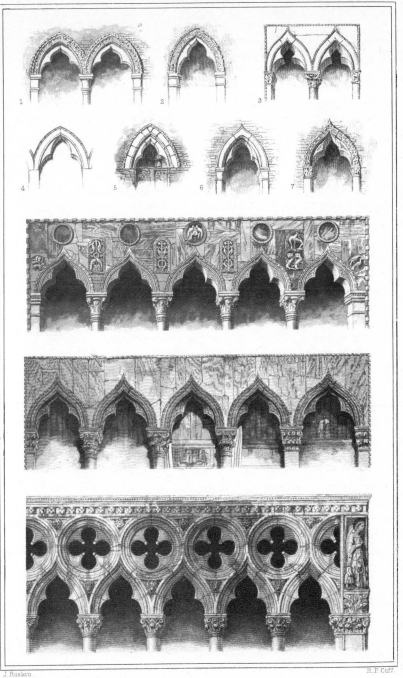

J. Ruskin. R. P. Cuff.

Ruskin's drawing of windows of early Gothic palaces showing the transition from the fourth order of Gothic arches (Figures 1, 2, 4 and 5) to the fifth order (Figures 3, 6, 7 and below). Figures 1 and 2 show windows in the Rio della Tana (Volume II, Plate XVII).

the city rise little above low-water mark, attain by degrees a higher level, and knit themselves at last into fields of salt morass, raised here and there into shapeless mounds, and intercepted by narrow creeks of sea. One of the feeblest of these inlets, after winding for some time among buried fragments of masonry, and knots of sunburnt weeds whitened with webs of fucus, stays itself in an utterly stagnant pool beside a plot of greener grass covered with ground ivy and violets. On this mound is built a rude brick campanile, of the commonest Lombardic type, which if we ascend towards evening (and there are none to hinder us, the door of its ruinous staircase swinging idly on its hinges), we may command from it one of the most notable scenes in this wide world of ours. Far as the eye can reach, a waste of wild sea moor, of a lurid ashen grey; not like our northern moors with their jet-black pools and purple heath, but lifeless, the colour of sackcloth, with the corrupted sea-water soaking through the roots of its acrid weeds, and gleaming hither and thither through its snaky channels. No gathering of fantastic mists, nor coursing of clouds across it; but melancholy clearness of space in the warm sunset, oppressive, reaching to the horizon of its level gloom. To the very horizon, on the north-east; but, to the north and west, there is a blue line of higher land along the border of it, and above this, but farther back, a misty band of mountains, touched with snow. To the east, the paleness and roar of the Adriatic, louder at momentary intervals as the surf breaks on the bars of sand; to the south, the widening branches of the calm lagoon, alternately purple and pale green, as they reflect the evening clouds or twilight sky; and almost beneath our feet, on the same field which sustains the tower we gaze from, a group of four buildings, two of them little larger than cottages (though built of stone, and one adorned by a quaint belfry), the third an octagonal chapel, of which we can see but little more than the flat red roof with its rayed tiling, the fourth, a considerable church with nave and aisles, but of which, in like manner, we can see little but the long central ridge and lateral slopes of roof, which the sunlight separates in one glowing mass from the green field beneath and grey moor beyond. There are no living creatures near the buildings, nor any vestige of village or city round about them. They lie like a little company of ships becalmed on a far-away sea.

II. Then look farther to the south. Beyond the widening branches of the lagoon, and rising out of the bright lake into which they gather, there are a multitude of towers, dark, and scattered among square-set shapes of clustered palaces, a long and irregular line fretting the southern sky.

Mother and daughter, you behold them both in their widowhood—Torcello, and Venice.

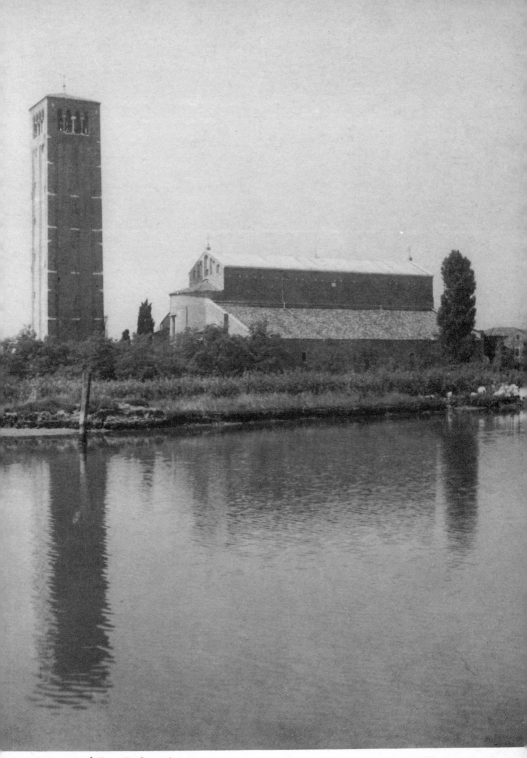

Cathedral of Torcello from the sea.

Thirteen hundred years ago, the grey moorland looked as it does this day, and the purple mountains stood as radiantly in the deep distances of evening; but on the line of the horizon, there were strange fires mixed with the light of sunset, and the lament of many human voices mixed with the fretting of the waves on their ridges of sand. The flames rose from the ruins of Altinum; the lament from the multitude of its people, seeking, like Israel of old, a refuge from the sword in the paths of the sea.

The cattle are feeding and resting upon the site of the city that they left; the mower's scythe swept this day at dawn over the chief street of the city that they built, and the swathes of soft grass are now sending up their scent into the night air, the only incense that fills the temple of their ancient worship. Let us go down into that little space of meadow land.

III. The inlet which runs nearest to the base of the campanile is not that by which Torcello is commonly approached. Another, somewhat broader, and overhung by alder copse, winds out of the main channel of the lagoon up to the very edge of the little meadow which was once the Piazza of the city, and there, stayed by a few grey stones which present some semblance of a quay, forms its boundary at one extremity. Hardly larger than an ordinary English farmyard, and roughly enclosed on each side by broken palings and hedges of honeysuckle and briar, the narrow field retires from the water's edge, traversed by a scarcely traceable footpath, for some forty or fifty paces, and then expanding into the form of a small square, with buildings on three sides of it, the fourth being that which opens to the water. Two of these, that on our left and that in front of us as we approach from the canal, are so small that they might well be taken for the outhouses of the farm, though the first is a conventual building, and the other aspires to the title of the 'Palazzo publico', both dating as far back as the beginning of the fourteenth century; the third, the octagonal church of S. Fosca, is far more ancient than either, yet hardly on a larger scale. Though the pillars of the portico which surrounds it are of pure Greek marble, and their capitals are enriched with delicate sculpture, they, and the arches they sustain, together only raise the roof to the height of a cattle-shed; and the first strong impression which the spectator receives from the whole scene is, that whatever sin it may have been which has on this spot been visited with so utter a desolation, it could not at least have been ambition. Nor will this impression be diminished as we approach, or enter, the larger church, to which the whole group of building is subordinate. . . .

The cathedral
. . . It has evidently been built by men in flight and distress, who sought

in the hurried erection of their island church such a shelter for their earnest and sorrowful worship as, on the one hand, could not attract the eyes of their enemies by its splendour, and yet, on the other, might not awaken too bitter feelings by its contrast with the churches which they had seen destroyed. There is visible everywhere a simple and tender effort to recover some of the form of the temples which they had loved, and to do honour to God by that which they were erecting, while distress and humiliation prevented the desire, and prudence precluded the admission, either of luxury of ornament or magnificence of plan. The exterior is absolutely devoid of decoration, with the exception only of the western entrance and the lateral door, of which the former has carved sideposts and architrave, and the latter, crosses of rich sculpture; while the massy stone shutters of the windows, turning on huge rings of stone, which answer the double purpose of stanchions and brackets, cause the whole building rather to resemble a refuge from Alpine storm than the cathedral of a populous city; and, internally, the two solemn mosaics of the eastern and western extremities—one representing the Last Judgment, the other the Madonna, her tears falling as her hands are raised to bless—and the noble range of pillars which enclose the space between, terminated by the high throne for the pastor and the semi-circular raised seats for the superior clergy, are expressive at once of the deep sorrow and the sacred courage of men who had no home left them upon earth, but who looked for one to come, of men 'persecuted but not forsaken, cast down but not destroyed'.

IV. I am not aware of any other early church in Italy which has this peculiar expression in so marked a degree; and it is so consistent with all that Christian architecture ought to express in every age (for the actual condition of the exiles who built the cathedral of Torcello is exactly typical of the spiritual condition which every Christian ought to recognize in himself, a state of homelessness on earth, except so far as he can make the Most High his habitation), that I would rather fix the mind of the reader on this general character than on the separate details, however interesting, of the architecture itself. I shall therefore examine these only so far as is necessary to give a clear idea of the means by which the peculiar expression of the building is attained.

The interior: shafts and capitals
V. [*Ruskin's drawing gives*] a rude plan of the church. I do not answer for the thickness and external disposition of the walls, which are not to our present purpose, and which I have not carefully examined; but the interior arrangement is given with sufficient accuracy. The church is built on the usual plan of the Basilica, that is to say, its body divided into a nave and

Fig.1.

Torcello.

a

d

p

c

b

c

Ruskin's plan of Torcello Cathedral (Volume I, Plate I, Figure I).

aisles by two rows of massive shafts, the roof of the nave being raised high above the aisles by walls sustained on two ranks of pillars, and pierced with small arched windows. At Torcello the aisles are also lighted in the same manner, and the nave is nearly twice their breadth [*dimensions are given in Appendix 3 to Volume II—the extract is included below*]. The capitals of all the great shafts are of white marble, and are among the best I have ever seen, as examples of perfectly calculated effect from every touch of the chisel. Mr Hope calls them 'indifferently imitated from the Corinthian' [Historical Essay on Architecture, *3rd edition 1840*]: but the expression is as inaccurate as it is unjust; every one of them is different in design, and their variations are as graceful as they are fanciful. I could not, except by an elaborate drawing, give any idea of the sharp, dark, deep penetrations of the chisel into their snowy marble, but a single example is given in [*Figure 1 of Ruskin's drawing*] of the nature of the changes effected in them from the Corinthian type. In this capital, although a kind of acanthus (only with rounded lobes) is indeed used for the upper range of leaves, the lower range is not acanthus at all, but a kind of vine, or at least that species of plant which stands for vine in all early Lombardic and Byzantine work [*Ruskin refers the reader to Appendix 8 of Volume I, where he discusses this and other contrasting aspects of Lombardic and Byzantine work*]; the leaves are trefoiled, and the stalks cut clear so that they might be grasped with the hand, and cast sharp dark shadows, perpetually changing, across the bell of the capital behind them. I have drawn one of these vine plants larger in Figure 2, that the reader may see how little imitation of the Corinthian there is in them, and how boldly the stems of the leaves are detached from the

1

2

4

3

5

Ruskin's drawings of the acanthus leaf—3 and 4—and its treatment in the Cathedral
of Torcello—1, 2 and 5—(Volume II, Plate II).

ground. But there is another circumstance in this ornament still more noticeable. The band which encircles the shaft beneath the spring of the leaves is copied from the common classical wreathed or braided fillet, of which the reader may see examples on almost every building of any pretensions in modern London. But the mediaeval builders could not be content with the dead and meaningless scroll: the Gothic energy and love of life, mingled with the early Christian religious symbolism, were struggling daily into more vigorous expression, and they turned the wreathed band into a serpent of three times the length necessary to undulate round the shaft, which, knotting itself into a triple chain, shows at one side of the shafts its tail and head, as if perpetually gliding round it beneath the stalks of the vines. The vine, as is well known, was one of the early symbols of Christ, and the serpent is here typical either of the eternity of his dominion, or of the Satanic power subdued.

VI. Nor even when the builder confines himself to the acanthus leaf (or to that representation of it, hereafter to be more particularly examined, constant in Romanesque work) can his imagination allow him to rest content with its accustomed position. In a common Corinthian capital the leaves nod forward only, thrown out on every side from the bell which they surround: but at the base of one of the capitals on the opposite side of the nave from this of the vines, two leaves are introduced set with their sides outwards, forming spirals by curling back, half-closed, in the position shown in [*Figure 4 of Ruskin's drawings of the acanthus*], there represented as in a real acanthus leaf; for it will assist our future inquiries into the ornamentation of capitals that the reader should be acquainted with the form of the acanthus leaf itself. I have drawn it, therefore, in two positions [*Figures 3 and 4*]; while Figure 5 is the translation of the latter form into marble by the sculptor of Torcello. It is not very like the acanthus, but much liker than any Greek work; though still entirely conventional in its cinquefoiled lobes. But these are disposed with the most graceful freedom of line, separated at the roots by deep drill holes, which tell upon the eye far away like beads of jet; and changed, before they become too crowded to be effective, into a vigorous and simple zigzagged edge, which saves the designer some embarrassment in the perspective of the terminating spiral. But his feeling of nature was greater than his knowledge of perspective; and it is delightful to see how he has rooted the whole leaf in the strong rounded under-stem, the indication of its closing with its face inwards, and has thus given organization and elasticity to the lovely group of spiral lines; a group of which, even in the lifeless sea-shell, we are never weary, but which becomes yet more delightful when the ideas of elasticity and growth are joined to the sweet succession of its involution.

VII. It is not, however, to be expected that either the mute language of early Christianity (however important a part of the expression of the building at the time of its erection), or the delicate fancies of the Gothic leafage springing into new life, should be read, or perceived, by the passing traveller who has never been taught to expect anything in architecture except five orders: yet he can hardly fail to be struck by the simplicity and dignity of the great shafts themselves; by the frank diffusion of light, which prevents their severity from becoming oppressive; by the delicate forms and lovely carving of the pulpit and chancel screen; and, above all, by the peculiar aspect of the eastern extremity of the church, which, instead of being withdrawn, as in later cathedrals, into a chapel dedicated to the Virgin, or contributing by the brilliancy of its windows to the splendour of the altar, and theatrical effect of the ceremonies performed there, is a simple and stern semi-circular recess, filled beneath by three ranks of seats, raised one above the other, for the bishop and presbyters, that they might watch as well as guide the devotions of the people, and discharge literally in the daily service the functions of bishops or *overseers* of the flock of God.

VIII. Let us consider a little each of these characters in succession; and first (for of the shafts enough has been said already), what is very peculiar to this church, its luminousness. This perhaps strikes the traveller more from its contrast with the excessive gloom of the Church of St Mark's; but it is remarkable when we compare the Cathedral of Torcello with any of the contemporary basilicas in South Italy or Lombardic churches in the North. S. Ambrogio at Milan, S. Michele at Pavia, S. Zeno at Verona, S. Frediano at Lucca, S. Miniato at Florence, are all like sepulchral caverns compared with Torcello, where the slightest details of the sculptures and mosaics are visible, even when twilight is deepening. And there is something especially touching in our finding the sunshine thus freely admitted into a church built by men in sorrow. They did not need the darkness; they could not perhaps bear it. There was fear and depression upon them enough, without a material gloom. They sought for comfort in their religion, for tangible hopes and promises, not for threatenings or mysteries; and though the subjects chosen for the mosaics on the walls are of the most solemn character, there are no artificial shadows cast upon them, nor dark colours used in them: all is fair and bright, and intended evidently to be regarded in hopefulness, and not with terror.

The mosaics

IX. For observe this choice of subjects. It is indeed possible that the walls of the nave and aisles, which are now white-washed, may have been covered with fresco or mosaic, and thus have supplied a series of subjects, on the choice of which we cannot speculate. I do not, however, find record

of the destruction of any such works; and I am rather inclined to believe that at any rate the central division of the building was originally decorated, as it is now, simply by mosaics representing Christ, the Virgin, and the apostles, at one extremity, and Christ coming to judgment at the other. [*A further brief reference to the Torcello mosaics is given towards the end of this item.*] And if so, I repeat, observe the significance of this choice. Most other early churches are covered with imagery sufficiently suggestive of the vivid interest of the builders in the history and occupations of the world. Symbols or representations of political events, portraits of living persons, and sculptures of satirical, grotesque, or trivial subjects are of constant occurrence, mingled with the more strictly appointed representations of scriptural or ecclesiastical history; but at Torcello even these usual, and one should have thought almost necessary, successions of Bible events do not appear. The mind of the worshipper was fixed entirely upon two great facts, to him the most precious of all facts—the present mercy of Christ to His Church, and His future coming to judge the world. That Christ's mercy was, at this period, supposed chiefly to be attainable through the pleading of the Virgin, and that therefore beneath the figure of the Redeemer is seen that of the weeping Madonna in the act of intercession, may indeed be matter of sorrow to the Protestant beholder, but ought not to blind him to the earnestness and singleness of the faith with which these men sought their sea-solitudes; not in hope of founding new dynasties, or entering upon new epochs of prosperity, but only to humble themselves before God, and to pray that in His infinite mercy He would hasten the time when the sea should give up the dead which were in it, and Death and Hell give up the dead which were in them, and when they might enter into the better kingdom, 'where the wicked cease from troubling and the weary are at rest'.

One of the references to the cathedral mosaics, listed at the start of the Torcello section, refers to a passage in the chapter on 'The Nature of Gothic'. Here Ruskin cites one of the Torcello mosaics as an example of the stylized form of Romanesque pictorial presentation in contrast to Gothic naturalism.

II–VI–LXV. . . . when an idea would have been by a Roman, or Byzantine, symbolically represented, the Gothic mind realizes it to the utmost. For instance, the purgatorial fire is represented in the mosaic of Torcello (Romanesque) as a red stream, longitudinally striped like a riband, descending out of the throne of Christ, and gradually extending itself to envelope the wicked. When we are once informed what this means, it is enough for its purpose; but the Gothic inventor does not leave the sign in need of interpretation. He makes the fire as like real fire as he can; and

in the porch of St Maclou at Rouen the sculptured flames burst out of the Hades gate, and flicker up, in writhing tongues of stone, through the interstices of the niches, as if the church itself were on fire. This is an extreme instance, but it is all the more illustrative of the entire difference in temper and thought between the two schools of art, and of the intense love of veracity which influenced the Gothic design.

The mosaics on the west wall have been extensively restored. They and those of the apse were originally of the twelfth century.

The chancel screen

II–II–X. Nor were the strength and elasticity of their minds, even in the least matters, diminished by thus looking forward to the close of all things. On the contrary, nothing is more remarkable than the finish and beauty of all the portions of the building, which seem to have been actually executed for the place they occupy in the present structure, the rudest are those which they brought with them from the mainland; the best and most beautiful, those which appear to have been carved for their island church of these, the new capitals already noticed, and the exquisite panel ornaments of the chancel screen, are the most conspicuous; the latter

Interior of Torcello Cathedral showing chancel screen of eleventh century Byzantine work. The panel paintings are of the fifteenth century. To the left is the ambo or pulpit.

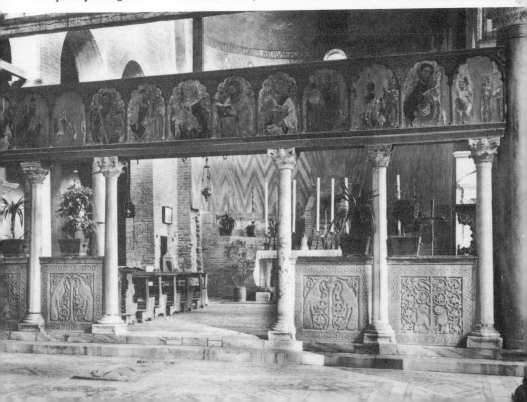

form a low wall across the church between the six small shafts whose places are seen in the plan, and serve to enclose a space raised two steps above the level of the nave, destined for the singers, and indicated also in the plan by an open line *a b c d* [*see Ruskin's plan on page 272*]. The bas-reliefs on this low screen are groups of peacocks and lions, two face to face on each panel, rich and fantastic beyond description, though not expressive of very accurate knowledge either of leonine or pavonine forms. And it is not until we pass to the back of the stair of the pulpit, which is connected with the northern extremity of this screen, that we find evidence of the haste with which the church was constructed.

The pulpit

XI. The pulpit, however, is not among the least noticeable of its features. It is sustained on the four small detached shafts marked at *p* in the plan, between the two pillars at the north side of the screen; both pillars and pulpit studiously plain, while the staircase which ascends to it is a compact mass of masonry (shaded in the plan), faced by carved slabs of marble; the parapet of the staircase being also formed of solid blocks like paving-stones, lightened by rich, but not deep, exterior carving. Now these blocks, or at least those which adorn the staircase towards the aisle, have been brought from the mainland; and, being of size and shape not easily to be adjusted to the proportions of the stair, the architect has cut out of them pieces of the size he needed, utterly regardless of the subject or symmetry of the original design. The pulpit is not the only place where this rough procedure has been permitted; at the lateral door of the church are two crosses, cut out of slabs of marble, formerly covered with rich sculpture over their whole surfaces, of which portions are left on the surface of the crosses; the lines of the original design being, of course, just as arbitrarily cut by the incisions between the arms, as the patterns upon a piece of silk which has been shaped anew. The fact is, that in all early Romanesque work, large surfaces are covered with sculpture for the sake of enrichment only; sculpture which indeed had always meaning, because it was easier for the sculptor to work with some chain of thought to guide his chisel, than without any; but it was not always intended, or at least not always hoped, that this chain of thought might be traced by the spectator. All that was proposed appears to have been the enrichment of surface, so as to make it delightful to the eye; and this being once understood, a decorated piece of marble became to the architect just what a piece of lace or embroidery is to a dressmaker, who takes of it such portions as she may require, with little regard to the places where the patterns are divided. And though it may appear, at first sight, that the procedure is indicative of bluntness and rudeness of feeling, we may perceive, upon reflection, that it may also indicate the re-

dundance of power which sets little price upon its own exertion. When a barbarous nation builds its fortress-walls out of fragments of the refined architecture it has overthrown, we can read nothing but its savageness in the vestiges of art which may thus chance to have been preserved; but when the new work is equal, if not superior, in execution, to the pieces of the older art which are associated with it, we may justly conclude that the rough treatment to which the latter have been subjected is rather a sign of the hope of doing better things, than of want of feeling for those already accomplished. And, in general, this careless fitting of ornament is, in very truth, an evidence of life in the school of builders, and of their making a due distinction between work which is to be used for architectural effect, and work which is to possess an abstract perfection; and it commonly shows also that the exertion of design is so easy to them, and their fertility so inexhaustible, that they feel no remorse in using somewhat injuriously what they can replace with so slight an effort.

XII. It appears, however, questionable in the present instance, whether, if the marbles had not been carved to his hand, the architect would have taken the trouble to enrich them. For the execution of the rest of the pulpit is studiously simple, and it is in this respect that its design possesses, it seems to me, an interest to the religious spectator greater than he will take in any other portion of the building. It is supported, as I said, on a group of four slender shafts; itself of a slightly oval form, extending nearly from one pillar of the nave to the next, so as to give the preacher free room for the action of the entire person, which always gives an unaffected impressiveness to the eloquence of the southern nations. In the centre of its curved front, a small bracket and detached shaft sustain the projection of a narrow marble desk (occupying the place of a cushion in a modern pulpit), which is hollowed out into a shallow curve on the upper surface, leaving a ledge at the bottom of the slab, so that a book laid upon it, or rather into it, settles itself there, opening as if by instinct, but without the least chance of slipping to the side, or in any way moving beneath the preacher's hands. Six balls, or rather almonds, of purple marble veined with white are set round the edge of the pulpit, and form its only decoration. Perfectly graceful, but severe and almost cold in its simplicity, built for permanence and service, so that no single member, no stone of it, could be spared, and yet all are firm and uninjured as when they were first set together, it stands in venerable contrast both with the fantastic pulpits of mediaeval cathedrals and with the rich furniture of those of our modern churches.

Ruskin then discusses pulpits, preachers and sermons generally, returning to the subject of Torcello with paragraph XV.

The apse

xv. But the severity which is so marked in the pulpit at Torcello is still more striking in the raised seats and episcopal throne which occupy the curve of the apse. The arrangement at first somewhat recalls to the mind that of the Roman amphitheatres; the flight of steps which lead up to the central throne divides the curve of the continuous steps or seats (it appears in the first three ranges questionable which were intended, for they seem too high for the one, and too low and close for the other), exactly as in an amphitheatre the stairs for access intersect the sweeping ranges of seats. But in the very rudeness of this arrangement, and especially in the want of all appliances of comfort (for the whole is of marble, and the arms of the central throne are not for convenience, but for distinction, and to separate it more conspicuously from the undivided seats), there is a dignity which no furniture of stalls nor carving of canopies ever could attain, and well worth the contemplation of the Protestant, both as sternly significative of an episcopal authority which in the early days of the Church was never disputed, and as dependent for all its impressiveness on the utter absence of any expression either of pride or self-indulgence.

xvi. But there is one more circumstance which we ought to remember as giving peculiar significance to the position which the episcopal throne occupies in this island church, namely, that in the minds of all early Christians the Church itself was most frequently symbolized under the image of a ship, of which the bishop was the pilot. Consider the force which this symbol would assume in the imaginations of men to whom the spiritual Church had become an ark of refuge in the midst of a destruction hardly less terrible than that from which the eight souls were saved of old, a destruction in which the wrath of man had become as broad as the earth and as merciless as the sea, and who saw the actual and literal edifice of the Church raised up, itself like an ark in the midst of the waters. No marvel if with the surf of the Adriatic rolling between them and the shores of their birth, from which they were separated for ever, they should have looked upon each other as the disciples did when the storm came down on the Tiberias Lake, and have yielded ready and loving obedience to those who ruled them in His name, who had there rebuked the winds and commanded stillness to the sea. And if the stranger would yet learn in what spirit it was that the dominion of Venice was begun, and in what strength she went forth conquering and to conquer, let him not seek to estimate the wealth of her arsenals or number of her armies, nor look upon the pageantry of her palaces, nor enter into the secrets of her councils; but let him ascend the highest tier of the stern ledges that sweep round the altar of Torcello, and then, looking as the

pilot did of old along the marble ribs of the goodly temple-ship, let him repeople its veined deck with the shadows of its dead mariners, and strive to feel in himself the strength of heart that was kindled within them, when first, after the pillars of it had settled in the sand, and the roof of it had been closed against the angry sky that was still reddened by the fires of their homesteads—first, within the shelter of its knitted walls, amidst the murmur of the waste of waves and the beating of the wings of the sea-birds round the rock that was strange to them—rose that ancient hymn, in the power of their gathered voices:

THE SEA IS HIS, AND HE MADE IT:
AND HIS HANDS PREPARED THE DRY LAND.

The dimensions of the cathedral
In Appendix 3 to Volume II, Ruskin gives several dimensions of the cathedral to demonstrate the delicacy of proportions.

. . . The entire breadth of the church within the walls is 70 feet; of which the square bases of the pillars, 3 feet on each side, occupy 6 feet; and the nave, from base to base, measures 31 ft 1 in; the aisles from base to wall, 16 feet odd inches, not accurately ascertainable on account of the modern wainscot fittings. The intervals between the bases of the pillars are 8 feet each, increasing towards the altar to 8 ft 3 in, in order to allow for a corresponding diminution in the diameter of the bases from 3 ft to 2 ft 11 in or 2 ft 10 in. This subtle diminution of the bases is in order to prevent the eye from feeling the greater narrowness of the shafts in that part of the nave, their average circumference being 6 ft 10 in; and one, the second on the north side, reaching 7 feet, while those at the upper end of the nave vary from 6 ft 8 in to 6 ft 4 in. It is probable that this diminution in the more distant pillars adds slightly to the perspective effect of length in the body of the church, as it is seen from the great entrance: but whether this was the intention or not, the delicate adaptation of this diminished base to the diminished shaft is a piece of fastidiousness in proportion which I rejoice in having detected; and this the more, because the rude contours of the bases themselves would little induce the spectator to anticipate any such refinement.

The date of the cathedral
II–Appendix 4. The first flight to the lagoons for shelter was caused by the invasion of Attila in the fifth century, so that in endeavouring to throw back the thought of the reader to the former solitude of the islands, I spoke of them as they must have appeared '1300 years ago'. Altinum, however, was not finally destroyed till the Lombard invasion in 641, when the episcopal seat was removed to Torcello, and the inhabitants of the mainland city, giving up all hope of returning to their former homes built

their Duomo there It is a disputed point among Venetian antiquarians, whether the present church be that which was built in the seventh century, partially restored in 1008, or whether the words of Sagornino, 'ecclesiam jam vetustate consumptani recreare' [*to recreate the church now wasted with age*], justify them in assuming an entire rebuilding of the fabric. I quite agree with the Marchese Selvatico in believing the present church to be the earlier building, variously strengthened, refitted, and modified by subsequent care; but, in the case of the pulpit and chancel screen, which, if the Chevalier Bunsen's conclusions respecting early pulpits in the Roman basilicas be correct [*see Appendix 5 of Volume II*], may possibly have been placed in their present position in the tenth century, and the fragmentary character of the workmanship of the latter noticed in II–II–X and XI, would in that case have been the result of innovation, rather than of haste. The question, however, whether they are of the seventh century, does not in the least affect our conclusions, drawn from the design of these portions of the church, respecting pulpits in general.

Church of S. Fosca

S. Fosca, set alongside the cathedral of Torcello, is a church of the eleventh and twelfth centuries. Ruskin mentions it in his general description of Torcello (see above, II–II–III). Elsewhere Ruskin cites it as providing an example of a continuous cornice which forms the abacus of a capital.

I–IX–XXIV. [*Ruskin's drawing of a part of S. Fosca shows that*] the cornice or string course, which goes round every part of the church, is not strong enough to form the capitals of the shafts. It therefore forms their abaci only; and in order to mark the diminished importance of its

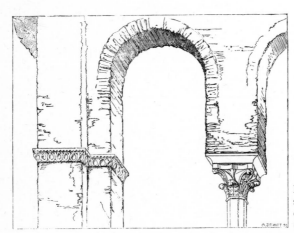

Ruskin's drawing of the string course in the Church of S. Fosca at Torcello (Volume I, Figure XXVIII).

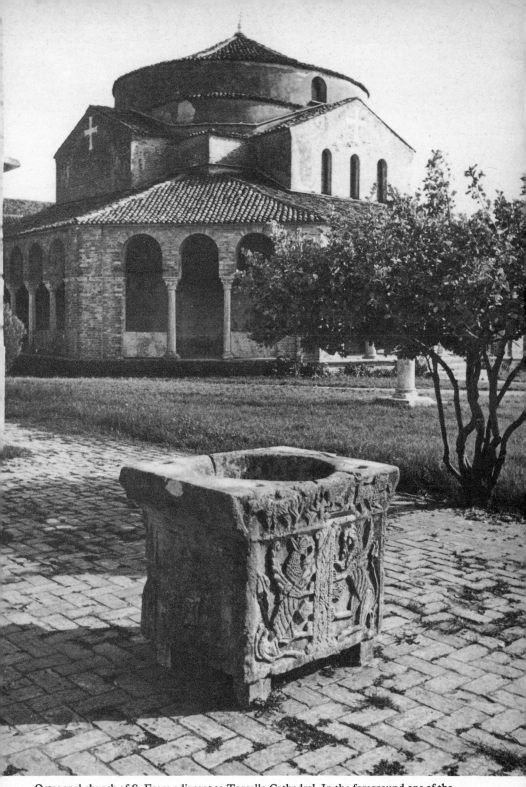

Octagonal church of S. Fosca adjacent to Torcello Cathedral. In the foreground one of the many well heads to be seen in Venice, this one a lively example of Byzantine work.

function, it ceases to receive, as the abacus of the capital, the decoration which it received as the string course of the wall.

T R E V I S A N , P A L A Z Z O, I–Appendix 6, III–Appendix 4. *It is appropriate to quote the second Appendix first, since this offers some brief details on the dating of this palace. Ruskin had gathered his information from his friend, Rawdon Brown, at one time owner of the Palazzo Businello (see the note on Brown under that heading).*

III–Appendix 4. 'The Trevisana Cappello House in Canonica, was once the property (AD 1578) of a Venetian dame fond of cray-fish, according to a letter of hers in the archives, whereby she thanks one of her lovers for some which he had sent her from Treviso to Florence, of which she was then Grand Duchess. Her name has perhaps found its way into the English annals. Did you ever hear of Bianca Cappello? She bought the house of the Trevisana family, by whom Selva (in Cicognara) and Fontana (following Selva) say it was ordered of the Lombardi, at the commencement of the sixteenth century: but the inscription on its façade, thus,

SOLI	HONOR. ET
DEO	GLORIA.

reminding one both of the Dario House, and of the words NON NOBIS DOMINE inscribed on the façade of the Loredano Vendramin Palace at S. Marcuola (now the property of the Duchess of Berri), of which Selva found proofs in the Vendramin Archives that it was commenced by Sante Lombardo, AD 1481, is in favour of its being classed among the works of the fifteenth century.'

The Palazzo Trevisan-Cappello is by the Fondamenta di Canonica, near St Mark's. Bianca Cappello, of noble birth, ran off with a clerk, Pietro Bonaventura in 1564. This was considered such a disgrace that, in her absence, she was condemned to death. However, she later married Francesco de' Medici, Grand Duke of Tuscany, for which the Republic forgave her her earlier escapade. James Morris reports that she died of poisoning in 1587 'but the Republic did not go into mourning, just in case it was the Grand Duke who had poisoned her'. (Venice).

The other appendix examines two ornamental marble insets in the Palazzo Trevisan. Only one is shown here as the other was not suitable for reproduction.

I–Appendix 6. There having been three principal styles of architecture in Venice, the Greek or Byzantine, the Gothic, and the Renaissance, it will be shown, in the sequel, that the Renaissance itself is divided into three correspondent families: Renaissance engrafted on Byzantine, which is

earliest and best; Renaissance engrafted on Gothic, which is second, and second best; Renaissance on Renaissance, which is double darkness, and worst of all. The palaces in which Renaissance is engrafted on Byzantine are those noticed by Commynes [*French diplomat and historian of the late Middle Ages*]: they are characterized by an ornamentation very closely resembling, and in some cases identical with, early Byzantine work; namely, groups of coloured marble circles inclosed in interlacing bands. [*Ruskin's drawing shows*] one of these ornaments, from the Ca' Trevisan, in which a most curious and delicate piece of inlaid design is introduced into a band which is almost exactly copied from the church of Theotocos at Constantinople, and correspondent with others in St Mark's There is also much Byzantine feeling in the treatment of the animals, especially in the two birds of the lower compartment, while the peculiar curves of the cinque cento leafage are visible in the leaves above. The dove, alighted, with the olive-branch plucked off, is opposed to the raven with restless expanded wings. Beneath are evidently the two sacrifices 'of every clean fowl and of every clean beast'. The colour is given with green and white marbles, the dove relieved on a ground of greyish green, and all is exquisitely finished.

Ruskin then discusses a second, circular ornament which he illustrates in Plate I of Volume I. In this same plate he also shows another ornament, made up of circular insets, which is from the Palazzo Dario. The appendix continues:

Selvatico, indeed, considers both the Ca' Trevisan (which once belonged to Bianca Cappello) and the Ca' Dario, as buildings of the sixteenth century. I defer the discussion of the question at present, but have, I believe, sufficient reason for assuming the Ca' Dario to have been built about 1486, and the Ca' Trevisan not much later.

Ruskin's drawing of wall-veil decoration with coloured marble disks at the Palazzo Trevisan (Volume I, Plate xx).

J. Ruskin J.C.Armytage

TROVASO, CHURCH OF S. Itself of no importance, but containing two pictures by Tintoretto, namely:

1. *The Temptation of St Anthony.* (Altar piece in the chapel on the left of the choir.) A small and very carefully finished picture, but marvellously temperate and quiet in treatment, especially considering the subject, which one would have imagined likely to inspire the painter with one of his most fantastic visions. As if on purpose to disappoint us, both the effect and the conception of the figures are perfectly quiet, and appear the result much more of careful study than of vigorous imagination. The effect is one of plain daylight; there are a few clouds drifting in the distance, but with no wildness in them, nor is there any energy or heat in the flames which mantle about the waist of one of the figures. But for the noble workmanship, we might almost fancy it the production of a modern academy: yet, as we begin to read the picture, the painter's mind becomes felt. St Anthony is surrounded by four figures, one of which only has the form of a demon, and he is in the background, engaged in no more terrific act of violence towards St Anthony, than endeavouring to pull off his mantle; he has, however, a scourage over his shoulder, but this is probably intended for St Anthony's weapon of self-discipline, which the fiend, with a very Protestant turn of mind, is carrying off. A broken staff, with a bell hanging to it, at the saint's feet, also expresses his interrupted devotion. The three other figures beside him are bent on more cunning mischief: the woman on the left is one of Tintoretto's best portraits of a young and bright-eyed Venetian beauty. It is curious that he has given so attractive a countenance to a type apparently of the temptation to violate the vow of poverty, for this woman places one hand in a vase full of coins, and shakes golden chains with the other. On the opposite side of the saint, another woman, admirably painted, but of a far less attractive countenance, is a type of the lusts of the flesh, yet there is nothing gross or immodest in her dress or gesture. She appears to have been baffled, and for the present to have given up addressing the saint: she lays one hand upon her breast, and might be taken for a very respectable person, but that there are flames playing about her loins. A recumbent figure on the ground is of less intelligible character, but may perhaps be meant for Indolence; at all events, he has torn the saint's book to pieces. I forgot to note, that, under the figure representing Avarice, there is a creature like a pig; whether actual pig or not is unascertainable, for the church is dark, the little light that comes on the picture falls on it the wrong way, and one third of the lower part of it is hidden by a white case, containing a modern daub, lately painted by way of an altar-piece; the meaning, as well as the merit, of the grand old picture being now far beyond the comprehension both of priests and people.

2. *The Last Supper.* (On the left-hand side of the Chapel of the Sacrament.) A picture which has been through the hands of the Academy, and is therefore now hardly worth notice. Its conception seems always to have been vulgar, and far below Tintoretto's usual standard. There is singular baseness in the circumstance that one of the near Apostles, while all the others are, as usual, intent upon Christ's words, 'One of you shall betray me', is going to help himself to wine out of a bottle which stands behind him. In so doing he stoops towards the table, the flask being on the floor. If intended for the action of Judas at this moment, there is the painter's usual originality in the thought; but it seems to me rather done to obtain variation of posture, in bringing the red dress into strong contrast with the tablecloth. The colour has once been fine, and there are fragments of good painting still left; but the light does not permit these to be seen, and there is too much perfect work of the master's in Venice to permit us to spend time on retouched remnants. The picture is only worth mentioning, because it is ignorantly and ridiculously referred to by Kugler as characteristic of Tintoretto.

The present building of S. Trovaso is a Renaissance work erected 1584–1657. Its name derives from a corruption of SS. Gervasio and Protasio, to whom the church is dedicated. In addition to the two Tintorettos, the church contains a Gothic painting by Michele Giambono, 'St Chrysogonus' and, in the Clary chapel in the south transept, a fine marble bas-relief of an angel choir. This was carved in about 1470 by an unknown master. Restoration work on this church and its paintings is proceeding with the assistance of the American Save Venice Inc.

TURCHI, FONDACO DEI. See FONDACO.

V

VENDRAMIN CALERGI, PALAZZO, on the Grand Canal. *Ruskin does not mention this but it is one of the most admired of early Renaissance palaces in Venice. Commenced in 1481 to the designs of Mauro Coducci, it was continued by Pietro Lombardo and has many distinctive features. The bifurcated arched windows on the three stories and the Corinthian engaged columns give a rich, decorative effect to a well-proportioned façade, capped with a bold projecting cornice. Wagner died in this palace in 1883.*

VITALE, CHURCH OF S. Said to contain a picture by Vittore Carpaccio, over the high altar: otherwise of no importance.

The Church of S. Vitale is a Renaissance building erected in the early eighteenth century to the design of Andrea Tirali. It is no longer used as a church but serves as an art gallery. It is still possible to see the picture by Carpaccio, an altar piece of St Vitalis on horse-back with saints and Madonna in clouds.

VOLTO SANTO, CHURCH OF THE. An interesting but desecrated ruin of the fourteenth century; fine in style. Its roof retains some fresco colouring, but, as far as I recollect, of later date than the architecture.

A hospice and scuola, with oratory, were established in the Cannaregio quarter by a guild of silk workers from Lucca. The scuola, or guild, was dedicated to the 'Volto Santo', or sacred countenance, in memory of a crucifix for which the Cathedral of Lucca was renowned.

Z

ZACCARIA, CHURCH OF S. Early Renaissance, and fine of its kind; a Gothic chapel attached to it is of great beauty. It contains the best John Bellini in Venice, after that of S. G. Grisostomo, 'The Virgin, with Four Saints'; and is said to contain another John Bellini and a Tintoretto, neither of which I have seen.

The present building of S. Zaccaria is transitional in character from Gothic to Renaissance, and was erected in 1444–1500 to the designs first of Antonio Gambello and then of Mauro Coducci. The Giovanni Bellini altarpiece painted in 1505, mentioned by Ruskin, is one of the artist's finest works. Another work, said to be an early G. Bellini, is 'The Circumcision'. The painting by Tintoretto is 'The Birth of John the Baptist'. Restoration work on the church was carried out in 1969–1972 with the assistance of the American Committee to Rescue Italian Art.

ZANIPOLO, CHURCH OF S. See GIOVANNI E PAOLO, CHURCH OF SS.

ZITELLE, CHURCH OF THE. Of no importance.
Dedicated to S. Maria della Presentazione, this is more commonly known as the Church of the Zitelle, or virgins, after the foundation of an institute for poor girls, established in the eighteenth century. Situated on the Giudecca, the church was built to a design by Palladio and was completed in 1586.

Palazzo Vendramin Calergi, a much admired Renaissance building
designed by Mauro Coducci and Pietro Lombardo. It is now the winter casino.

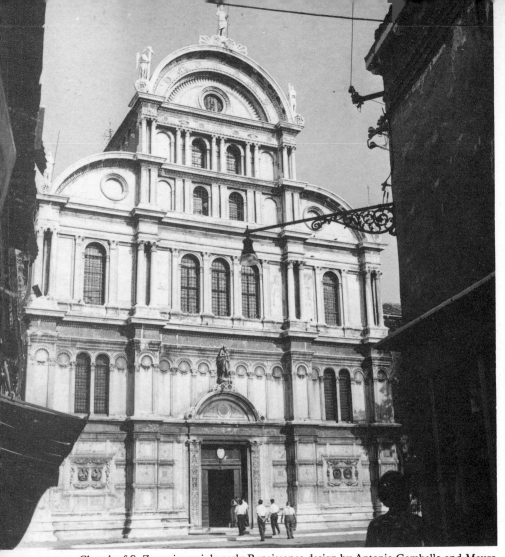

Church of S. Zaccaria, mainly early Renaissance design by Antonio Gambello and Mauro Coducci.

ZOBENIGO, CHURCH OF S. MARIA, III–III–XXI. It contains one valuable Tintoretto, namely:

Christ with S. Justina and S. Augustin. (Over the third altar on the south side of the nave.) A picture of small size, and upright, about ten feet by eight. Christ appears to be descending out of the clouds between the two saints, who are both kneeling on the seashore. It is a Venetian sea, breaking on a flat beach, like the Lido, with a scarlet gallery in the middle distance, of which the chief use is to unite the two figures by a

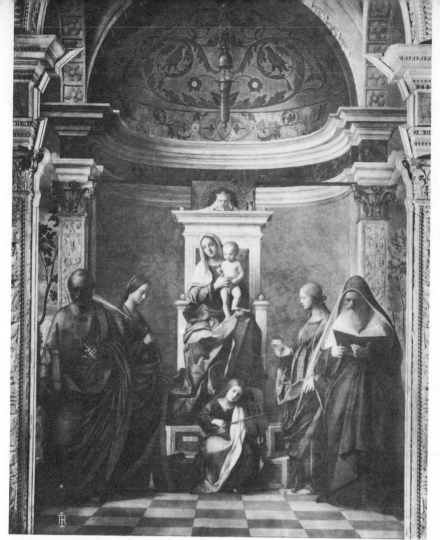

'Virgin and Child with four Saints' by Giovanni Bellini in the Church of S. Zaccaria.

point of colour. Both the saints are respectable Venetians of the lower class, in homely dresses and with homely faces. The whole picture is quietly painted, and somewhat slightly; free from all extravagance, and displaying little power except in the general truth or harmony of colours so easily laid on. It is better preserved than usual, and worth dwelling upon as an instance of the style of the master when *at rest*.

Reference III–III–XXI occurs in the chapter on 'Grotesque Renaissance'. Just as the Churches of S. Maria Formosa and S. Moise (qv) were virtually monuments to particular Venetian families so:

Church of S. Maria Zobenigo (said to be from the name of its founders, the family of 'Jubanico') or S. Maria del Giglio as it is also known.

. . . the Church of S. Maria Zobenigo is entirely dedicated to the Barbaro family; the only religious symbols with which it is invested being statues of angels blowing brazen trumpets, intended to express the spreading of the fame of the Barbaro family in heaven. At the top of the church is Venice crowned, between Justice and Temperance, Justice holding a pair of grocer's scales, of iron, swinging in the wind. There is a two-necked stone eagle (the Barbaro crest), with a copper crown, in the centre of the pediment. A huge statue of a Barbaro in armour, with a fantastic head-dress, over the central door; and four Barbaros in niches, two on each side of it, strutting statues, in the common stage postures of the period —'Jo. Maria Barbaro, sapiens ordinum'; 'Marinus Barbaro, Senator' (reading a speech in a Ciceronian attitude); 'Franc. Barbaro, legatus in classe' (in armour, with high-heeled boots, and looking resolutely fierce); and 'Carolus Barbaro, sapiens ordinum': the decorations of the façade being completed by two trophies, consisting of drums, trumpets, flags and cannon; and six plans, sculptured in relief, of the towns of Zara, Candia, Padua, Rome, Corfu, and Spalatro.

This church was a foundation of the ninth century. Parts of the early sixteenth-century building remain, but the campanile collapsed in 1774. Much of the church as it now appears, including the main façade, was erected in the late seventeenth century to the design of Giuseppe Sardi, and is an interesting example of Baroque. The many paintings that it contains are by minor artists chiefly of the late sixteenth and seventeenth centuries. It was recently restored with the help of funds provided by the International Fund for Monuments of New York.

Venice preserved

The unique beauty and cultural value of Venice needs no stressing. For centuries famous writers and artists from many countries have sung its praises and responded to its magic in various ways.

But increasingly the picture of Venice is tinged with nostalgia: it risks being seen as a dying city. The problems it faces are both physical and social and are of tremendous social and cultural concern to the world.

Venice: the physical problems

The physical phenomena, by their very nature, have caught the public imagination and numerous articles—not always well informed—have been devoted to them in the press since the disaster of 1966. Venice is subject to periodic flooding, the city is gradually sinking, and atmospheric and water pollution threatens much of her cultural heritage. These physical difficulties threaten the well-being, indeed the very existence, of the whole urban ensemble, with its architecture and art treasures. Although related, they pose separate problems and solutions.

The causes of the phenomena will be better understood from a glance at the geographical history of Venice and its region.

Geographical history

The Lombard Plain, which lies to the west of Venice, was formed over the course of thousands of years by deposits of alluvial soil, brought down by the numerous rivers which rise in the Alps and flow down into the Adriatic.

With the constant discharge of alluvial soil from the mountains, lagoons and estuaries have progressively silted up in the course of thousands of years, land has in many places encroached on the sea, and the Lombard Plain has gradually been extended eastwards. What is now the railway line from Mestre to Monfalcone near Trieste, three to eight miles inland, was at many points the coastline as recently as Roman times. Ravenna was once a coastal town with a network of canals like Venice today, and in Roman times was an important naval port, but it is now an inland city five miles from the sea.

Such would have been the fate of Venice had not extensive civil engineering works been undertaken by the Venetians as early as the twelfth century to preserve their lagoon. From small beginnings Venice

grew into a formidable republic and became one of the chief naval powers. The Venetians were constantly faced with the engineering problem of keeping the lagoon with its three entrances open for shipping, whilst maintaining it as a harbour for their fleet, and denying access to a potential enemy.

This was accomplished in the course of centuries mainly by diverting the rivers that flowed into the sea through the lagoon. The rivers Sile and Piave, which once flowed into the Venetian lagoon, were diverted to flow into the sea to the north-east; the river Brenta, which in Roman times must have been a torrential river, was extensively canalized and later controlled by sluices. It still flows into the lagoon at its Fusina mouth, but the real outlet has been transferred by canal farther south and it has filled up the lagoon of Brondolo. Nor were the operations limited to controlling the direct flow into the lagoon. Work was carried out on the mainland to the rivers Po and Adige which were depositing silt and threatening to close the southern entrance to the lagoon. The seven mouths of the Adige were reduced to one, while Pliny mentions that the delta of the Po was called the Seven Seas and that canals were constructed to control it to make it suitable for navigation. One was the canal of Augustus extending to Ravenna.

By such means the Venetians have been able to preserve their unique island city and keep the lagoon open for shipping. The latter, however, could only be done by keeping the channels, which follow the original beds, well dredged. Since the port of Marghera on the mainland opposite the city was developed, the channels of the lagoon have been further dredged for larger ships, including tankers. Sometimes at low tide much of the lagoon appears as a series of large sand banks, with maritime plants and algae visible on the landward side. These barene, as they are called, serve two highly useful purposes: they are covered when the tide is high and act like sponges to absorb excess of water: they also circumscribe the areas where fish can breed. Ruskin himself noted that 'a fall of eighteen or twenty inches is enough to show ground over the greater part of the lagoon; and at the complete ebb the city is seen standing in the midst of a dark plain of sea-weed, of gloomy green, except only where the larger branches of the Brenta and its associated streams converge towards the port of the Lido'.

Flooding of the city

High tides have periodically flooded the city for a thousand years and evidence of their nature has been given by various writers. One of the most precise is that given by Ruskin about 125 years ago in *The Stones of Venice* and it is worth quoting.

Venice and its environs.

'The lowest and highest tides take place in Venice at different periods, the lowest during the winter, the highest in the summer and autumn. During the period of the highest tides, the city is exceedingly beautiful, especially if, as is not unfrequently the case, the water rises high enough partially to flood St Mark's Place. Nothing can be more lovely or fantastic than the scene, when the Campanile and the Golden Church are reflected in the calm water, and the lighter gondolas floating under the very porches of the façade. On the other hand, a winter residence in Venice is rendered peculiarly disagreeable by the low tides, which sometimes leave the small canals entirely dry, and large banks of mud beneath the houses, along the borders of even the Grand Canal. The difference between the levels of the highest and lowest tides I saw in Venice was 6 ft 3 in. The average fall rise is from two to three feet.' (Volume II, Appendix 3)

Sir Ashley Clarke points out, however, that 'Ruskin is precise but wrong about highest and lowest tides which are governed by phenomena which occur at all times of the year such as wind and the phases of the moon'. 'Nowadays', he adds, 'the height of an *acqua alta* is measured not from the previous low water (as Ruskin does) but from the average mean level of the water in the lagoon.'

During the present century high tides have been of increasing frequency and height, reaching unusually high levels in the flooding of November 1966.* They have continued to occur several times every year since with diminishing frequency and severity in the three years 1971–4, but again in 1975. The occurrence is cyclical.

One of the major tasks, therefore, in order to preserve Venice is to control the floods. The first step in any such work is to establish the cause of the floods and so far there has not been complete agreement on the subject. There are several theories, including one which argues that a gradual rise in the earth's temperature has meant that a greater volume of glaciers and polar ice is melting, thus raising the general sea level.

A more widely held theory is that man has provoked the problem by interfering with natural processes without properly understanding them. It is argued that the increasing depth of the channels in the lagoon has meant a greater volume of water entering at high tide; but more importantly the mud banks that would have absorbed the water, as previously implied, have been replaced by concrete which adds to the difficulties. As the tide falls the three *porti* are not adequate to ensure a normal speed in the fall of the water level, especially as the falling tide carries with it the sewage from the city. Whilst this does not account for the exceptional height of the tides in the sixties, it does explain a prolongation of high

* There is evidence of very high tides occurring at intervals during the last thousand years. In 1240 flood water was recorded higher than a man. High floods in recent times reached heights of 4 ft 9 in in 1960, 6 ft 4½ in in 1966 and 4 ft 9 in in 1967.

water which occurred with the flooding in November 1966 when the water was at flood level for twenty hours.

Sir Ashley Clarke has given four conditions which conduce to the flooding, 'which', he says, 'if they were to operate at maximum intensity simultaneously, could even today practically submerge Venice under nine or ten feet of muddy, oily water. The conditions are first the tides, secondly the marine currents, thirdly the "scirocco"—a warm south wind which sometimes blows for three days on end—and fourthly the so-called "seiches". This last expression describes an oscillatory motion which occurs five or six times a year from end to end of this narrow and relatively shallow sea: there are few places in the Adriatic where there is a depth of water of more than ten fathoms (60 feet).'*

Among the measures suggested to minimize the flooding are the introduction of sluices, which could be closed whenever a very high tide is imminent. The introduction of sluices would necessitate a new sewage disposal system for Venice to augment the natural process of the tidal sea waters coursing through the canals and keeping them clean. Many designs of sluices or locks have been produced, and three in particular have been selected for research and examination.

At the end of 1974 a model of an inflatable dam was demonstrated as a method of temporarily closing the entrances. In this demonstration the dam was quickly pumped with water and later reversed and the dam sunk out of sight. This is possibly one promising method.

Sinking

Many calculations have been made of the rate that Venice has been sinking in recent years. The available evidence shows that the degree of sinking varies in different parts of Venice, and there is evidence that, though St Mark's Square has sunk, the area round the Ponte Rialto has not sunk at all.

Nevertheless it is a major threat. The sinking has been ascribed to a number of causes: to the deterioration of the wood piles that form the foundations of the buildings and on which the masonry rests, to the weight of the buildings, and to the fall in the water-table. The last is widely accepted as being the main cause, and is put down to the excessive extraction of water by industry from artesian wells at Marghera on the mainland. The consequent fall in the water dries the earth which then shrinks.

The obvious answer is to restrict the use of artesian wells and to insist that industry should obtain water elsewhere. New legislation prohibits the sinking of fresh artesian wells and additional water will be taken

* The Transactions of the Ancient Monuments Society, Volume 17, 1970.

from rivers and lakes outside the area by means of pipes and aqueducts. To make this possible an aqueduct to carry water from the river Sile, 10 miles away, to Marghera has been constructed by the Municipality of Venice and is now complete. It is adequate to supply both industrial zones with all the fresh water they need.

Pollution

Venice, like most cities, has suffered from the effects of pollution for centuries. Conditions are particularly severe for Venice because of the destructive effects of the acidity and salinity of both the sea water and, latterly, the water-borne industrial waste from factories on the mainland and oil from ships. Combined, these corrode foundations and steps and —when flooding occurs—attack even the upper parts of walls.

Since the early nineteenth century Venice has suffered much from atmospheric pollution, first from coal smoke and later from oil fumes. Writing in the middle of the last century, Ruskin describes the approach to Venice: 'there rises, out of the wide water, a straggling line of low and confused brick buildings, which, but for the many towers which are mingled among them, might be the suburbs of an English manufacturing town. Four or five domes, pale and apparently at a greater distance, rise over the centre of the line; but the object which first catches the eye is a sullen cloud of black smoke brooding over the northern half of it, and which issues from the belfry of a church.'

Venice is built mainly on timber piles, surmounted by stone masonry for the foundations, with brick walls—occasionally as two leaves with rubble between. Many of the walls of the more palatial buildings are covered with coloured marble encrustations. There is also considerable use of cream limestone from Verona and Istria in such components as plinths, damp-proof courses (which take the form of stone slabs), occasional walls and wall facings, columns, capitals, arches, relief carvings and sculpture. In clean air limestone weathers fairly well, especially if it is periodically sprayed softly with plain water. But chemicals in the atmosphere, mixed with rain and sea spray, form destructive corrosive agents.

In addition, deposits of salts and dirt stain the light-coloured stone and marble. Masonry becomes more vulnerable to frost and the surfaces of buildings show blistering and scabbing.

This corrosive process has become very active and widespread and demands urgent action to prevent further damage from taking place. Efforts have been made to minimize pollution from the petro-chemical works on the mainland. Firms have spent much money on control and have reduced it considerably. Oil-fired domestic central heating was another source of pollution: recent clean-air legislation has meant that methane gas, supplied by the city, has been substituted for oil.

It is essential that corrosive and unsightly patches of black (such as can been seen on the carved capitals of the Ducal Palace on page 96) should be removed from sculpture and carvings. This will necessarily take time, but delay means further corrosion and the matter is therefore urgent if this part of the Venetian heritage is valued. And when the sculpture is cleaned it is necessary to preserve the stone against further corrosion.

Water is the agent by which the acid attack on stone is effected; it is, therefore, vital to impregnate the stone with some water repellent. Experience over the last thirty years has shown that silicone is an effective agent and it is being used increasingly for stone preservation throughout Europe. The lower range of marble panels on the exterior of Florence Cathedral was treated with silicone water repellent about fifteen years ago, and it might well prove useful for some of the buildings in Venice, although some of the Istrian stone is so finely grained as to resist much penetration.

There is so much restoration and maintenance of stonework and sculpture to be done that it would be a good plan if Venice could become a centre for stone craftsmanship, which could include new work as well. This could be on the same lines as in England (at Chichester and York, for example) where restoration of the stonework of some of the cathedrals is so extensive that workshops have been set up which have become regional centres for stone craftsmanship.

Restoration work

Although in its last decades the Republic of Venice had become one of the pleasure cities of Europe, there was yet among Venetians a strong consciousness of its artistic and cultural heritage and thoughts were directed to the preservation of the city and of its art treasures. One indication was that in 1778 a laboratory was established in the Monastery of SS. Giovanni e Paolo for the restoration of pictures.

With the invasion of Napoleon in 1797 the Republic came to an end. In the same year Venice was ceded to Austria, but in 1805 it became part of Napoleon's Kingdom of Italy. The French sought to destroy the entire ducal system. Under their rule, most of the Venetian churches were closed, no less than seventy were demolished, the *scuole* (partly religious, partly educational and cultural institutes) were suppressed and along with them all such institutions as the new restoration laboratory. The prodigious artistic wealth of eighteenth-century Venice was gravely diminished and dispersed. In 1814 the city was returned to Austria. There was one unsuccessful rebellion in 1848. In 1866, however, Venice succeeded in liberating itself while the Austrians were fully occupied in defending themselves against the Prussians under Frederick the Great, and Venice became a part of the new Kingdom of Italy. But the Venice of the Doges

had vanished, and with it the civic discipline which had been its greatest pride.

Nevertheless, all was not loss, for Venice began to benefit by the state systems of conservation. Yet, with such a unique collection of architecture, sculpture and paintings the needs of conservation have steadily outstripped official means to fulfil them. Since all the problems of Venice are inter-locked and need simultaneous treatment, they now demand not only national but also international treatment, not only official but also private generosity.

After the end of World War II but before the flooding disaster of 4 November 1966, Venice had benefited by two magnificent and truly model restorations: to commemorate his only son who was the victim of a flying accident in 1949, Count Vittorio Cini completely restored the monastery and other buildings on the Island of St George, turning them into an international cultural foundation which he has since most generously continued to support; and Italian radio and television have completely restored the Palazzo Labia, converting the upper stories for their technical purposes.

After the unprecedented flooding of the city in November 1966 the Italian Government sought international help through Unesco. It gradu-ally emerged that the Government's members of Unesco were unwilling to support the latter's campaign for Venice unless the Italian Government evolved an overall plan and undertook the lion's share itself. Unesco therefore devoted itself primarily to encouraging the Italian Government to meet this requirement which (in principle) it did by securing the passage on 13 April 1973 of a Special Law for Venice. Except for help given in 1967 to the two Superintendents of Galleries and Monuments to draw up catalogues of the works óf art and monuments in need of restoration, Unesco did not intervene directly in Venice until the latter part of 1973. It now has an active representative office there.

Meanwhile, it fell to a number of foreign voluntary organizations (stimulated by Italia Nostra) to give impetus to the desperately needed work of restoration. These were later joined by several Italian organiza-tions, notably the Italian Committee for Venice, the Dante Alighieri Society, the Committee for the Historic Jewish Centre and Venezia Nostra. Among the first in the field were the American Committee for the Rescue of Italian Art, the British Italian Art and Archives Rescue Fund (both formed within a fortnight of the disaster) and a German organization. These were soon joined by a French organization, several other American (especially the International Fund for Monuments of New York, Save Venice Inc, and the America-Italy Society of Philadelphia), Swiss and Austrian organizations, the British Venice in Peril Fund, a second German fund, and Netherlands and Iranian organizations.

All these contributed money, some of them personnel and one or two of them expertise (notably the British). But naturally the whole responsibility lay with the Superintendents of the Galleries and Monuments who were alsó able to make substantial contributions from official Italian funds.

On 9 April 1975 the Italian Government announced its guidelines for the work of preserving Venice from the dangers of sinking, flooding and pollution. These include the construction of barriers across the three entrances to the lagoon to prevent flooding; a reduction in the number of big oil tankers crossing the lagoon; a ban on further refineries; and a limitation of new building in Venice. These measures are implementations of the 1973 act, in which in the region of 300,000 million lire was to be provided for the restoration and maintenance of the city.

Some notes on the restoration work are given in the commentary that intersperses Ruskin's Index. Among the buildings and the works of art restored with the aid of individual countries are:

Italy
Church of S. Stefano, Church of the Redentore, Scuola di S. Giorgio, Frari (cloister, capitular room and refectory), Church of S. Sebastiano (Veronese frescoes), Church of S. Zaccaria ('Madonna and Child' by Giovanni Bellini), Arsenal, Rialto Bridge, Procuratie Vecchie (pilot operation).

United States of America
Church of S. Pietro in Castello, Church of S. Maria del Giglio, Church of the Gesuiti (east end and high altar), Church of S. Donato in Murano (mosaic floor), Frari (companile and Donatello figure of St John the Baptist), Ca' Rezzonico (Tiepolo ceiling), Scuola di S. Giovanni Evangelista, Scuola di S. Rocco (all Tintoretto's paintings), Scuola dei Carmini, Church of S. Giobbe, Scuola Levantina, Ca' d'Oro (marble frieze), many paintings in the Churches of SS. Giovanni e Paolo, S. Zaccaria, S. Trovaso, S. Giovanni Grisostomo, Madonna dell'Orto.

France
Church of S. Maria della Salute, Ca' d'Oro (two gilded ceilings), Venier Ridotto, paintings in the Churches of the Scalzi, Gesuati, Ateneo Veneto, S. Michele, S. Cassiano, S. Antonio and the Frari.

Germany
Church of S. Maria dei Miracoli, Church of S. Bartolomeo, Palazzo Barbarigo della Terrazza (Deutsches Studien-Zentrum), Church of S. Gregorio (laboratory lighting and equipment), paintings in S. Maria del Giglio.

Great Britain
Church of the Madonna dell'Orto, Church of S. Nicolò dei Mendicoli, Loggetta del Sansovino, Church of S. Gregorio (chemical laboratory and equipment), Porta della Carta.

Australia
Church of S. Martino di Castello (windows).
Switzerland
Church of S. Andrea delle Zirade (roof and *intonaco*), Frari (the 'Lunetta Cornaro' with Venice in Peril).

The future of Venice as living city

A depopulated city?

The physical difficulties facing Venice have received wide publicity. What have been less widely discussed are the social questions. What is the future for Venice as a living city with a flourishing, productive society of its own? For not only are the art treasures and architectural ensemble of Venice under threat, the traditional life of the city, in all its many aspects, is in danger of dying so that the city could become little more than a museum—another form of decay.

How real is this threat?

It is important to try to see the picture as a whole so as to discount one myth. The metropolitan area of Venice, with a population of about 370,000, comprises historic Venice with the islands of the lagoon, the Lido, and the Venetian mainland with the town of Mestre, the port of Marghera and adjoining industrial developments. In addition there is a population of about 120,000 on the periphery of the mainland development so that altogether the conurbation, as it is sometimes called, has a population of about half a million. Against these figures the population of the historic island city of Venice appears to be declining rather rapidly. Some have said in consequence that much of the life is departing from historic Venice, and that many of the younger people have gone to the mainland. For example from 1950 to 1970 there was a drop in population from about 175,000 to about 105,000.*

Yet this gives a somewhat misleading impression. While 123,000 people left the island city between 1951 and 1966, it received 65,000 immigrants. Evidence indicates that many of the former left for industrial employment

* The population of Venice seems to have been fairly constant since the early seventeenth century, when it was estimated at about 158,000. In 1706 it stood at about 143,000, in 1785 at about 139,000, and in 1881 at about 133,000.

on the mainland, and for less costly and more up-to-date living accommodation, whereas many of the immigrants were able to afford the accommodation which had been improved by the landlords. In addition, although about 5,000 residents leave the city every day for work chiefly on the mainland, there are about 17,000 who come into the city each day to work, chiefly from the mainland and the Lido. Venice therefore has a changing population.

A more important aspect of these population figures is that Venice was, after all, an overcrowded city in 1950 and, some would say, still is today. (It is still difficult to find furnished or unfurnished accommodation to rent in the city.) In 1951 there was a great deal of overcrowding and some reduction in population was essential if better space standards were to be obtained. Indeed a survey carried out between 1951 and 1966 showed that the prime cause of depopulation was overcrowded living conditions.

Finding a role in the future

Nevertheless this does not dispel entirely the fear of Venice becoming a museum city. The preservation of its active traditional life is still a problem. When we speak of conservation in Britain we so often think of the architecture and urban setting, but this rarely comprehends the social life that is a vital part of the urban scene and is an important aspect of preservation. With Venice there is always the risk that, although the architectural setting will survive with its art treasures, Venetian life itself will be destroyed. That would be disastrous and efforts must be made to prevent it from happening.

For half the delight to the visitor with more than a passing interest in the city is that the Venetian men and women are an integral part of the ensemble, with physical characteristics like those of the figures that people the canvases of Giorgione, Carpaccio and Tintoretto, and to see them again in the piazzi and narrow ways and on the *vaporetti* is to feel the continuing life of this unique city. Whilst preserving the architecture of the city, it is important to maintain its residential life, to make it easy for Venetians who want to stay there to do so, whilst continuing their way of life. The stage setting has little life without the actors, and if the drama attracts a big audience, as it does and continues to do, then there should be a good participation between the two. Yet today, as in Henry James's time, the least attractive feature of Venice is the tourist. Too many are encouraged by agencies to pay fleeting visits, with guides on how to see the city in a day. An impossibility, while the attempt makes the city less pleasant for the audience as a whole.

Venice as a centre for education and the arts

Many suggestions have been made for the future development of Venice so that its traditional life is maintained with a character of its own, without becoming merely a picturesque tourist city. Among the best that have been discussed is that it should be further developed as an educational and arts centre, international in scope. In this way it could take its logical place in the larger metropolitan Venice with its shipping and harbour facilities, its airport, and its manufacturing industries.

Since the Middle Ages Venice has been a place for festivals and pageants and it would be fitting that it should continue as such. A modern requirement is for attractive congress or conference centres, and what better place in the world for these than Venice, especially if the conferences are related to the arts and sciences. Can it be hoped that Louis Kahn's design for a Congress Hall in the gardens to the east of the city may one day be realized?

Further developments of Venice as an international centre for the arts in the widest sense merits international support and it is good that Unesco is already doing something in this direction. This would bring more life to many of its present activities, such as the periodic exhibitions of the visual arts in many of the *palazzi* and in the Biennale which has held world famous international art exhibitions in the Napoleonic Gardens since 1895. Venice is also a musical centre with one of the finest opera houses in Europe, while concerts are held in some of the *palazzi*. There is scope for enlargement, although ease of accessibility is sometimes thought to be a difficulty. The question of improved communications which is an important part of the future development of Venice has been a subject of discussion for years.

Renovation or rebuilding

Whilst bearing in mind the demand for residential accommodation, it would be possible to convert many buildings for artistic and educational purposes, with some degree of internal remodelling thus preserving the external shell. Already many of the *palazzi* have been converted to different uses. They have been divided into domestic apartments, converted to schools (sometimes with adjoining premises comprehended in the conversion), they have been converted to public and private offices, to store-rooms, showrooms, and in one case to quite a large departmental store with escalators, while the façade still presents the old Gothic windows to the outside world.

Preservation should not be followed at all costs and when deciding whether or not to retain an outer shell, the historic and aesthetic values have to be assessed. An entirely new building in harmony might be

preferable. Venice already has a few twentieth-century buildings that add a note of modern distinction to the scene, among them the fine railway station with its spacious forecourt. On the other hand, it is perhaps a pity that the opportunity of giving a modern, distinctive, yet harmonious note to the Grand Canal was not taken when Frank Lloyd Wright designed a new neighbour for the Palazzo Balbi. A few more good modern buildings could well replace some of the derelict buildings that have little architectural merit. Indeed a programme of new building would itself serve to give life to Venice for there are many needs that, with an enlightened administration, exist to be satisfied. The project for a hospital on a site on the north side of the city, designed by Le Corbusier, if undertaken, would not only be answering a need but would give a further modern note of distinction to the city. The Arsenal, once the centre of much activity, could be revived to new life in many ways.

The suggestion that Venice should develop further as an educational and arts centre does not mean that other traditional activities should not continue. It has numerous public offices, banks, insurance companies and shipping offices, which obviously like to be maintained and probably enlarged in the historic centre.

Venice as a craft centre

Another suggestion for the development of Venetian life is the provision of facilities to enable craftsmen to continue their traditionl crafts: glass making with the recent successful excursions into glass sculpture, mosaic work of various kinds, furniture, stucco works, lace making and many others. To stimulate the traditional work of Venetian craftsmen there could be a craft centre, as in London, with periodic exhibitions. If necessary the state or municipality should make such premises possible, for in the long run this would be in their own interest.

The fostering of crafts does not necessarily mean their separation from industry, since the prototype created by the artist-craftsman can be reproduced by industrial process on the Bauhaus principle, but the survival of the artist craftsmen is the essential. Joan Fitzgerald, a sculptor, comments (*Sunday Telegraph*, 10 September 1972) that life depends on people far nearer the roots of Venice than the high-powered cultural visitors and, in particular, on the native craftsmen. Artistic vitality in Venice depends on the encouragement of the artisans. The great funds will spend 100,000 dollars on a church floor, but nothing on helping a wood carver to retain his lodgings.

An industrial solution?

It has been suggested that there is inevitable conflict between the preserva-

tion of the historic city and the progressive industrial port of Venice on the mainland. The world needs both modern expanding industry and the conservation of areas of historic and aesthetic value to humanity, and it would be a much poorer world if one is sacrificed to the other. Where, however, they are in close proximity and would appear therefore to have conflicting interests, the claims of both have to be considered very carefully so as to decide what measures of give-and-take there should be. The claims of historic Venice are widely acknowledged by the world. The claims of industry are more restricted to Italian industrialists and their employees.

There are dreams of many Venetians, including prominent officials of the city, that Marghera should surpass Rotterdam and become Europe's greatest port. Rotterdam has become the largest port in the world, mainly because harbours have been provided for larger and larger oil tankers and such should, it is argued, be the provision at Venice. It will be necessary perhaps to provide even deeper channels through the lagoon to accommodate them. The dream is that great oil tankers should bring petroleum from the Middle East into the harbours at Marghera, and then be transported along a new autostrada to Munich or another European centre. Italian industrialists would dislike such transportation to be through Yugoslavia, as they are anxious that it should be kept for the free world, but those political arguments are of doubtful validity.

The question should be asked, are not these ambitions nourished by antiquated thinking? By making provision for huge oil tankers to enter the lagoon are they not planning for something that will become obsolete by, say, the year 2000. Already the transportation of oil over long distances is carried out partly by pipes, and this is developing. (There is an oil pipeline from Trieste to Ingolstadt with a branch to Vienna. What is more, tankers could easily discharge outside the lagoon into pipelines as at Trieste, thus making it unnecessary for them to enter the lagoon.) It is possible that, by the year 2000, most of the world's oil supplies will be by a network of pipes crossing the world. That is surely a more profitable way of thinking than making provisions for bigger and bigger tankers which could well be transformed into white elephants in due course.

The challenge facing Venice is formidable, but the appeal of the city has for centuries been international and has inspired international help, for many countries have now responded with help to Italy in the task of restoring and preserving its treasures. This worldwide response inspires confidence that Venice will survive—and in better condition than for the last two centuries—for future generations to enjoy.

Arnold Whittick

Bibliography

Note: With the exception of the Sansovino and Selvatico/Lazari *Guides*—both mentioned by Ruskin—only works in English (either originally or in translation) have been included.

(1) WORKS BY RUSKIN RELATING TO VENICE

The Stones of Venice, Volume I, London: Smith, Elder & Co, 1851
The Architecture of Venice, selected and drawn from the edifices, 1851, London: Smith, Elder & Co
The Stones of Venice, Volumes II and III, 1853
The Stones of Venice, Second edition, Volume I, 1858
The Stones of Venice, Second edition, Volumes II and III, 1867
The Stones of Venice, Third edition, 1874
The Stones of Venice, Traveller's abridged edition in two volumes, 1879. This went into several subsequent editions.
The Stones of Venice, Fourth edition, Orpington: George Allen, 1886. This was the last edition to have been revised by Ruskin.
The Stones of Venice, edited by J. G. Links, 1961, Collins. A recent abridgment in one volume.

Modern Painters, Volume I, 1843; Volume II, 1846; Volumes III and IV, 1856; Volume V, 1860; London: Smith, Elder & Co. There are numerous subsequent editions of each volume. Each volume contains references to the works of Venetian painters (Volumes III–VI of the Library Edition of Ruskin's works—see below).
Seven Lamps of Architecture, 1849; Second edition, 1855; London: Smith, Elder & Co. There are numerous subsequent editions (Volume VIII of the Library Edition).
The Relation between Michael Angelo and Tintoret, London: Smith, Elder & Co, 1872. This was the seventh in a course of lectures given at Oxford 1870–71 (Volume XXII of the Library Edition). The whole course was published as *Aratra Pentelici* in 1872 (Volume XX of Library Edition).
Guide to the Principal Pictures in the Academy of Fine Arts at Venice, First edition in two parts, 1877; Second edition in two parts, 1882–83; Third edition in one part, revised and corrected by Alexander Wedderburn, 1891,

Orpington: George Allen. This is included in Volume XXIV of the Library Edition.

St Mark's Rest: A History of Venice—written for the help of the few travellers who still care for her monuments. Originally written in three parts with two supplements and an appendix (1877, 1879 and 1884) and first published as a complete volume in 1884, Orpington: George Allen. Second revised edition, 1894. There have been numerous subsequent editions. This is included in Volume XXIV of the Library Edition.

The work is divided into eleven chapters. Chapter IX—'Sanctus, Sanctus, Sanctus'—is an account of the mosaics in the Baptistry of St Mark's by A. Wedderburn, and edited by Ruskin. It is, as Wedderburn says, 'a catalogue of the mosaics in the Baptistry written in 1882 and sent to Ruskin as a contribution to his collected records of the church'. Chapter XI—'The Place of the Dragons' by James Reddie Anderson (with a preface by Ruskin reflecting on his feelings with advancing age)—is a description of the Scuola di S. Giorgio degli Schiavoni, which contains a number of paintings by Carpaccio, among which are three representing the legend of St George and the dragon.

Fors Clavigera—Letters to the Workmen and Labourers of Great Britain, four volumes, Orpington: George Allen, 1871–84. There are many references to Venice in these letters, and several were written from Venice in 1876–77 when Ruskin was staying at what is now the Pensione Calcina. In letters 77 and 78 some further descriptive comments are given of capitals of the Ducal Palace (Volumes XXVII–XXIX in the Library Edition).

Praeterita—outlines of scenes and thoughts perhaps worthy of memory in my past life, three volumes, Orpington: George Allen, 1885–86. An autobiography covering the early years of Ruskin's life from 1819–64. There are some allusions in this work to the writing of *The Stones of Venice* (Library Edition Volume XXXV).

A *collected edition* of some of Ruskin's works was published in eleven volumes in 1871–83, by George Allen (Orpington). These are mainly of lectures on art and crafts, on political economy, and related subjects.

The *Library Edition* of Ruskin's works, edited with notes by E. T. Cook and Alexander Wedderburn, was published in thirty-nine volumes in 1903–12, London: George Allen. *The Stones of Venice* forms Volumes IX–XI. *The Examples of the Architecture of Venice,* first published separately in 1851 in conjunction with the first volume of *The Stones of Venice,* was included at the end of Volume XI of the Library Edition, to a reduced page size.

(2) SOME BOOKS ON RUSKIN

Ruskin has attracted a considerable literature, including many biographies. A brief selection is given below.

W. G. Collingwood, *The Life and Work of Ruskin,* two volumes, London: Methuen, 1893. The most exhaustive early biography. A fully revised edition was published in 1900.

Among the best of other early biographies are:

E. T. Cook, *The Life of John Ruskin*, two volumes, London: George Allen, 1911

Frederic Harrison, *Ruskin*, London: Macmillan, 1902

Alice Meynell, *Ruskin*, London: Blackwood, 1900

H. Spielman, *Ruskin*, London: Cassell, 1900

A. Wingate, *Life of Ruskin*, London: Walter Scott, 1910

Among later biographies are:

D. Larg, *John Ruskin*, London: Peter Davies, 1932

Derrick Leon, *Ruskin—The Great Victorian*, London: Routledge & Kegan Paul, 1949. An excellent biography giving a vivid picture of its subject, selecting the really significant points and making fair assessment of controversial matters.

John D. Rosenberg, *The Darkening Glass—A Portrait of Ruskin's Genius*, Columbia University Press, 1961; and London: Routledge & Kegan Paul, 1963. A thesis on the sources of Ruskin's ideas and a psychological study of his mind.

Of special interest for Ruskin's life in Venice are:

Mary Lutyens (editor): *Effie in Venice: Unpublished Letters of Mrs John Ruskin written from Venice between 1849–52*, London: John Murray, 1965. These letters, together with Mary Lutyens' notes, give an interesting picture of how Ruskin and his wife lived during their time in Venice, and of the social life there which Effie enjoyed, and of which John saw less, being intent on his work on *The Stones of Venice*.

R. de la Sizeranne, 'Ruskin in Venice', London: George Allen, 1906

Count A. Zorzi, 'Ruskin in Venice', *Cornhill Magazine*, August–September 1906

Among other recent books are:

James S. Dearden, *Facets of Ruskin: Some Sesquicentennial Studies*, London: Charles Skilton, 1970. This contains chapters on Ruskin's homes in London and Brantwood, and on the Ruskin Galleries at Bembridge School, Isle of Wight, of which the author is curator.

Kristine O. Garrigan, *Ruskin on Architecture: His Thought and Influence*, Wisconsin University Press, 1973

J. Howard Whitehouse, *Ruskin the Painter and his Works at Bembridge*, London: Oxford University Press, 1938. This gives notes of 345 drawings and watercolours of Ruskin, including several of Venetian buildings, in the Galleries at Bembridge.

For an assessment of the literary significance of Ruskin's writing:

Graham Hough, *The Last Romantics*, London: Duckworth, 1949

On the occasion of the Ruskin Centenary Exhibition at the Royal Academy, London, in 1919, lectures were given by Bernard Shaw, John Masefield, W. R. Inge, H. W. Nevinson, Arthur Severn and J. Howard Whitehouse,

which were subsequently published under the editorship of the latter in 1920 by George Allen & Unwin (London).

(3) HISTORY OF VENICE

Maurice Andrieux (translated by Mary Fitton), *Daily Life in Venice in the Time of Casanova*, London: George Allen & Unwin, 1972

Horatio F. Brown, *Venice—An Historical Sketch of the Republic*, London: Percival & Co, 1893

Horatio F. Brown, *Studies in the History of Venice*, London: John Murray, 1907

Milton Grundy, *Venice Recorded*, London: Blond, 1971

W. C. Hazlitt, *The Venetian Republic*, London: A. & C. Black, 1900

F. C. Hodgson, *The Early History of Venice, from the foundation to the conquest of Constantinople, AD 1204*, London: George Allen, 1901

F. C. Hodgson, *Venice in the Thirteenth and Fourteenth Centuries, from the conquest of Constantinople to the accession of Michele Steno, AD 1204–1400*, London: George Allen, 1910

P. G. Molmenti (translated by Horatio F. Brown), *Venice—Its Individual Growth from the Earliest Beginnings to the Fall of the Republic*, London: John Murray, 1906–08. This work is in six volumes and falls into three parts: (1) The Middle Ages; (2) The Golden Age; (3) The Decadence.

Philippe Monnier, *Venice in the Eighteenth Century*, London: Chatto & Windus, 1910

Thomas Okey, *The Story of Venice*, London: Dent, 1914

W. R. Thayer, *A Short History of Venice*, London: Macmillan, 1905

(4) ART AND ARCHITECTURE

Edoardo Arslan (translated by Anne Engel), *Gothic Architecture in Venice*, London: Phaidon, 1971

Bernhard Berenson, *The Venetian Painters*; this was later published together with other works as *Italian Painters of the Renaissance*, Glasgow: Collins, 1969; and London: Phaidon, 1968 (see Volume I: 'Venetian and North Italian Schools')

Tancred Borenius, *The Painters of Vicenza, 1480–1550*, London: Chatto & Windus, 1909

G. B. Cavalcaselle and Sir Joseph A. Crowe, *History of Painting in North Italy*, three volumes; revised edition edited by Tancred Borenius; London: John Murray 1912

W. G. Constable, *Canaletto*, Oxford: Clarendon Press, 1962. Descriptions of all the paintings and drawings of Canaletto known to the author; in two volumes.

Herbert Cook, *Giorgione*, London: Bell, 1900

Roger Fry, *Giovanni Bellini*, London: Unicorn Press, 1899

Georg Gronau (translated by Alice M. Todd), *Titian*, London: Duckworth, 1904

Michael Levey, *Painting in Nineteenth Century Venice*, London: Phaidon, 1959

P. G. Molmenti and G. Ludwig (translated by R. H. H. Cust), *The Life and Works of Vittore Carpaccio*, London: John Murray, 1907

Vittorio Moschini, *The Galleries of the Academy of Venice*, Rome: Istituto Poligrafico dello Stato. A small guide published in several languages; it is periodically up-dated.

Walter Pater, 'The School of Giorgione', first published in the *Fortnightly Review*, October 1877, and included in the collected essays *The Renaissance*, London: Fontana, 1973

E. M. Philips, *Tintoretto*, London: Methuen, 1912

E. M. Philips, *The Venetian School of Painting*, London: Macmillan, 1912

Unesco, *The Courier*, December 1968 issue is mainly devoted to Venice

Unesco, *Venice Restored*, Paris, 1973. An account of restoration work on buildings, sculpture and paintings in Venice which has been undertaken by various countries in recent years.

Giuseppe Ungaro, *The Basilica of the Frari, Venice*, published by the Fraris

Giorgio Vasari, *The Lives of the Painters, Sculptors and Architects*. This work, completed in 1547 and published in 1551, is the source of much of our information about Italian art of the Renaissance, although for any detailed study the information given by Vasari should be verified, where possible, by that from other sources.

The first edition was followed by numerous Italian editions, some with commentaries. The first complete English edition was by Mrs J. Foster (London, 1850). More recently an 'Everyman' edition was published with a translation by A. B. Hinds (London: Dent); and another translation, by G. Bull, is available in Penguin (Harmondsworth, 1970).

Vasari was a Florentine, and it is perhaps understandable that his lives of Venetian artists are rarely so full as those of Florentine artists. He considers Jacopo, Giovanni and Gentile Bellini in one short essay, and Giorgione in a very scant bibliography. He is more generous in his treatment of Michele San Michele, Titian and Jacopo Sansovino. Tintoretto and Veronese were younger contemporaries of Vasari and were active too late for him to devote much attention to them. There are notes on both artists at the end of Vasari's biography of Francesco Franco.

Johannes Wilde, *Venetian Art from Bellini to Titian*, Oxford: Clarendon Press, 1975

Architectural Review, special number on Venice, Vol CXLIX, No 891, May 1971. The principal contents are: 'Prologue'—James Morris; 'Venice in Perplexity'—Abraham Rogatnick; 'Threats to the Fabric of Venice'; 'Housing Study'—John Gaitanakis; 'The Humble Venetian House'— E. R. Trincanato; 'Rediscovering the Palazzo'—Giorgio Bellavitis; 'Traditional House Construction'—Mario Pavanini; 'The Nineteenth Century's Contributions'; 'The Politics of Rescue'; 'The New Scale of the City'; 'Three Profiles'; 'Present Architecture'; 'Future of the Biennale'.

(5) GUIDEBOOKS

Karl Baedeker, *Northern Italy*, numerous English editions 1899–1930 (fifteenth edition). A thorough guide in a compact form; Baedeker's guides have numerous imitators but rarely are they as good.

Hugh Douglas, *Venice on Foot*, London: Methuen, 1907

Augustus J. C. Hare, *Venice*, London: George Allen, 1891

Hugh Honour, *Companion Guide to Venice*, Glasgow: Collins, 1965

J. G. Links, *Venice for Pleasure*, London: Bodley Head, 1966

Giulio Lorenzetti (translated by John Guthrie), *Venice and its Lagoon*, Rome: Istituto Poligrafico dello Stato, 1961. This is the most complete and detailed guidebook to Venice in English.

Teriso Pignatti, *Venice* (World Cultural Guides series), London: Thames & Hudson, 1971

Stuart Rossiter (editor), *Blue Guide to Northern Italy*, Sixth edition 1971, London: Ernest Benn

John Ruskin, *A Guide to the Principal Pictures in the Academy of Fine Art*. For further details, see section (1) above.

Francesco Sansovino, *Venetia citta nobilissima et singolave descritta*, 1581. This was the first comprehensive guide to the city, and was the source of much information for subsequent guide books. A second edition, revised by Stringa, was published in 1604, and a further edition with commentary by Giustiniano Martinioni was published in 1663. A facsimile of his edition was published by Gregg International Publishers in 1969.

 Francesco Sansovino (1521–1583) was the son of Jacopo Sansovino (1486–1570) the famous architect and sculptor. Ruskin refers several times in his chapter on the Ducal Palace to Francesco Sansovino as a source of information.

P. Selvatico and V. Lazari, *Guida artistica e storica di Venezia e delle isole circonvicine*, Venice, Milan and Verona, 1852

Ronald Shaw-Kennedy, *Art and Architecture in Venice—The Venice in Peril Guide*, London: Sidgwick & Jackson, 1972

(6) GENERAL WORKS

Horatio F. Brown, *In and around Venice*, London: Rivingtons, 1905

J. R. Hale, 'Quattrocento Venice' in *Cities of Destiny*, London: Thames & Hudson, 1967. An excellent essay on the greatest Venetian period in history.

Henry James, *Italian Hours*, Boston: Houghton Mifflin; and London: Heinemann, 1909 The first three essays—written in 1872, 1882 and 1892—are on Venice.

James Morris, *Venice*, London: Faber & Faber, 1960

Michelangelo Muraro (introduction by Peggy Guggenheim), *Invitation to Venice*, London: Paul Hamlyn, 1963. A mainly illustrative book with detailed captions.

Index

ITALIC REFERENCES DENOTE ILLUSTRATIONS